Art of Celebration

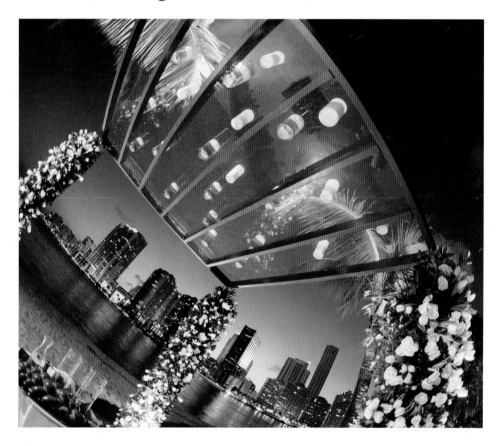

THE MAKING OF A GALA—SOUTH FLORIDA STYLE

Published by

P A N A C H E P A R T N E R S

Panache Partners, LLC
1424 Gables Court
Plano, TX 75075
469.246.6060
Fax: 469.246.6062
www.panache.com

Publishers: Brian G. Carabet and John A. Shand

Printed in Malaysia

Distributed by Independent Publishers Group
800.888.4741

PUBLISHER'S DATA

Art of Celebration South Florida

Library of Congress Control Number: 2009930912

ISBN 13: 978-1-933415-74-1
ISBN 10: 1-933415-74-6

First Printing 2010

10 9 8 7 6 5 4 3 2 1

Panache Partners, LLC, is dedicated to the restoration and conservation of the environment. Our books are manufactured using paper from mills certified to derive their products from environmentally managed forests. We are committed to continued investigation of alternative paper products and environmentally responsible manufacturing processes to ensure the preservation of our fragile planet.

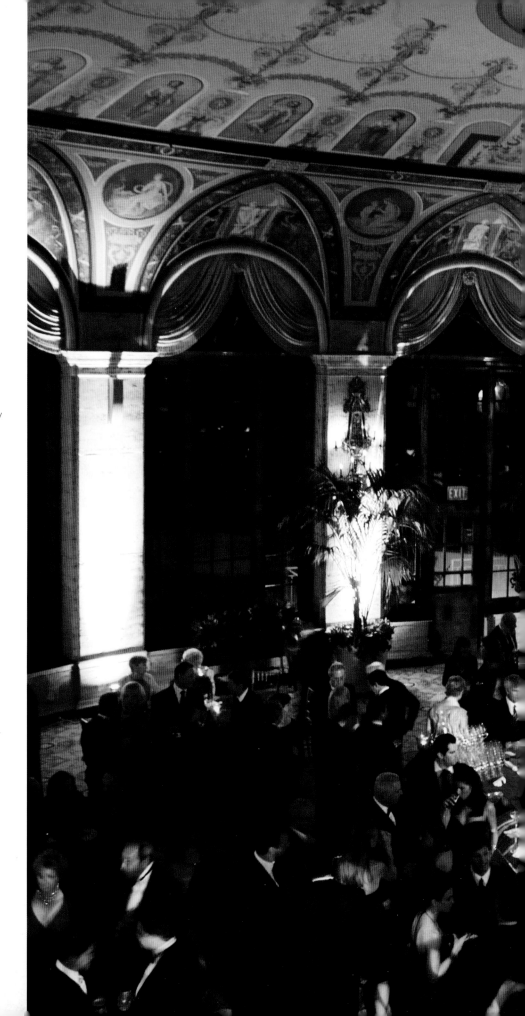

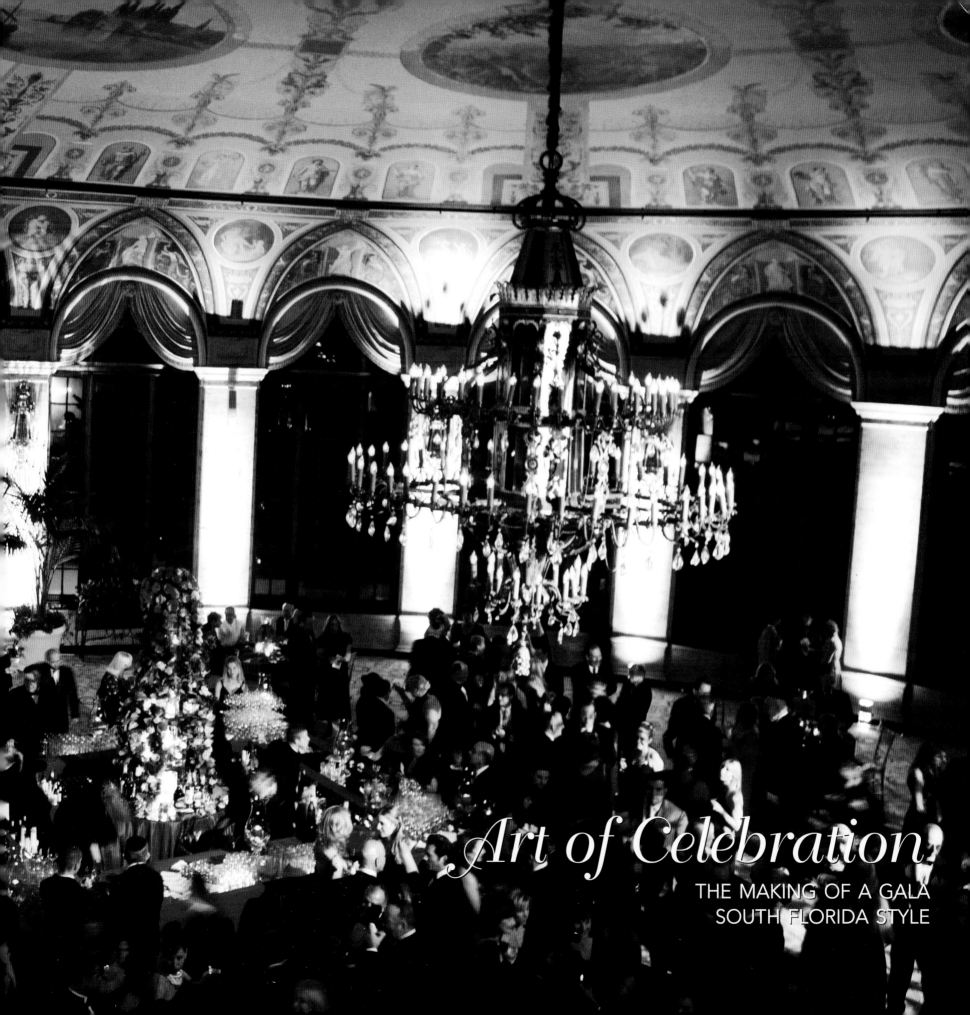

Art of Celebration

THE MAKING OF A GALA
SOUTH FLORIDA STYLE

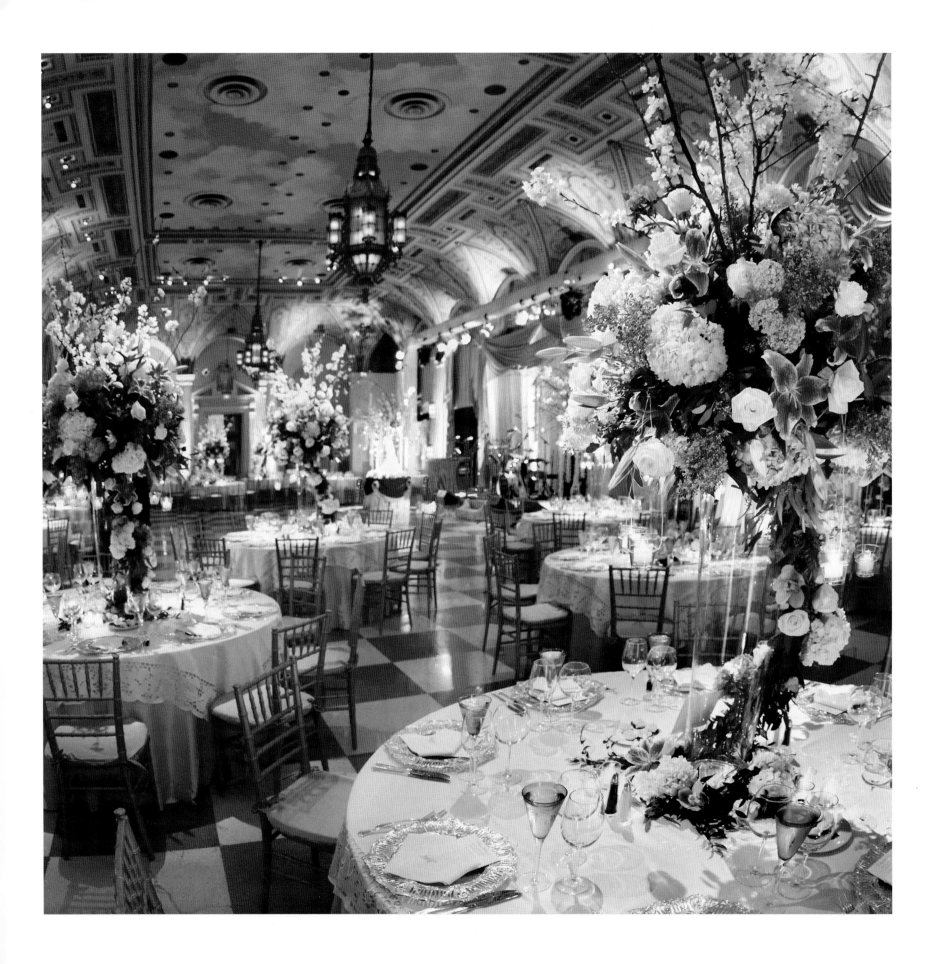

INTRODUCTION

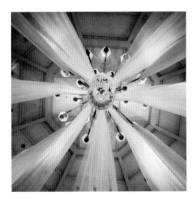

Celebrations are woven into our lives from the moment we are born; rituals have existed since the inception of mankind. How we celebrate identifies cultures, kingdoms, milestones, rites of passage, even faith. The undertaking of such events has always required the vision of a select few, the work of many and the motivation of all.

In *Art of Celebration: The Making of a Gala—South Florida Style*, we celebrate and document the region's elite, modern-day visionaries who have made it their life's purpose to mastermind and create remarkable events that will forever become the memories of those they have touched.

It is with great collaboration that the magic of a phenomenal celebration is achieved. Throughout the pages of this book, we take you on a journey, sharing the insights and creations of these gifted few. We start this journey with the event planners, the directors and producers who pull it all together, manage and execute the visions even Before the Music Begins. And because once you've set the date, the next step is Location, Location, Location, we turn our focus to South Florida's most incredible venues, which become inspirational backdrops. From there, it's all in the details. The event, floral and lighting designers are true visionaries of Creating an Ambience. Their passion and love for what they do and the emotional impact it has on every guest is paramount to the magic they create. Eat, Drink & Be Merry in the culinary world of the caterer, as works of art and ingenious creations delight the palate and astound the mind. Finally, Capturing the Moment in these celebratory events includes musicians and entertainers as well as the amazingly talented photographers and videographers who literally capture the memories that forever keep alive the experiences of life's ritual—the Art of Celebration.

This book represents a collection of talents never before assembled in one book. Their collective work at its least will inspire and inform and at its best will take your breath away!

Carpe diem and celebrate!

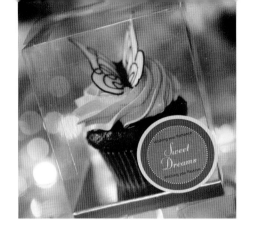

CONTENTS

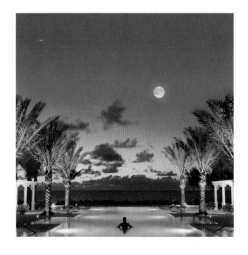

CHAPTER FOUR—EAT, DRINK & BE MERRY

CHAPTER FIVE—CAPTURING THE MOMENT

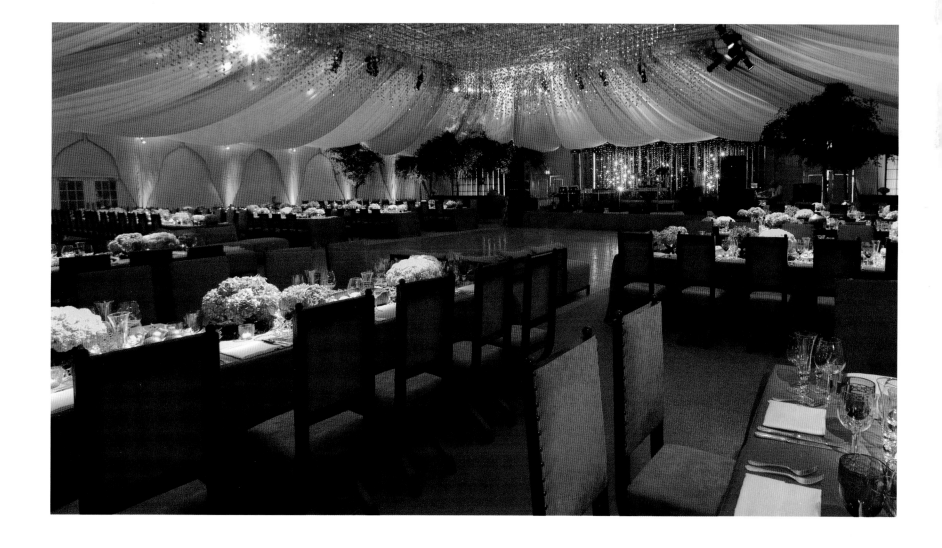

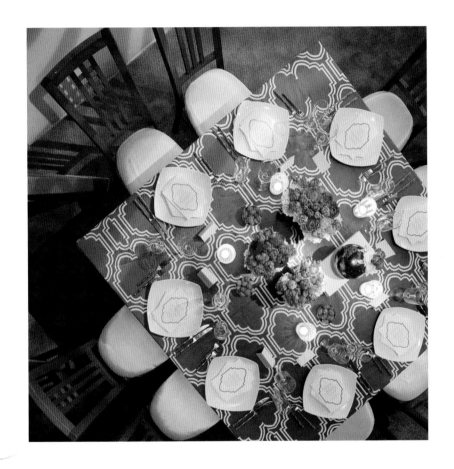

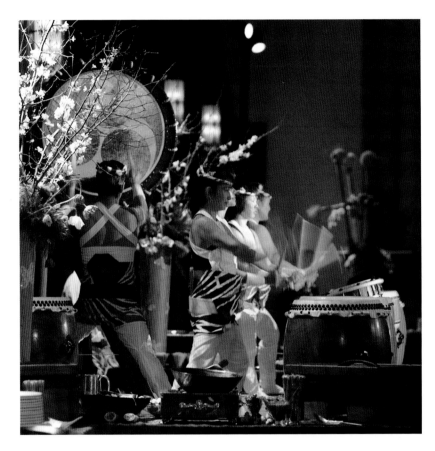

"To come up with truly original ideas, you have to look at the world in a different way."

—Jose Graterol

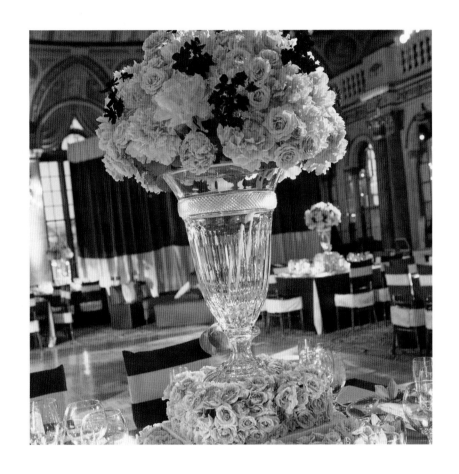
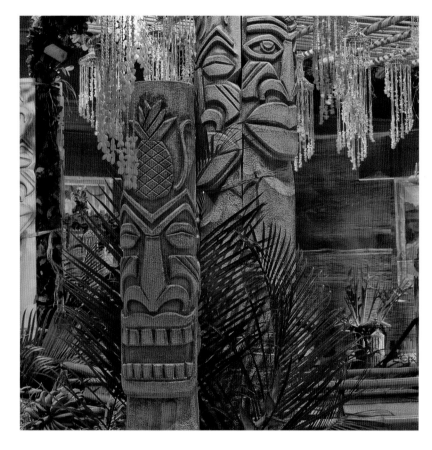

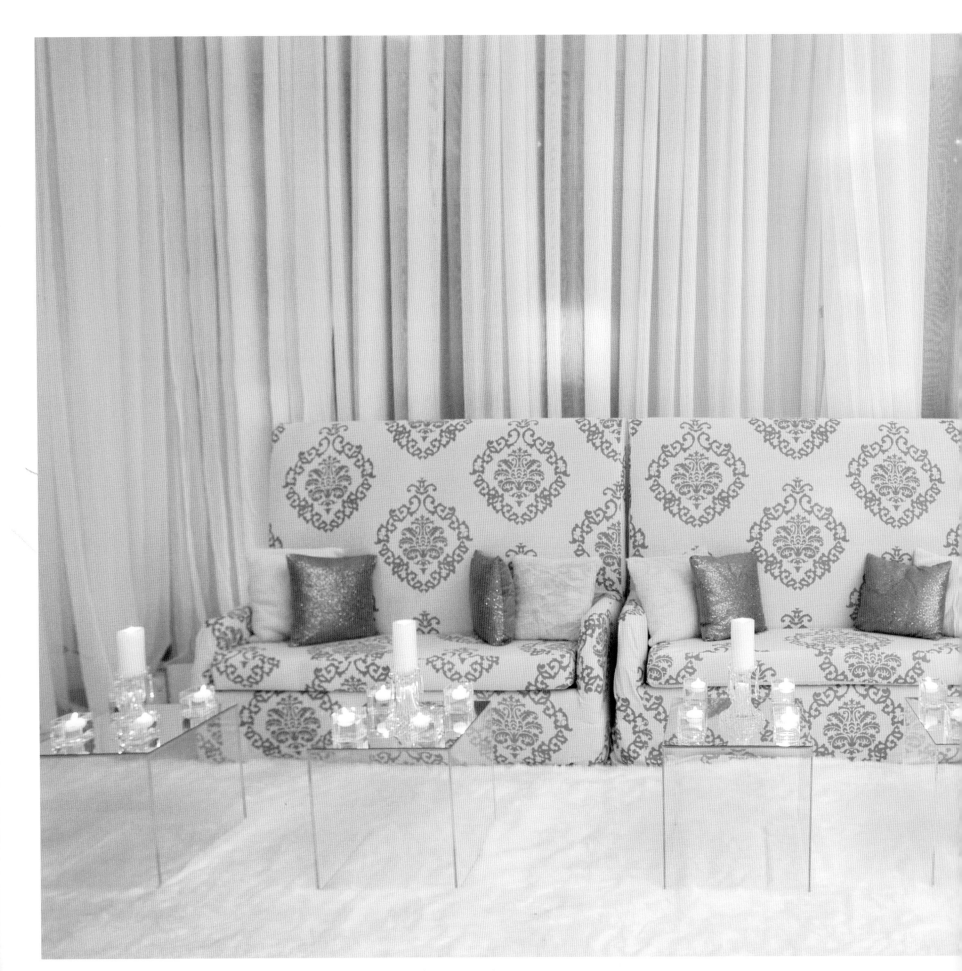

"When simple and elegant is the look you want to convey, attention to detail is vital."

—Kelly Murphy

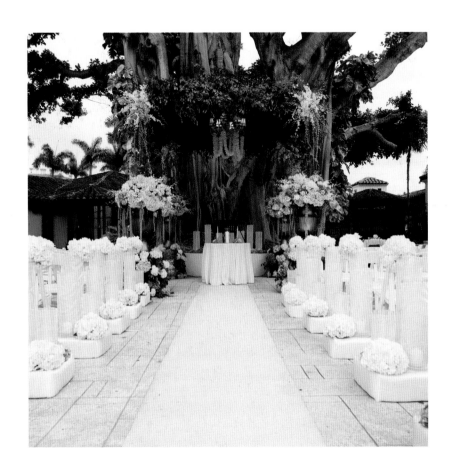

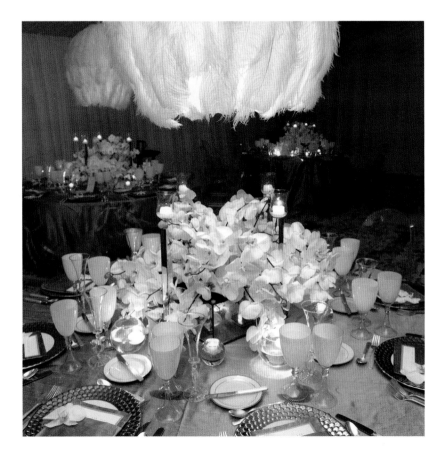

"The more eclectic, the better. People will remember it."

—Karen Cohen

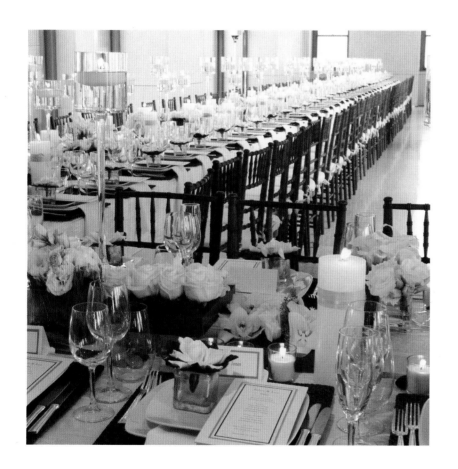

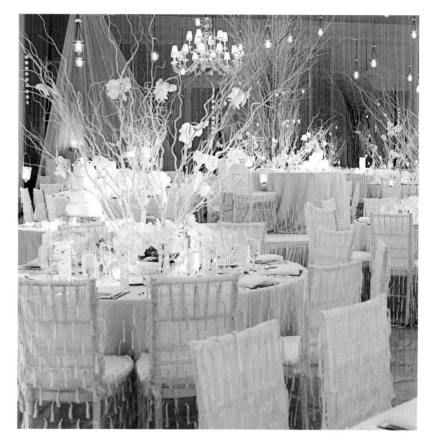

Before the

NOVEMBER 4, 2006

LOVE

PALM BEACH, FLORIDA

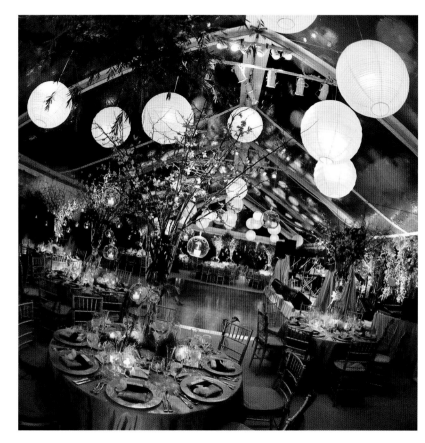

Music Begins

DAZZLE CREATIVE EVENTS

JAMES S. ROTA | DON MASSETTI | SHERRI FUCHS

The team at Dazzle Creative Events treats each of their events as a grand production. They offer creative and professional services in all phases of meeting and event planning and management. With varied backgrounds, including hotel and restaurant management, interior design, display design, vendor relations and human resources, founder James S. Rota and partners Don Massetti and Sherri Fuchs have more than 40 years of combined experience. Fortunate to gain clients expressly through word-of-mouth, the trio works with multiple generations of Palm Beach's most prominent residents as well as a worldwide clientele. They nurture professional enthusiasm that challenges and utilizes creative energy and expertise, with their clients' successful events as the common goal.

Their combined strengths have produced successful, award-winning events throughout the world as a result of their high standards and attention to the smallest of details. Each Dazzle-produced event is designed to leave a lasting impression on every guest. Whether those details involve a corporate rollout with a large budget to match or a private dinner party, the consideration is just the same. At least one of them is on-hand from start to finish of every event. Committed to innovative creativity in tandem with exceptional service, James, Don and Sherri know that every client's event should be unique. Their talent, wisdom, professional experience and, of course, ability to keep calm, cool and stay focused in times of high stress have earned them a loyal following.

Some events call for what can only be described as a "logistical ballet." You can't tell from the photo, but the same room where this reception took place actually held the beautiful ceremony just an hour before. It was an amazing party for a dear client's daughter. She uses Dazzle exclusively and trusted us enough to give us carte blanche. Live music was provided by a well-known band that was flown into Palm Beach from Los Angeles. Events like these are perfect examples of how critical an event planner is to the success of an event. We had to carefully time each vendor to take down their specific contribution to the ceremony, while at the same time allowing others to assemble their elements of the reception; precision was key. While the guests attended a poolside cocktail reception and fireworks display, the room transformation was taking place. Every detail was attended to; nothing was left to chance.

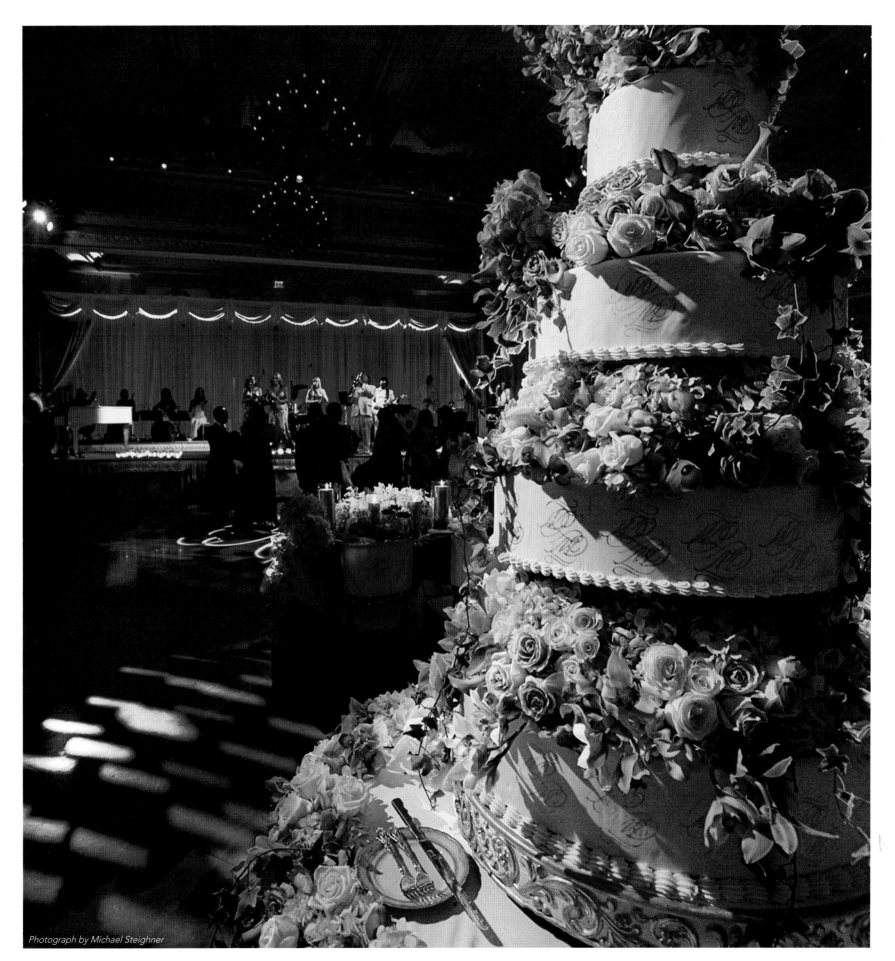

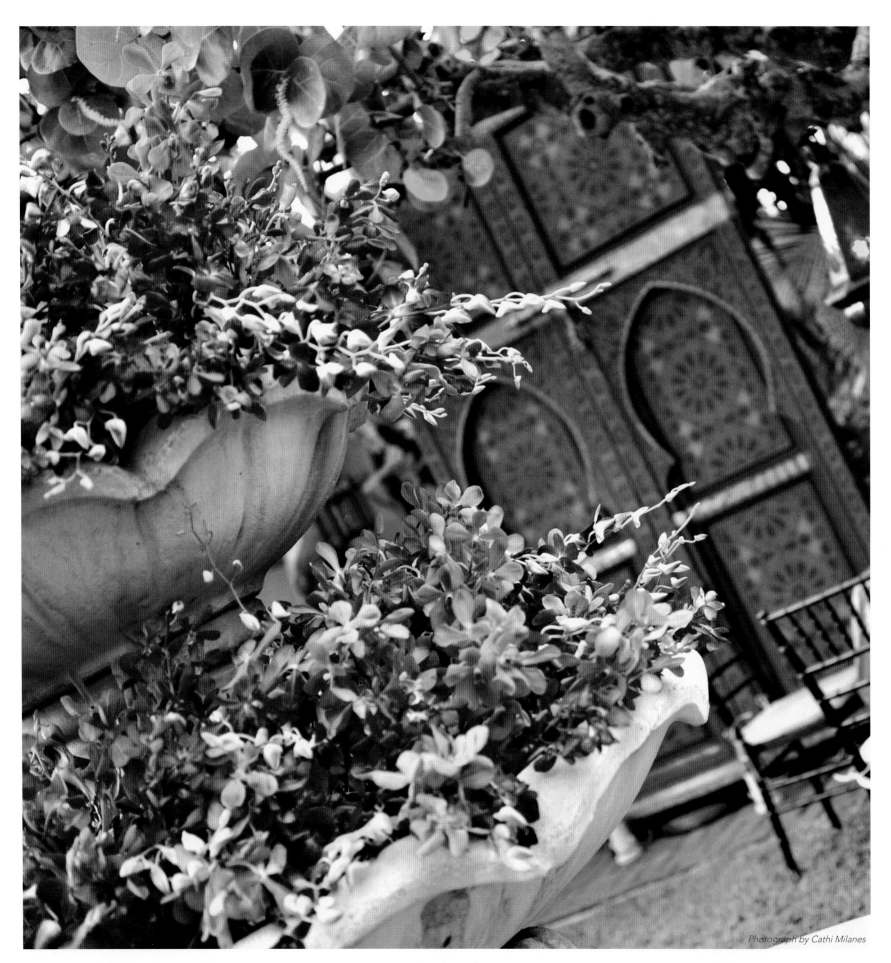

Creating the atmosphere takes a lot of work and imagination, but it is always worth it. Inspired by the client's love of world travel and her favorite color—purple—we planned a Moroccan-themed party with textiles rich in purples, reds and exotic flair. As guests arrived via a chartered trolley car, they were greeted by beautiful belly dancers in multicolored costumes. The party took place at the host's gorgeous historic Palm Beach estate where thousands of colorful fresh orchid blossoms and authentic Moroccan furnishings decorated the backyard. We had one obstacle: the pool. In order to entertain a group this size, we needed to cover it. So four days prior to the celebration, scaffolding was erected from the bottom of the pool up to create a floor. Then, a huge tent was placed over the entire pool and sitting area. The pool was then illuminated from below for the evening. The final effect was exactly what we were hoping for. It was both captivating and stunning.

Photograph by Cathi Milanes

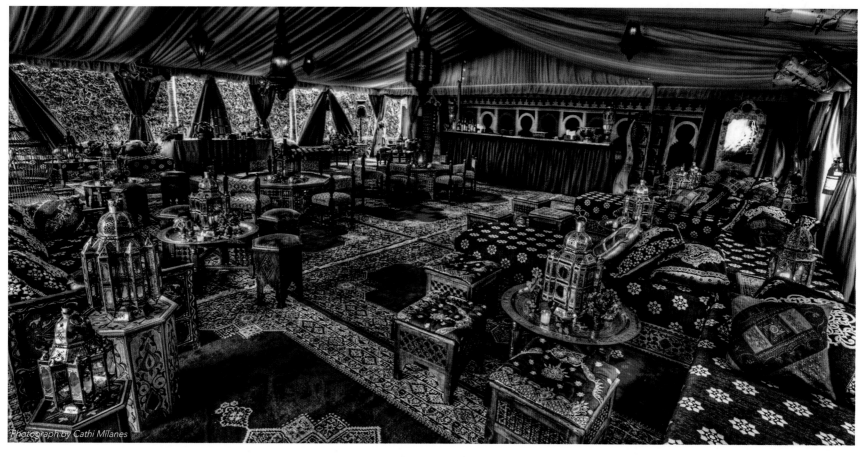

Photograph by Cathi Milanes

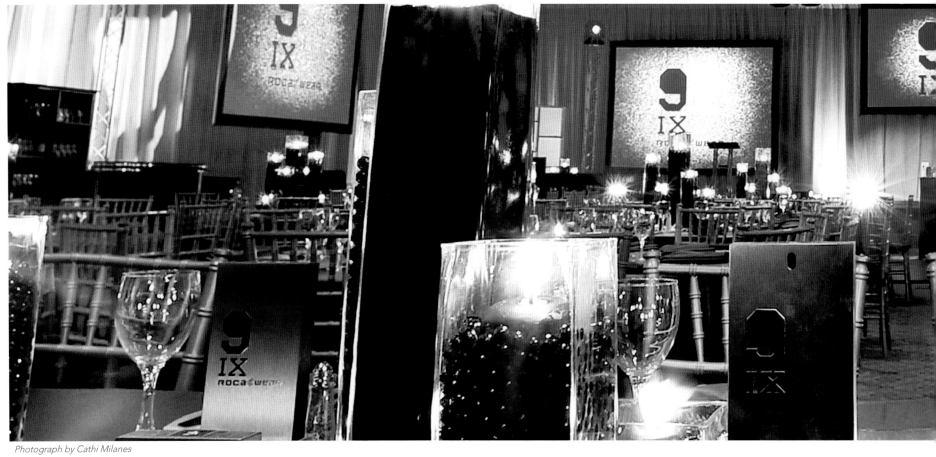

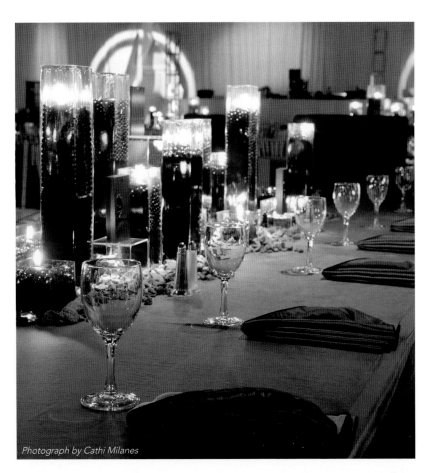

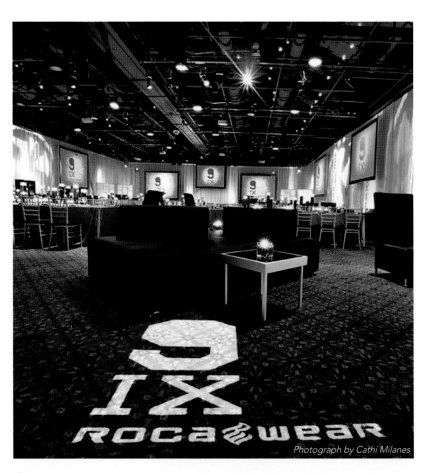

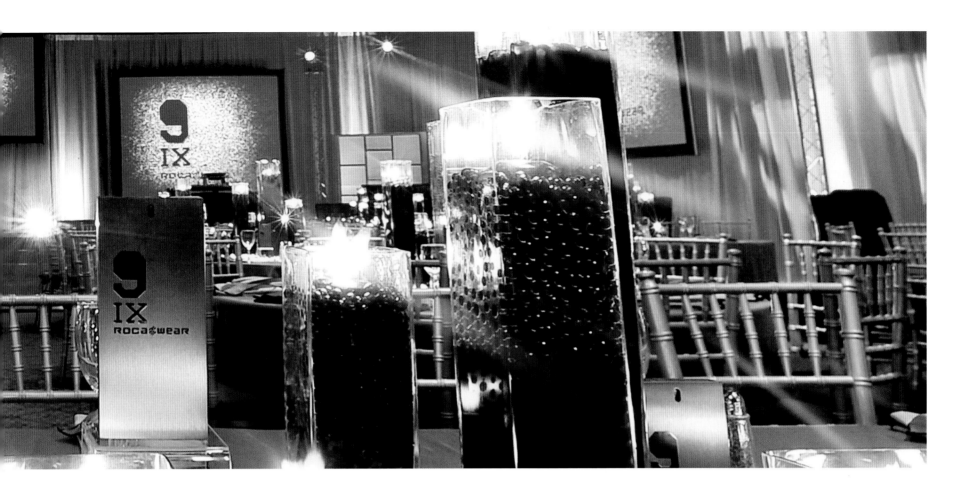

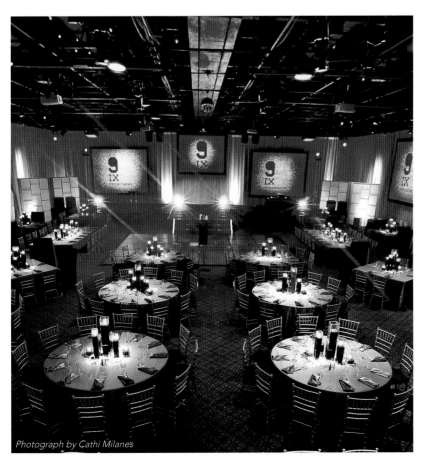

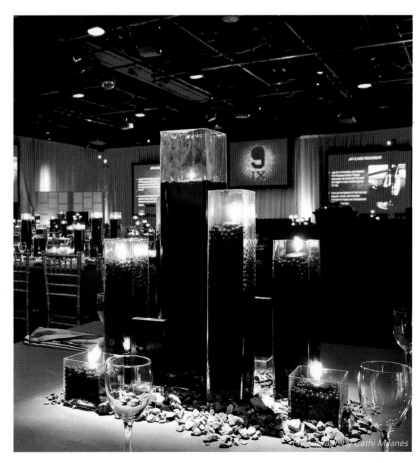

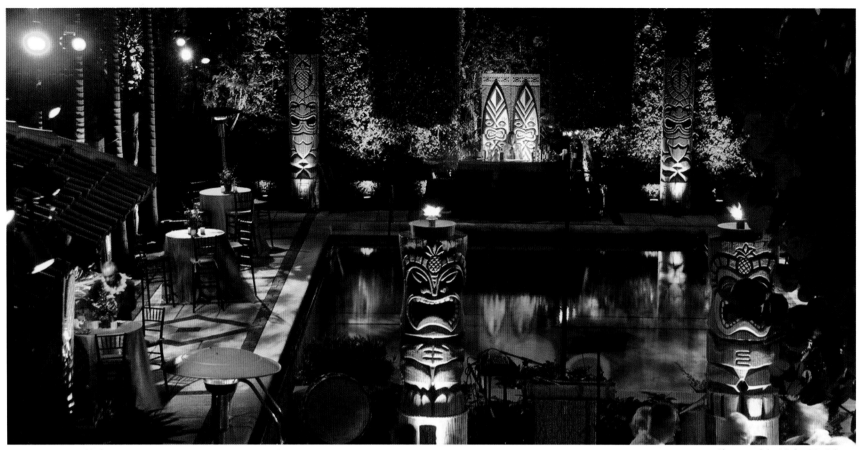

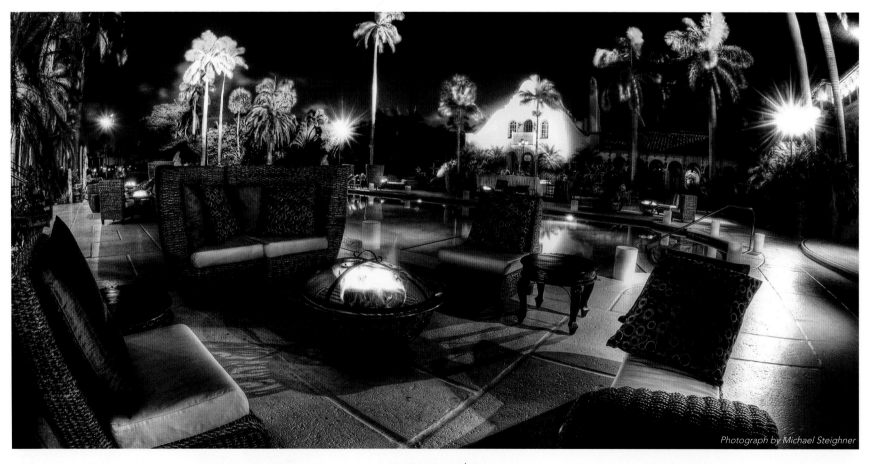

Photograph by Cathi Milanes

"When working in tandem with corporate organizations, the goal is to set the stage to motivate, educate and maximize brand awareness."

—Sherri Fuchs

Right: Color plays an important role in event design. This is especially true with new product launches. The obvious femininity of these products is celebrated at a Juicy Couture event (above) and a Britney Spears Fantasy event (bottom).

Facing page top: We helped a loyal client open her home for a charity event with a Polynesian flair in support of the Christian Appalachian Project. Guests were delighted by fire dancers, as well as 10-foot-high tiki statues and décor that were cleverly carved out of lightweight foam especially for this event.

Facing page bottom: The after party has become as important as the party itself. It's a great segue for guests to continue to enjoy themselves and visit with friends while winding down. The atmosphere we create is obviously different; it's more relaxing as opposed to the high-energy party they just experienced.

Previous pages: We love the diversity of projects that we have the privilege of being a part of. Corporate launch parties are a great way to flex our creative muscle. For a sales summit and fashion show to introduce a new men's fragrance by musician Jay Z, we created a very urban atmosphere. The brand came alive through cutting-edge lighting and nine huge video screens. Drawing our color inspiration from the product packaging, we commissioned the linens to be made of gunmetal colored dupioni silk. In lieu of traditional centerpieces, glass cylinders in assorted sizes were placed on the tables, like modern art representing an urban skyline. The party continued into the night, allowing guests to enjoy the club environment and its many lounges.

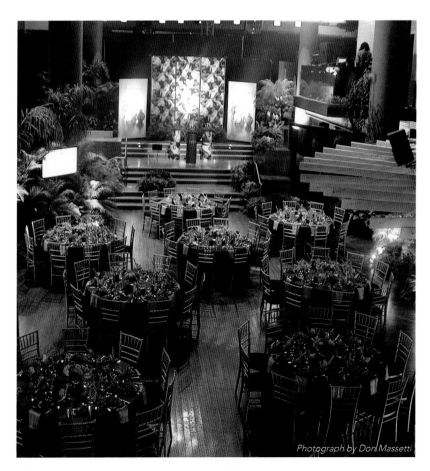

Photograph by Don Massetti

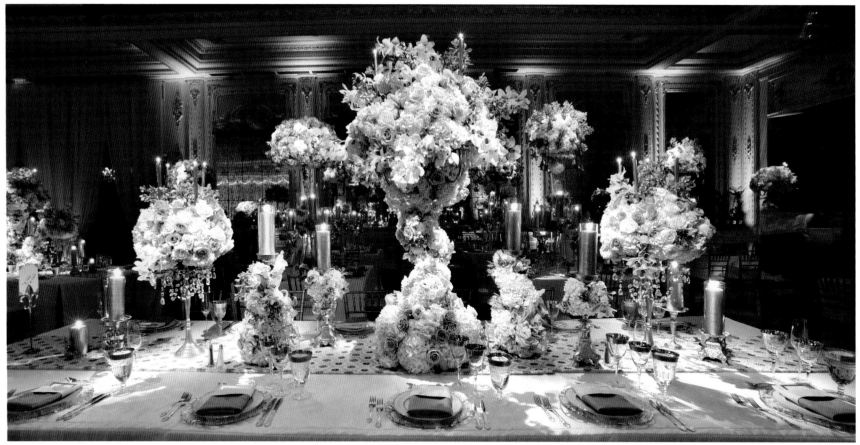

Photograph by Cathi Milanes

"A diverse team of experts, wonderful professional alliances and a unique approach—these are the secrets to creating successful events."

—Don Massetti

Above: Tables should be designed to please the eye. We always avoid a sea of the same centerpieces; there's no interest in that. When you look around the room, everything should coordinate but certainly not appear as carbon copies of each other. For added appeal, we like to combine round, square and royal tables, and even use different place settings—it's all about creating interest.

Facing page: It's all in the details. These special touches will hold your guests' interest and set your party apart from others. Put your signature on your event: Monogrammed elements add simple sophistication.

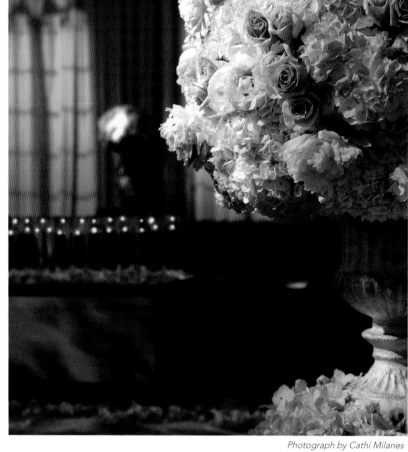

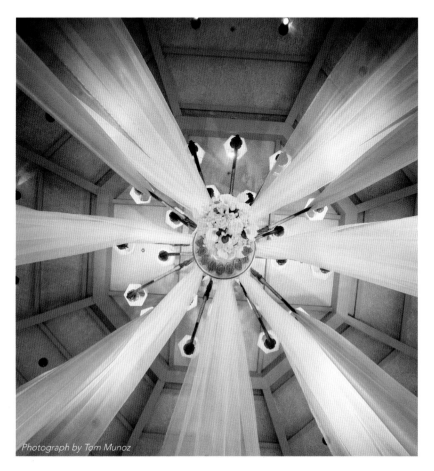

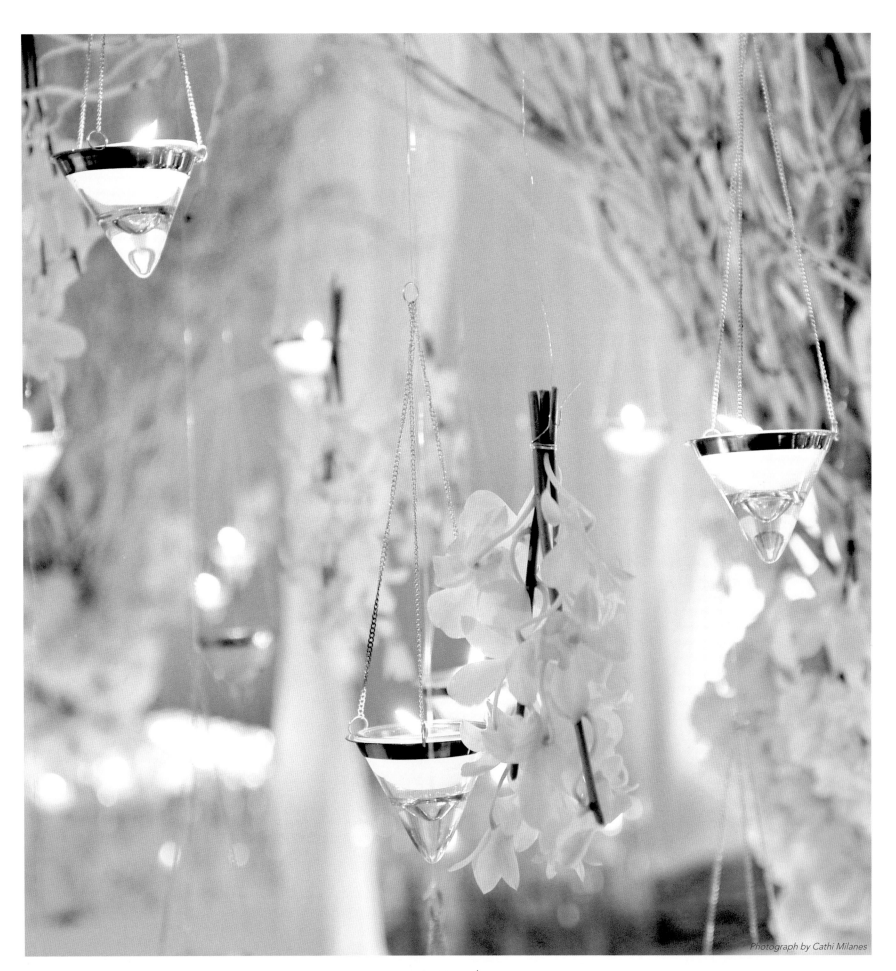

"Events require an amazing amount of organizing, planning and coordinating, but all of that should stay behind the scenes so that everyone can focus on the beautiful environment and how much fun they're having."

—James S. Rota

Right: There are times when only simple and elegant will make the best impression. Sometimes knowing how to exercise careful restraint creates the most impactful and graceful décor. Because we know every party inside and out—from the décor to the timing of activities—we're able to ensure seamless events that our clients and their guests will savor.

Facing page: Elegance can be attained in the simplest yet most effective ways. We create a "Winter Wonderland" with custom 12-foot-high trees of white branches from which hung hundreds of twinkling, romantic tea lights.

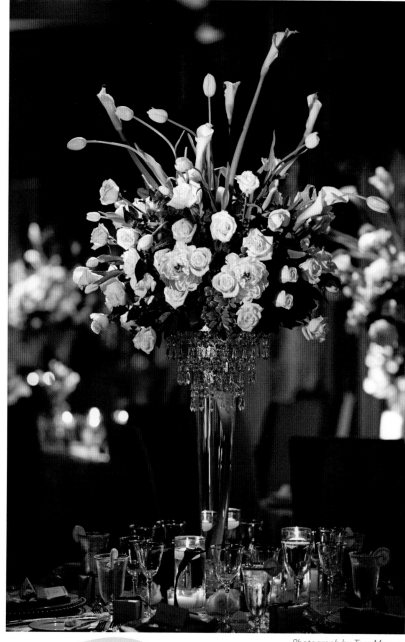

Photograph by Tom Munoz

views

❖ When your décor budget is not what it should be, create a "wow" factor as a central focal point versus spreading small amounts of décor around the room.

❖ The easiest way to create ambience and change the feeling of a room is with specialty lighting.

❖ To save money on décor, let the existing environment work for you.

❖ Go with the look, color and style of the space and build upon it for dazzling results.

DESIGNS BY SEAN

SEAN DE FREITAS

Inspired by his colorful childhood in Trinidad, Sean De Freitas has applied his infinite energy and creative visual expression to the world of event planning since 1994. Crowned Junior King of Carnival at the age of 11, Sean first created original costume designs reminiscent of island carnival traditions. Soon after moving to the United States, he began his career as a decorator for the annual Fort Lauderdale boat parade, and has since become one of South Florida's leading talents as an award-winning producer, designer and creative director for corporate and social events. From colorful fabrics and lighting to extraordinary illuminated tabletop designs and five-star entertainment staging and special effects, Sean and his professional team transform venues into memorable, magical experiences.

Upon entering a room designed by Sean, one immediately notices his creative use of color, always daring, never ordinary. His imaginative ability to create a mood through amazing lighting effects turns each venue into a theatrical presentation that captivates guests at first glance and engages them throughout the event. His original designs always create a buzz about town and within the events industry. Sean expresses his passion for life by applying his natural talents to transform a space. He has mastered his visual art form, meant to energize, delight and impress all with beautiful memories.

Swathed in vivid imported fabrics, a gigantic tent became a prismatic jewel of excitement. The party theme was "Color My World," and our technical expertise for theatrical lighting mixed with rich fabrics brought to life a brilliant palette, creating an unforgettable event.

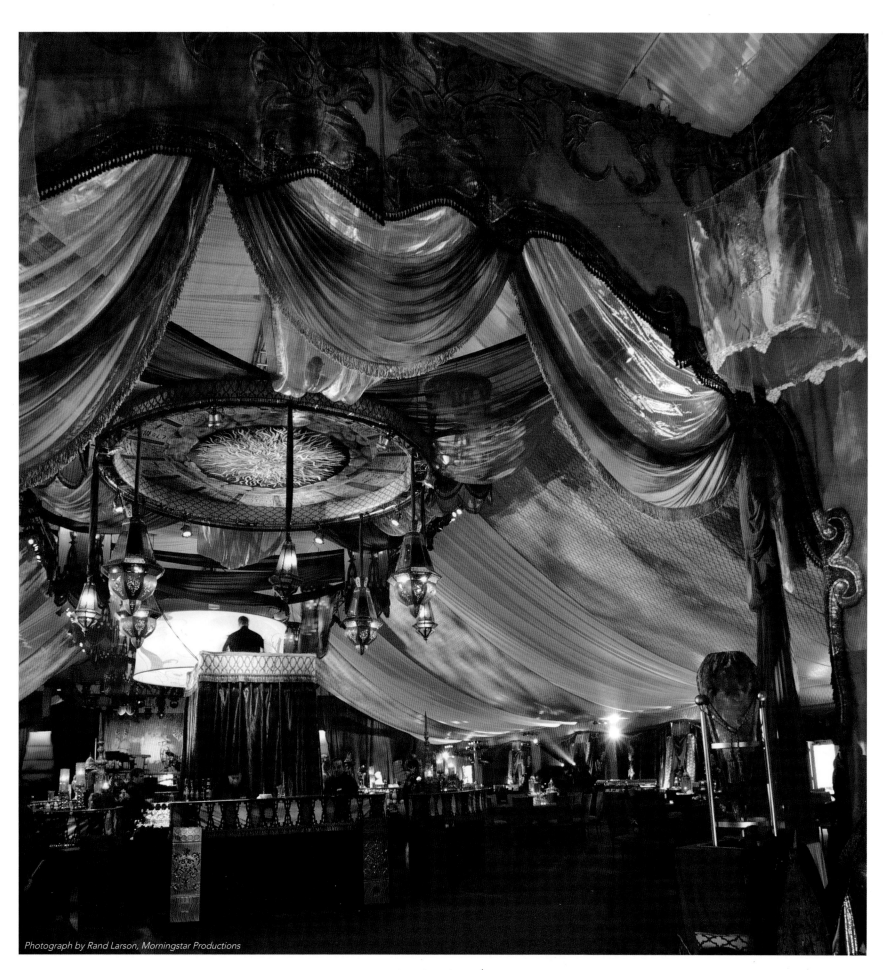

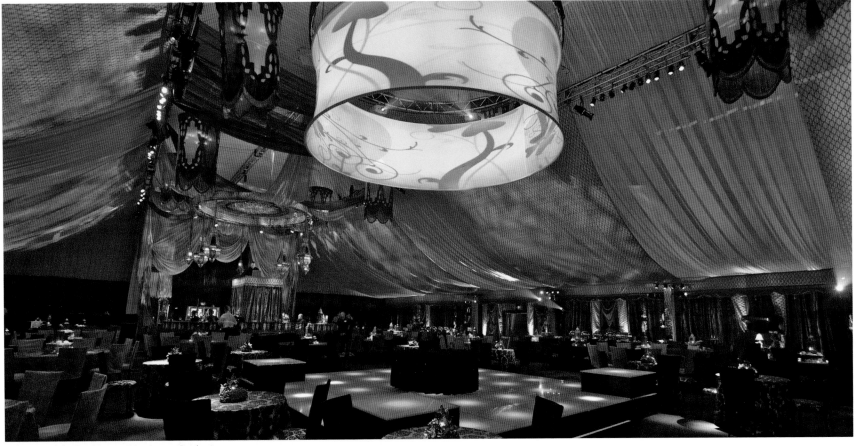

Photograph by Rand Larson, Morningstar Productions

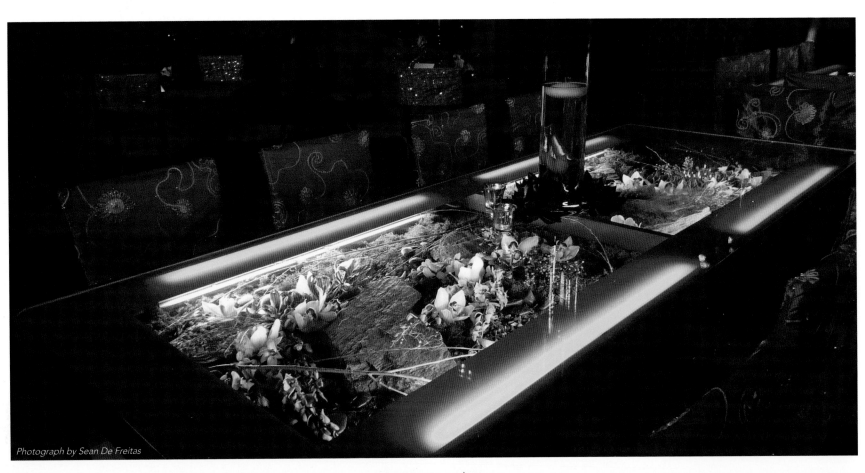

Photograph by Sean De Freitas

"Designing events with high energy, created through seamless presentation, is my passion."

— Sean De Freitas

Imagine the dynamics of an explosion of color as your first impression in a ballroom or tent. The event begins with coordinating cocktails and a thematic dinner setting, mood-altering musicians and performance art. I love to create awe-inspiring designs that evoke an emotional and sensory experience involving movement, sound, touch, scent and taste. My creative touches often include softgoods and technical lighting for imaginative, kinetic designs that are mesmerizing.

Taking an empty space and envisioning a dramatic place, often bringing the spirit of the outdoors indoors, is my signature. Our innovative custom designs have a Hollywood vibe, much like movie sets, yet are more than mere props or backdrop. Each venue design evolves from scene to scene as people arrive and continues throughout the course of an event. Brilliant color palettes and luxurious fabric textures become inviting layers so guests are fully engaged in the aesthetic.

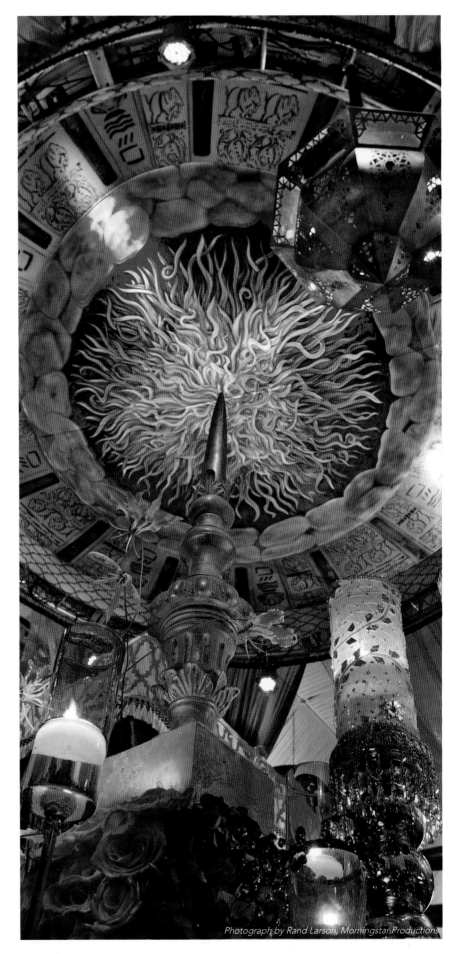

Photograph by Rand Larson, Morningstar Productions

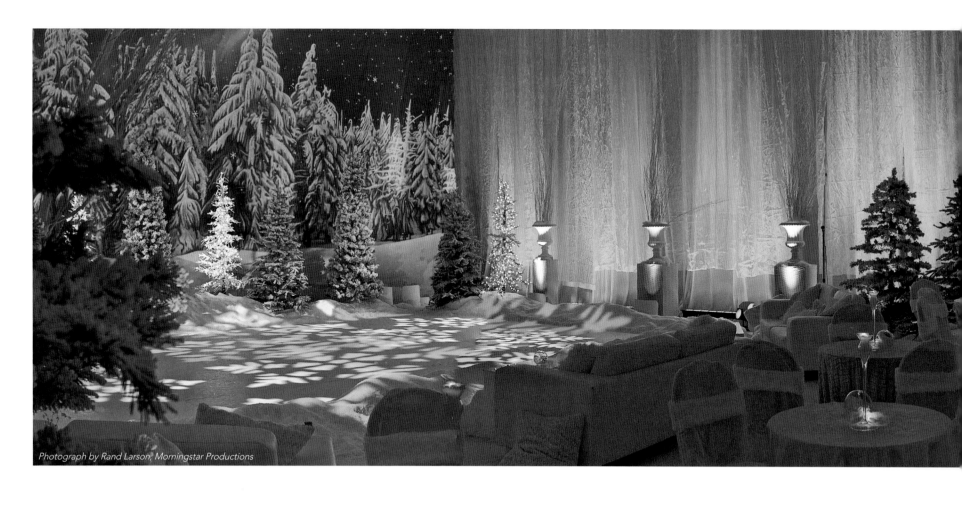

Photograph by Rand Larson, Morningstar Productions

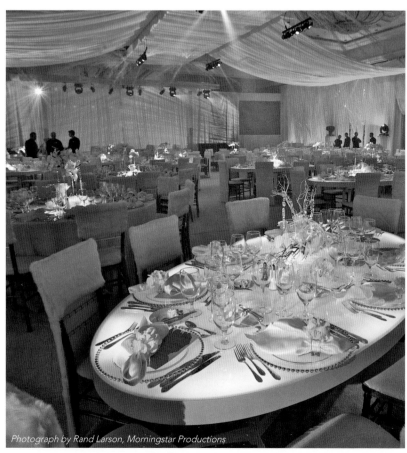

Photograph by Rand Larson, Morningstar Productions

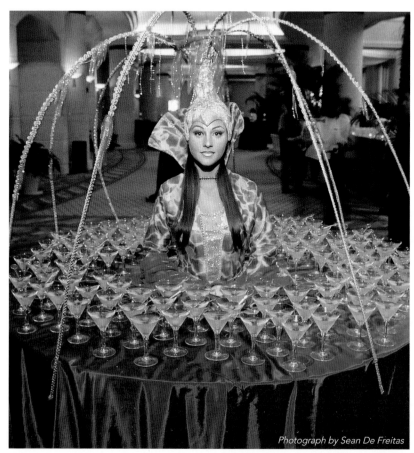

Photograph by Sean De Freitas

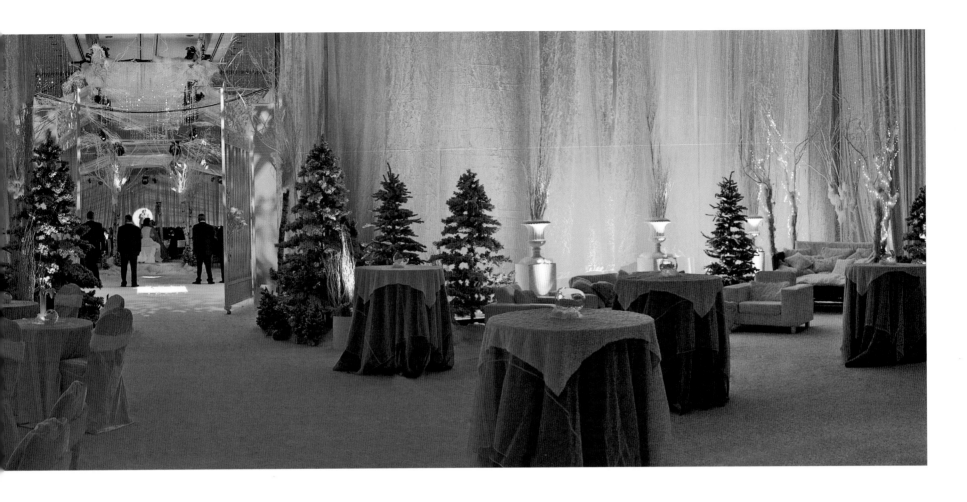

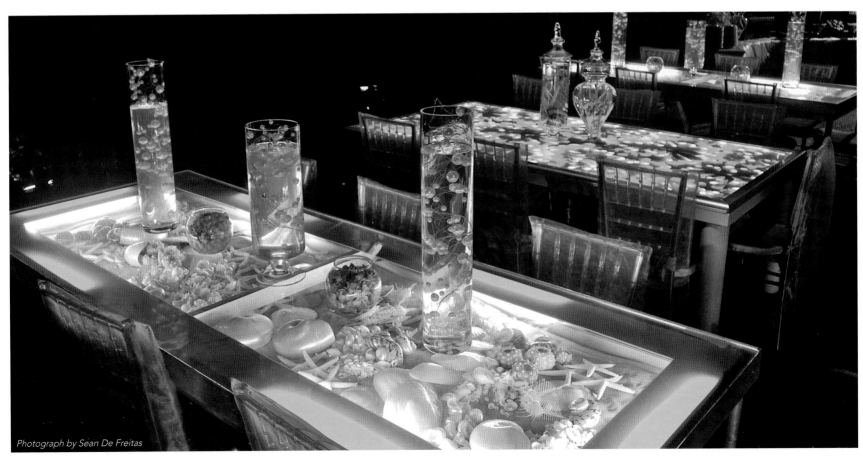

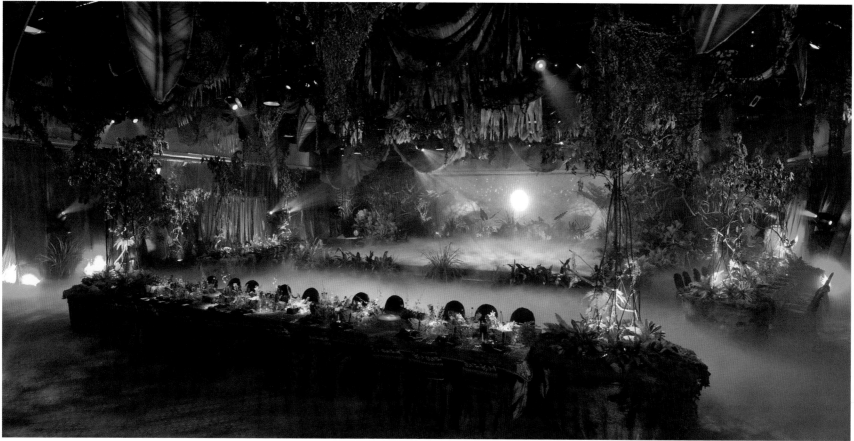

Photograph by Riley Arnold Productions

Above: For "Evening of Everglades Elegance," decorations with live tropical foliage were used. Guests enjoyed cocktails and then traveled across a bridge to the formal dining area where a retractable grid ceiling swung upward to reveal the full scene. The setting sun against low-lying fog immediately created the mood; during the main course, the moon rose while premier entertainment and five-star Ritz-Carlton service were enjoyed.

Facing page: Brightly hued, hand-painted floral linens adorn the tables at a bat mitzvah buffet dinner. Eight-foot-tall masked centerpieces using an abstract design were assembled to emphasize the Carnival theme. Birds of paradise, brilliant croton leaves, purple orchids and pink flowers became stunning visuals, complementing the hand-painted tabletop art.

Previous pages left: "A Winter Night's Dream" awoke in the grand ballroom. We transformed the space into a frigid splendor of a winter solstice replete with an acrylic ice rink for performers and a human martini bar. Sheer fabric panels, real evergreens and snowflake projections enhanced the illusion.

Previous pages right: We designed an oceanic theme for an alfresco evening event at The Breakers. Custom tables showcasing seashells and green coral transparency tabletops were built by our team, then illuminated for drama.

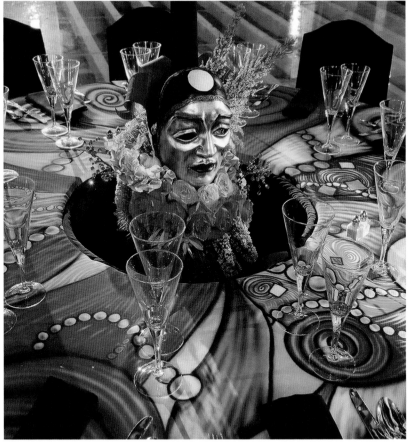

Photograph by Sean De Freitas

"Living décor can transform even stagnant events into perpetual motion, giving them their own distinct personalities."

—Sean De Freitas

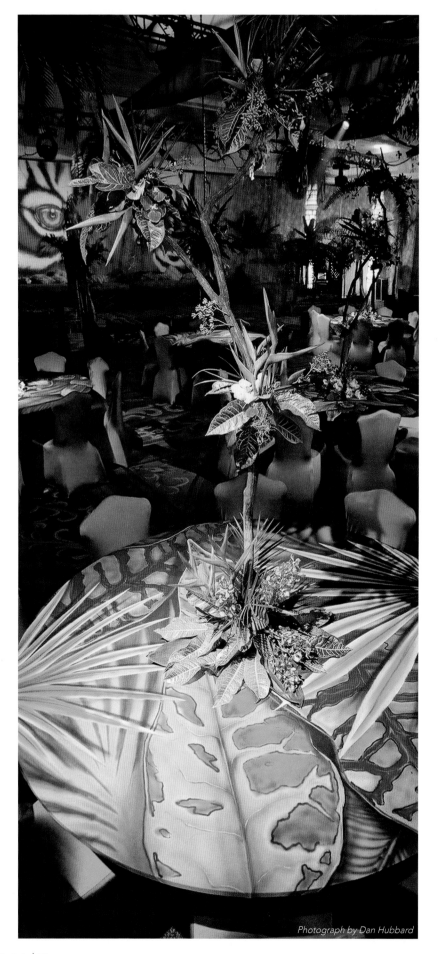

Photograph by Dan Hubbard

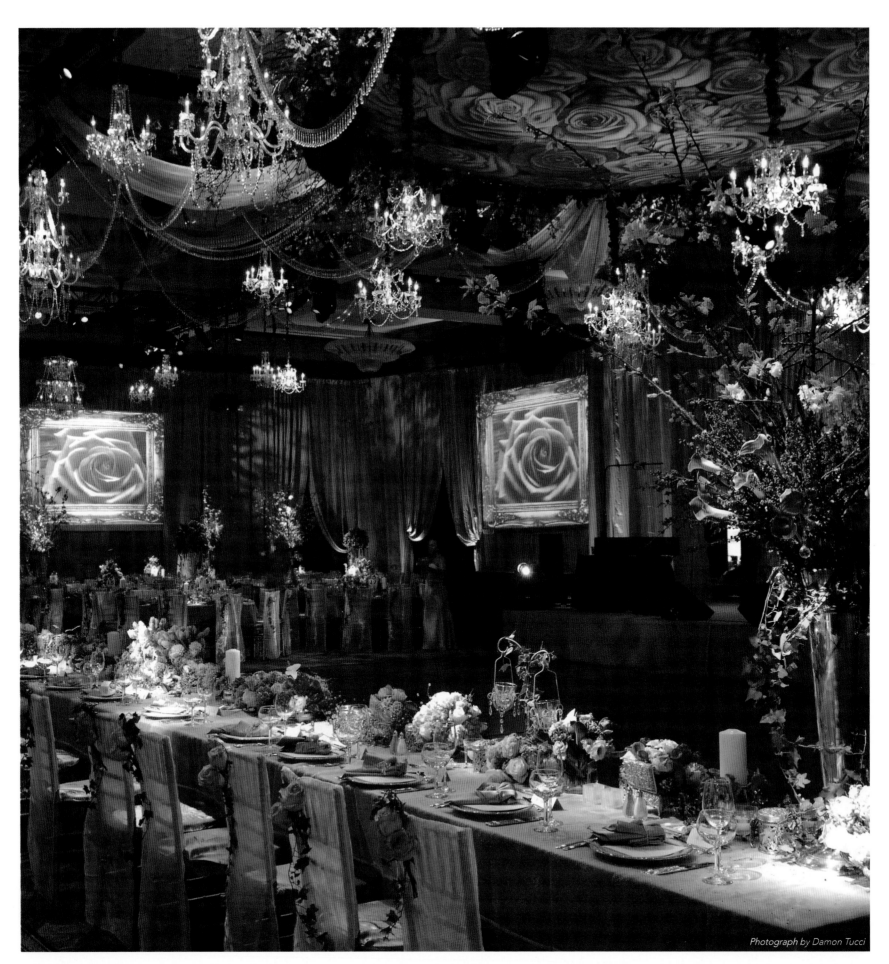

Photograph by Damon Tucci

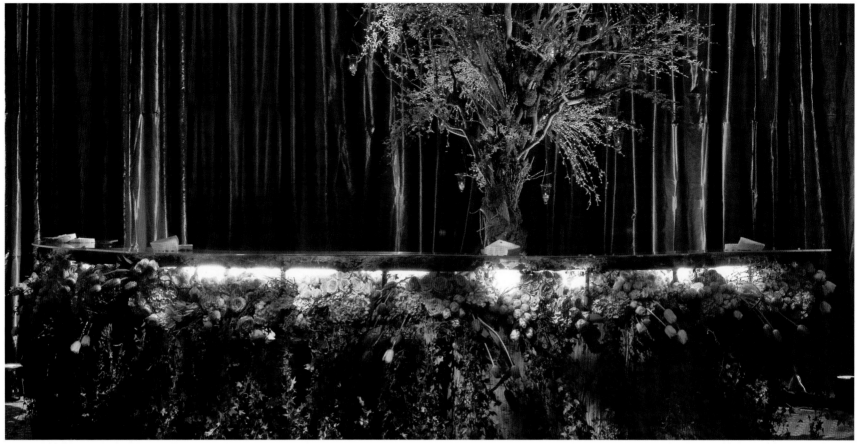

A fairy-tale theme became deliciously romantic with airbrushed pink roses on the ceiling illuminated by more than 50 crystal chandeliers interconnected with crystal beads. Large video screens in virtual picture frames were also suspended from the ceiling, while projections of roses and other flowers appeared all night long. Fabulous floral arrangements, sculptural softgoods and pink and lavender lighting effects created memorable moments.

Bringing the outdoors in, an acrylic-top semicircular bar is covered in moss and illuminated from within to showcase the elaborate floral sprays and English ivy; the back bar is accented by one woodland tree for a secret garden ambience.

"You don't have to over-decorate every corner. One beautiful statement can make an everlasting impression."

—Sean De Freitas

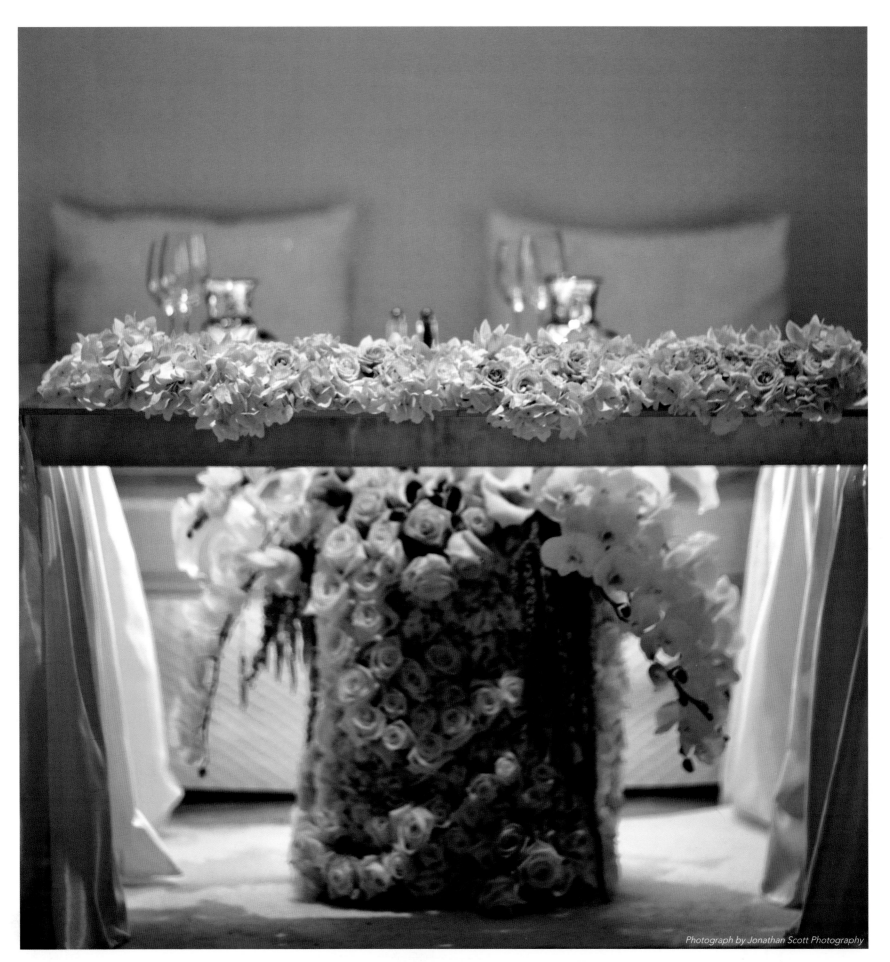

Photograph by Jonathan Scott Photography

"Every event should be as special as a sunrise or sunset. They happen every day but each one radiates its own unique beauty."

—Sean De Freitas

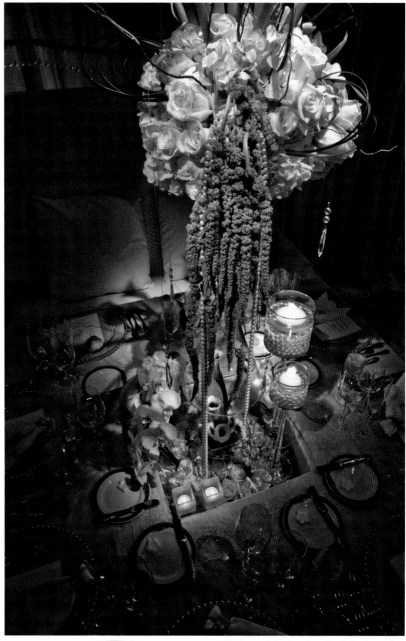

Right: Private alcoves secluded in a ballroom were the focus in creating a sense of architecture. By grouping one square table with three formal chairs and a banquette, we created this illusion. Our crew custom-cut a square hole into each table surface to fit a clear acrylic case that displayed fresh flowers that ascend through the table into a vase of white roses and hanging amaranthus. Lustrous pearls and crystal accents complemented the design. I love the art of gardening and my tabletop designs inspire exotic floral expressions.

Facing page: The guest-of-honor table was an impressive 24-foot structure adorned with a blanket of fresh pastel roses and white orchids. Illuminated for added magnificence, the creative tablescape debuted at The Mar-a-Lago Club of Palm Beach. The fantasy floral table setting created quite a stir.

views

Allow an event space to speak to you. Before I begin designing, I derive inspiration from the venue and pay attention to its limitations and creative possibilities. Whether designing indoors or outdoors, I strive to seamlessly blend all elements including floral and table design, color and lighting, entertainment and catering. Reinvent yourself—be open and don't just recreate something you have already seen before; expand upon it and own your creation.

THE ZANADU GROUP
CHERYL BEITLER

An atmosphere that exudes your breathtaking vision. A color palette that reflects your personal sensibilities. Ambient lighting that brings each element of your design to life. Innovative presentations that punctuate every creative detail you have imagined. Each is an important element in creating your celebration.

But according to Cheryl Beitler, owner of The Zanadu Group, it's the people who make an event memorable, who bring it to life and give it its sense of spirit. It's only natural, then, that Cheryl, along with Dale Flam, Director of Social Event Coordination, creates every event as a celebration not only of the hosts, but of each of their guests, as well. The team's dedication to creating an unforgettable experience for all in attendance, whether there are 15 or 1,500, has earned the full-service event planning and production firm a loyal client following and the respect of numerous industry leaders with whom The Zanadu Group frequently collaborates.

Key to The Zanadu Group's philosophy is the idea that a successful event requires a fusion of the elements. Everything from the color scheme to the table settings to the lighting to the live entertainment should merge to create an environment that inspires awe, evokes joy and, above all, embodies the spirit of the people being celebrated.

Each event should transport guests to another place. Certainly, the team had to do so to achieve a winter wonderland in Palm Beach! Décor designer Michelle Rago, with her design, set the scene for this transformation. Lights from flickering candles in the chandeliers and centerpieces danced on suspended crystals, while sheer white fabric cascaded from the ceiling and blanketed the tables and chairs, creating an image of gentle snow drifts. Wintry white branches surrounded by clusters of white orchids completed the seasonal celebration.

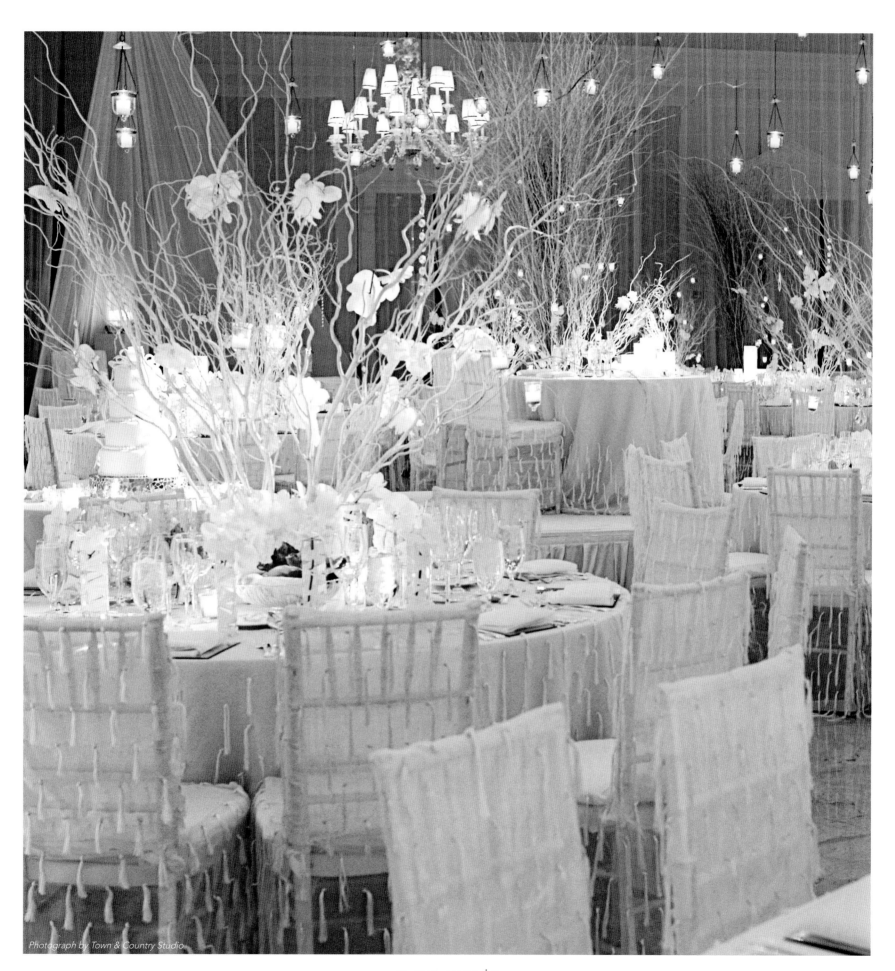

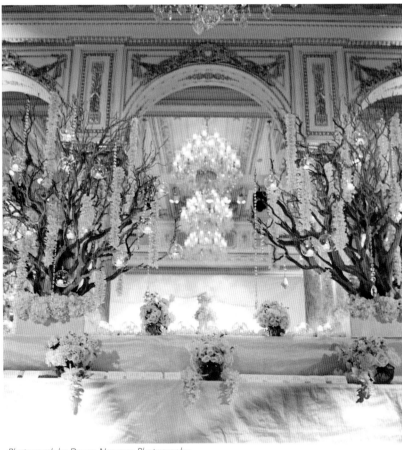

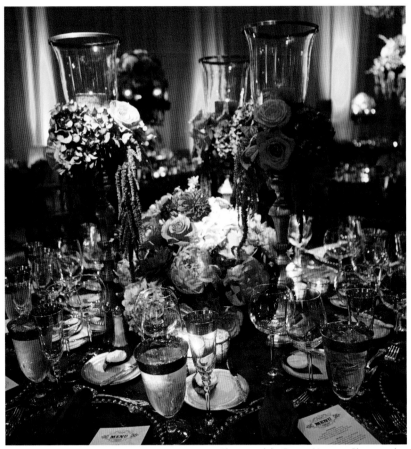

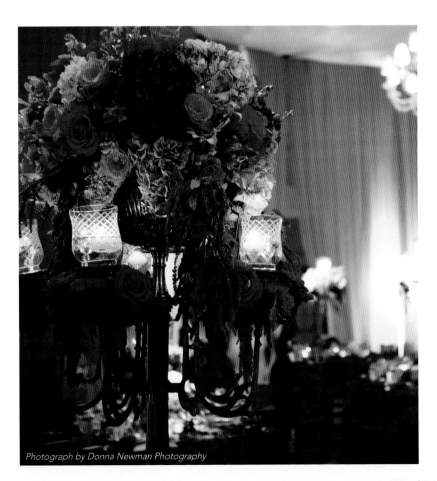

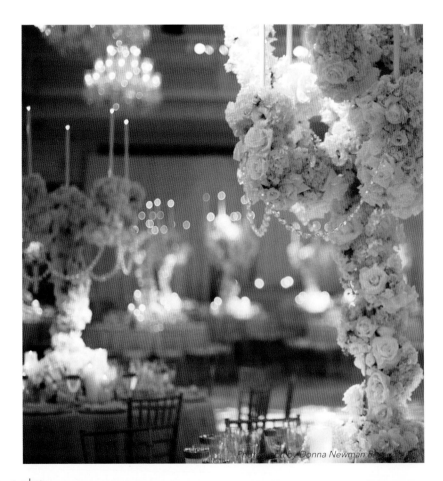

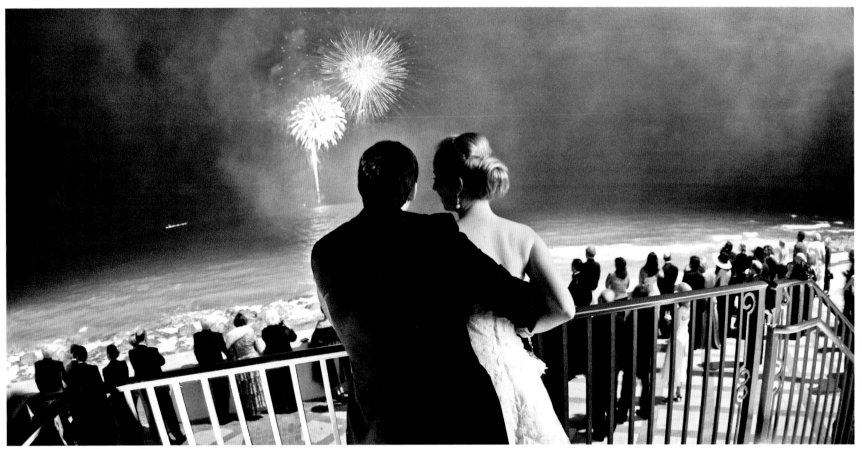

Photograph by Jeff Greenough Photographers

Above: Incorporating an element of surprise will guarantee an unforgettable evening. A fireworks show over the water expressed the celebratory mood of the evening and inspired awe in the guests and guests of honor. Since the event's venue was on the ocean, arrangements needed to be made to tug a barge out into the Atlantic Ocean and launch the fireworks from off shore. The reward was certainly worth the effort—the bursts of colored light reflected in the shimmering water created a magical scene worthy of the momentous occasion!

Facing page top left: You only get one chance for a first impression, so the view from the entrance is critical. The Breakers Palm Beach Design Studio helped us achieve this continuity between the entry hall and ballroom. White florals and golden accents on the escort card table greeted guests, marrying venue and theme and providing a taste of the magical reception to come.

Facing page top right & bottom left: The primary focal point of nearly every event is the table setting, essential to creating just the right ambience. Here, the opulence of the evening is echoed by jeweled table linens, tall crystal candlesticks and gold-rimmed glassware and china. The lush, jewel-toned floral centerpieces create a romantic ambience inherent to its Moulin Rouge theme.

Facing page bottom right: One of the biggest challenges event planners face is keeping a theme consistent without becoming repetitive—especially in a very large space. Three different styles of centerpieces and varying shades of white and ivory florals add a subtle diversity.

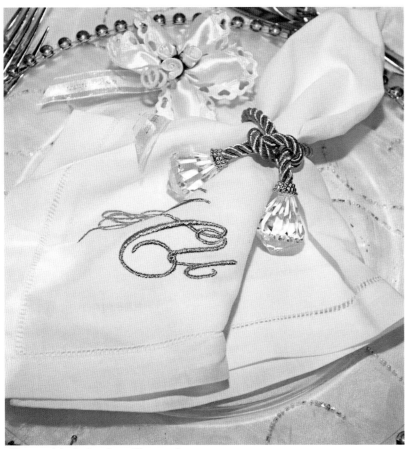

Left & below: Achieving intimacy in a large space becomes possible with careful décor design and personalized details. Monogrammed linen napkins make a formal place setting feel personal; while cozy, pillow-filled sofas and plush chairs—courtesy of The Breakers Palm Beach Design Studio—create a small living room on an expansive beachfront setting.

Facing page: Every element is vital to the event design. Long, rectangular tables placed close together can accommodate many guests, while still allowing guests to interact and have fun. Tall, floral centerpieces on either end create verticality and add visual diversity. Dramatic uplighting offsets the soft, rose-colored wash that softens the room and creates warmth.

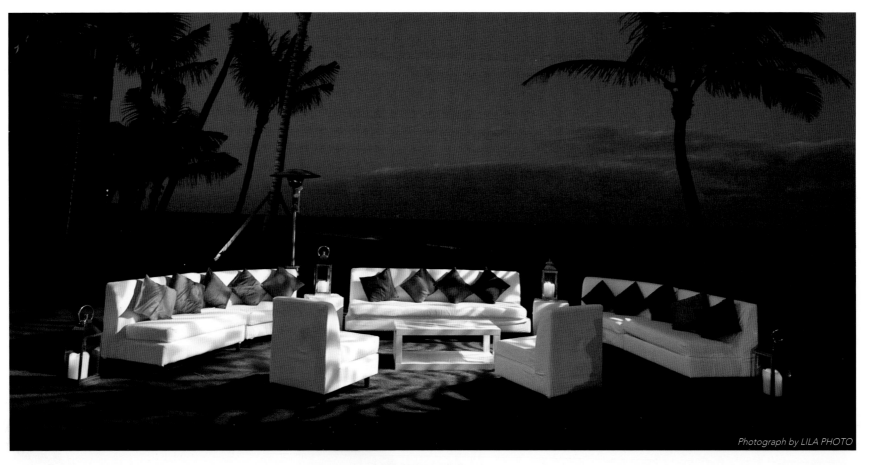

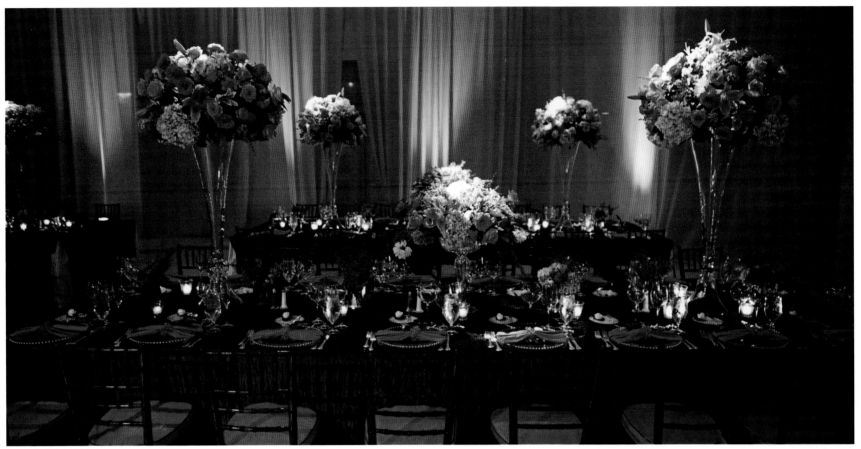

Photograph by Donna Newman Photography

"The most successful events are
driven by a passion for people,
a passion to create an amazing
environment that truly reflects who
they are."

—Cheryl Beitler

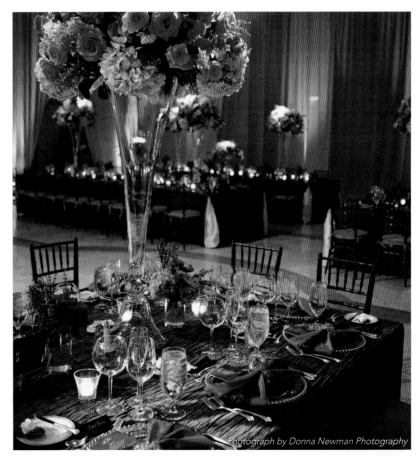

Photograph by Donna Newman Photography

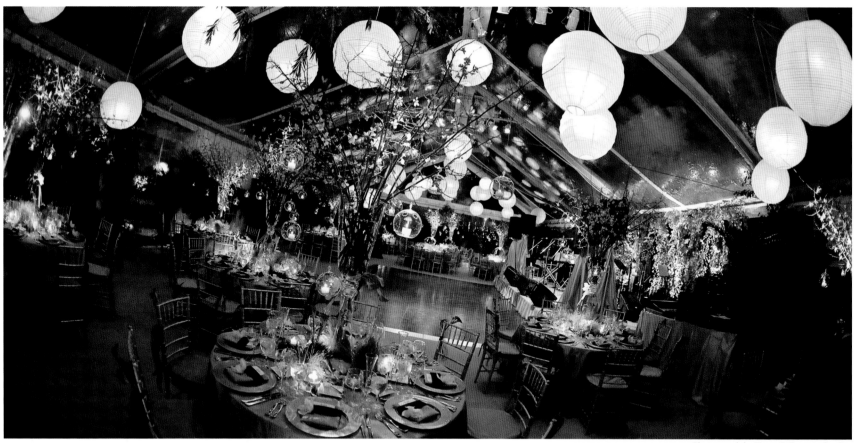

Photograph by Town & Country Studio

NOVEMBER 4, 2006

LOVE

PALM BEACH, FLORIDA

Photograph by Donna Newman Photography

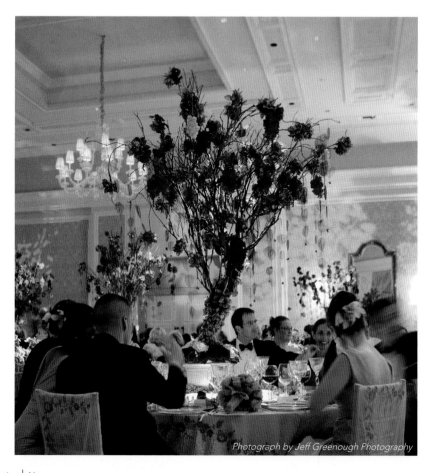

Photograph by Jeff Greenough Photography

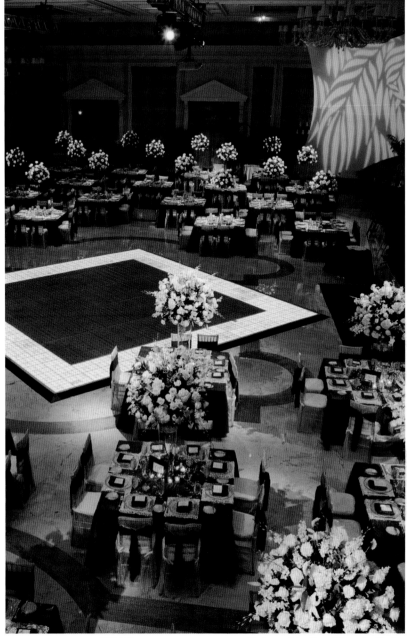

"Producing an event is like giving birth—we're bringing people's creative visions to life."

—Cheryl Beitler

Right: Anything interactive intrigues our senses! The guests become part of the setting as a lighted dance floor changes colors with the dancers' movements and becomes a fascinating focal point at a beach-themed party.

Facing page: Establishing the theme begins with the invitation and doesn't end until the last guest leaves. Colors, textures and visual details—whether printed on a page or assuming a physical form in a venue—give each event its distinctive flair.

views

❖ A party should tell a story about the guests of honor. We encourage people to use their senses, to reach inside themselves and discover what truly represents them. Their answer becomes the event's theme.

❖ All senses are engaged in creating ambience. The colors, textures, lighting, sound and smells should envelop guests in warmth and excitement.

❖ One of our preferred methods of lighting is candlelight. The soft glow and subtle shadow-play it produces create an otherworldly atmosphere perfect for nearly every occasion.

EVENT MANAGEMENT GROUP
MARC GAMBELLO | MARK KELLER

Lights, color, visual splendor! An Event Management Group-designed space instantly ignites every sense; anyone who has ever thrown a grand affair or even an intimate dinner party will agree that a successful event encompasses equal parts sight, sound, smell, touch and taste. The perfect fusion of those ingredients is just what Marc Gambello and Mark Keller achieve with each fabulously original experience they create.

Although catering to both private and corporate clients, the Fort Lauderdale-based event planning and production company has garnered an unparalleled reputation in the specialized niche of corporate events. These intricate large-scale product launches, sales meetings and grand openings have served to broaden their talents, at the same time granting them the freedom to design events that go far beyond the anticipated. Fortune 500 companies across the United States and internationally call upon EMG to design annual conferences, themed events, fashion shows, VIP receptions, board meetings and multi-day programs, just to name a few. Clients trust Marc and Mark implicitly to design a space that will deliver their company's message and create an extraordinary experience with exceptional value. EMG calls it Intelligent Events; their clients couldn't agree more. Though the guests and even the client may never know every minute detail of the experience, the point is, they choose EMG so they never have to.

A large corporate client wanted to energize its Latin American division sales force using the theme "The Heat Is On." With huge value placed on lighting in our business, one can see how the theme is completely animated by it. The event just happened to coincide with the Miami Heat winning the NBA championship, which was kismet at its finest and added a bit more poignancy to the event.

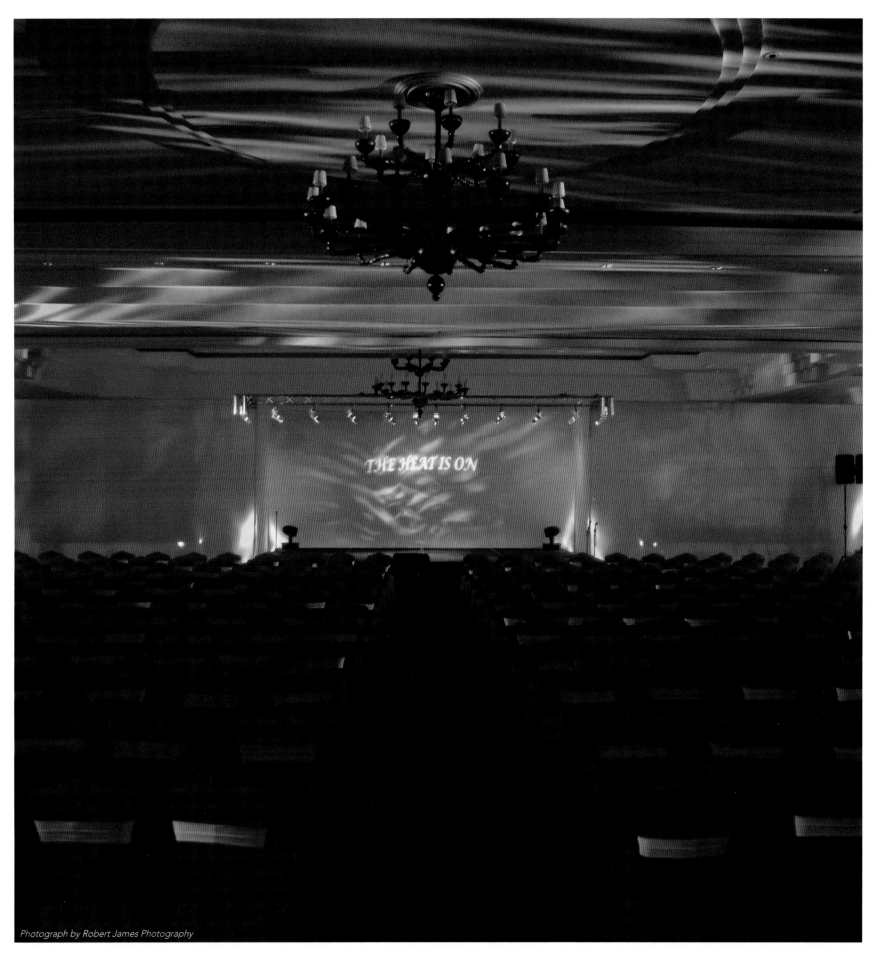

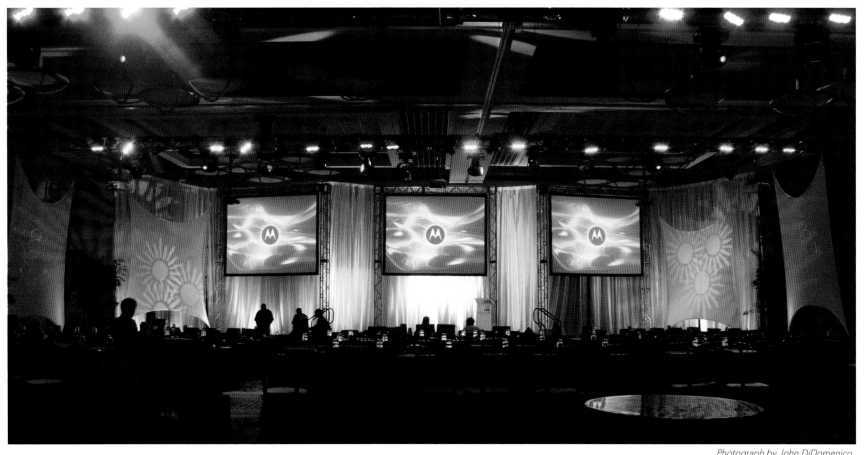

Photograph by John DiDomenico

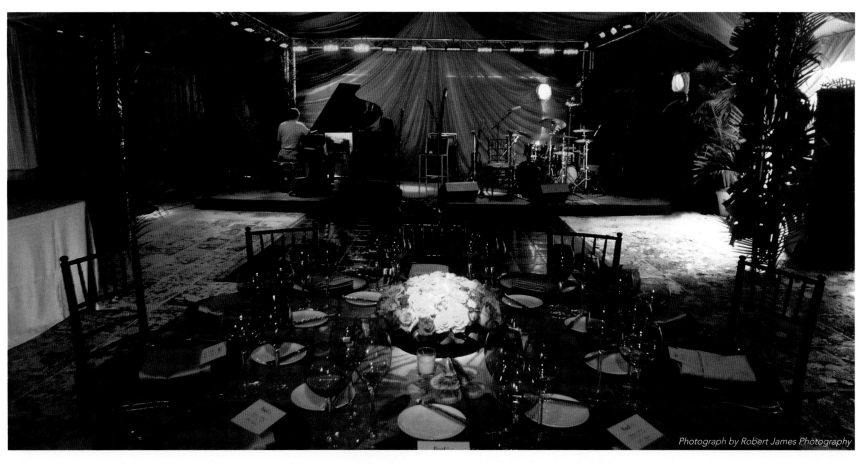

Photograph by Robert James Photography

"In any event, opening night is your closing night."

—Mark Keller

Right: Take creative advantage of a space's existing architecture; the results are as amazing as you make them.

Facing page: Any successful event environment starts with a color palette—one that reflects the desired mood of that event. Spaces come alive through color and lighting.

Photograph by John DiDomenico

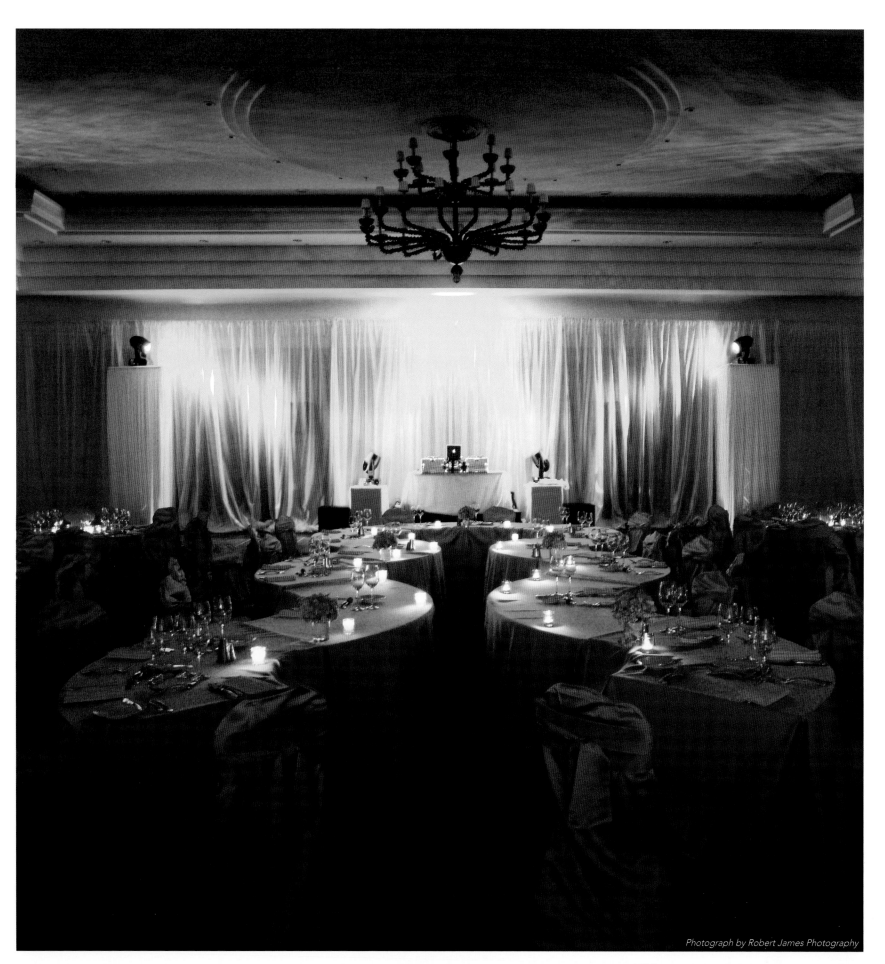

"We truly feel passionate about what we do...it's a labor of love to a huge extent."

—Marc Gambello

Right: Capitalizing on the strengths of a venue and the value that it delivers must always be considered. The venue had an incredible built-in lighting system and LED wall that afforded us the opportunity to create dramatic changes to the room at the touch of a button. With the budgetary efficiencies passed on to our client, we were able deliver a show-stopping stage performance by AJ Croce and a fantastic table design that was as unique as the venue itself. To this day, the clients still speak of this event as one of the best they have ever attended.

Facing page: We dramatically transformed the very same large meeting space used for "The Heat Is On" concept. Understanding that we had less than two hours to convert the entire room into that night's formal dinner destination, we needed a design that would allow a dramatic change with very little labor. Once again, lighting played center stage as the entire perimeter was changed without a single item moved or refocused. With a creative layout plan for the dining tables, the room was changed with time to spare. This concept not only delivered incredible value to the client, but it also allowed the hotel and our production team to move efficiently into the space and make the conversion seamless.

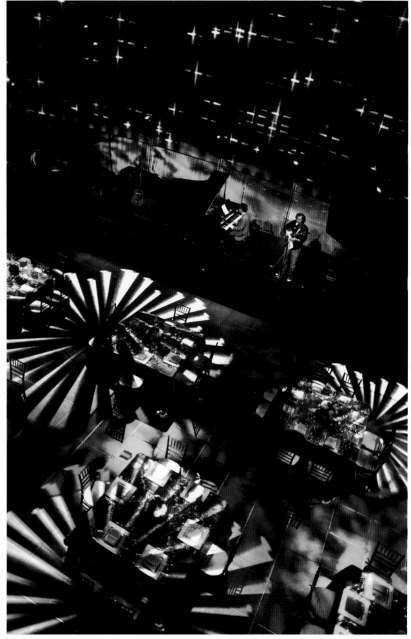

Photograph by Evrim Icoz Photography

views

❖ Choose vendors who have a team-player mentality. It takes partners with a shared vision to create the extraordinary.

❖ Accessibility is key. Make sure that the collaborators will be there when you need them—before, during and even after the event.

❖ If you want a truly customized experience, select professionals who relish new challenges and never duplicate their work.

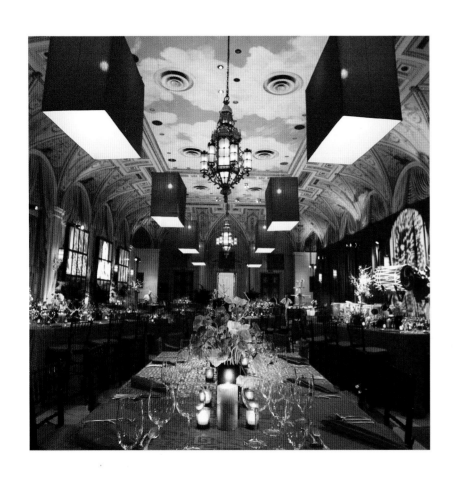

Location, Loca

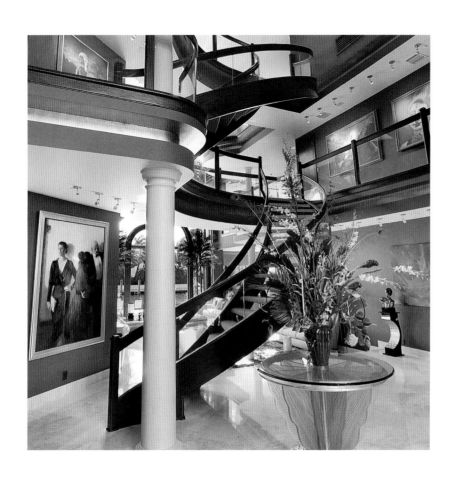

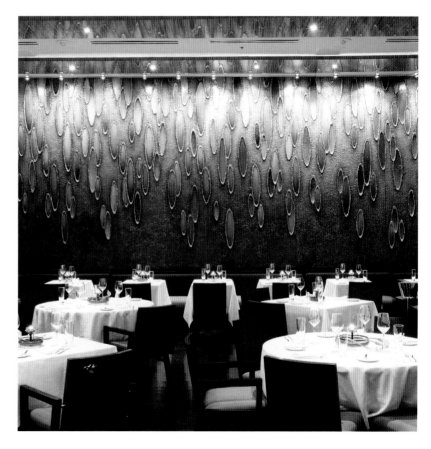

tion, Location

THE BREAKERS PALM BEACH

An architectural gem situated in the heart of Palm Beach, The Breakers has been a premier oceanfront destination and coveted venue since 1896. The expansive island treasure is surrounded by statuesque palm trees, and those in-the-know enjoy basking in its alluring atmosphere while appreciating an array of luxurious amenities. Palm Beach's Italian Renaissance-inspired oceanfront hotel is iconic. In an ongoing commitment to excellence, the legendary resort has invested 250 million dollars in renovations over the past 15 years to preserve its original splendor and ensure that South Florida's jewel remains appealing for years to come. But beyond the resort's incomparable beauty, hospitality and amenities, lavish events shine brightest—charity, social and corporate galas reflect the magnificent ambience.

Upon entering the lobby reminiscent of the Palazzo in Genoa, a feeling of graciousness envelops guests. Groups from 20 to 1,000 are easily accommodated in well-designed and superbly appointed indoor and outdoor venues of distinct character, style and flexibility. Settings abound from four majestic ballrooms and elegant, yet comfortable boardrooms, to manicured courtyards, lush gardens, and breathtaking beachfront and poolside locations amid the 140-acre privately owned property. These classic venues are artfully transformed through the hotel's Design Studio in tandem with the executive chef and professional catering team, who passionately design and create thematic décor, imaginative menus and gorgeous floral and lighting effects to celebrate any occasion. Creative directors work one-on-one with discriminating clientele to develop signature parties with a true sense of place.

The Design Studio at The Breakers transformed the Mediterranean Ballroom with its classical architecture and original fresco ceilings through elements of décor. Bathed in a golden glow of floral cones and a profusion of hydrangeas, roses, bells of Ireland and hanging amaranthus, the space has a breathtaking ambience.

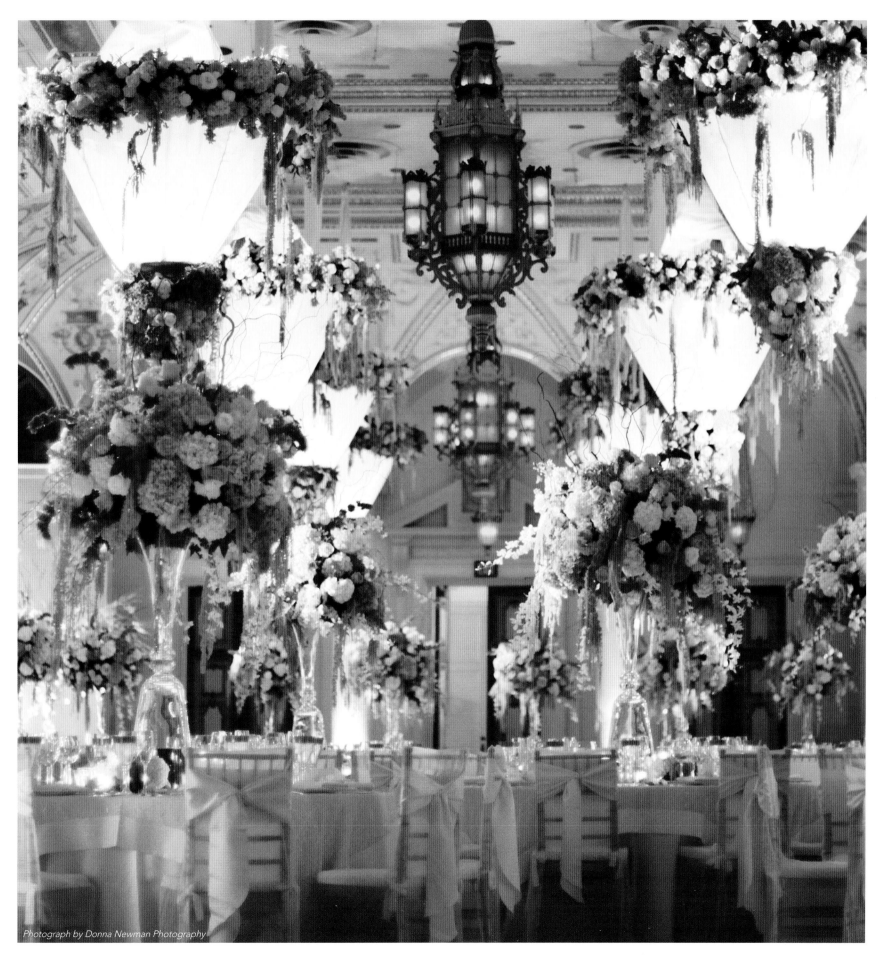

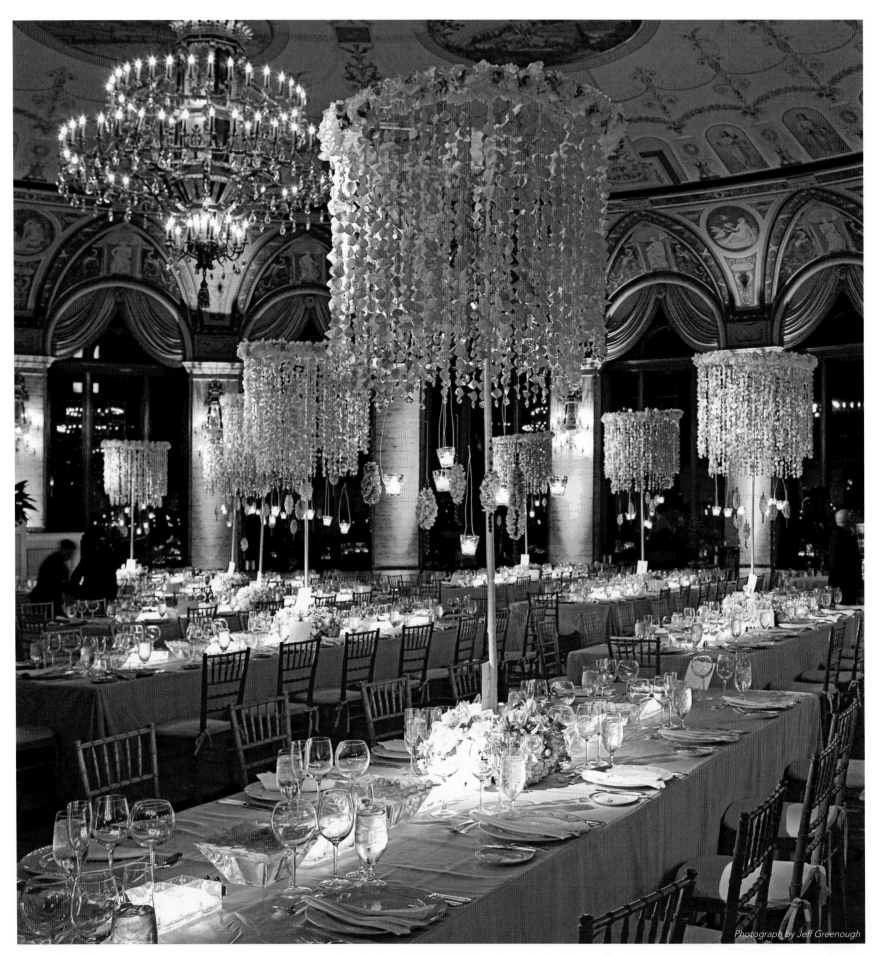

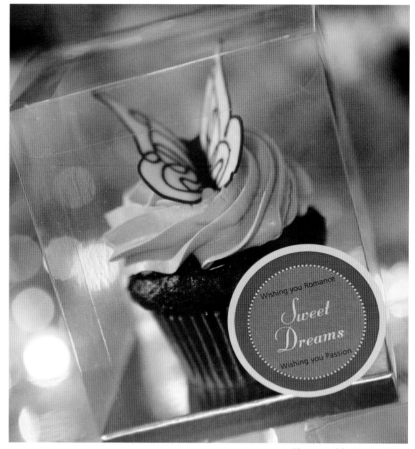

Photograph by Nancy Cohn

"Rely on experts with an ability to visualize the event from beginning to end. First impressions and final impressions must exude the same breathtaking impact."

—Joan Bever

Top right: Custom cupcakes are lovely send-offs for guests. Our signature "Sweet Dreams" dessert features a handmade chocolate butterfly. All of life's celebrations should end with an artful take-home confection so memories linger long after the party.

Bottom right: The grand Venetian Ballroom is dressed in pink perfection for a charity gala. Alternating styles of crystal vases filled with roses and fragrant stargazer blooms, elegant floor-to-ceiling pink draping and brilliant fuchsia lighting magically envelop the room to create an entirely new ambience.

Facing page: The soirée was a collaboration with world-renowned event designer Preston Bailey. The Circle, with its curved walls, domed ceiling and partial ocean view, became a fantasy rehearsal dinner in the round. Hanging orchid trees lit with glimmering votive candles create an eclectic, romantic mood.

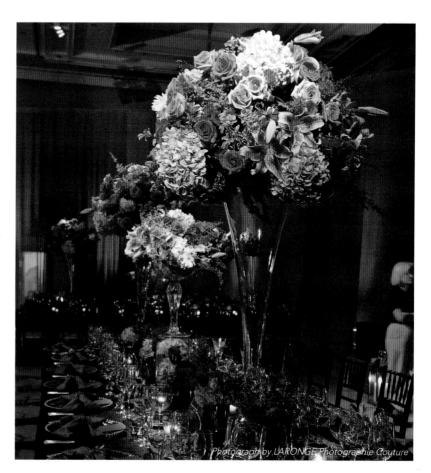

Photograph by LARONGE Photographie Couture

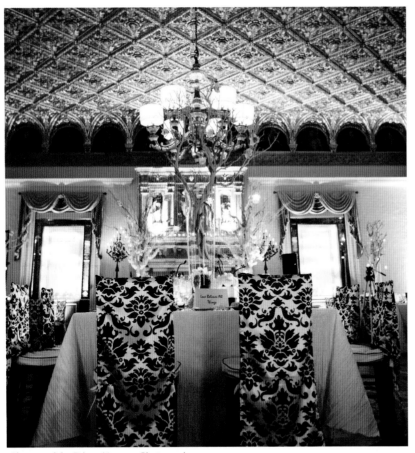

Photograph by Donna Newman Photography

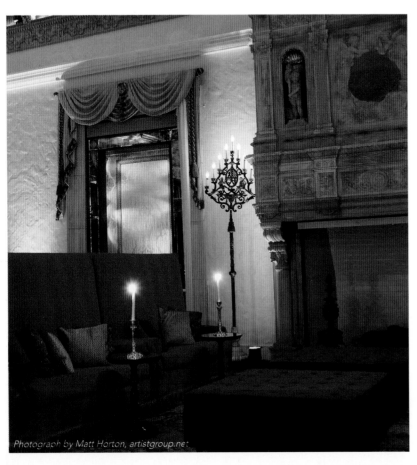

Photograph by Matt Horton, artistgroup.net

"All events should have at least one element of surprise that leaves the guests mesmerized."

—Joan Bever

Hosting events in our architecturally awe-inspiring venues allows for traditional glamour as well as contemporary flair. We especially love the Gold Room—with its acclaimed cherub-adorned ceiling—for intimate affairs accommodating 75 to 100 guests. Whether a private dinner party, boasting dramatic centerpieces of natural Manzanita branches and bold chair covers, or a corporate after-dinner party with a fireside club atmosphere, the feeling of warmth infuses the event. The room was adeptly transformed by the Design Studio with custom furnishings and décor, ethereal lighting and musical entertainment to create a mood and bring dreams to reality.

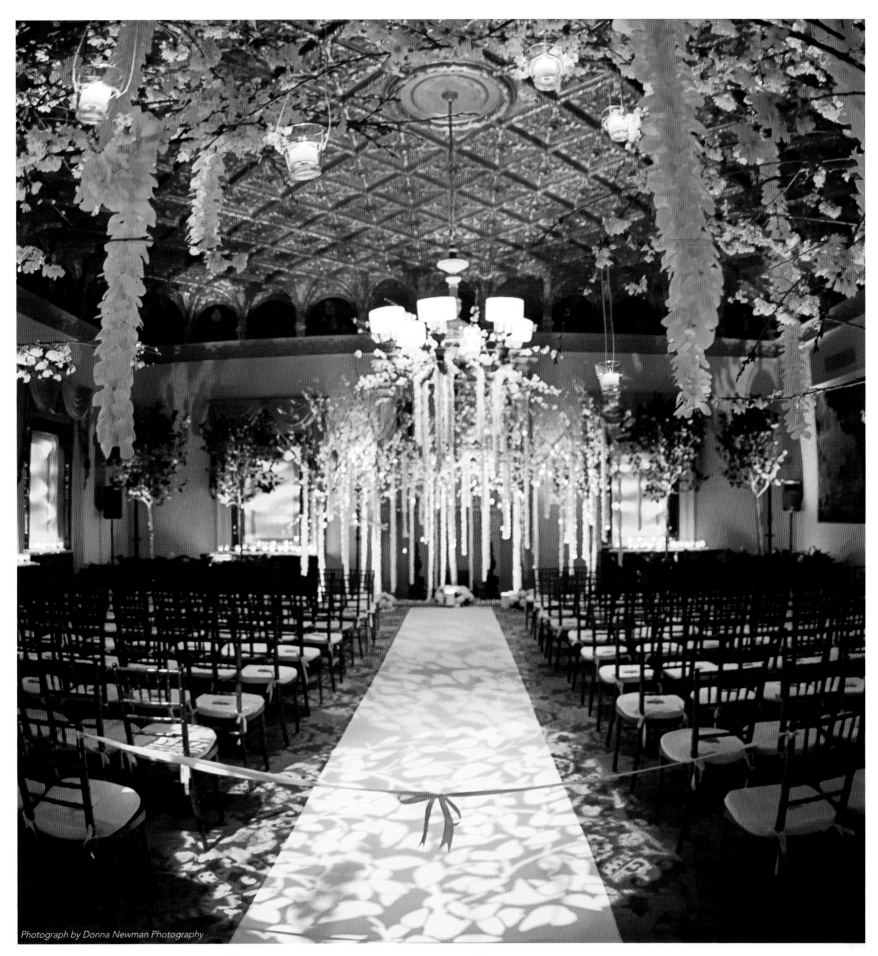

Photograph by Donna Newman Photography

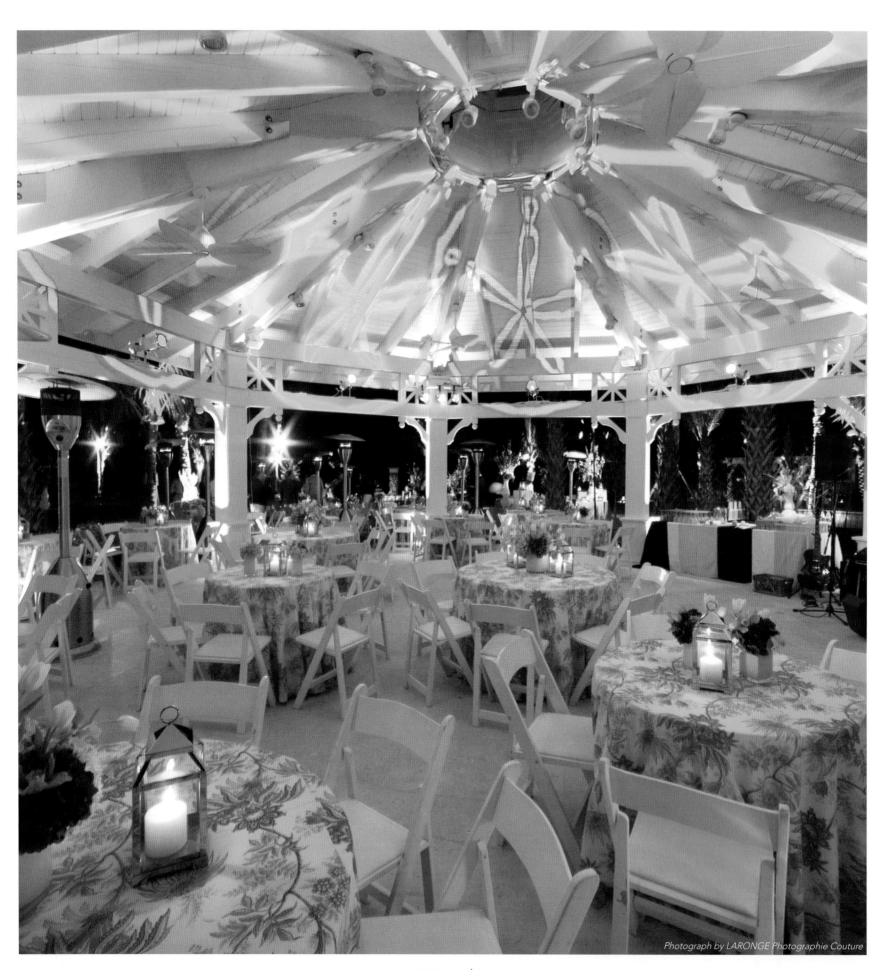

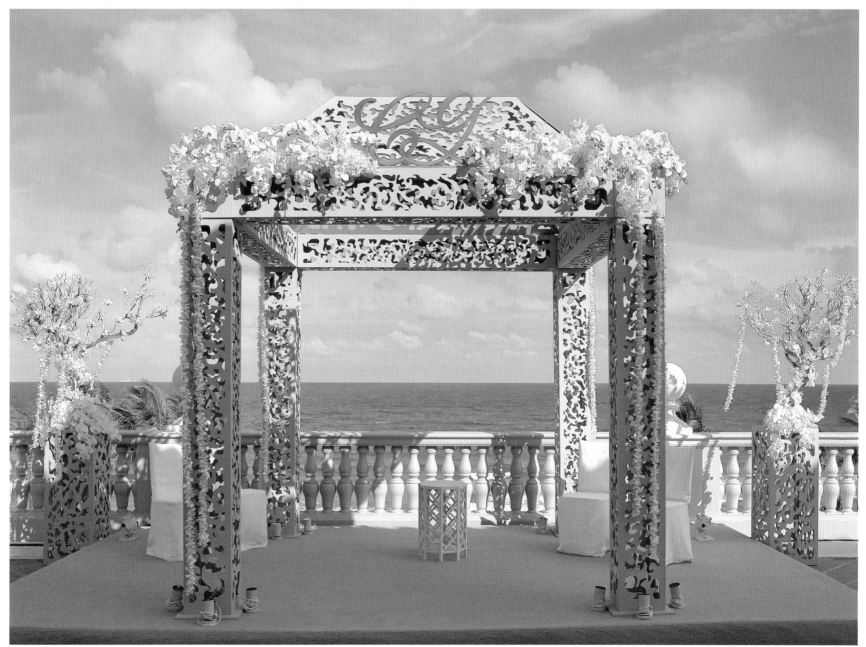

Photograph by Sigvision, courtesy of Michelle Rago Ltd.

Above: We collaborated with designer Michelle Rago for this alfresco event. Erected on the Ocean Terrace, an ornately carved, custom wooden chuppah with flanking pedestals was inspired by delicate Alençon lace on the bridal gown. A plethora of white orchids and a gilded, cursive monogram personalized the ceremonial structure with refined beauty. Expansive ocean vistas are directly behind the second-story terrace, so the glorious view is unobstructed.

Facing page: An elegant, station-style cocktail buffet was served under the poolside gazebo where guests enjoyed the adjacent oceanfront lawn for a picture-perfect charity event. The turquoise, blue and green color scheme of the custom table linens reflected its seaside setting, while illuminated lanterns, projected light patterns and fresh tulips created a night of pure enchantment.

"In the end, when the flowers, food and music are gone, the memory remains; this memory must be the one that lasts a lifetime."

—Joan Bever

Left: The Design Studio team transformed the Mediterranean Ballroom with décor, food and entertainment. A corporate event had a contemporary Asian theme replete with exotic drummers on stage. The outdoor cocktail party was an extension of the room, featuring a living fountain with one costumed geisha spraying water from her fingertips, and a Chinese dragon ice sculpture became the main attraction.

Facing page: The mixture of bar-height and low tables created an interesting effect for dining. Tailored tablescapes displayed exciting colored linens, contrasted by small black pots filled with poppies and Ranunculus in the same hues.

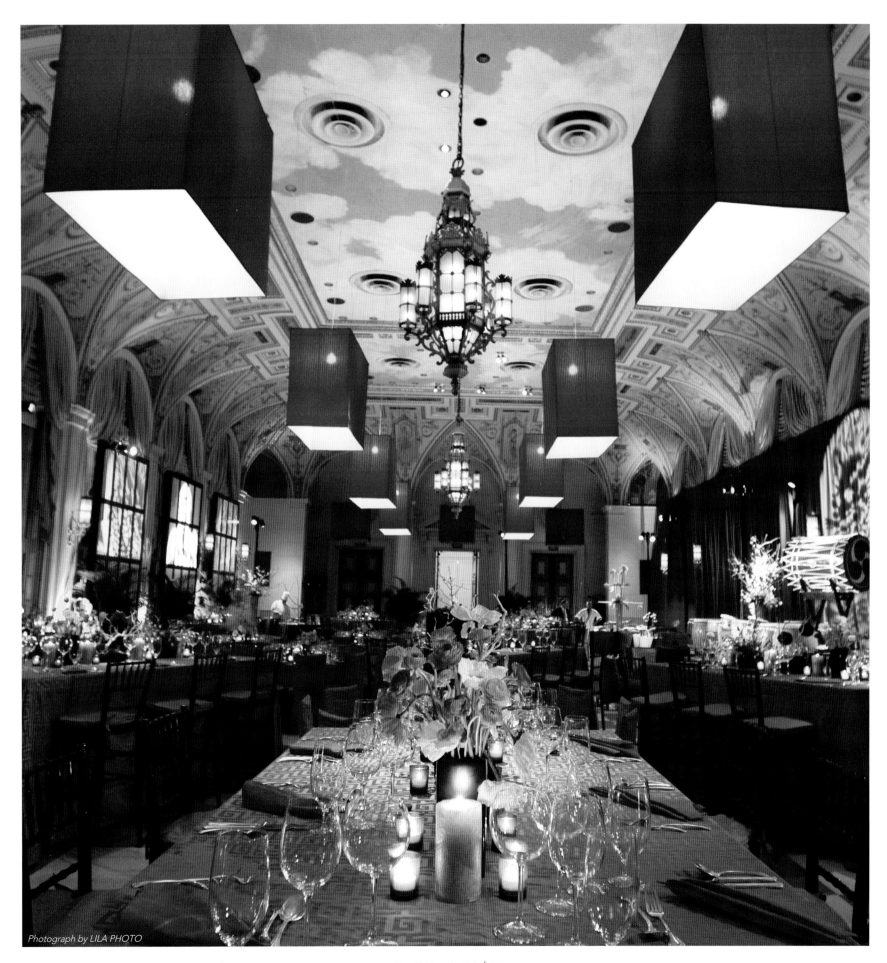

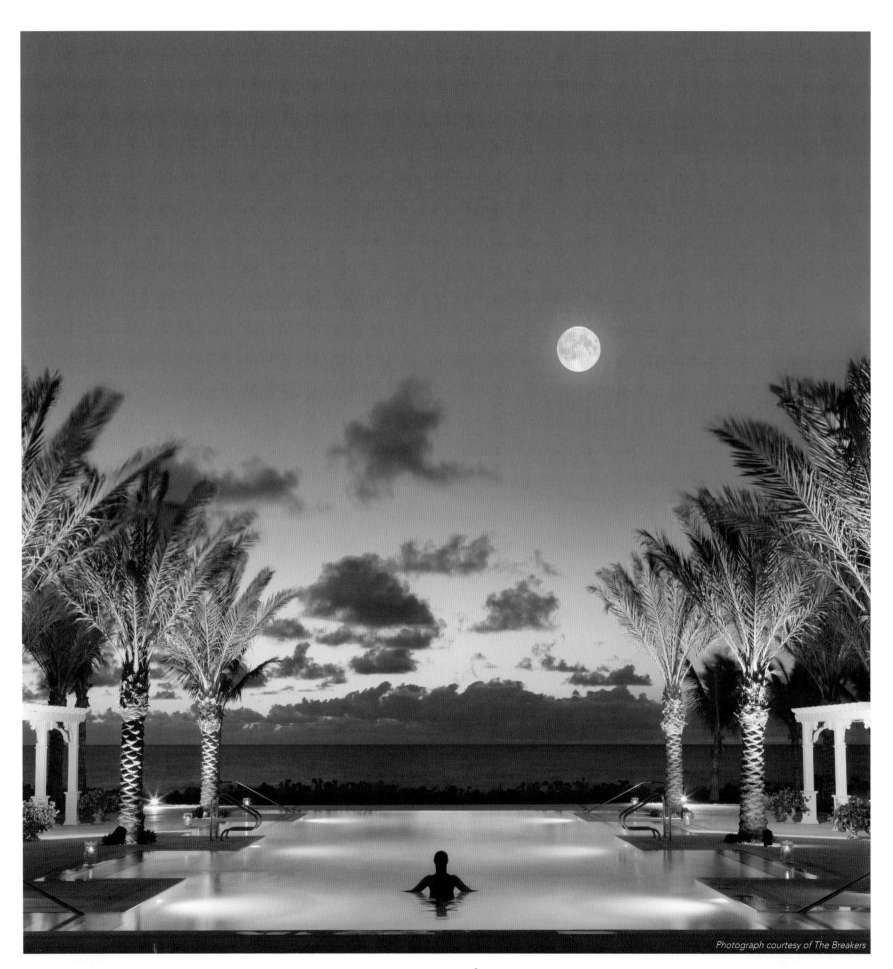

"It is that one special moment or tangible element that leaves a lasting impression."

—Joan Bever

Beyond the enjoyment of stellar events, invited guests can immerse themselves in everything the luxury resort has to offer. Amenities and activities include a relaxing and pampering spa, five pools, luxury bungalows and cabanas, two championship golf courses, tennis courts, world-class dining and on-site shopping. Our spectacular oceanfront property spans 140 acres, from sandy beaches to lush, tropical gardens, making it an idyllic setting for celebrations year-round.

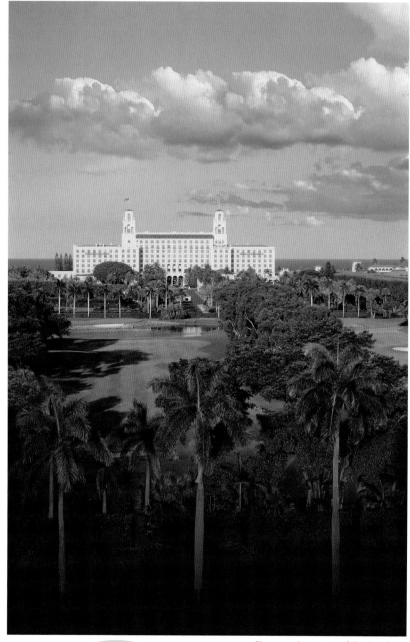

Photograph courtesy of The Breakers

views

Make sure that the staff associated with your venue has breadth of experience, from expert designers to tenured food and beverage teams. Look for a caring attitude and impeccable personalized service. A flawless event is all in the details. Be sure to consider unexpected weather and go over precise timelines. Most of all, your event designer should be a passionate perfectionist so that your celebration is successful start to finish.

LOCATIONS EXTRORDINAIRE, INC.

VERNA SHORE | BRIAN CORBIN

Representing more than a thousand prestigious private residences from the Florida Keys to Palm Beach County—and a hundred-plus in New York—Verna Shore has been the premier resource for elite locations for upward of three decades. This is the kind of niche that a person can't create for herself overnight or even over a lifetime, yet for Verna, the business simply evolved. Verna is a fashion and lifestyle model by profession. And when she began introducing photographers and cinematographers to acquaintances who owned spectacular estates, she realized a huge void and knew exactly how to fill it.

Over the years, through social networking, Verna has significantly grown Locations Extrordinaire. And although the company is now several divisions strong—catering to fashion, film and television shoots, corporate events, private engagements and even mansion tours—Verna maintains the personal connection that has allowed her such success. Verna and vice president Brian Corbin enjoy the privilege of introducing glorious estates to an enthusiastic clientele, and their passion for it is evident in their ever-expanding company.

Photographers, cinematographers, creative directors and art directors from Los Angeles and New York to the most exciting cities in Europe are innately drawn to South Florida for its weather, quality of light, views and stylistic diversity in architectural backdrops. And when a work of architecture is stunning enough for print and film artists, it naturally makes a wonderful event venue.

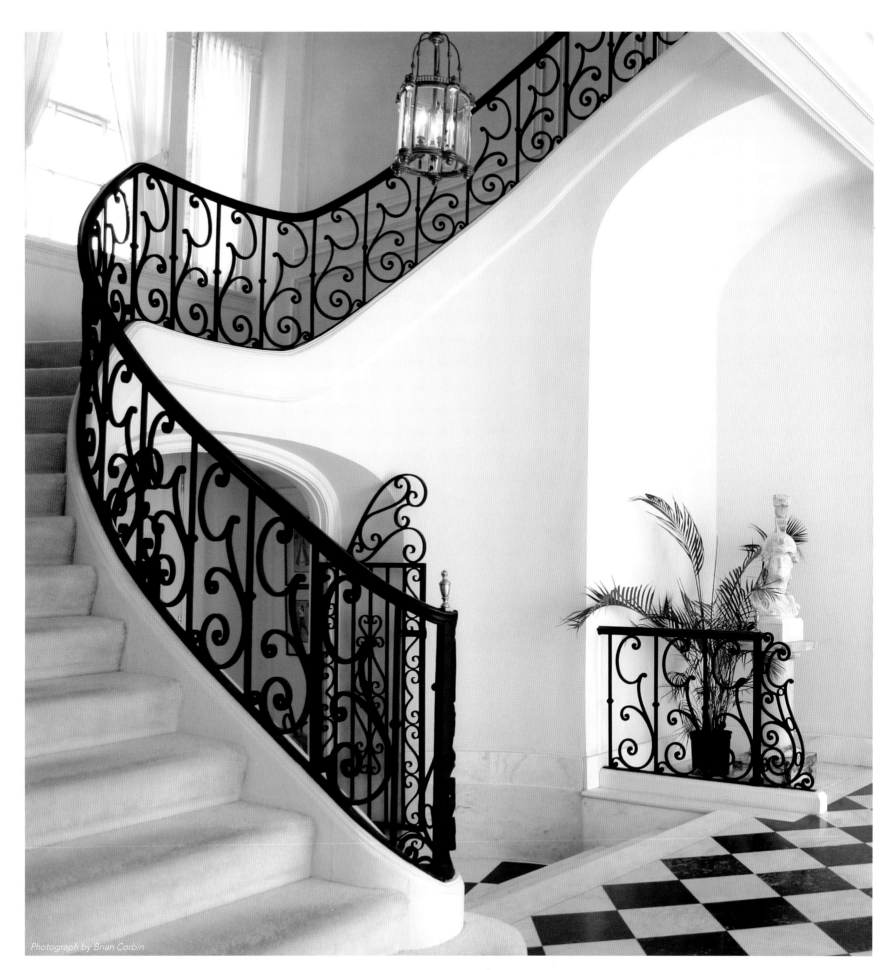

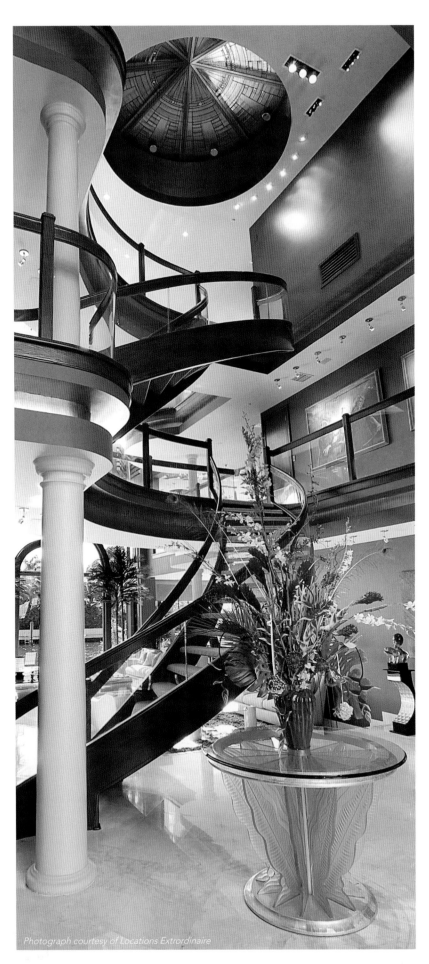

Left: There are so many elements to consider when we're assisting clients in securing an event location: the architectural style, the size of the property, does the loggia spill onto the lawns, is the flooring stone or wooden, will guests possibly be arriving by limo or yacht, and does the mansion owner wish to be on property for the event. From ultra-contemporary properties to Old World mansions, we represent them all. A stunning contemporary residence with a spiral staircase resembles pure art. The open layout, bar on each of the three levels and the owners' extraordinary art collection makes wandering through this divine architectural masterpiece a visual treat for the eyes.

Facing page: Many corporate clients desire Old World charm; often they'll have conferences at a hotel and plan a special black-tie gala or awards ceremony at a nearby grand mansion for a refreshing change of scenery. It's interesting to see what architectural flavor people choose—the younger crowds usually go for contemporary and those from the West Coast are often looking for Southern charm, but we never cease to be surprised.

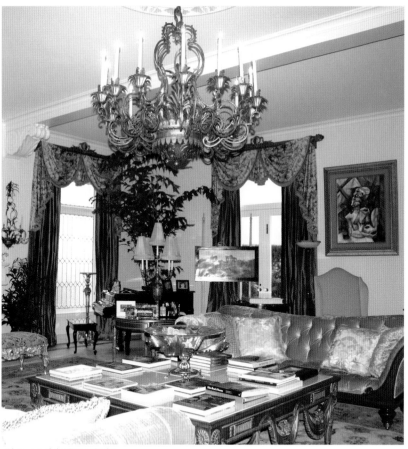

Photograph by Brian Corbin

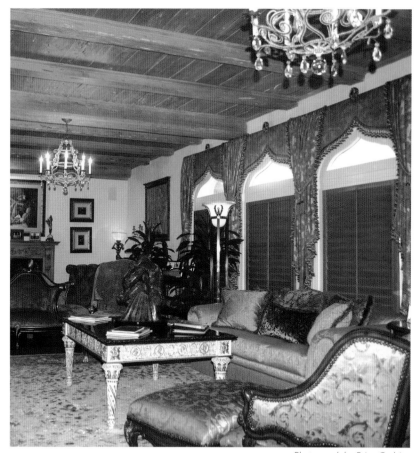

Photograph by Brian Corbin

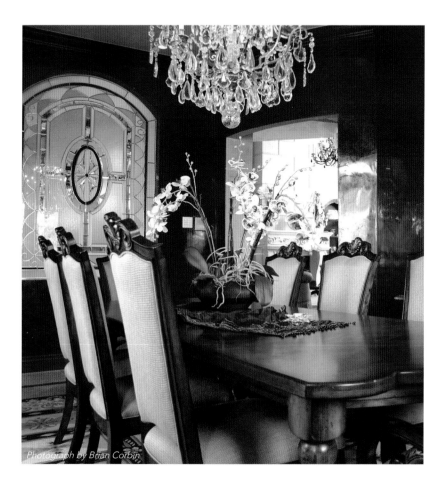

Photograph by Brian Corbin

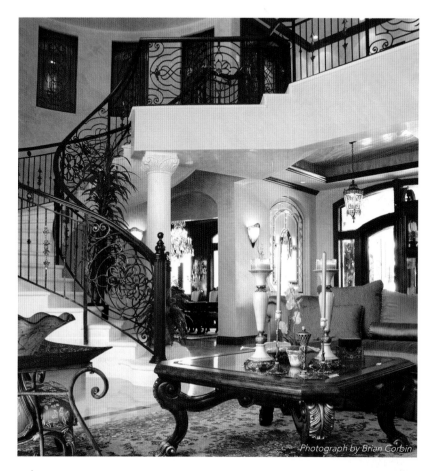

Photograph by Brian Corbin

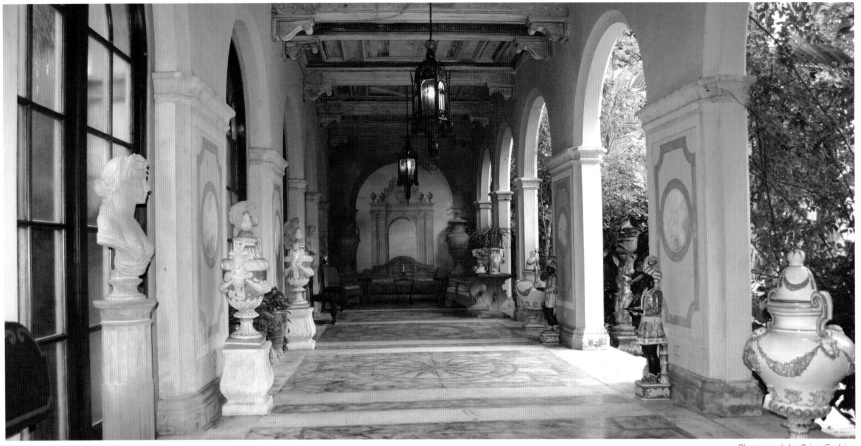

Above & left: Maintaining a historic mansion is a labor of love. The owner is a brilliantly talented set designer and artist; he personally created the trompe l'oeil at the end of the upper loggia, which overlooks an expansive courtyard with fountain. The space is marvelous because it comfortably seats 130 and keeps guests completely protected from the elements because of the architectural design. The upper loggia connects to a lower-level terrace that has a huge open fireplace, indoor-quality furnishings and an authentic pecky cypress ceiling. Because these loggias live like outdoor rooms, the entertaining potential is endless.

Facing page: Those who want a Delano-esque feel without the restrictions of a hotel are pleased with what they can do with the space. The nearly four-story ceiling volume, floor-to-ceiling sheer draperies and minimal amount of furniture give it a clean-lined contemporary aesthetic, but mix in elements like the grand staircase, massive chandelier and travertine floors and it becomes a stunning and intriguing residence.

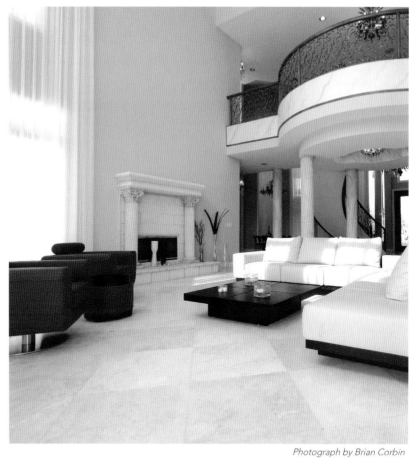

"I truly feel it is both a privilege and an honor to be in a position to offer such glorious estates to my clientele."

—Verna Shore

Photograph by Brian Corbin

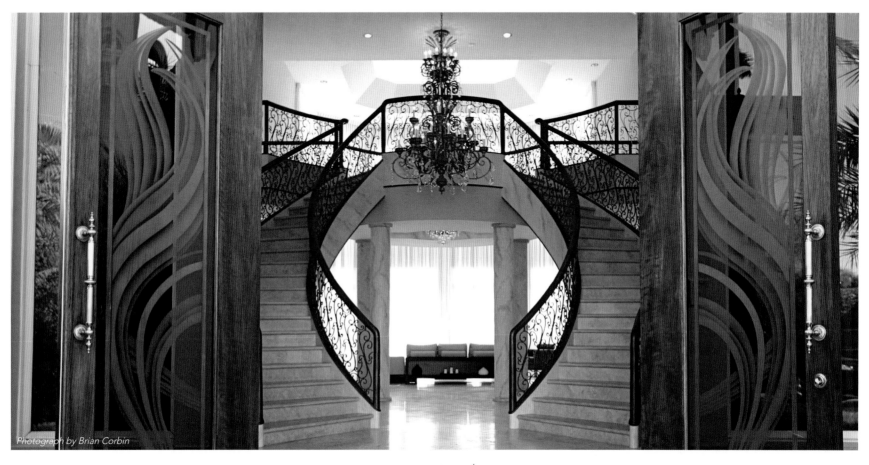

"Over the years it has given me great pleasure to find the perfect match to suit our clients' needs."

—Brian Corbin

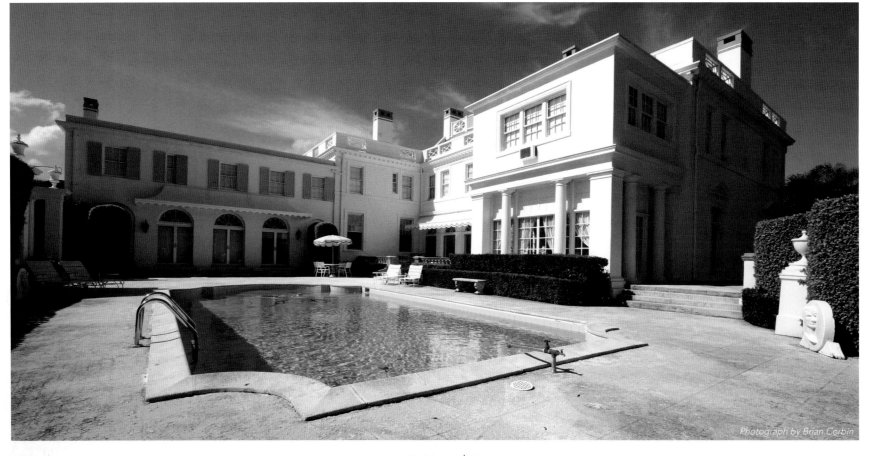

Photograph courtesy of Locations Extrordinaire

Above & right: The most spectacular views in Fort Lauderdale wrap around the dazzling penthouse—the owner designed it expressly for entertaining. Event planners who typically like to completely redo the space they're given find remarkably little to change. Audiovisual technologies afford glorious sound and allow photos to be transmitted to the flat-screen televisions as they're taken. Mixed with this state-of-the-art aspect are antique chandeliers from Murano and gold leafing galore.

Facing page: It's a photographer's paradise and a party planner's dream. Because the pool terrace isn't closed in by towering palms, the sunlight is unobstructed and allows plenty of light for shooting. The gracious open space around the swimming pool is ideal for dinner parties since guests can be seated all around the pool. Most pools can be converted into dance floors, but we always recommend leaving one end uncovered so that the pool lights can shine upward for a breathtaking nighttime focal point.

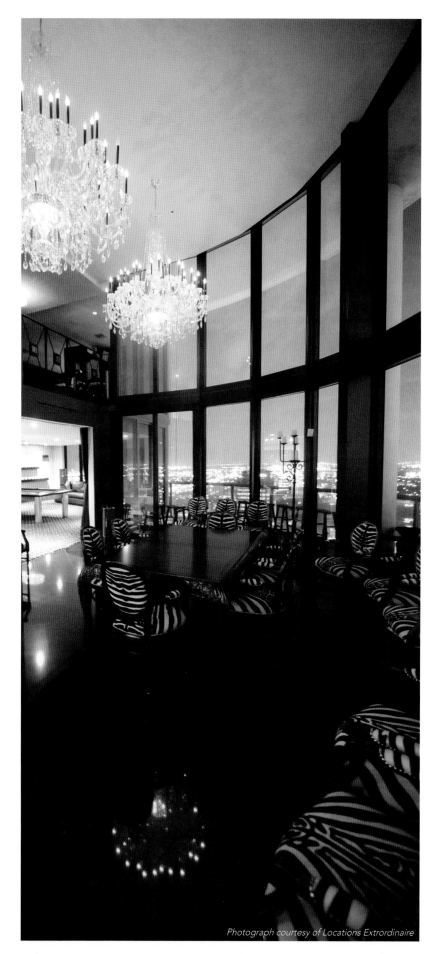

Photograph courtesy of Locations Extrordinaire

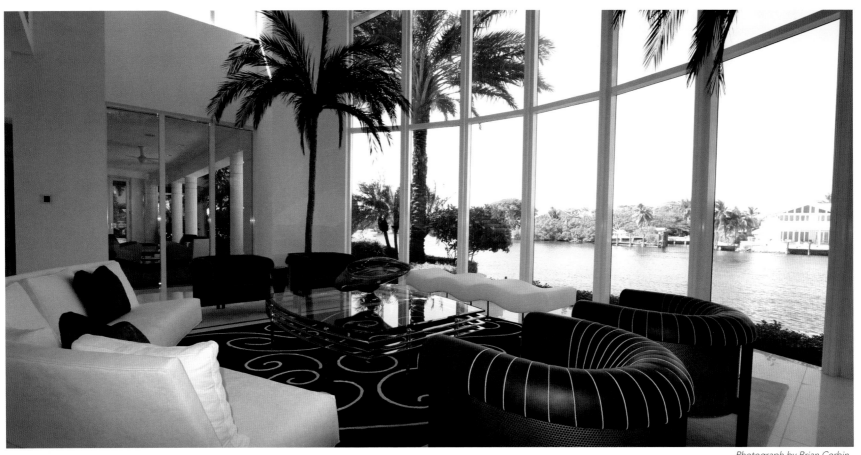

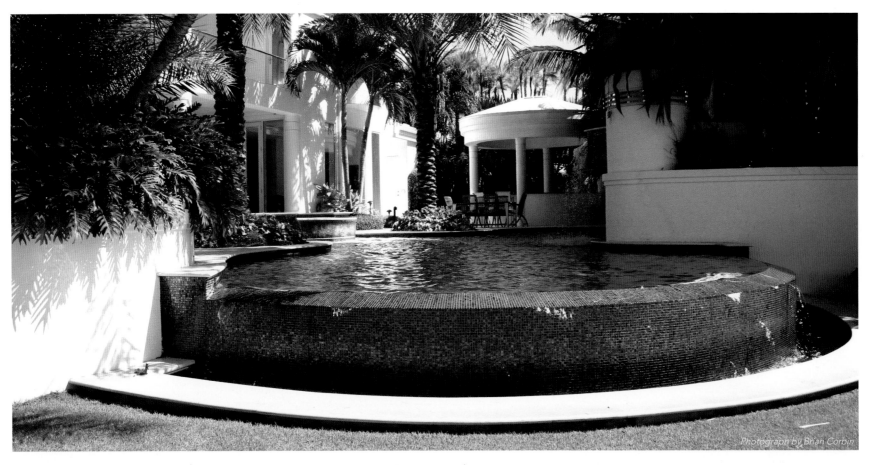

"I find it very exciting to be able to offer my clients various options for their guests to arrive at the estates we represent. It is always a treat to watch guests' reactions as they enter the property, whether by yacht, motor coach, limousine or even helicopter."

—Verna Shore

The combination of unsurpassed architectural talent and beautiful natural surroundings leaves a lasting impression with guests. Whether celebrated purely for aesthetics or integrated into a special evening's events, water and lush tropical landscaping are always the key ingredients in the alluring South Florida lifestyle.

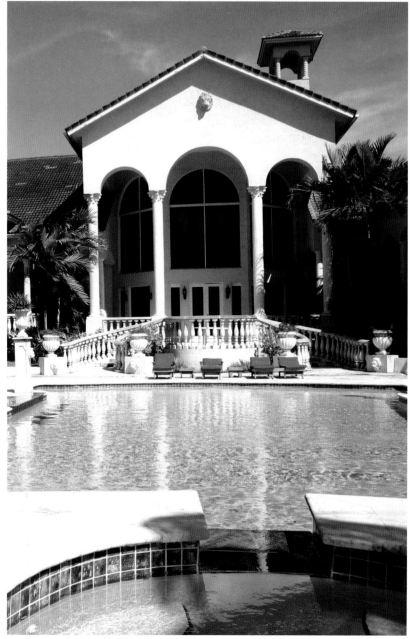

Photograph by Brian Corbin

views

Elaborate evening events may consist of dinners for eight or 800—there are so many marvelous ways for privileged guests to enjoy majestic mansions and elegant estates. We have the honor of coordinating a perfect estate for each client. It is also most rewarding to be a part of the charity events that happen in season. It's special to see how people open their hearts and gorgeous homes to host a charity function; raising dollars for worthy causes is the best reason of all to have a celebration.

THE HISTORIC ALFRED I. DUPONT BUILDING
GARY RESSLER, ABC MANAGEMENT SERVICES, INC.

The Historic Alfred I. Dupont Building began construction in 1937 and opened its doors on Christmas Day, 1939. This 17-floor Miami skyscraper was completed at just the right time; it offered the promise of economic recovery and signaled the conclusion of one the bleakest decades in American history.

The mezzanine level of the building, formerly a bank headquarters, became a special events venue in 2001 after an extensive restoration in 1992 by its current owners; a more recent restoration followed in 2005. Details of the Depression Moderne-style architecture—stunning at its inception—are the same charming characteristics that make the venue's two ballrooms highly desired today. It may take all evening to fully absorb the beauty of the spaces—including hand-painted heart of cypress wood ceilings, detailed scroll work, and brass elevator doors adorned with bas relief native flora and fauna—but the stately aura surrounding the venue is lost on no one.

Rather than a cavernous event space absent of character, the stately yet unobtrusive '30s architecture complements each event it hosts. The building is a true Miami gem—a bit of New York in the heart of Miami's central business district—and clients appreciate that their extraordinary moments will be forever intertwined with the nostalgia of The Historic Alfred I. Dupont Building.

The only Art Deco-era skyscraper in Miami cuts a dramatic figure against the night sky. The mezzanine, or event venue level, is characterized by double-height, 30-foot windows, which showcase the gleaming lights of downtown Miami. The Historic Alfred I. Dupont Building was honored with the 2009 Spotlight Award for "Best Event Site."

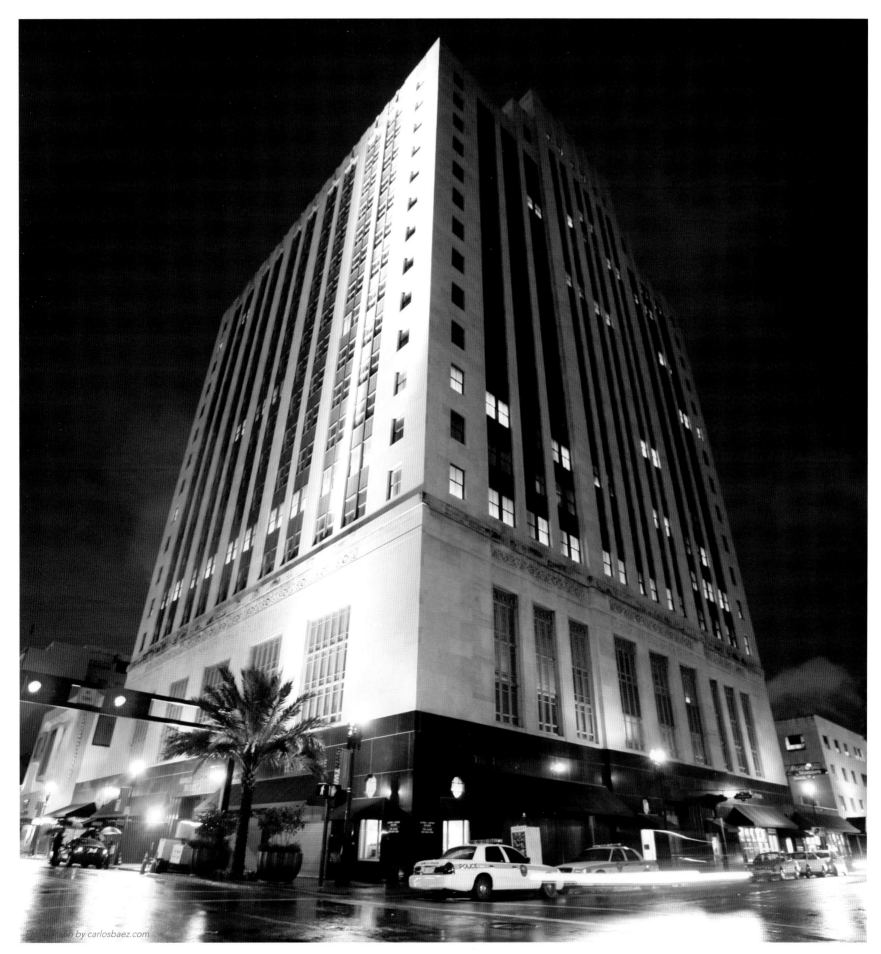

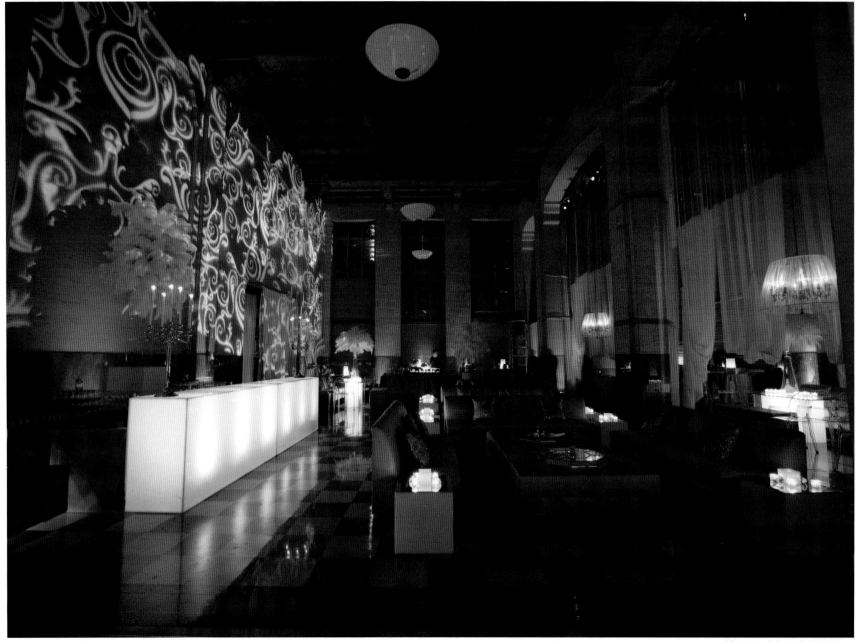

"It is difficult to find a venue that is truly unique and one of a kind. There is no other event space like this around; literally, it is the only Art Deco skyscraper in Miami."

—Gary Ressler

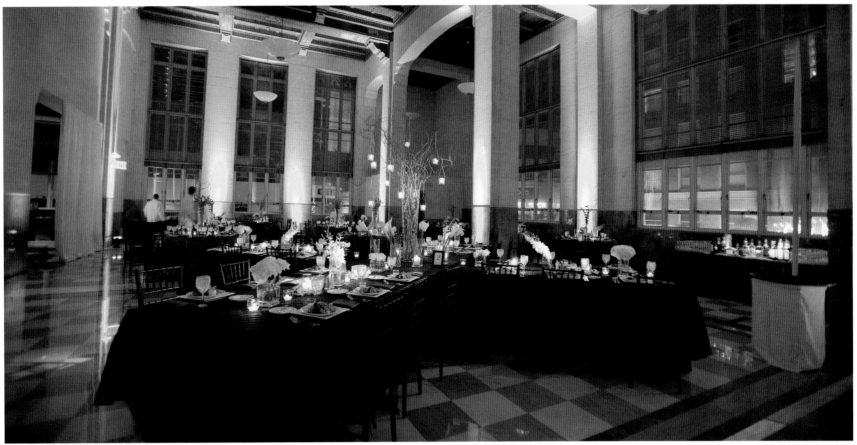

Photograph by carlosbaez.com

The architecture of the venue is distinct, yet it supports the theme of any event. Limestone walls perfectly absorb diverse lighting schemes, creating the desired impact. During the major restoration in 1992, the heart of cypress wood paneling on the ceiling was painstakingly restored by hand, and because the marble had been largely pillaged, it had to be replaced. Fortunately, the current owners' commitment to return the building to its former glory paid off beautifully. They were able to procure the last slab of Tennessee marble from the same quarry used in the original construction. Tennessee marble can also be found on the floor of Congress as well as Rockefeller Center.

Photograph courtesy of Karla Conceptual Event Experiences

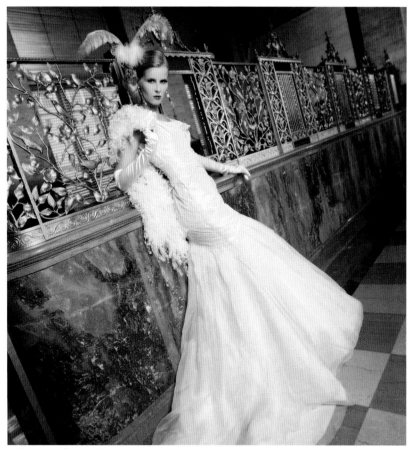

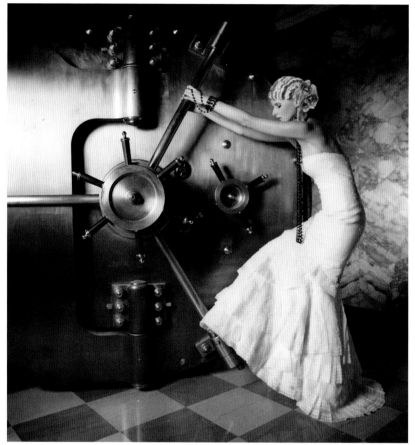

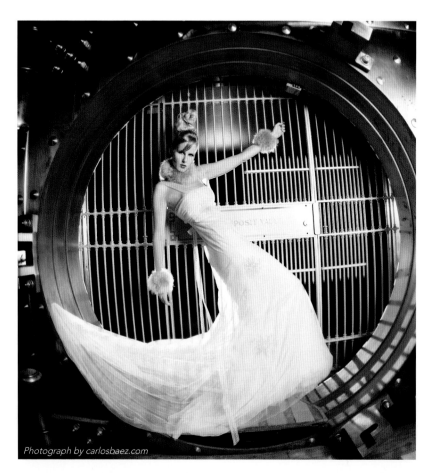

Above & left: The Historic Alfred I. Dupont Building is also a sought-after location for photo shoots and filming. A Miami bridal boutique highlights some of the details that make the venue so interesting. The relics of the building's past life as a bank—the vault, sometimes used as an intimate dining area and the teller windows, now used as the bar—set a totally unique and glamorous tone.

Facing page: The same space transforms so completely to fit each diverse event—from a formal fashion show to an Asian-inspired theme—that sometimes we find it hard to believe it's the same place.

"The ballrooms are used for an incredible array of events. From fashion shows and film shoots to galas, themed events and weddings, there is no end to the creative flexibility that the space offers."

—Gary Ressler

Photograph by carlosbaez.com

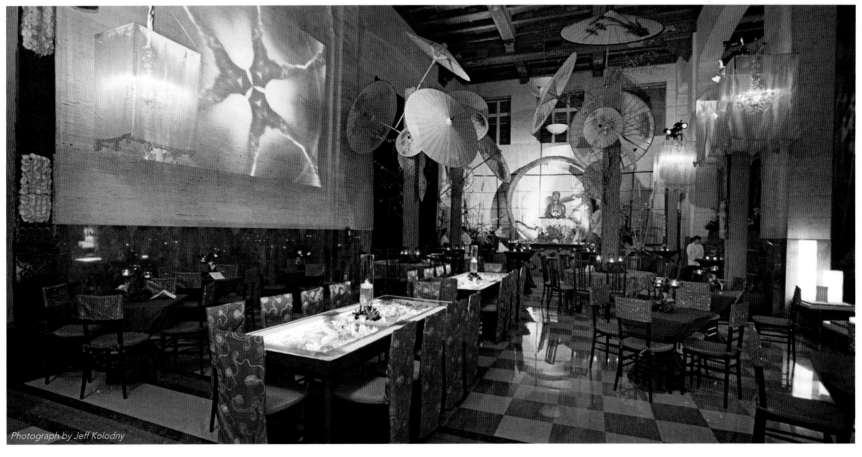

Photograph by Jeff Kolodny

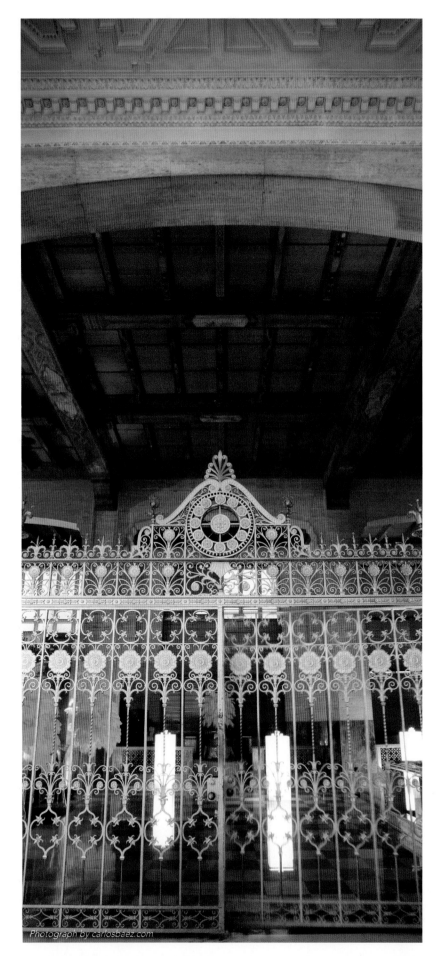

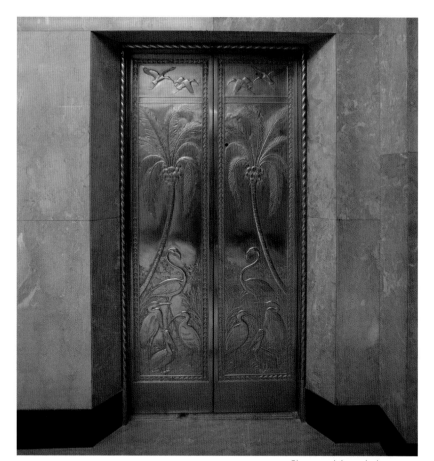

"When you start with a glamorous venue, the production simply falls in place."

—Gary Ressler

Right: A red carpet leads the way from an event at the Gusman Center for the Performing Arts, a restored 1920s-era theater, to a grand reception at The Historic Alfred I. Dupont Building. This was an amazing way to create an entrance.

Facing page: Brass gates welcome all to the building's ballrooms. Intricate grillwork, very characteristic of 1930s' architecture, is found throughout the mezzanine and two ballrooms. A shining example of craftsmanship is the bas relief elevator door, decorated with local flora and fauna.

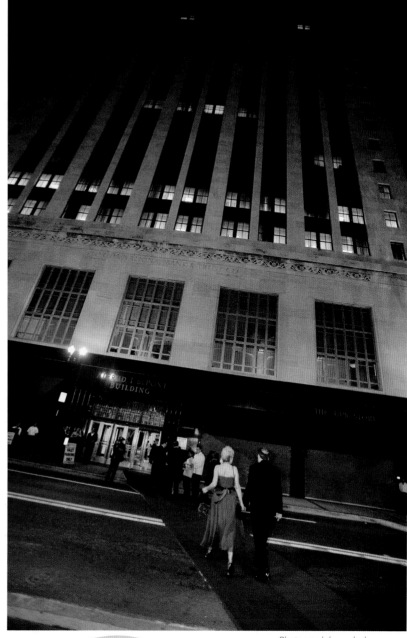

Photograph by carlosbaez.com

views

❖ When considering a venue, look at the surrounding architecture. A room with existing character is always more interesting than four plain walls.

❖ Utilize your event planner—delegate all communication with the venue to a single planner in order to make your event as seamless as possible.

❖ Consider the traffic flow of guests from entrance to exit; plan attention-grabbing touches along the way.

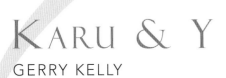

KARU & Y

GERRY KELLY

For those who have visited Miami's state-of-the-art entertainment venue, the name Karu & Y brings to mind luxury and energy, juxtaposed by entrancing and serene waterscapes. Its distinction as Miami's foremost destination among celebrities, athletes and A-listers as the place to see and be seen may come to mind as well. The name combination, which translates to "opulence" and "water," is a fitting moniker. The metropolis includes 50,000 square feet of diverse areas: a fine dining restaurant, the Y Ultralounge, Buddha nightclub and accompanying lush gardens. Karu & Y presents the best of Miami nightlife; it's the kind of place that must be experienced to understand its full magnitude.

The venue opened in 2006 to immediate success. However, when Ireland native Gerry Kelly stepped in as the hot spot's vice president in 2008, Karu & Y reached beyond nightclub status, becoming the venue of choice for corporate giants' large events and company meetings. The over-the-top success in the corporate arena came as no surprise to those who have sought Gerry Kelly's expertise in the past two decades. In 1992 the couture fashion designer was handpicked by musician Mick Hucknall of Simply Red to leave his Spain-based boutiques to run Mick and partner Sean Penn's Miami nightclub, Bash. Soon Gerry became South Beach nightclubs' go-to guy with a slew of successful clubs that were the result of his instinct, experience and talent. As a highly sought-after venue for everything from receptions to music videos and reality shows, Karu & Y has certainly been no exception to Gerry's golden touch.

The fine dining restaurant is open to the public or may be reserved for private events. In addition to the ample dining area, there is also a luxurious private champagne room for more intimate special events. Soft lighting and one-of-a-kind elegance surround each guest, beginning with the magnificent glass entrance and cascading waterfall. A special order Murano glass wall, totaling $2.1 million, brings opulence into tangible splendor before guests' eyes. Above, an original Dale Chihuly blue icicle chandelier incites the senses.

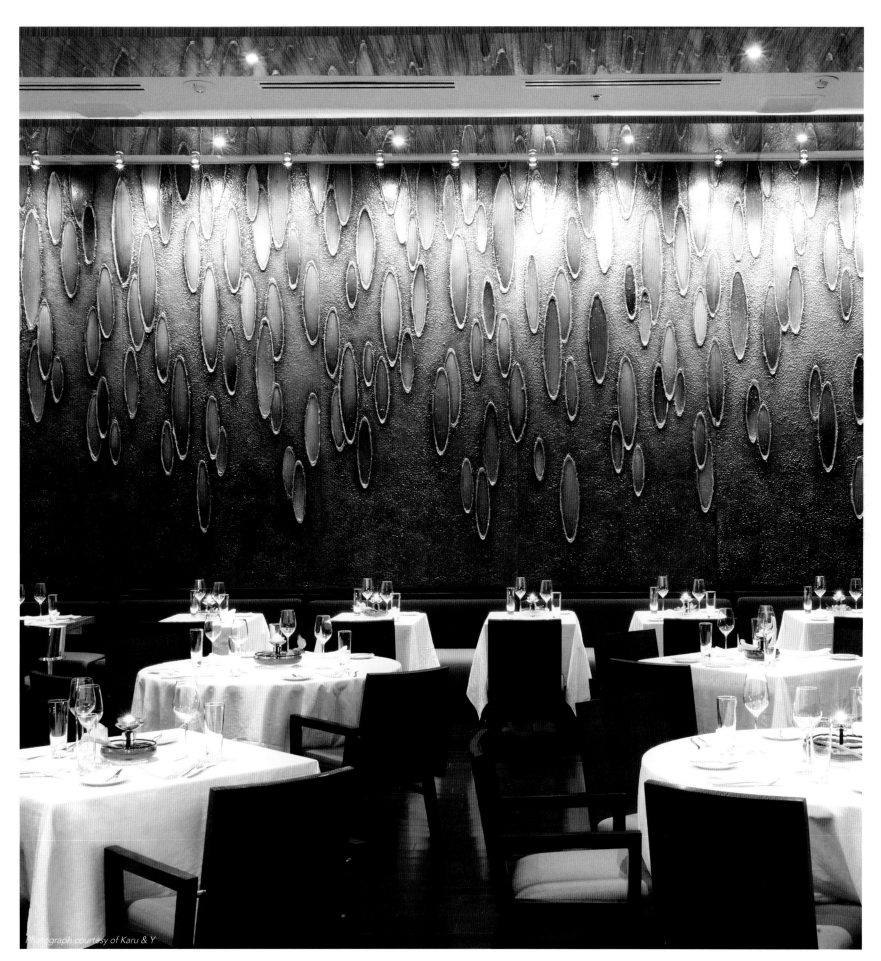

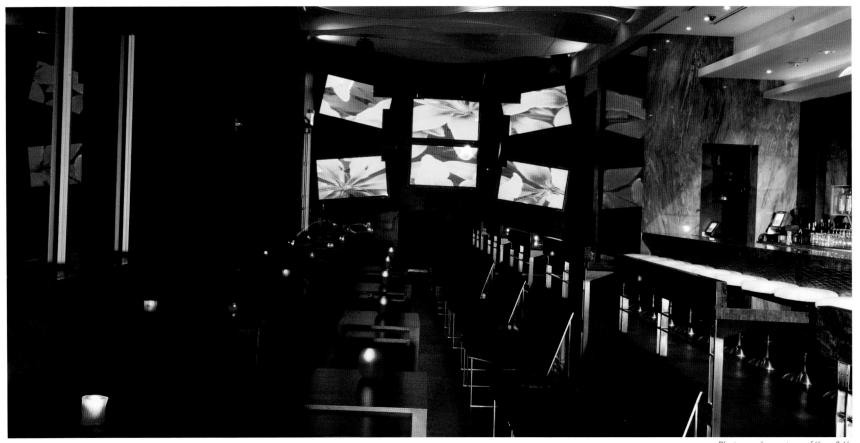

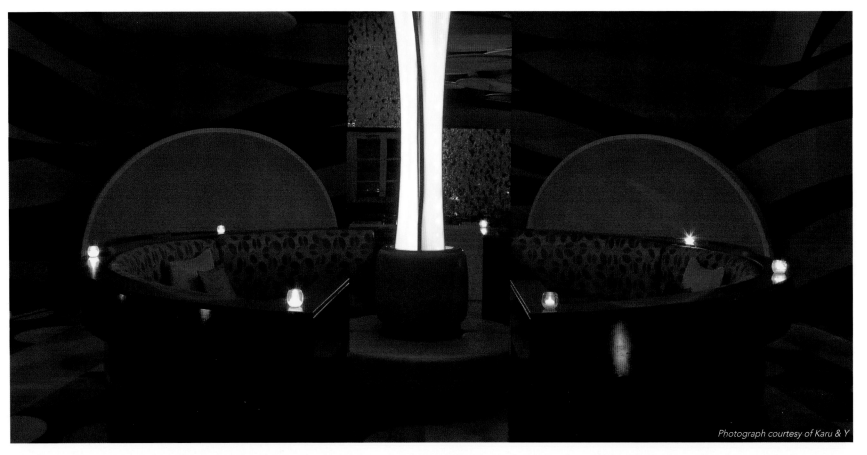

"When a venue can cater to events as diverse as private dinner parties and large corporate events, you have instant flexibility in your options and their offerings."

—Gerry Kelly

Right & facing page bottom: The Buddha Club draws its name from Far East-inspired décor. With over 30 moveable 11-foot totems that bestow a timeless, almost surreal mystique into 5,000 square feet, the room is one of endless possibilities and has a world-class sound system. It's a space of supernatural beauty and inspiration. The accompanying Buddha Gardens is a 13,000-square-foot ethereal dreamland enveloping your every sense. Wooden bridges arch over peaceful meandering rivers while splendid private cabanas and five cascading waterfalls add spice to the beautiful view.

Facing page top: The Y complex is divided into two areas: the Ultralounge and the gardens. An engaging spectrum of light, mood and atmosphere flows harmoniously through this haven of bold luxury. Flowing fabric hangs from the ceiling while soothing interior colors and images from 14 plasma screens frame blackstone slate and green marble floors. Exciting the senses and spirit, the Y Ultralounge encourages you to give in to the surrounding indulgences. The Y outdoor lounge surrounds you in outdoor beauty without sacrificing edginess. Individual air conditioning units also ensure that the mood most definitely stays cool.

Photograph courtesy of Karu & Y

views

❖ Consider the desires of your guests throughout the entirety of the event. Keep in mind that guests enjoy a change of scenery, whether that means gathering spots at the entrance or outdoors.

❖ Your special occasion's theme or tone should be carried out in the menu as well as throughout the venue's spaces.

❖ Never hesitate to begin with your vision of the venue. With the right people working with you, your dream will be their goal, too.

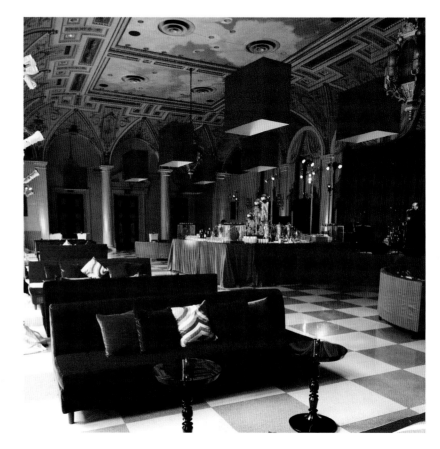

Creating an

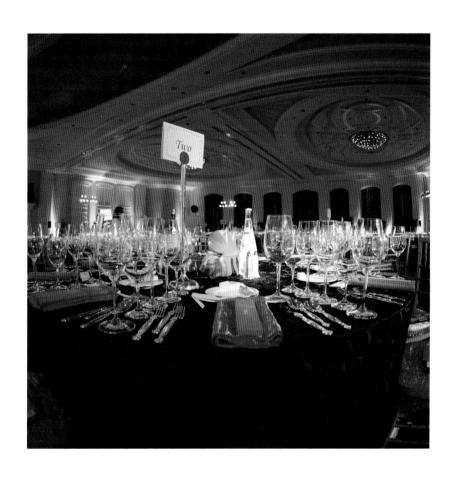

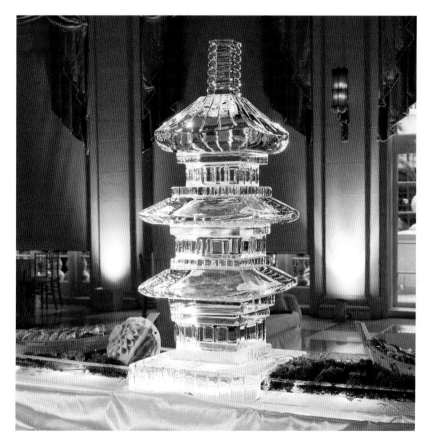

Ambience

ALWAYS FLOWERS AND EVENTS

KAREN COHEN | ELAINE CHEHEBAR

Welcome to Miami: where the flowers are fresh and the streets are vibrant. Always Flowers and Events emphasizes this urban vitality, producing events with a focus on upscale event and flower design.

Orchestrating innovative galas, parties and ceremonies, Karen Cohen and Elaine Chehebar create the most jaw-dropping spaces and coordinate with a strong team of designers, with backgrounds ranging from interior design and carpentry to fashion and art. "Team" is the operative word for the duo, who insist that collaboration is the only way to go. Since 1996, Karen, Elaine and their talented colleagues have catered to every culture, style and occasion. As a port city, Miami receives the highest quality flowers before the rest of the country, giving Always Flowers and Events an edge. Ties to Colombian flower farms and lush native trimmings add to the vivid designs and allow the events and designs to speak for themselves. With an array of venues, from abandoned mansions to office floors, Miami offers a location for every occasion. Whether it's a Chinese New Year ball or a Brazilian bash, Always Flowers and Events can produce it—beyond expectations.

How do we keep a fresh perspective for each event? Our clients. They fuel creativity like nothing else. Designed by Sky Productions of Israel, a New Year's Eve bash included acrobats who performed around a two-tier silver firepit while guests dined. Commanding and dramatic, the table accommodates 40 people—much larger than a typical event dinner setting. The floral centerpieces reinforced the elegance of the eclectic Asian theme.

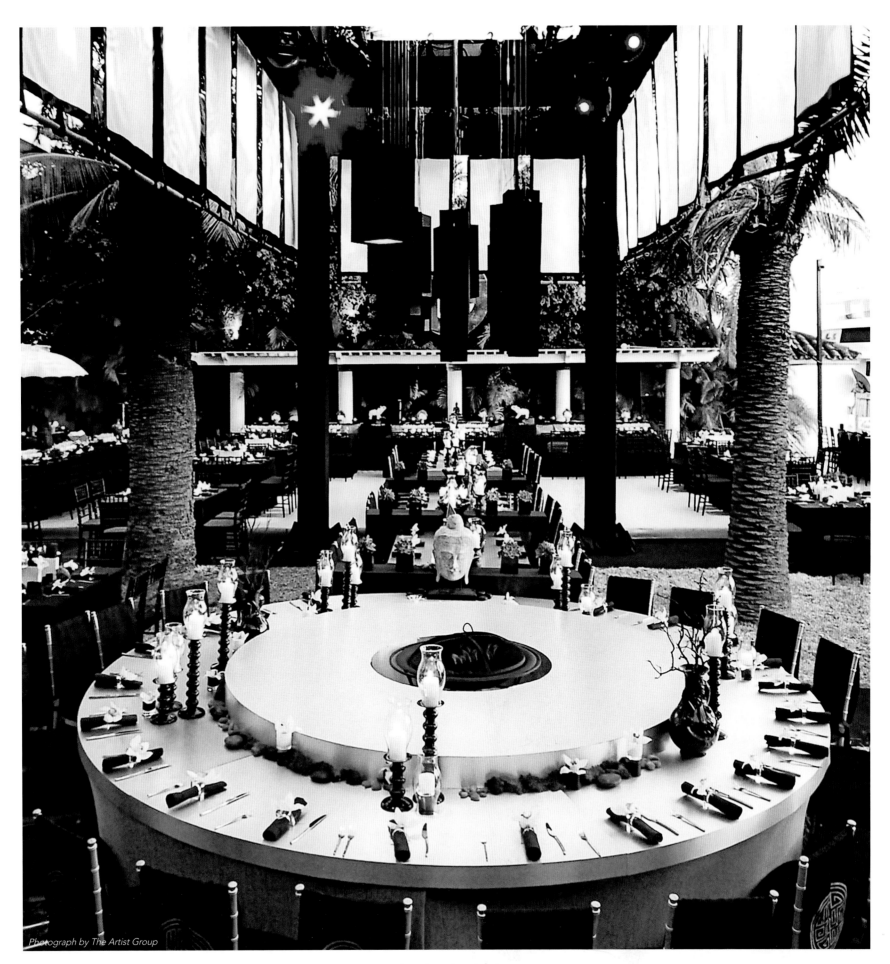

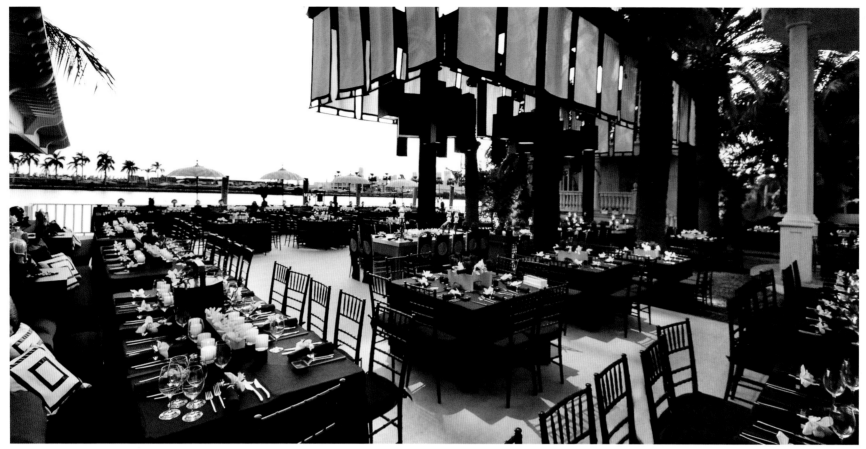

"Always go for the wow factor. Don't hold back."

—Karen Cohen

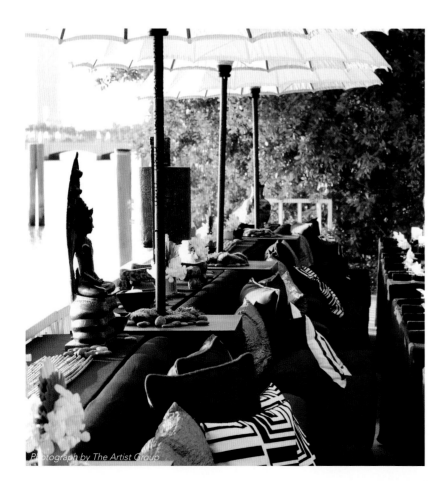

Above & right: A bar mitzvah at the Four Seasons appealed to both kids and adults. The room was divided into sections for each group without isolating one from the other. We wanted to keep the kids comfortable, but not stagnant, so we accessorized with wheat grass and lacrosse equipment alongside sofas, ottomans and tons of pillows. Adults sat at custom acrylic tables lit from within and framed by titanium-colored edging. Our centerpieces used red cymbidium orchids, wheat grass, succulents and red peonies.

Facing page: Black never goes out of style. We created black wood light fixtures, softly lighting the table and creating a mobile effect between the panels. Sleek frosted glass vases held vertical lines of white cymbidium orchid blooms. Black and white glass candles and clump moss adorned the base of the tables while dried palm husks with stems of white cymbidium orchids and river rocks connected the pieces together. And for dining seating, we used an eclectic approach that offers something for everyone. Pillows of different shapes, colors and textures sat on sofas beneath large fabric umbrellas, resulting in a relaxed feel. The sofas along with black Irish linen table covers from Nüage Designs Miami added elegance and maintained the high-end look.

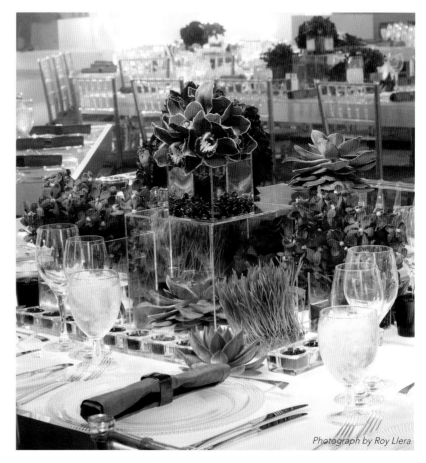

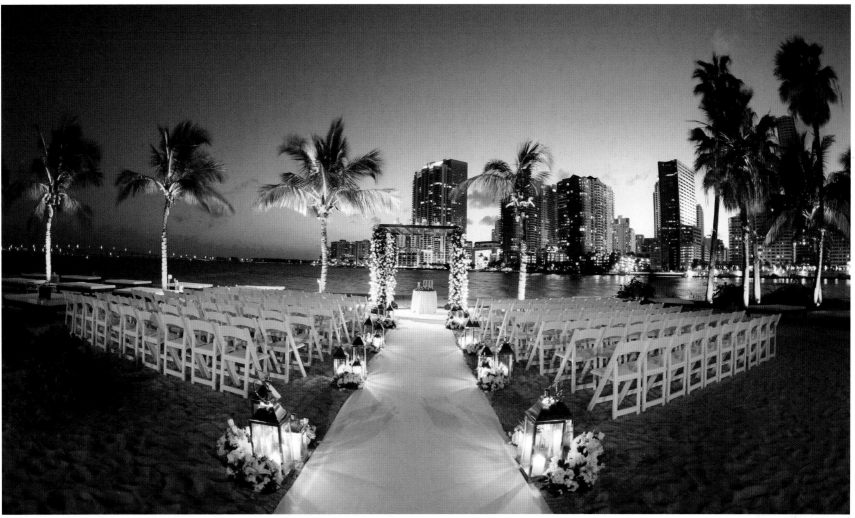

Photograph by Studio 1791

Planned by Melissa Davis Designs, a ceremony at the Mandarin Oriental hotel captured the beauty of the Miami skyline. Set on the beach, the chuppah was made of dark stained wood with an acrylic rooftop, holding a mixture of floating and pillar candles; the poles consist of green pittosporum and white spray roses with white tulips. The aisle treatment blends steel and glass lanterns containing pillar candles and uses a fabric runner for a sleek look.

"When you're working with a stunning backdrop, don't overdo it. Let the setting shine through."

—Elaine Chehebar

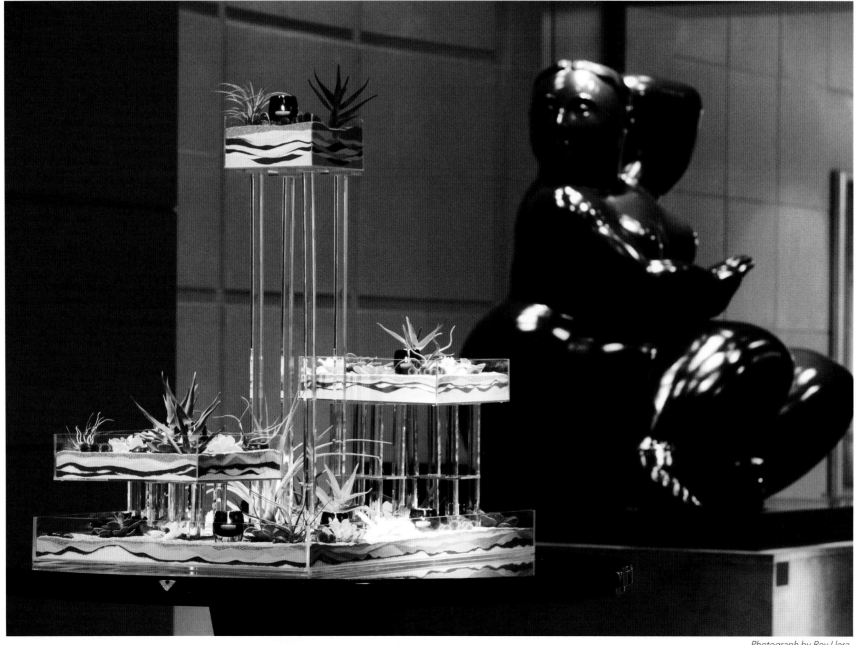

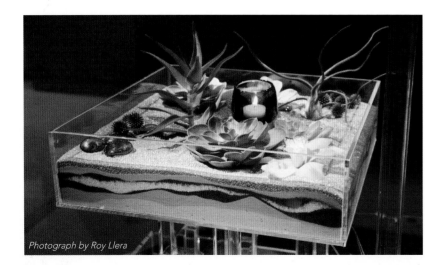

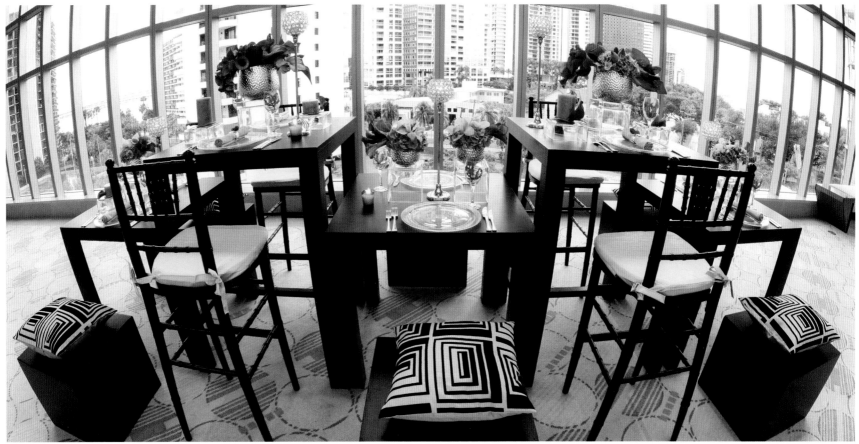

Photograph by Roy Llera

Above & right: Flowers sit within silver hammered bowls holding mango mini calla lilies, leaves, eucalyptus pods and green hydrangeas. With varying elevations, custom square wood tables create a long royal setting. Some seating is made by using wood cubes with pillows and some by using more traditional, black stools.

Facing page: The lobby of the Four Seasons Hotel in Miami is the ideal spot for us to showcase our creativity—we work in-house and do all of the displays. We reach for strong architectural designs with a Miami feel. Used as a main focal point in the building, a display of colored sand, air plants, succulents, purple glass rocks, thistle and votive candleholders is set in front of a Botero sculpture.

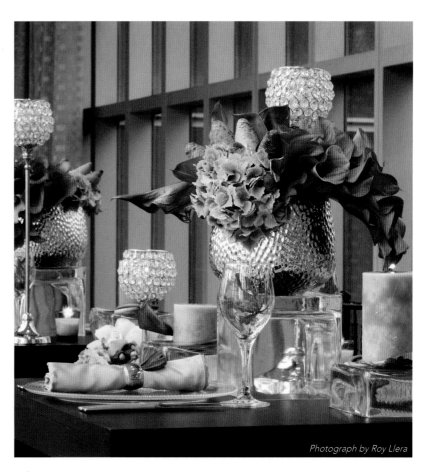

Photograph by Roy Llera

Photograph by Amy Hill

Photograph by Roy Llera

"The more eclectic, the better.
People will remember it."

—Karen Cohen

Above: We designed a nuptial ceremony at The Ritz-Carlton South Beach. The couple wanted an ultra chic, romantic feel with black, white and bold red. Wood candleholders held large pavés of black bacarra and black magic roses, while crystal garlands draped the design to soften it. The lounges and linens were in black and white, with walls draped in all-white, creating a blank canvas for lighting. On the oceanfront at the Regents Hotel in Bal Harbour, natural driftwood accented with baby shells made a heart shape. Berry garlands, succulents, green hypericum berries, celocia, galax leaves and green trachillium were also used. The letters came together with red roses in small bowls, creating a romantic message.

Facing page: For a surprise 60th birthday bash, the Mandarin Oriental Hotel proved the perfect venue. With a disco theme, the party included fog hazers, a color-changing dance floor, assorted lounge seating and moving disco balls on the ceilings. The Asian-influenced ballroom held S-shaped countertop seating and square tables.

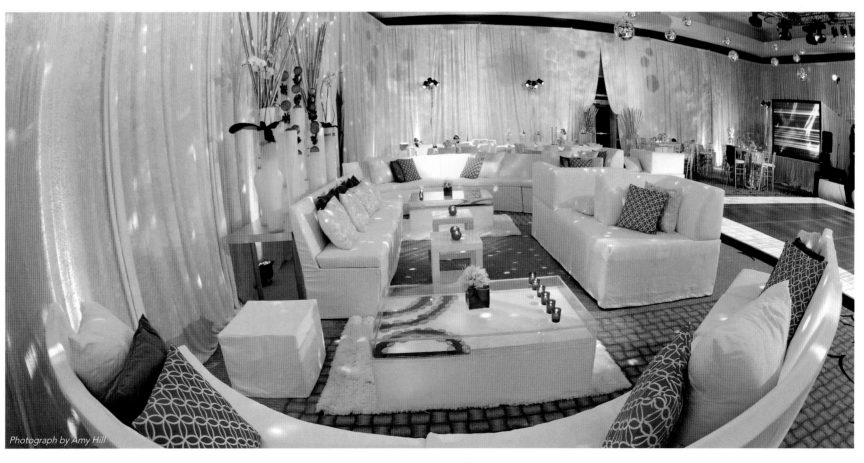

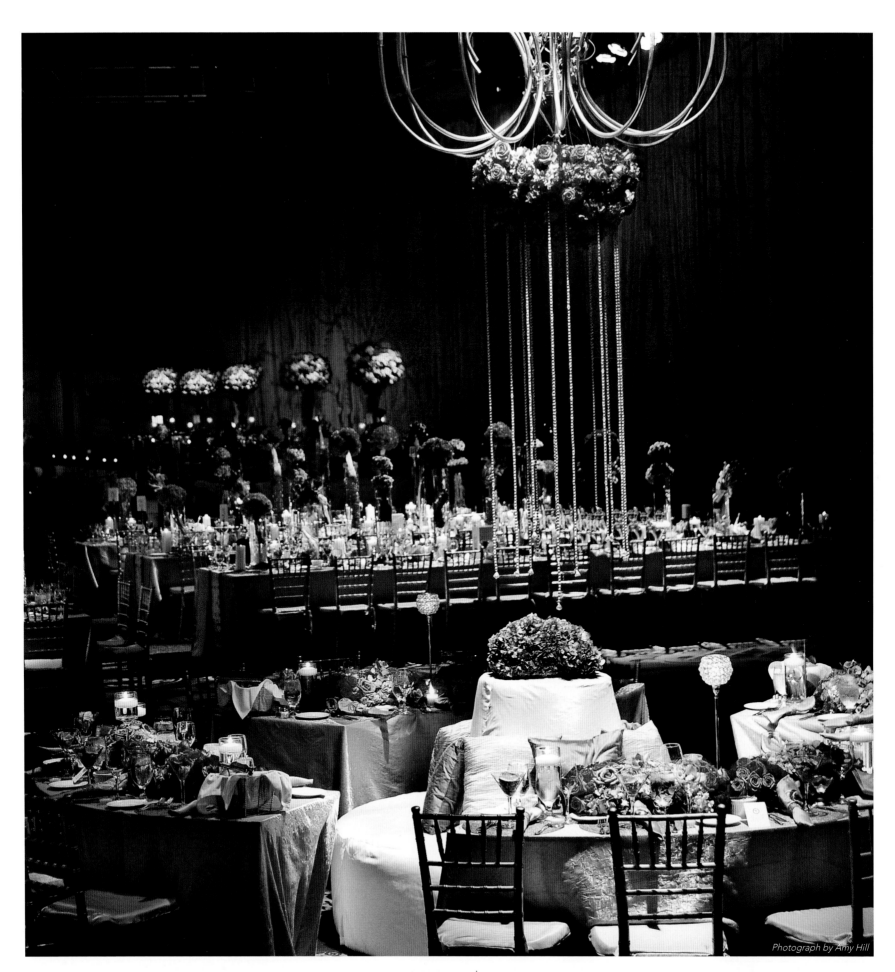

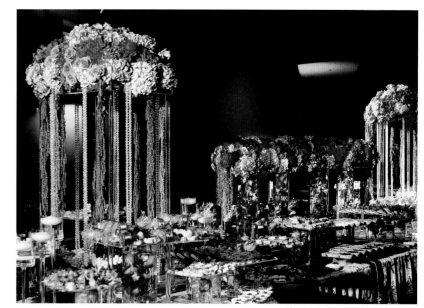

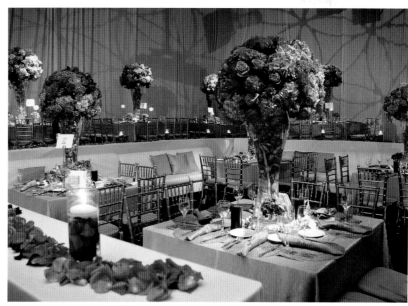

How do you plan a thousand-person event in a month? Find the best event producers; then roll up your sleeves and cross your fingers. Collaborating with event planning and design firm Sky Productions of Israel, we created the most elegant ceremony setting at the Doral Country Club, complete with seating levels in the ballroom. Gold chandeliers hung from the ceiling with centers of hot-pink hydrangeas and dangling crystal garland. White-draped walls projected gobo graphics in soft purples. Pavés of bright pink peonies, hydrangeas and burgundy amaranthus hang above confections and pastries, by Presence Party Planning. Large glass vessels have deep pink cymbidium orchid stems submerged inside. Shelves display floating candles in glass cylinders, lined with fresh rose petals.

views

The more you trust the designer, the better the results will be. Place confidence in the people you elect to do a job—they're professionals. Do all the research before choosing a designer, then let her take control. The results always impress.

HY-LITE PRODUCTIONS, INC.
MICHAEL STEIGHNER

After more than two and a half decades, Michael Steighner can actually remember the exact moment he was inspired to venture into this field. While under a stage at the Flagler Museum in Palm Beach, Michael knew he would someday enter and establish a presence in the lighting industry. It was a party for Palm Beach residents, and Michael was attempting to reach a fog machine that needed to be manually pumped. He stopped in this adrenaline-charged moment, among the sounds, commotion and electricity of the event and realized he was committed—the environment and experience was second-to-none. Since that day, Michael has been navigating between social, business and festival environments, flawlessly executing lighting presentations and managing elaborate corporate events.

Known for his attention to detail, Michael stays a step ahead of guests by clearly organizing his programs and collaborating with other designers. Whether designing or consulting in his home state of Florida, the other side of the country, Canada, Mexico, the Caribbean, South America, Europe or Asia, Michael brings the same attention to detail and fervor to each of his events. Having set the stage for the United States President six times, worked with national makeup brands and designed lighting for some of Florida's most prestigious mansions and hotels, Michael has extensive expertise—he truly has illuminated the very best of locales and some of the most recognizable faces. Utilizing his talent and passion for color, light and texture, Michael fosters an incredible collaborative environment that produces extraordinary results.

We were given a raw space to work with during a week-long convention—the main banquet room was an old theater. Raw spaces are always a challenge but certainly a pleasure to design within. In this case, the ambience was fairly ornate and the theme was far less stuffy, so we had to draw the focus toward lightweight décor and let unique lighting design be the player of the night.

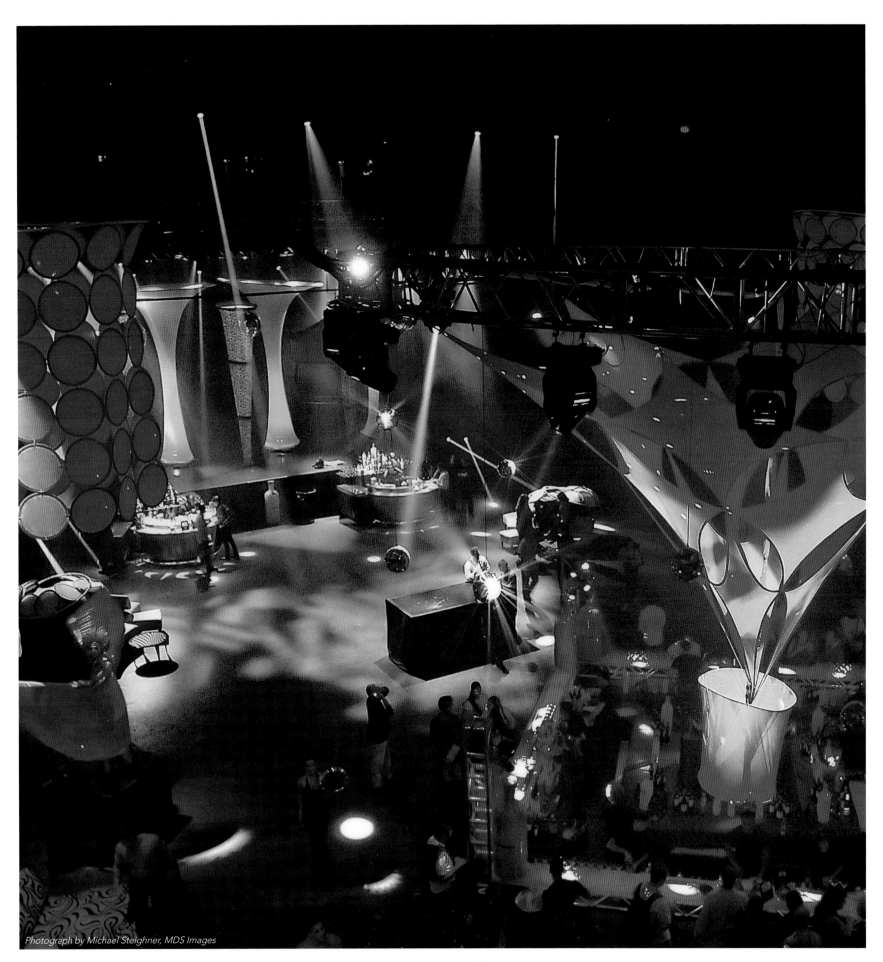

Photograph by Michael Steighner, MDS Images

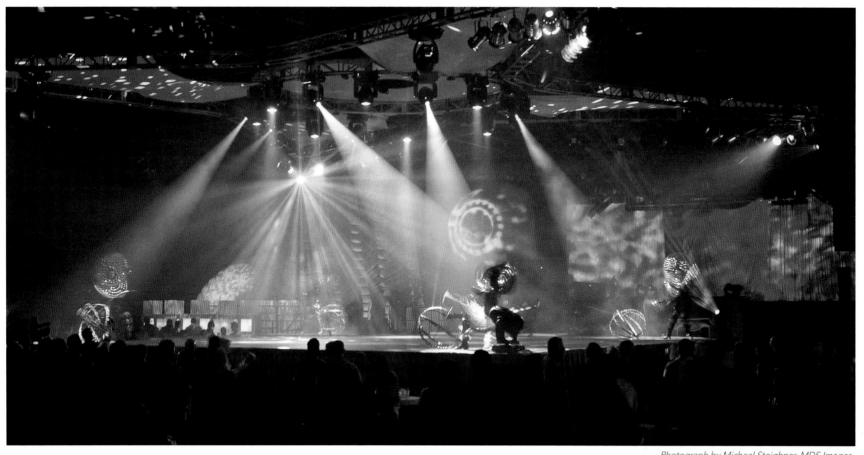

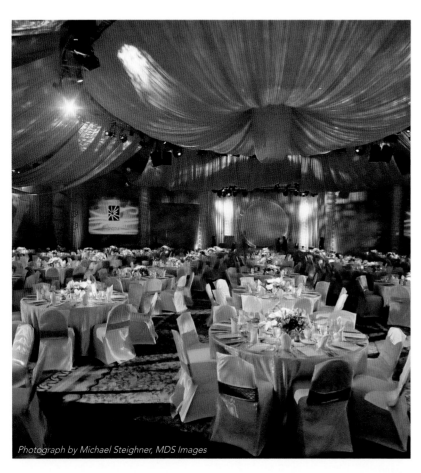

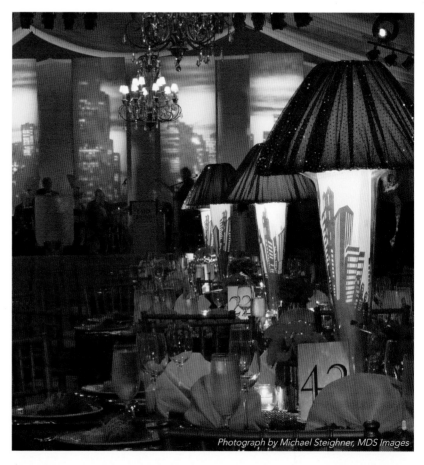

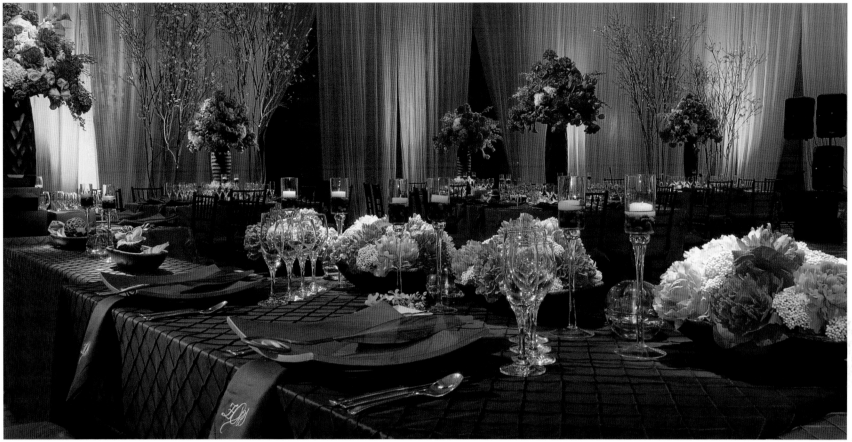

Photograph by Michael Steighner, MDS Images

Whether we're designing for a show with a high-tech theme or something more formal for a corporate event, it's often the lighting that guests don't specifically note, but subconsciously appreciate. Intricate ceiling draperies, chairs, centerpieces—all these elements have to work in coordination with accurate lighting—and on occasion, we're given an extremely small turnaround window from one event to the next within the same venue. But all these ingredients keep us vigilant and searching for the very best lighting and set-up solutions.

"Illumination technology has progressed so much that no event should lack the special pizzazz of professional lighting design."

—Michael Steighner

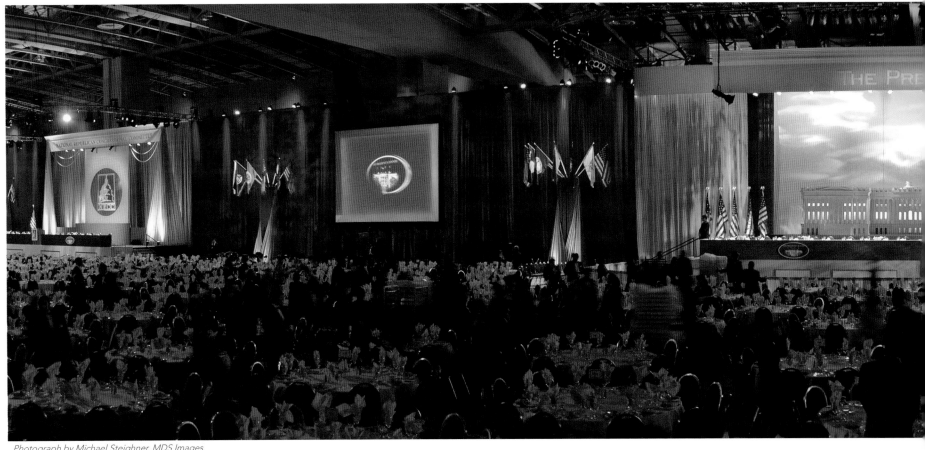

Photograph by Michael Steighner, MDS Images

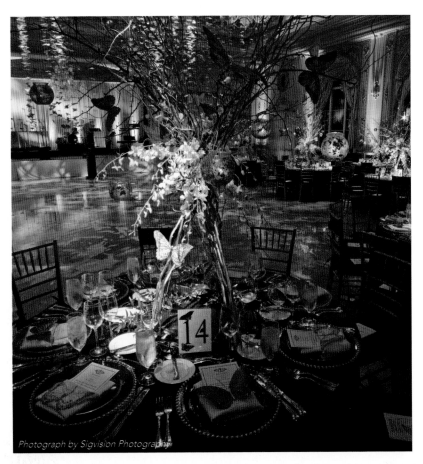

Photograph by Sigvision Photography

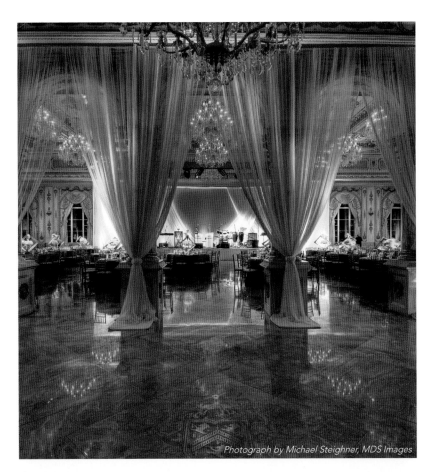

Photograph by Michael Steighner, MDS Images

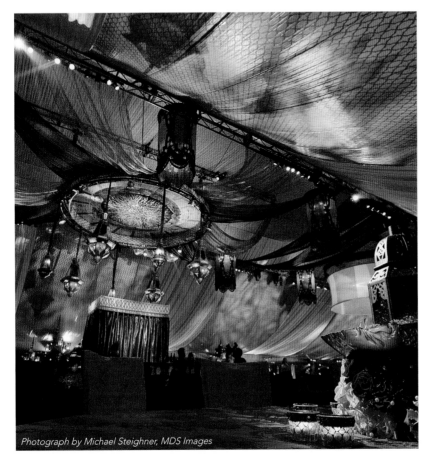

Photograph by Michael Steighner, MDS Images

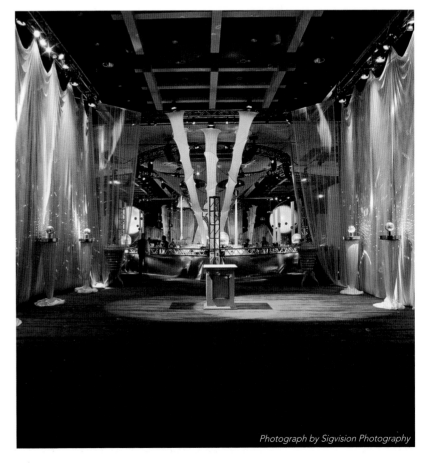

Photograph by Sigvision Photography

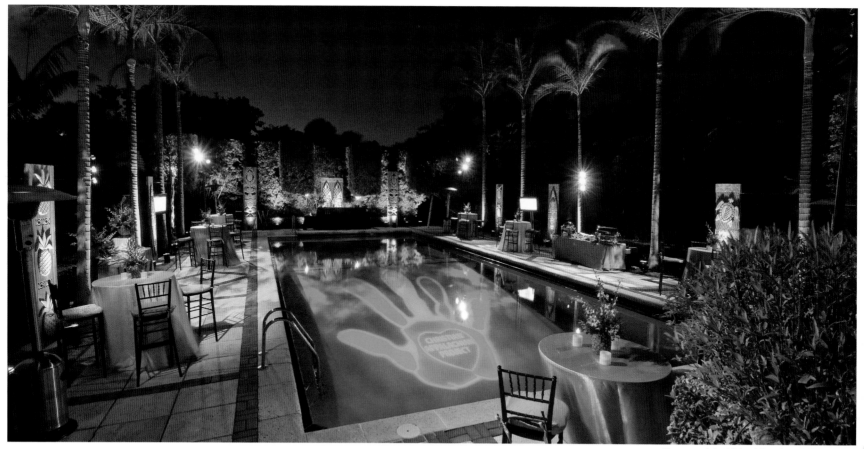

Photograph by Michael Steighner, MDS Images

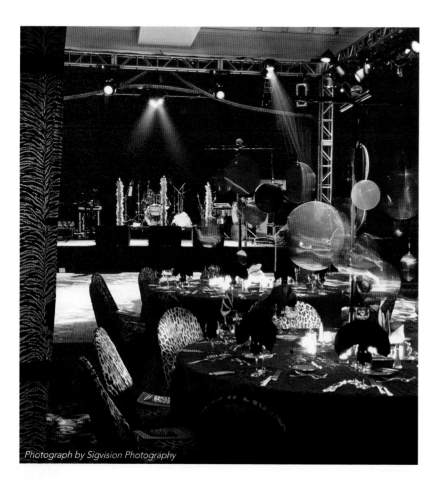

Above & left: Every event offers us an opportunity to try new techniques. For a charity event, we imprinted the host's logo in the swimming pool using a special light projection from an historical architectural upper patio to brand the event. In another fundraiser, we used automated lighting for a rock 'n' roll '80s theme: It definitely had an intimate club-like feeling with deep reds and ambers reflected on the wall. As the electricity increased in the room, the use of kinetic lighting charged the ballroom.

Facing page: By consolidating our efforts and being extremely organized, we were able to quickly transform a banquet hall from meeting space to gala dining space. For another event, the opening night of a Maybelline party in California, my entire creative team traveled cross-country to make sure we had every detail covered; the event started mid-afternoon so required both daylight and nighttime techniques for a smooth transition.

Previous pages: There's nothing like an intimate dinner for 6,000 people. Three stages were reserved for the Senate, the House and the executive guests at a Republican Party fundraiser—when the president is going to speak at a program, everything has to be perfectly synchronized. I literally walked around every chair to ensure a positive impact vantage point for each attendee.

Photograph by Sigvision Photography

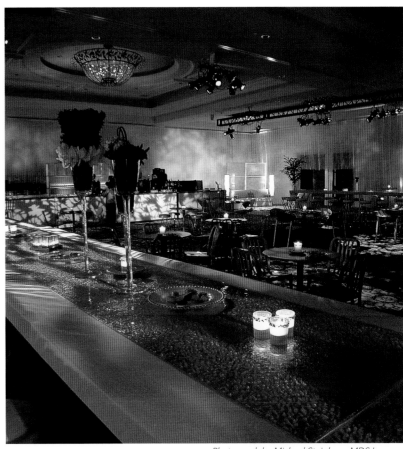

"It's nice to be the background layer for some of Florida's most prestigious locales. Light enhances mood and guides the progression of events."

—Michael Steighner

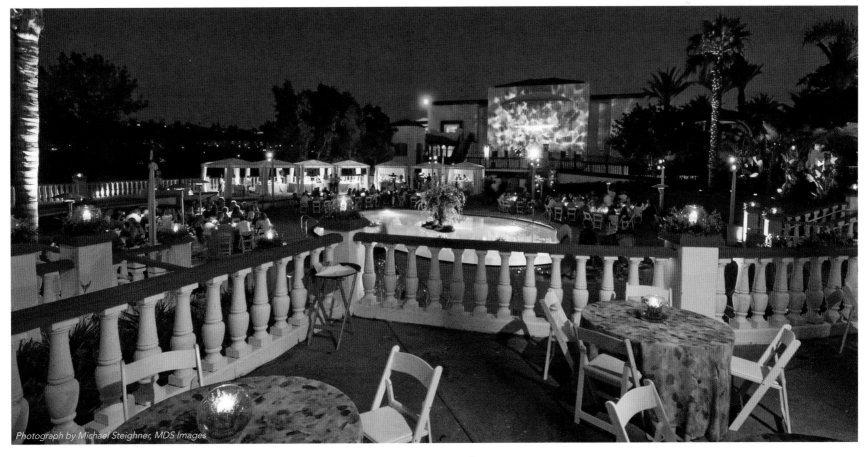

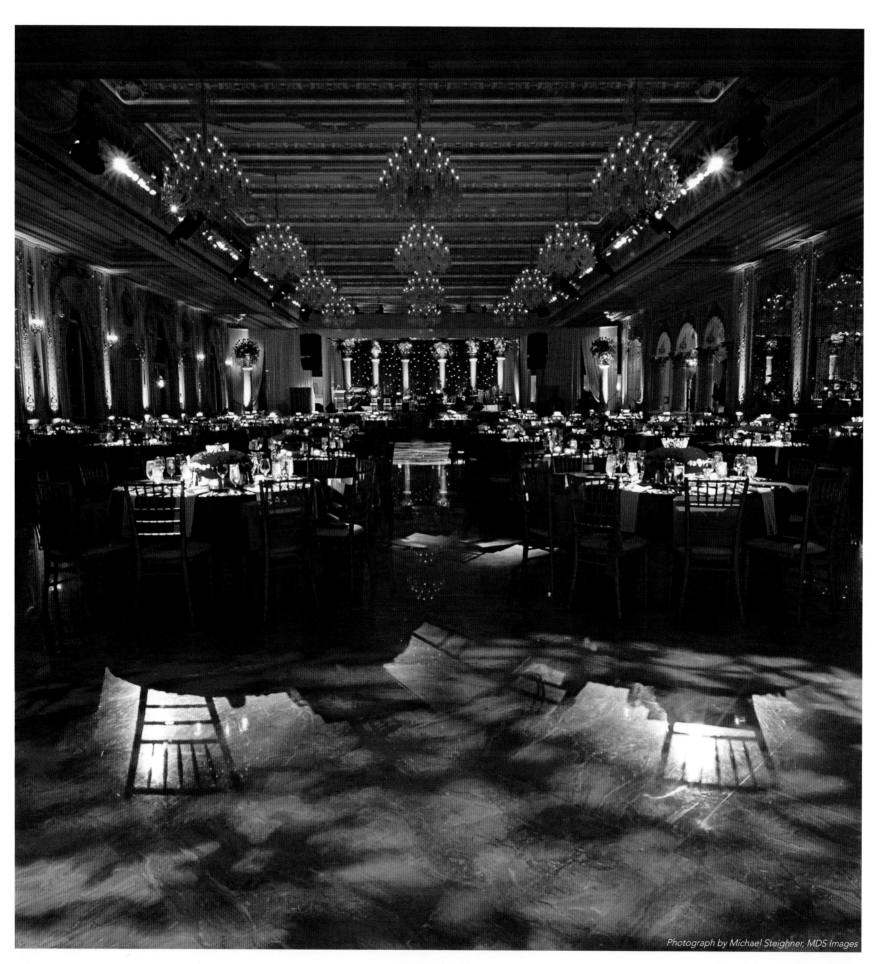

Photograph by Michael Steighner, MDS Images

Above & right: Google was among the sponsors at a political debate in St. Petersburg, and as such, we designed the company's behind-the-scenes resting area with a kaleidoscope of its logo's colors.

Facing page: The ballroom at Mar-a-Lago has beautiful architecture and chandeliers, so we wanted to be sure that the design would have a cohesive ambience. Soft textures gave an immediate sense of welcome, and uplit columns nicely framed the room.

Photograph by Michael Steighner, MDS Images

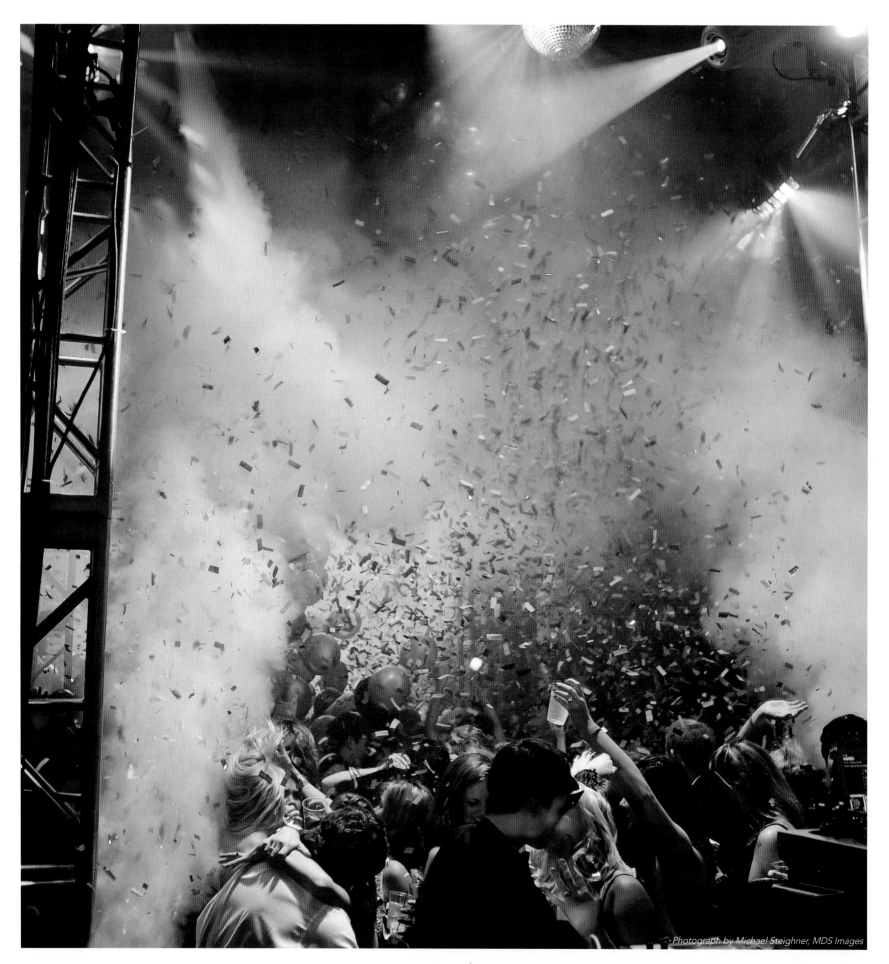

Photograph by Michael Steighner, MDS Images

"Many people aren't aware of how many ways lighting can function. If you want the best results, you have to know all of the tools and techniques that are available."

—Michael Steighner

I got my start designing New Year's Eve parties at the Flagler Museum, nearly 25 years ago. Every year we look forward to creating a new look for the locale—lighting cues, fog, confetti, all these work in coordination and help people celebrate the countdown to the new year.

Photograph by Michael Steighner, MDS Images

views

There are many things to consider when choosing lighting designers. Are they intensely passionate about light, color and texture? Do they possess electronic savvy, which can aid in troubleshooting on the event day? Will they thrive under the chaos and energy that pulses through events? Can I trust them to appreciate and respect the entire creative team? Do your homework and then go with your instinct.

ED LIBBY & COMPANY INC.

ED LIBBY

If you think "straight off the runway" is only associated with clothing and accessories, then you haven't been to an Ed Libby event. Ed Libby & Company was the first design studio to use layers of ingredients to blend atmosphere with living art to create a dramatic new dimension. Floral design and event production will never be the same.

Inspired by his clients, a love of travel and artistic talent, Ed continually challenges himself to reinvent. His diverse designs serve both to support his success and to distinctly represent each client's personality. But he wouldn't have it any other way: Challenge is what unearths creative brilliance. After 25 years of designing celebrated events from coast to coast and abroad, Ed leaves nothing to chance. Amidst his stunning backgrounds, accuracy counts. Each event's interior has been immaculately sketched down to the last crucial detail for the host—even the napkin rings go through painstaking selection. When the time for the event comes, the stage is strategically set for glamorous hostesses to enjoy their evening among "vignettes of visual delight."

Whether an Ed Libby-designed event is a glamorous society soirée or an outrageous celebrity birthday party, guests are struck by his chameleon-like ability to create across endlessly changing genres. From the mystical Far East to the very personification of one's paradise, chic elegance or pure whimsy, an Ed Libby experience appeals to all five senses.

For this chic soirée, the luxurious color of love served as a template for my design inspiration. Sultry scarlet crushed velvet dressed the guest tables and undulating banquette seating. I chose to mix dupioni silks and cherry-red crocodile leather accents for dimensions of textures and tones. By suspending elaborate floral chandeliers, a feeling of intimacy may be created, even in a cavernous venue. Tall floral candelabras dripping in luxurious crimson blooms mixed with rich ruby vessels and warm flickering candlelight create an environment of pure elegance. Using a combination of edgy plexi elements juxtaposed with lavish traditional touches brought out the hosts' "Uptown Elegance Meets Soho Chic" personality.

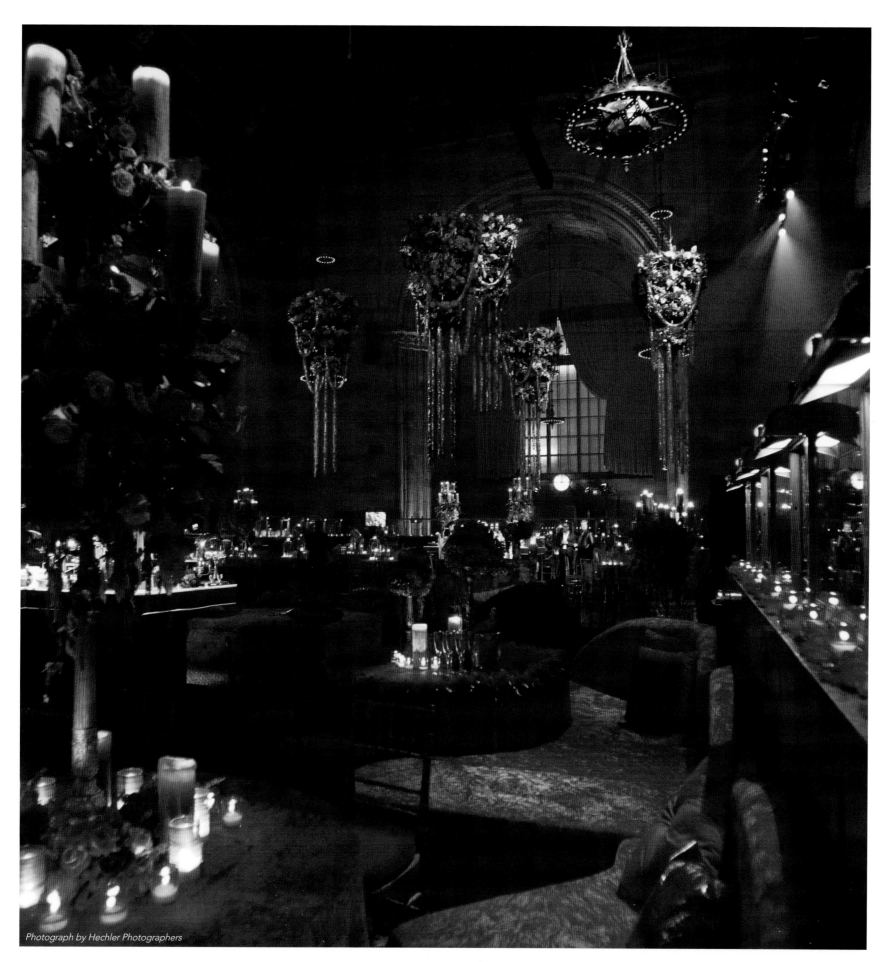

Photograph by Hechler Photographers

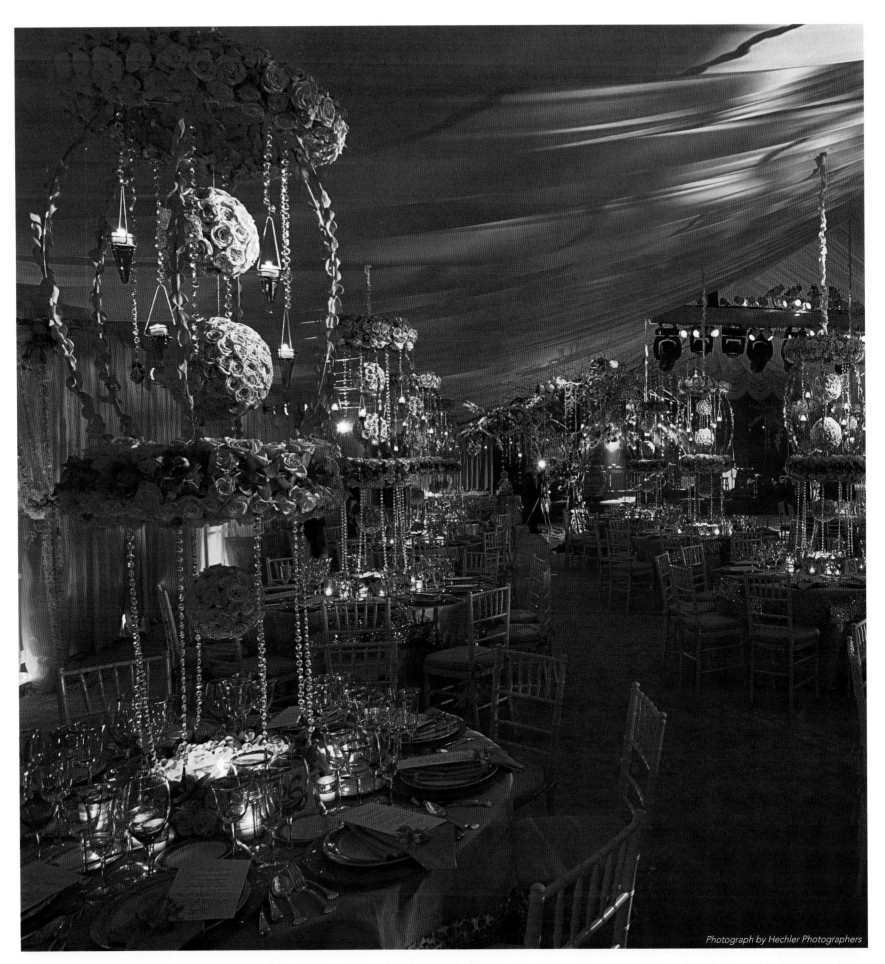

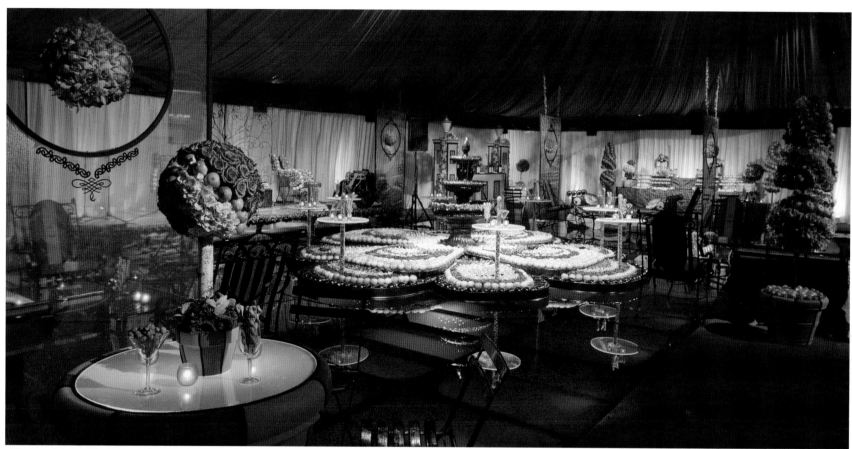

Above: A Lucite-covered swimming pool is awash with light from beneath and topped with an intricate botanical sculpture composed in highly stylized tiers of sumptuous orchids, green apples, eggplants and lavish florals. A trickling water feature at the center lends tranquility to the atmosphere. I designed sculpted "flowerpot" cocktail tables with topiaries to add to the pure whimsy my client requested. Enchanted custom-built furniture vignettes provided fanciful repose for guests to imbibe in the beauty around them.

Facing page: For this event, I decided that the walls and ceiling of the tent would be draped in flowing fabrics; the floors were covered in plush coral carpeting, adding to the beauty of the environment. Each of the guest tables sat beneath a fabulous floral and crystal chandelier encrusted with lavish blooms including roses and orchids in shades of amber, mango and peach. Three floral spheres hung from the center of the chandelier while delicate candles and shimmering strung crystal strands streamed toward the table. Centered below the chandelier is a fragrant pool of water accented with floating candles and embraced in a floral collar. I selected a sumptuous coral-colored dupioni silk cloth with a shimmering sheer palette overlay trimmed in leopard eyelash to dress the table.

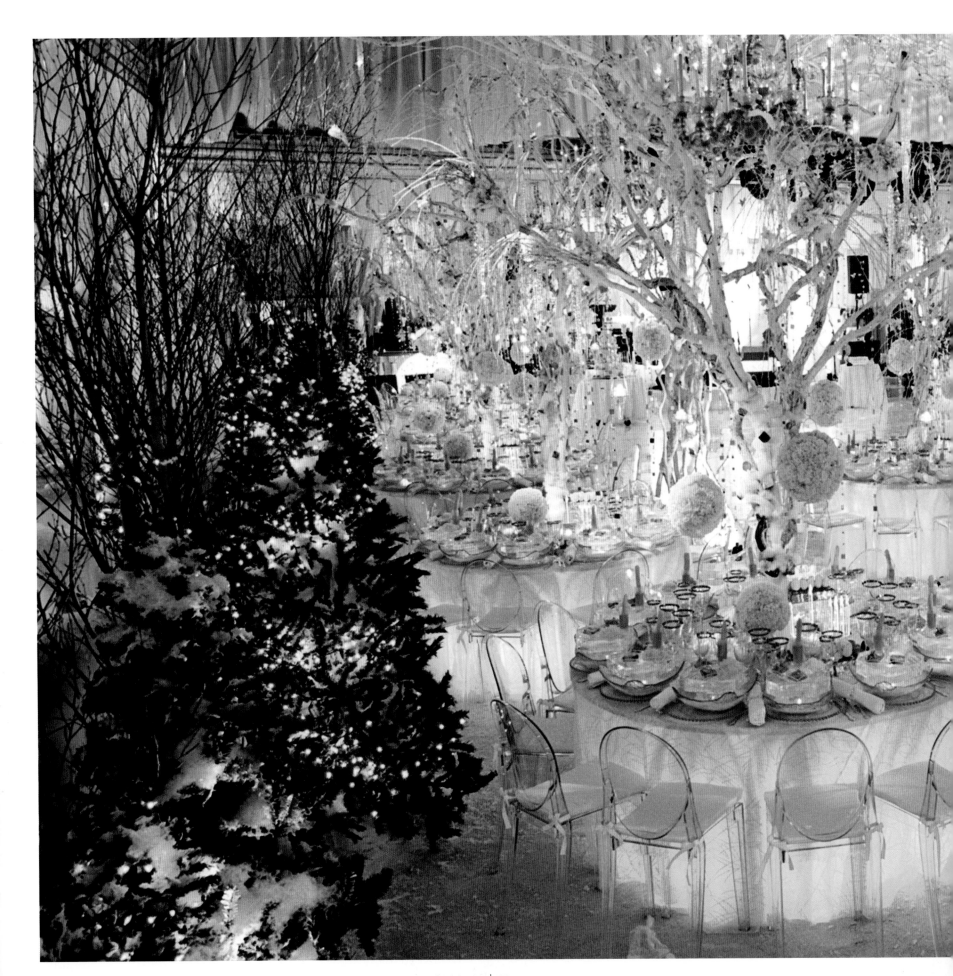

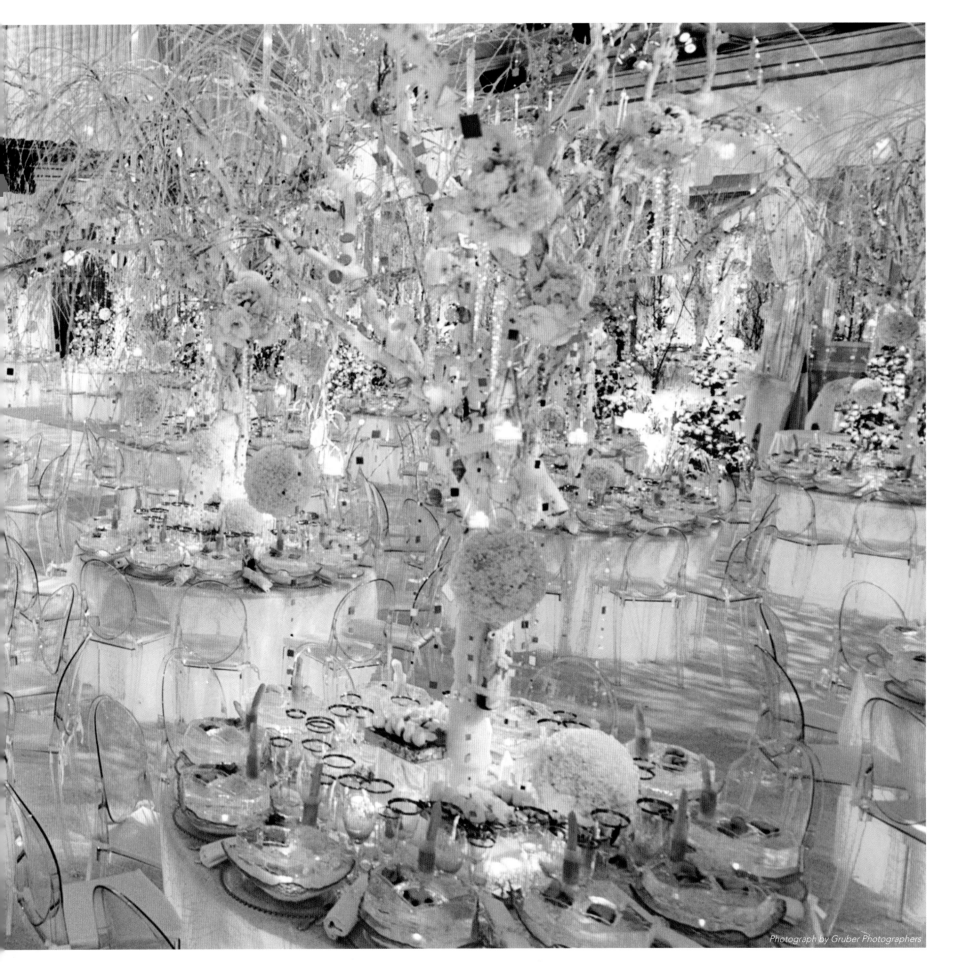

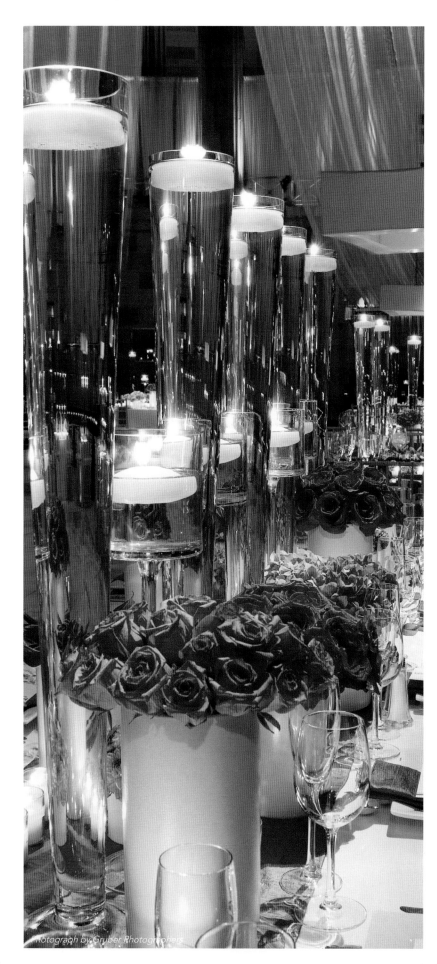

"I always tell my clients how important it is to incorporate at least one fabulous 'editorial moment' into every event; art for art's sake."

—Ed Libby

Left: For a very contemporary setting, we chose to wash the venue in color and sheer fabrics. The tables were dressed in white glossy patent leather cloths and topped with modern crystal vessels of varying heights, accented with romantic flickering candlelight. Sleek white liquid vinyl cylinders were artfully arranged and filled with clusters of hot-pink calla lilies, roses and hydrangeas with occasional touches of tangerine providing an extra pop of color.

Facing page: I am fortunate to have clients who appreciate elegance and are thrilled by originality. From an over-the-top gala to a Hollywood-themed event, I love the freedom of expression my clients allow. Customized set pieces, whether entry portals or lighting fixtures, create original moments at every signature event. Personalized center displays, tailored seating vignettes, and unique fabrics and color combinations mix for a truly unforgettable experience.

Previous pages: For a complete indoor winter white-out I began my design with volumes of billowing fabrics and wall-to-wall white carpeting to block all color from the venue. Transparent tables were lit from beneath, covered in sheer fabric and surrounded with Lucite ghost chairs. Soaring branches formed winter white trees that umbrellaed the guest tables, which were accented at their base with geometrical, stylized, white floral spheres glistening with mirrors and crystals. Votives cascaded from the branches and dotted the tabletop with flickering candlelight. The perimeter of the room was filled with natural branches and snow-flocked pine trees, which instantly transported guests to an opulent winter clearing in the middle of Manhattan.

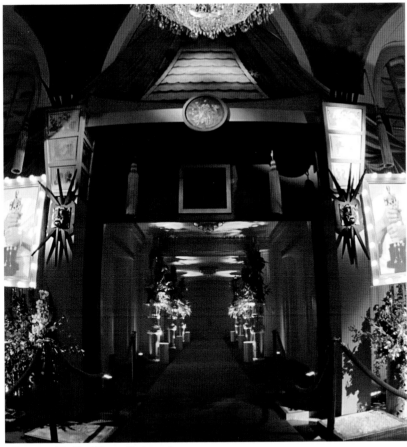

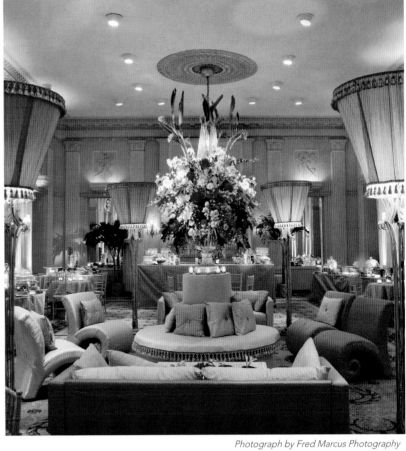

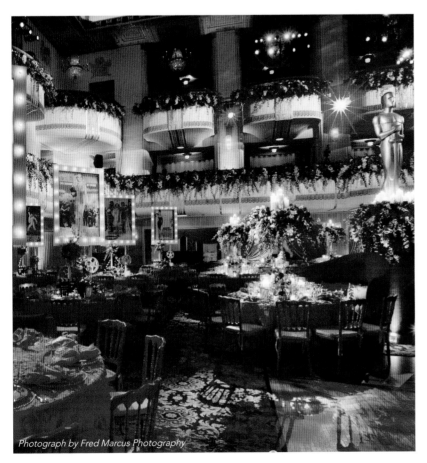

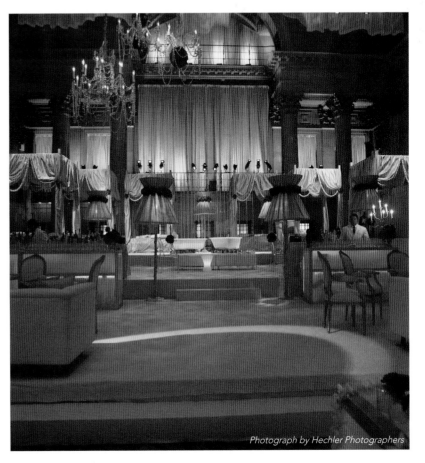

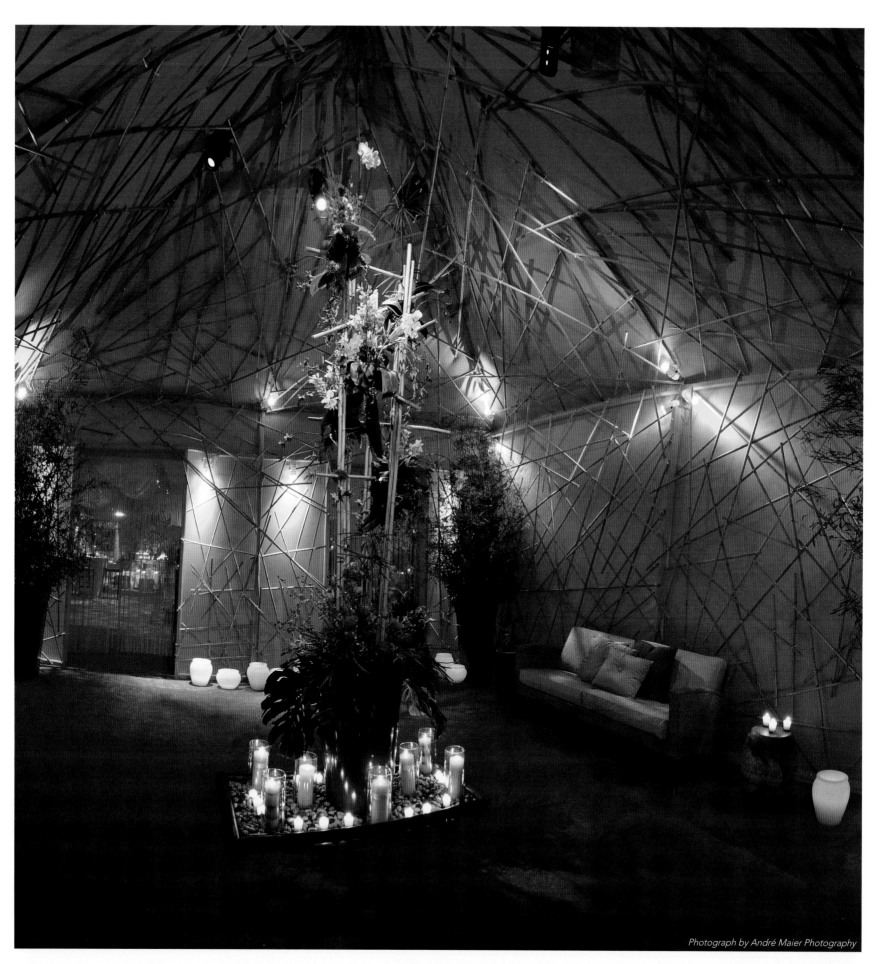

"I'm inspired by the idea that it's not what you do...it's what else you do."

—Ed Libby

Right: For a Hamptons-meets-Manhattan rehearsal dinner, I designed an intimate event in elegant whites with contrasting natural tones including Fruitwood chairs, beeswax candles and rattan chargers. The tables were dressed in crisp natural white linens with hemstitched napkins. Multilevel table scapes were created using multitudes of candles and teak bento boxes filled with orchids, gardenias, roses and lizianthus. Delicate stemware and place settings were topped with custom menus and placecards to complete this graceful, yet stylized design.

Facing page: Although simplistic and sleek, this Asian-inspired atmosphere is composed of a myriad of intricate details. A soaring bamboo tower features orchids and foliage rising from a tranquil stone and candlelit base, serving as a focal point of the room. Sleek furniture, restrained florals and illuminated majestic stands of bamboo complete the scene. Simple ingredients plus a flair for the dramatic equals Zen squared.

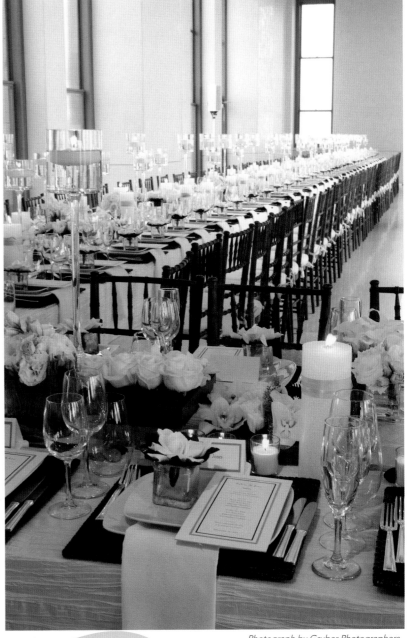

Photograph by Gruber Photographers

views

Each day, I have the opportunity to express myself through a unique art form for which I have an ever-growing passion. In order to create remarkable environments for my clients, I draw on life experiences: the journey of engaging all five senses, exploring new ideas and collaborating with friends. I feel truly blessed to be able to share my gift with the world and take others on this fantastic voyage of exploration.

THE SPECIAL EVENT RESOURCE AND DESIGN GROUP

S. MICHAEL ERESHENA | DALE MARYFIELD

The path to true success is paved with the heeding of one's own talents and creativity, as well as a willingness to share the spoils. This is certainly true for S. Michael Ereshena, whose aesthetics-centered career evolution began nearly four decades ago with his Pound Ridge, New York, floral shop. The retail hotspot became famous in the area for Michael's artistic flair and style-forward creations. Celebrity and socialite clients came to anticipate the shop's entire seasonal redo; each new theme was unveiled with a lavish cocktail affair.

As the seasons changed and the shop flourished, Michael set his sights on a new venture. The Special Event Resource and Design Group debuted in Palm Beach and has since found professional triumph in being the source for corporate and private special events. Michael, his business partner Dale Maryfield, and a talented staff provide floral arrangements, décor and an arsenal of creative entertainment ideas. Working out of their 16,000-square-foot office and inventory space, Michael's team overflows each event with exacting detail—from elegant china, glassware, furniture, linens and costumes to illustrious artwork, set design and props—all at each client's fingertips. The Special Event Resource and Design Group takes great pride in transforming raw rooms into innovative spaces rich in grandeur and limitless in imagination.

Although your event may take place within a cavernous space, it can still be an intimate affair coupled with the right room design. As with most spaces, lighting is critical. We hung our dramatically elegant chandeliers below the room's built-in ceiling lights. The resulting illumination is reflected in the mirrored tables complemented with silver detail place settings amid brown brocade linens with white flowering quince.

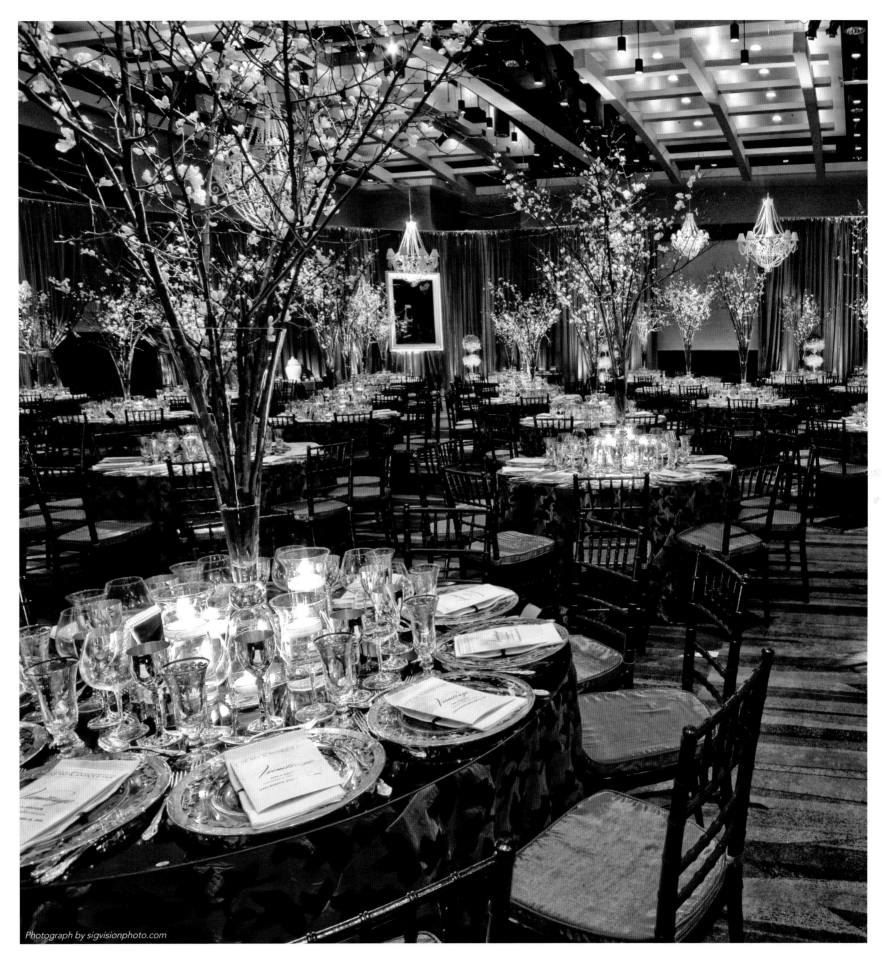

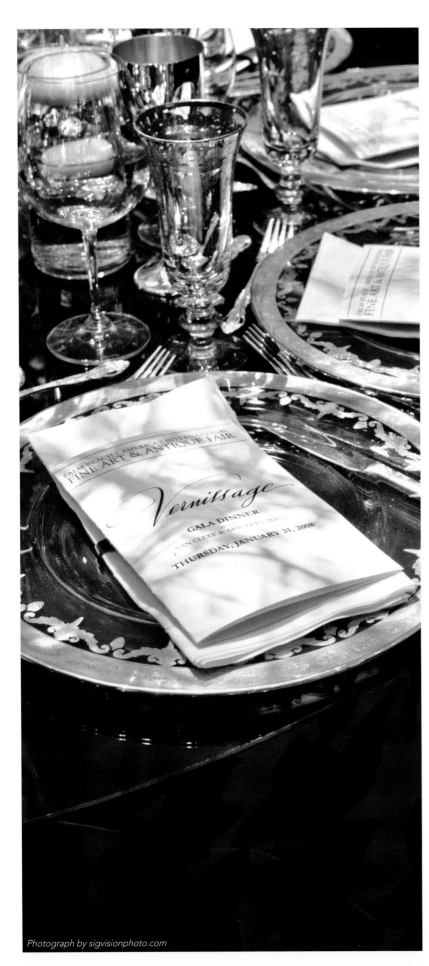

Photograph by sigvisionphoto.com

"Intricate mixing and matching of glassware and china replaces the commercial feeling with an 'at-home' feeling."

—S. Michael Ereshena

Left: The atmosphere for the fundraiser celebrating Palm Beach's Vernissage, the heavily anticipated premier fine arts and antiques show, had to appeal to the fine tastes of its patrons.

Facing page: Because jewelry was available as part of the fundraising event, rather than leave it to the imagination, live jewelry models were elevated on marbled platforms. From the gallery leading to the foyer, the effect was simply dramatic.

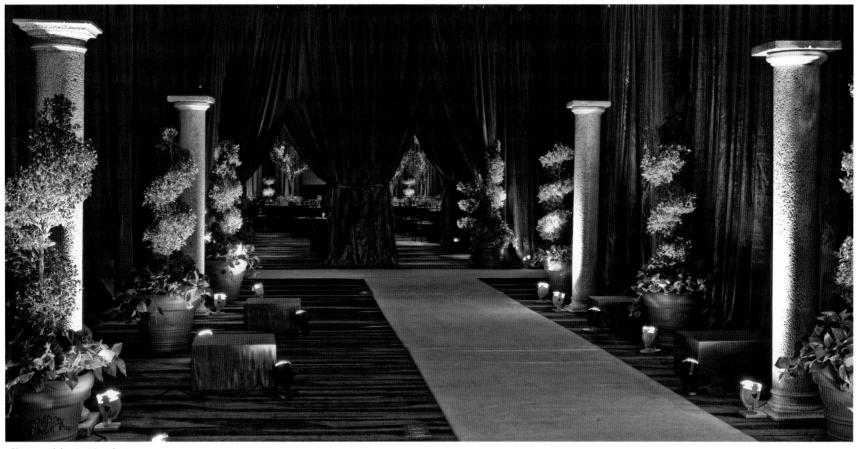

Photograph by sigvisionphoto.com

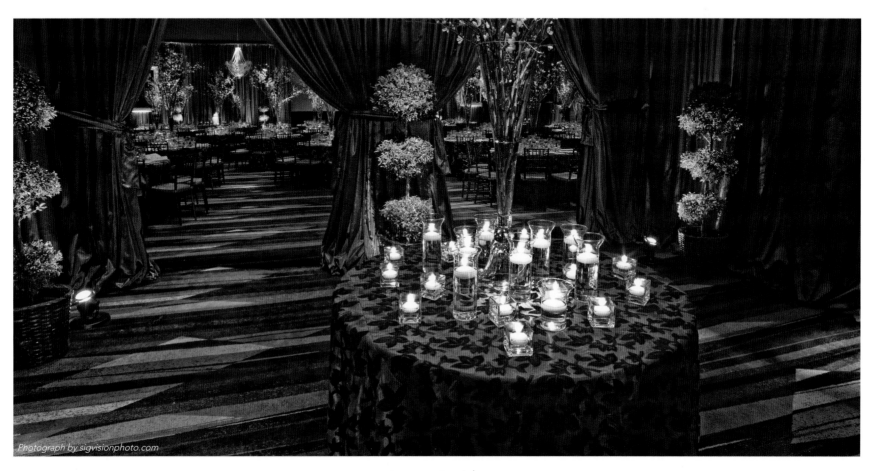

Photograph by sigvisionphoto.com

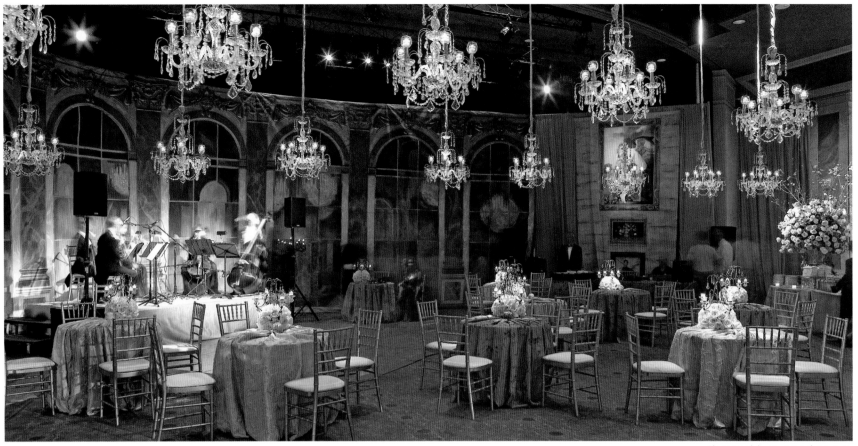

For a large cosmetic corporation's cocktail party, the feminine glamour of Versailles was meticulously recreated, from the hand-painted "Hall of Mirrors" down to the performers in period costumes. Dazzling chandeliers and candles delivered just the perfect amount of light while the floral arrangements of white dogwood, golden cymbidium orchids and copper hydrangeas solidified the design.

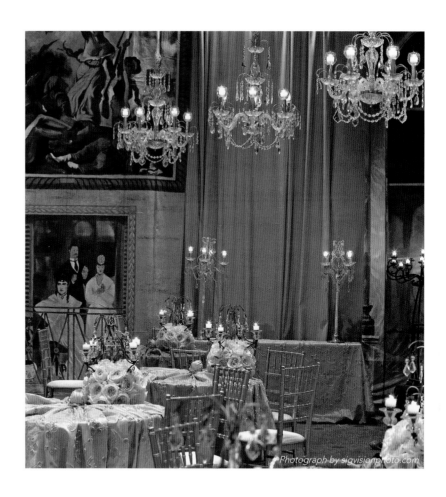

Photograph by sigvisionphoto.com

"To create a powerful look and cut back on financial impact, lay out the room to include a carefully designed central bar or buffet. This becomes a focal point and turns a vast space into a more intimate setting."

—S. Michael Ereshena

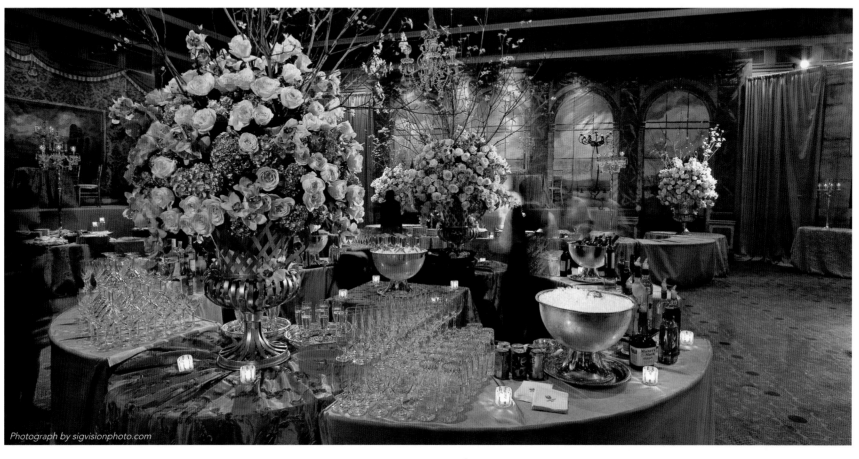

Photograph by sigvisionphoto.com

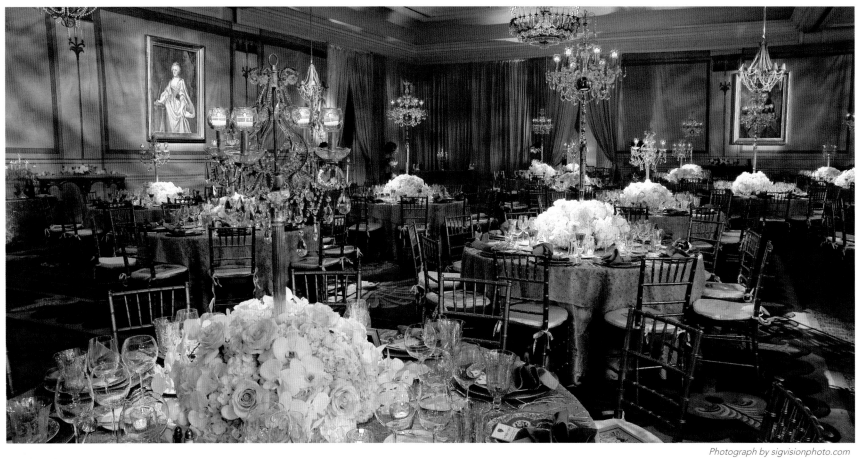

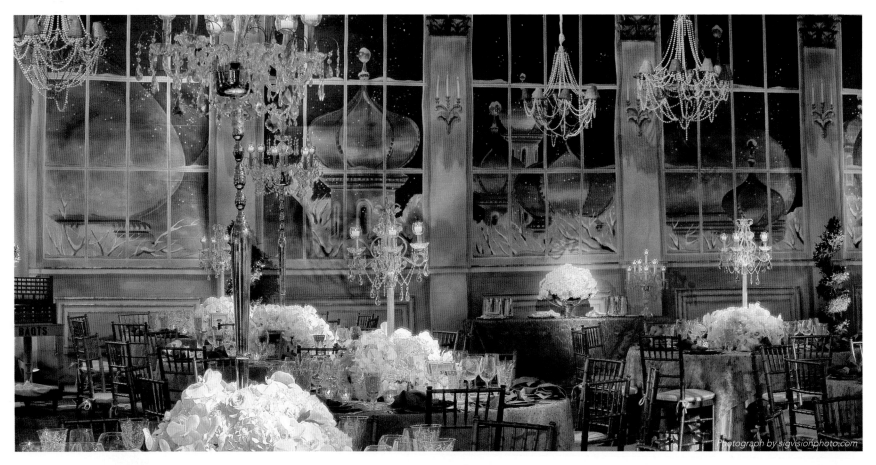

"Floral arrangements are the most expressive and elegant means to complete any tablescape. The perfect diversity or consistency and type of arrangement quietly captivates each guest in its own unique way."

—S. Michael Ereshena

Right: Tented structures offer myriad more opportunities for creativity. For a birthday party, a very contemporary black-and-white theme was echoed throughout. Of course, the most striking element is the five-foot-tall black vases filled with white French tulips.

Facing page: Nothing gives us more satisfaction than to witness the great culmination of our efforts. When a room is completely transformed from raw space to a well-designed room with lavish detail, we feel tremendous pride. Choosing a theme is an incredibly fun starting point; the design direction becomes amazingly clear and inspiring. For the American Heart Association, we chose "To Russia With Love." Eighteen-foot hand-painted walls of Russian architectural icons and czars were commissioned to adorn the walls. We kept the emphasis on the strong elements throughout the room, creating neutral yet beautiful tables of elegant china and florals of blush cabbage roses with sprays of phalaenopsis orchids.

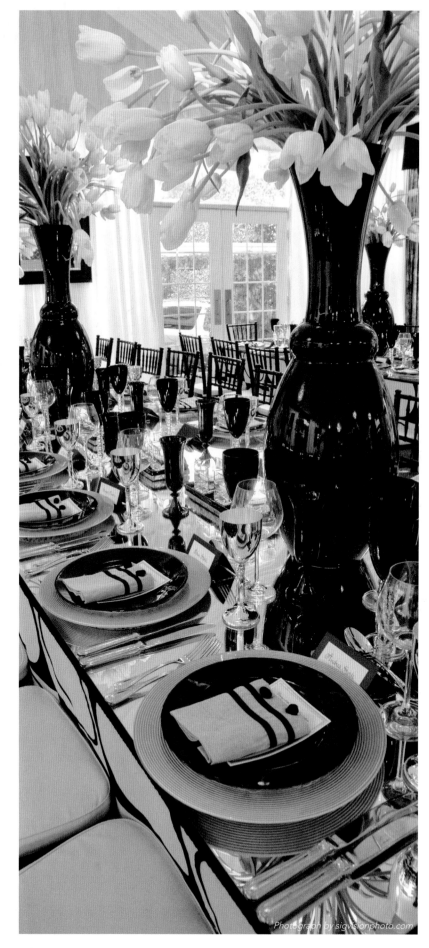

Photograph by sigvisionphoto.com

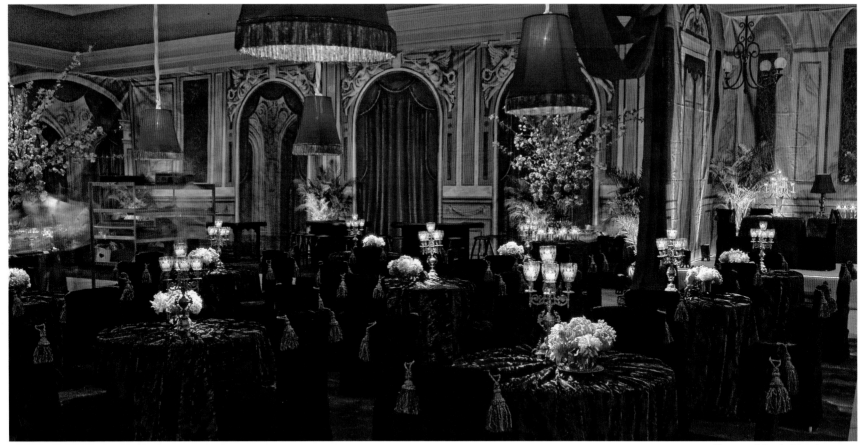

"The all-important first impression of an event begins outside the venue. Create a welcoming environment with a carefully designed entrance and foyer to set the desired tone of the evening."

—S. Michael Ereshena

My projects often require a great deal of research to capture the authentic feel of what I am recreating. For a cosmetic company's "Hotel de Paris Monte Carlo" themed event, my research resulted in the authentic design of a dining room created with rich crushed velvet draperies and linens in scarlet hues, hand-painted architecture, masses of candles and branches of flowering cherry blossoms. Guests walked through the "Casino Royale" and were immediately met with the overwhelming glamour, epicurean delights and feel of "Hotel de Paris Monte Carlo."

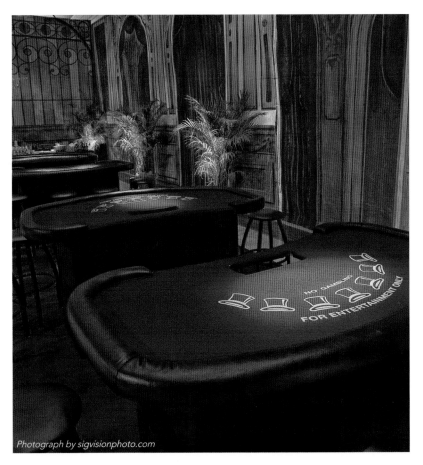

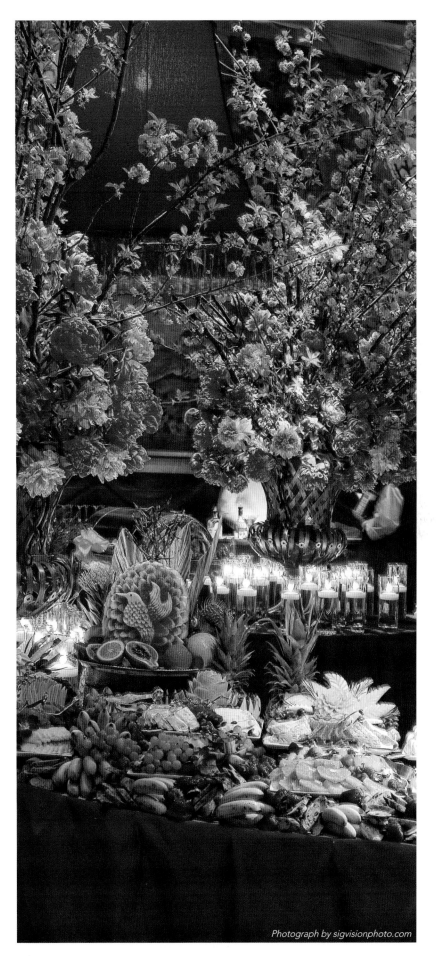

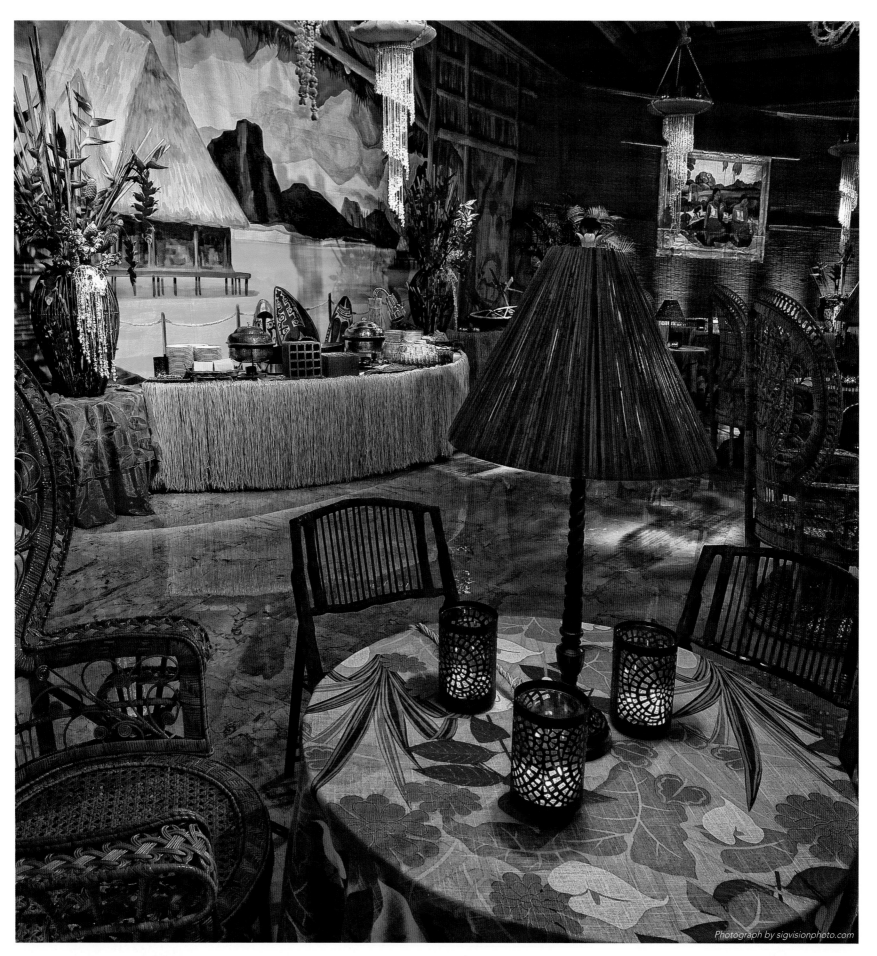

"Themed parties free the imagination and ignite creativity. Some of the most inventive decorative elements have been solutions to a challenge—whether it was a unique space, timing issue, or particular client desire—and the result is always remarkable."

—S. Michael Ereshena

Even an island theme can have style and sophistication. "French Tahiti" left no detail to chance with hand-painted bamboo detailing, massive tropical florals garnished with shells, tiki gods and reproductions of Gauguin paintings throughout.

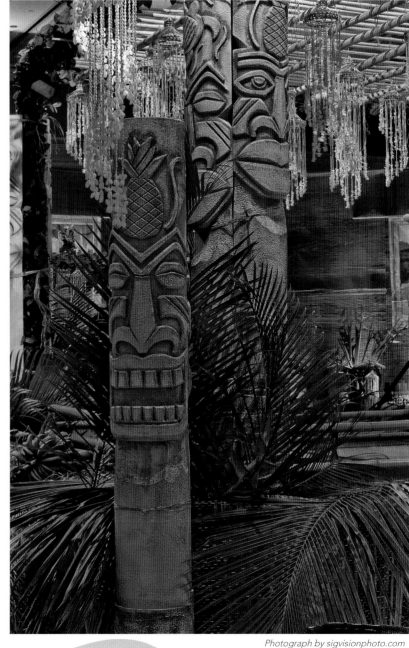

Photograph by sigvisionphoto.com

views

❖ Don't let an empty room be daunting. Think of it as a space that offers endless possibilities.

❖ Outrageous concepts are often the ones that evolve into the biggest successes.

❖ Even one object can capture the tone you desire; build from there.

JOSE GRATEROL DESIGNS

JOSE GRATEROL | STEVE LEVINE

It's rare yet possible for a single person to serve as event designer, floral artist and lighting specialist. But couture designer, wardrobe consultant, hairstylist, interior decorator and landscape designer as well? There is, indeed, a man in Miami who does it all. If he had the time, he'd volunteer to be the photographer, too. He didn't intend to master so many crafts—by popular demand, it happened naturally.

Jose Graterol is a life designer. After studying in Florence for his BFA in fashion design and working as an evening gown designer in pageants, Jose moved from his native Venezuela to the United States. With no defined plan but plenty of passion, he found himself working in a floral shop, realized he had a knack for the art and struck out on his own. Jose admittedly never dreamed he'd be working with names like Trump, Komen, Versace, Madonna and the Clintons, yet here he is, redefining event design.

There are so many ideas to explore that even if clients tell Jose exactly what they want, he insists on taking the concept further. Custom designs can't be bought; they have to be envisioned, and Jose will do whatever the concept requires: shop, sew, plan, fabricate, install. Jose's endless creativity and his partner Steve Levine's art and antiques background—Steve holds a B.A. from Cornell and hails from a family of antiques dealers—are a powerful blend. It's no wonder that time and again clients retain the firm's event planning services, fall in love with Jose's impeccable taste and ask him to design their home interiors, wardrobes—and, of course, their next event.

Turning a historic country club on the most exclusive island in the nation into a vibrant tropical setting with a 1950s' Cuba vibe was a welcome challenge. Guests who had been in the room dozens of times couldn't believe the transformation.

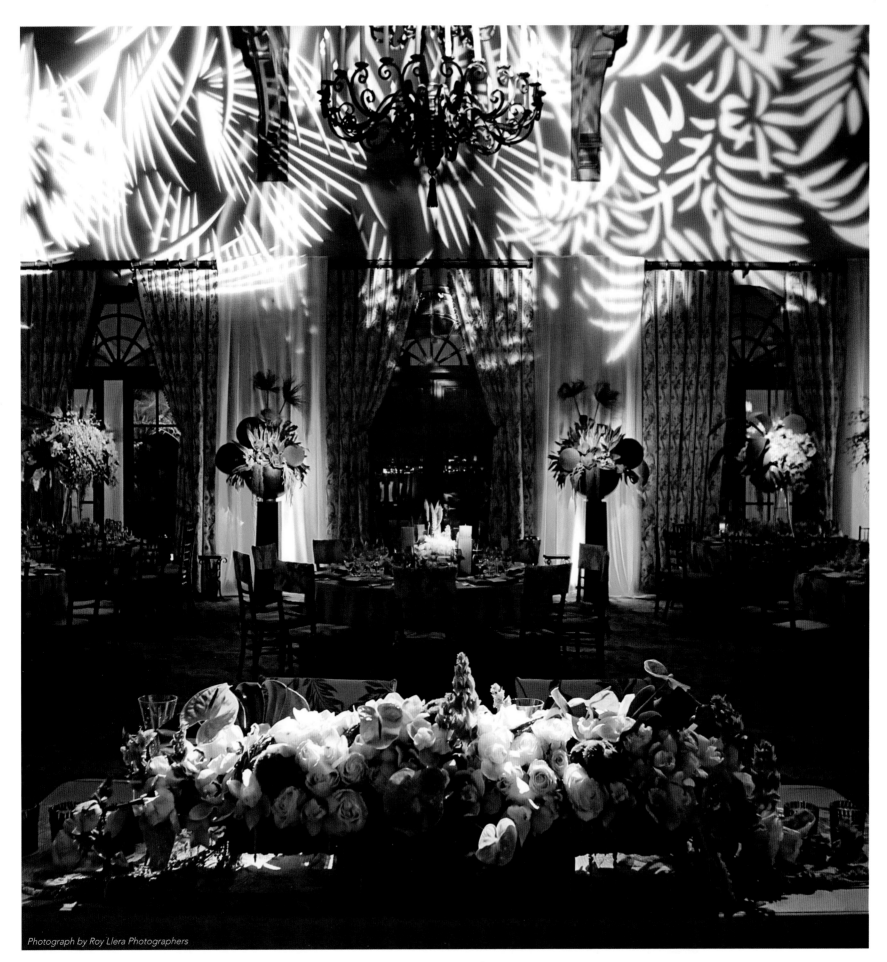

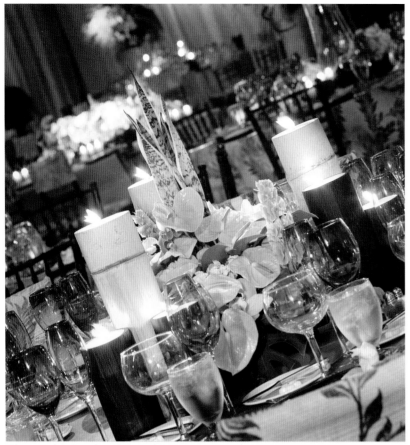

"To come up with truly original ideas, you have to look at the world in a different way."

—Jose Graterol

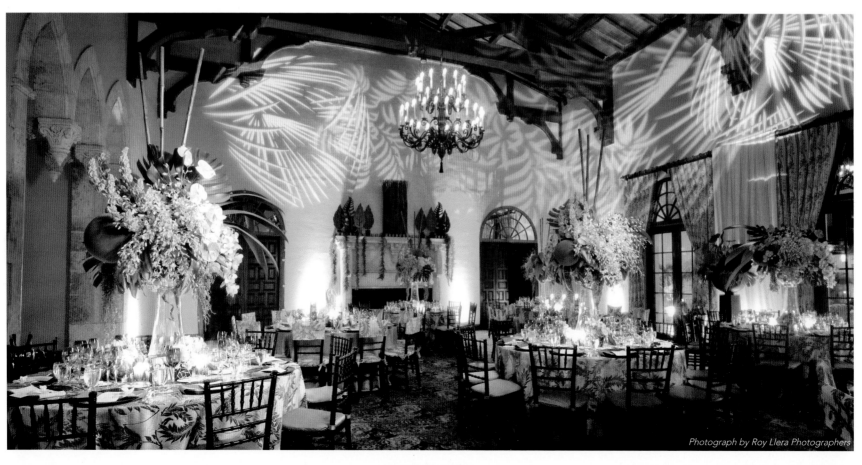

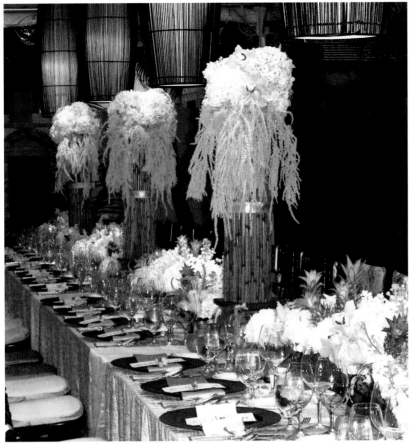

Photograph by Jose Graterol

Above & right: I drew my inspiration for a 50-person dinner party from the arches of the beachfront estate's architecture. Above the royal banquet table, the bamboo floral arrangements and chandeliers are placed to have an undulating effect and keep the eye engaged. It's fun to incorporate elements of surprise, especially midway through the event, when people least expect it. As guests transitioned from the pre-banquet location of the evening, a spotlight hit the tent and the sides dropped off, leaving only a clear roof so that guests were welcomed in to enjoy stargazing and garden-fresh air—the canopy was necessary to ward off unpleasant weather. A smaller-scale surprise was nestled into the innovative floral arrangements. Mini pineapples in hues of pink, yellow and green were the tables' central elements. I accentuated the spikiness of the fruit with soft-petal flowers including roses, lisianthus and orchids. The whole design nods to nature, uniting the event with its beautiful surroundings.

Facing page & previous page: Instead of trying to conceal the private country club's character, I embraced it and worked the architectural elements into my design. I created the fun and vibrant atmosphere the hosts wanted by developing an organic motif and reinterpreting it in varying scales for everything from the lighting to the floral arrangements. Bamboo, succulents, anthurium, orchids—these key ingredients are strategically placed to create the feeling of an island without the ocean or a grove of palms. My inspiration for the whole gala? A fabric pattern; I used it as a layer of the textural velvet and cotton table coverings.

Photograph by Jose Graterol

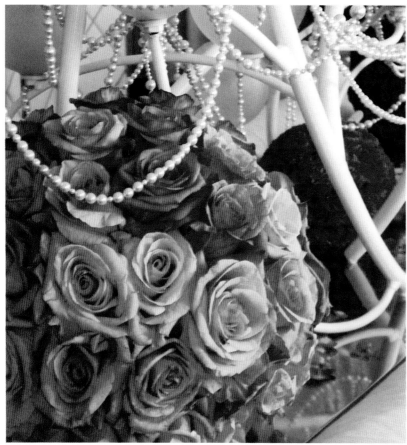

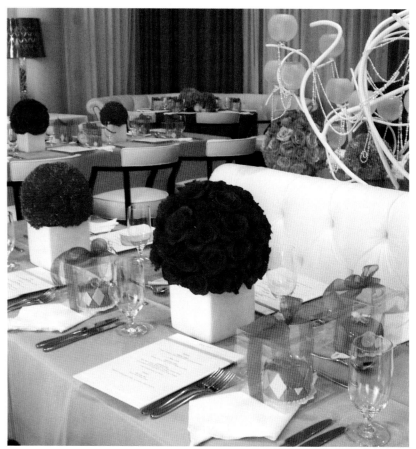

Photograph by Jose Graterol

Photograph by Jose Graterol

Above: Miami's Delano Hotel is an incredibly chic venue, but the all-white scheme and room alteration restrictions require extra creativity to pull off a design that people will love but won't expect or forget. For a baby shower, I started by creating excitement in the table formation and then designing around the sculptural candelabra—you're not allowed to touch the art, of course, but it's too beautiful and prominent to disregard. The balls of roses and carnations echo the shape of the sculpture but add much-need splashes of color—red, pink, orange and every shade in between. Each place setting has a box that serves as décor and contains a takeaway sugar pacifier-topped cake. I designed the baby shower for a woman I've worked with before; I did her engagement party and wedding and look forward to celebrating many more milestones with her family.

Facing page: Some people just come up with the concept and then delegate all of the details, but I like to personally design and execute as many details as is humanly possible. To really get the glam chic, trendy cool effect I wanted, I spray painted dozens of manzanita branches silver and placed them in large crystal vases—the branches seem to be suspended in mid-air. I placed the rose balls on upside-down silver votive candleholders, which, like the chargers, incorporate silver and crystal circles. I draped the branches with tons of crystal garlands that hang at random levels. I designed the Watteau-esque toile linen, too—it's one of my favorite textile creations. The fuchsia uplighting and gobo of leaves really make the concept pop.

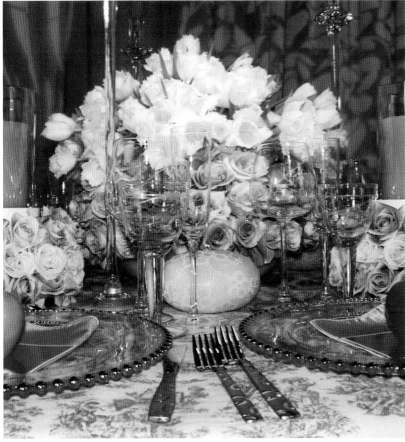

Photograph by Jose Graterol

"I love to blend sophistication and style with touches of the unexpected."

—Jose Graterol

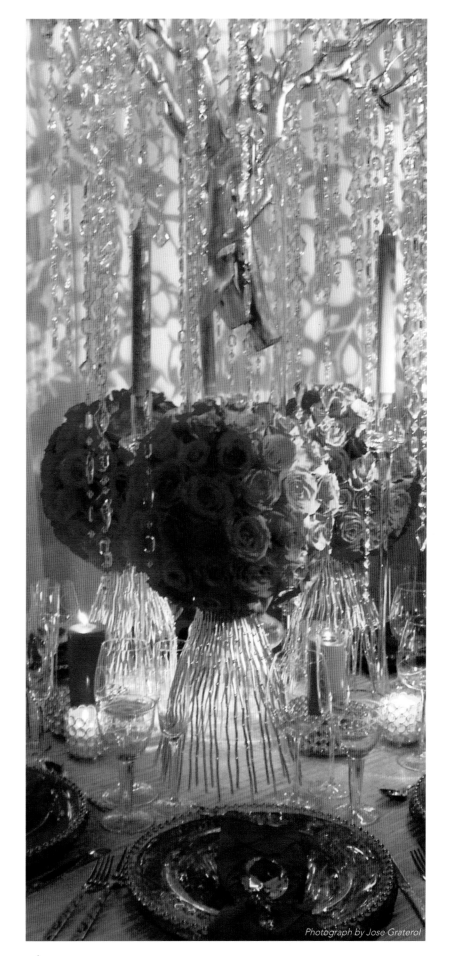

Photograph by Jose Graterol

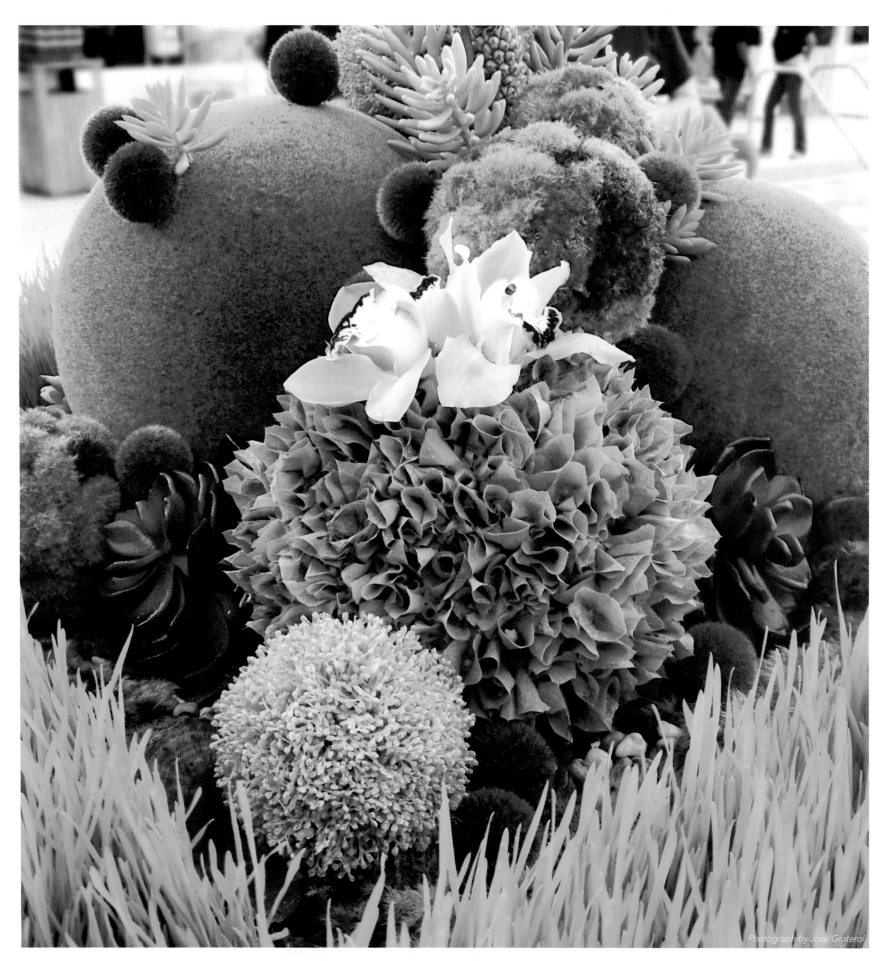

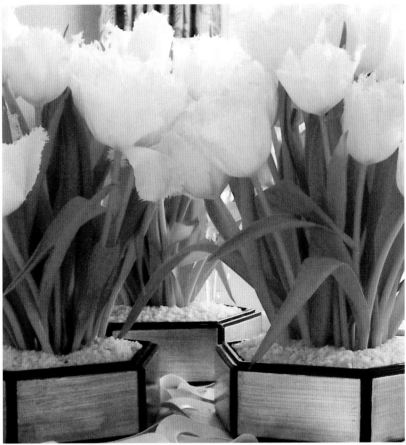

Photograph by Jose Graterol

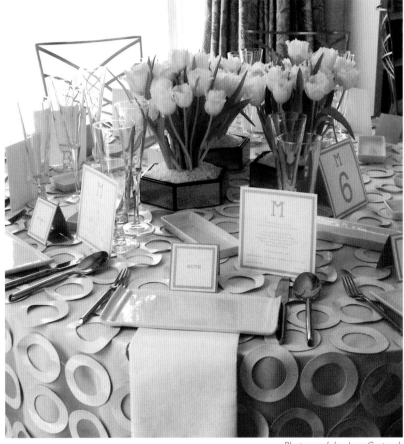

Photograph by Jose Graterol

Above: The moment I saw the silver leaf and black lacquer hexagonal jewelry boxes in a home décor store, I knew I had to use them! I popped off the cover, lined the bottom with wax paper, added an oasis and some white pebbles and used them to display tulips. I love how the geometry of the container plays off the whimsical lines of the flowers. The linens are just as original—they are white leather cutout circles applied to netting.

Facing page: What do you do with a 72-inch-square placecard table? Design a large and striking centerpiece. I really played up the textures: river rocks, wheatgrass, bells of Ireland, succulents, moss balls and orchids. The lush, organic concept was reinterpreted from the ballroom. I designed the other centerpieces to easily disassemble at the end of the evening so guests could take a potted phalaenopsis orchid home with them and let the party's memories live in their homes.

"I am fueled by the infinite possibilities out there. I love repurposing items and reinventing concepts to create the unforgettable."

—Jose Graterol

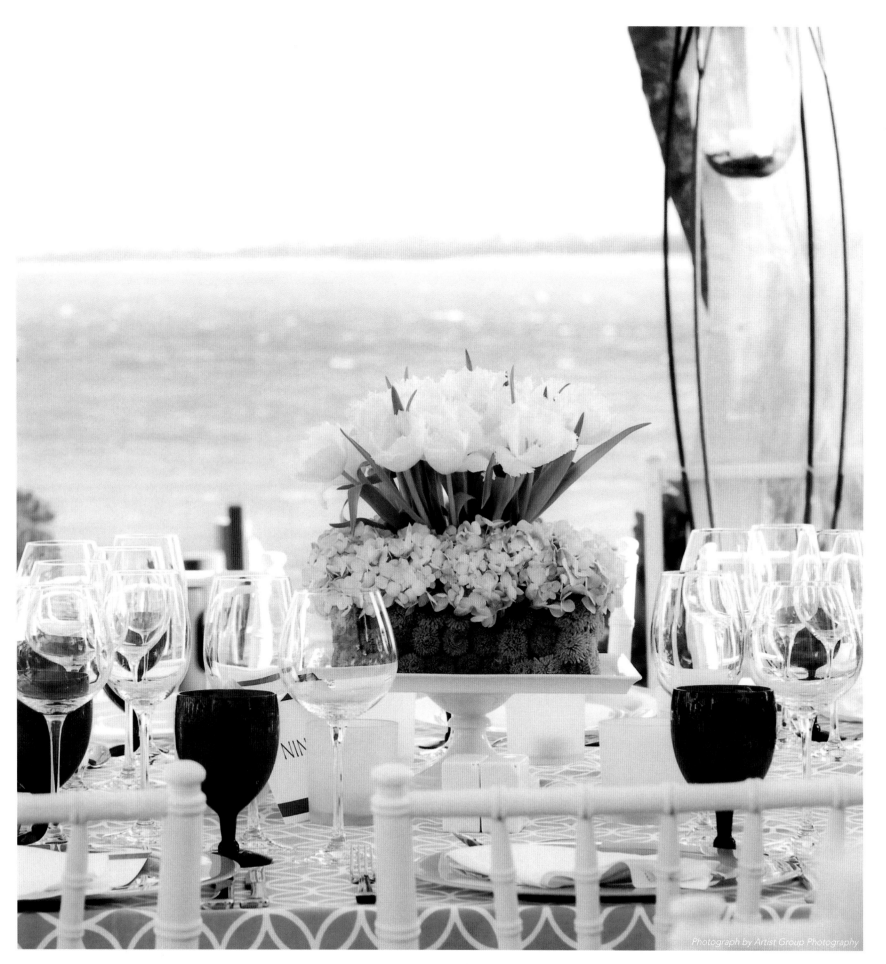

Photograph by Artist Group Photography

"An event should reflect the personality of its host. I like leading people to event designs they're going to love by combining the right textures, colors and details."

—Jose Graterol

A private estate at the point where the St. Lucie River meets the Atlantic Ocean—that's a venue. While I usually design the whole event, the planner brought me in exclusively for my floral expertise. Given a swatch of linen, I was able to capture the essence of a Greek island. I turned cake compotes from a department store into homes for white tulips, blue hydrangeas and chrysanthemums, mirroring the beautiful setting without detracting from it. My floral creations made the event memorable.

Photograph by Artist Group Photography

views

Inspiration is everywhere: furniture, paper, color, fashion, texture, fabric, windows, displays, lamps, towels, the list could go on forever. Random things big and small can serve as the foundation for truly great designs. And everything in this world has another use, so don't be afraid to try something unusual. Be inventive and your creativity will flow powerfully.

XQUISITE EVENTS

EDWARD H. GILBERT | NANCY GILBERT | JONATHAN BUICK | ROSE MCARTHUR

The collaborative genius of Ed Gilbert, Nancy Gilbert, Jonathan Buick and Rose McArthur is only part of what has catapulted Xquisite Events to the forefront of South Florida's ultra-competitive event production industry. Amazing talent and tenacity, boundless creativity, tireless planning and, of course, flawless execution of every intricate detail have earned Xquisite Events a place at the top of everyone's event production wish-list.

Attend any of Xquisite's events and you will understand why it enjoys a stellar reputation for quality and service. Breathtaking flower arrangements accompanied by originally designed, custom-made elements of décor characterize its many event productions. Xquisite seizes every opportunity to satisfy its discriminating clientele by orchestrating its productions with an eye toward perfection and to complete its mission ahead of schedule. Xquisite relishes the well-deserved accolades of its patrons, and its ongoing ability to attract and retain discerning clients is the truest measure of its spectacular success.

Xquisite's solid foundation has helped it achieve phenomenal successes in the less than five years since its debut on South Florida's vibrant social scene. Jonathan, Nancy and Rose have been part of the event design industry for many years and constitute the core of Xquisite Events' "dream team." Ed focuses his business and legal expertise on shaping Xquisite's operations and helping to turn their vividly imagined dreams into reality. Xquisite's principals all believe that their clients are entitled to enjoy events abounding with unique decorative details. The beauty and grandeur expressed in Xquisite's extraordinary productions invariably cause onlookers to wonder, "What unique and Xquisite designs will come next?"

Outdoor opulence at Miami's Casa Casuarina was achieved easily through this carefully-designed tablescape. Surrounded by lush flora, purple orchids and Venetian crystal globes, the tabletop made a powerful visual statement from afar. Looking more closely, guests were charmed by its eclectic blending of Old World elegance and contemporary beauty. An antiqued mirror at the base of the table added a final touch of glowing energy to the crystal glasses, silverware and platinum-detailed plate settings.

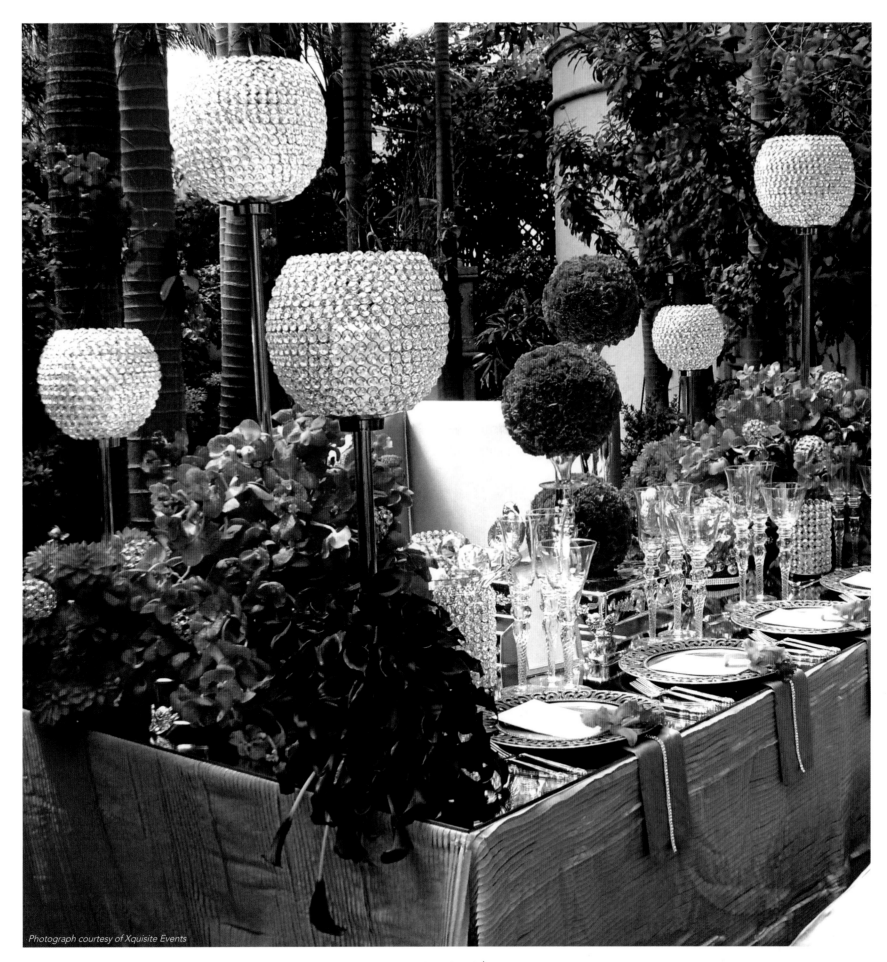

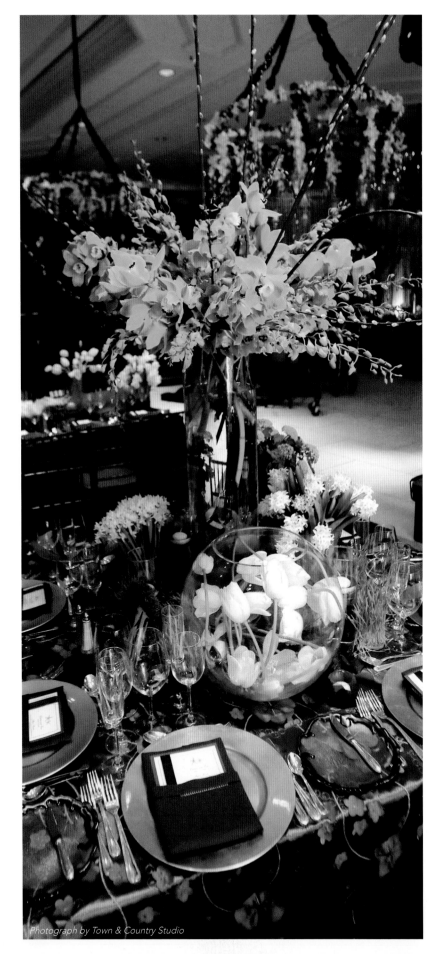

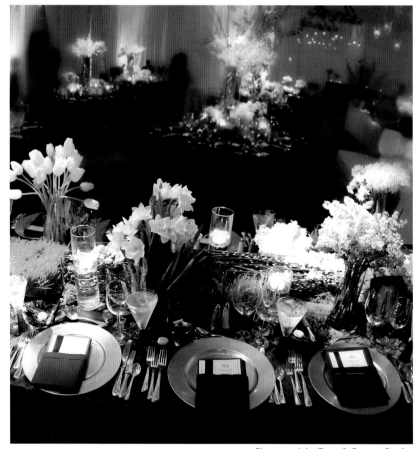

"Clients usually have very definite ideas of what they want. Our goal is to match our creative suggestions to our client's dreams and desires."

—Jonathan Buick

Right: Glamour and uniqueness were the goals set at Miami's Vizcaya, an exceptional Old World venue. A luxurious tented and draped space was created in a picturesque setting just off Miami's Biscayne Bay. We designed and custom-built ostrich-plumed chandeliers over each of the coordinating table centerpieces to create an extraordinary effect.

Facing page: Creating an organic feeling was the mission for this high-end event at The Ritz-Carlton. Understated sophistication was conveyed through our use of abundant greenery paired with stylishly wrapped white hyacinth, lilacs and tulips featured in glass bowls. True to the host's vision, earthy hues were dispersed throughout the room using chocolate table linens and gold chargers. Perfect little bread dishes were added to the tabletops to great effect. Even if our clients don't know precisely what they want, we find a way to turn their dreams into reality through our use of unique decorative details designed to enhance their venue's natural strengths.

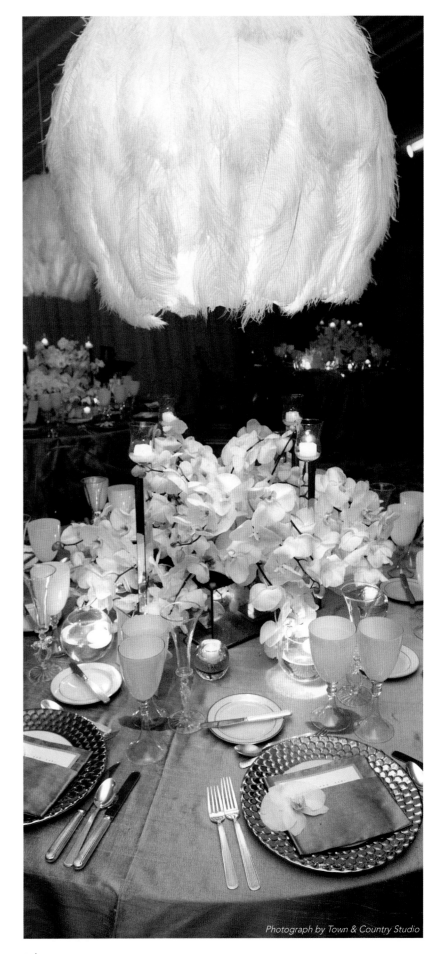

Photograph by Town & Country Studio

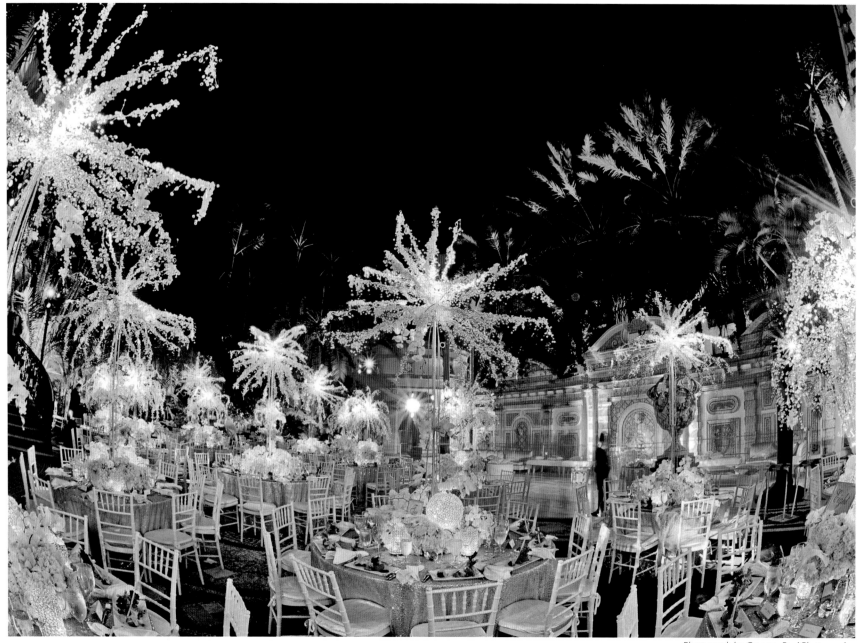

Photograph by Gregory Paul Photography

Above: Unapologetic glitz and over-the-top opulence ruled the night at the famed Casa Casuarina mansion. Crystal trees, diamond globes and rhinestone napkin rings sparkled in the glow of soft pastel lights, spectacular florals adorned the setting, and fireworks provided a fitting finale for this magnificent event. Challenges loomed in production due to an uncharacteristically short setup time between event components, but proper planning paved the way for our execution of this picture-perfect event.

Facing page: A feeling of awe as guests entered the room was the goal in our transformation of a Wellington estate's horse arena into a Moroccan ballroom for a bat mitzvah celebration. Brightly colored, jewel-toned flowers and fabric achieved stunning effects atop tables and as part of originally designed, custom-made chandeliers. Intricate tabletop details included jeweled elephants holding three handmade truffles that were intended for each guest as a keepsake. Guests were stunned by the complete transformation of the arena and overwhelmed by its exotic ambience.

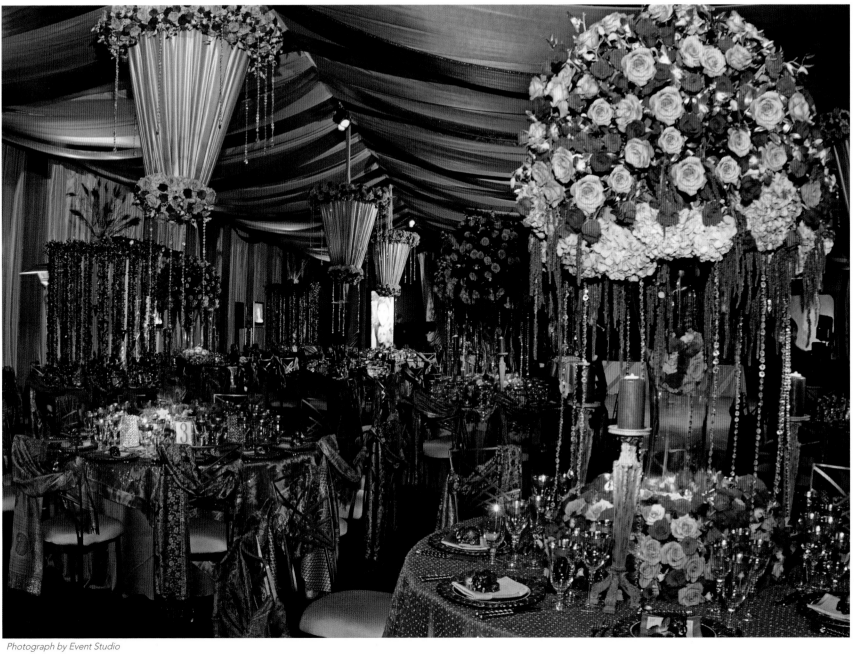

Photograph by Event Studio

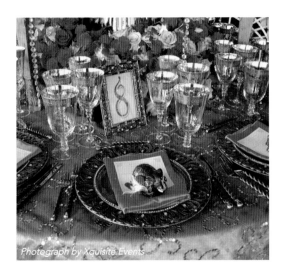

Photograph by Xquisite Events

Photograph by Xquisite Events

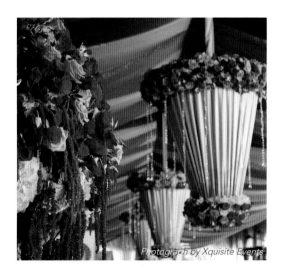

Photograph by Xquisite Events

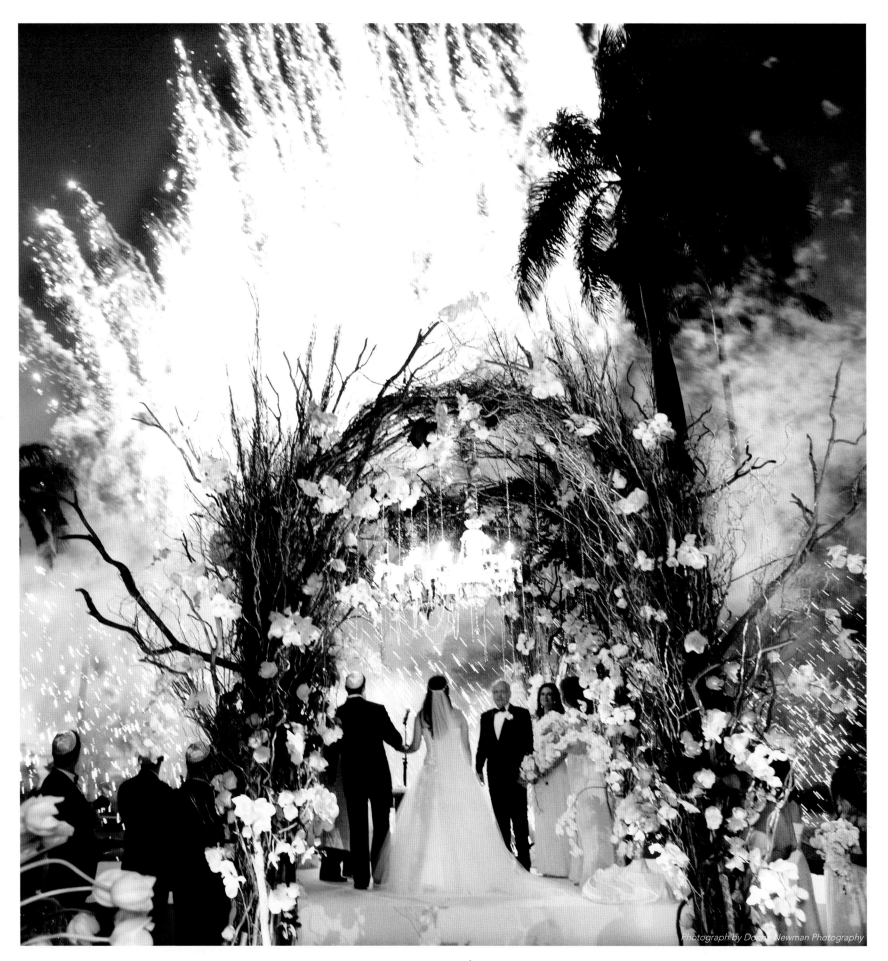

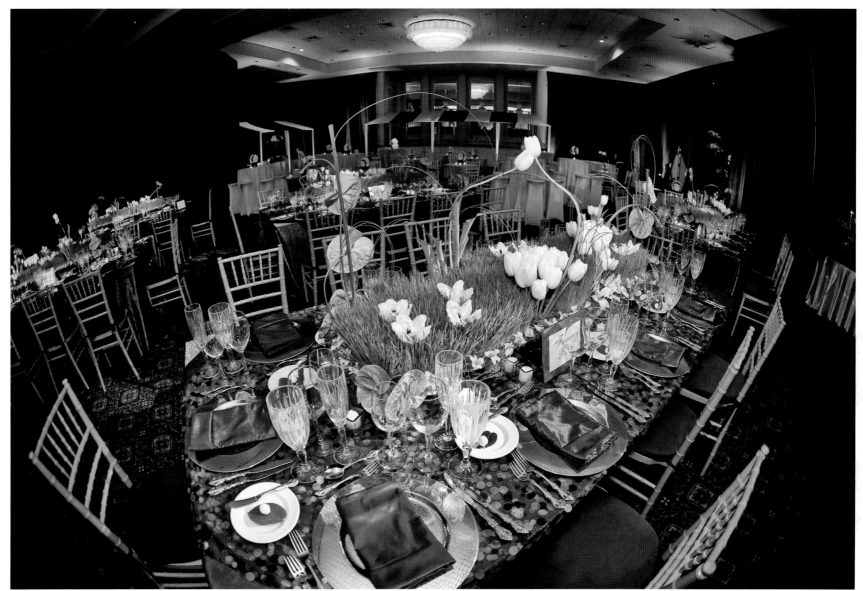

Photograph by Town & Country Studio

Above: The outdoor feel of baseball was created for an extraordinary indoor event. Custom-built mirrored boxes filled with aromatic baseball clay, wheatgrass, tulips, orchids and anthuriums were set on tables with earth-toned linens and glassware. Wheatgrass and flowers swayed in the breeze—a remarkable feat for a room with no natural wind—creating an uncanny sense among guests of being in a "Field of Dreams."

Facing page: Dazzling perfection was the order of the evening as guests were awed by a flawless sunset nuptial extravaganza. The couple exchanged their vows under an extraordinary custom-built dragonwood and orchid chuppah set beneath a stunning Palm Beach winter sky. As the traditional wine glass broke, fireworks exploded behind the chuppah and created an unexpected surprise for the guests.

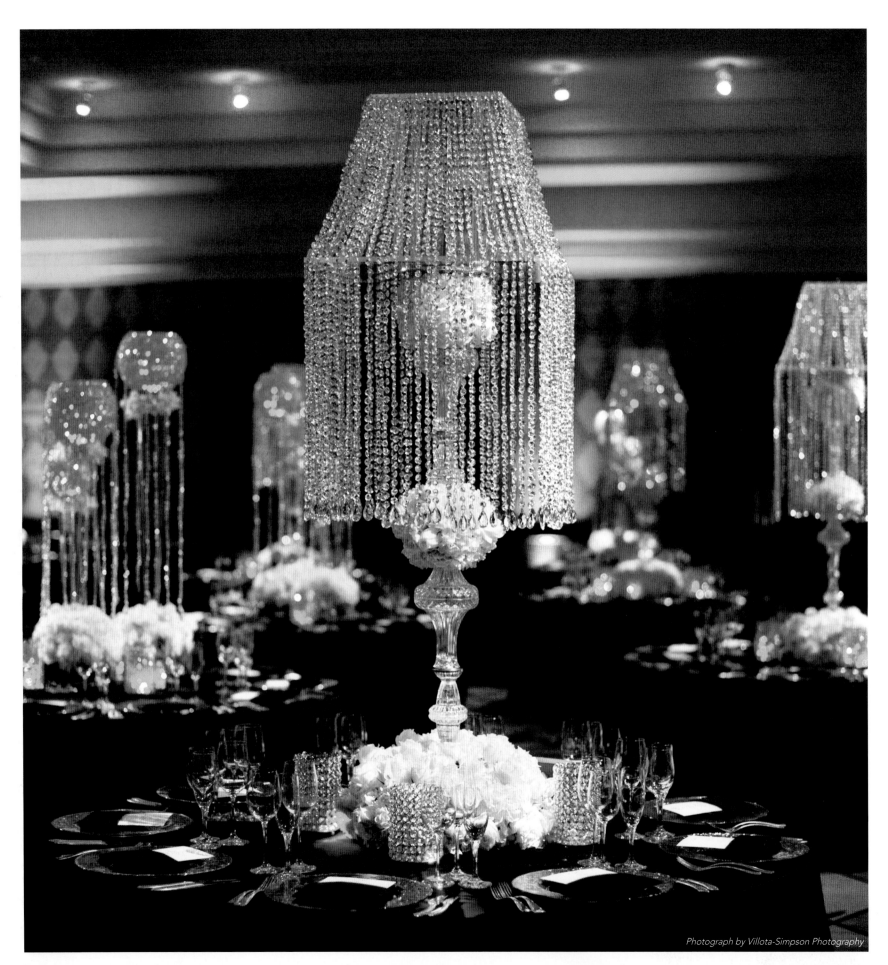

Photograph by Villota-Simpson Photography

"Color plays such an important role in the tone and feeling of a room. It comes from more than just the linens and flowers."

—Nancy Gilbert

Right: Quiet sensuality found expression in the sleek and modern elements showcased for the elegant dinner event. Simple white organza linens topped with stylish chrome-ringed matting gently led the eye to seven-foot reflective vases exploding with calla lilies, hydrangeas and dripping orchids. These gentle yet powerful aesthetic elements set the stage for a satisfying evening for the host's dinner guests.

Facing page: Our client's vision was for the room to take on the appearance of droplets of sparkling blue water. To realize this vision, the ballroom was transformed into a watery sanctuary with the help of blue focused lighting, originally designed and custom-made crystal chandeliers, and Venetian crystal globes with hanging crystal strands. Deep blue linen tablecloths set the stage for elegant silver and sparkling crystal accents.

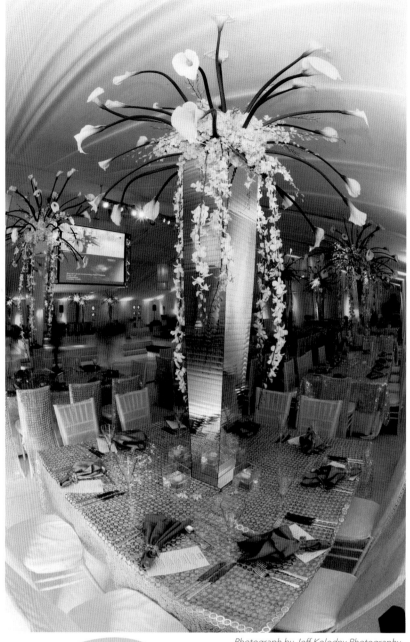

Photograph by Jeff Kolodny Photography

views

❖ Creativity without practical application is only a dream.
❖ A client's ability to trust his or her designer is one of the most important elements of a successful event.
❖ It takes an enormous effort by all involved to assure a perfect result.

So Cool Events, Inc.
MEG AND DEAN HOLDERMAN

When Meg Holderman and her husband Dean decided to become entrepreneurs in the events industry, they put their heads together with a clear-cut focus. The couple established So Cool Events in 2001 after many years of executive experience. Creative event décor specialists, they feature an extensive line of sensational options including LED-lighted acrylic tables and lounge furniture, ice and acrylic centerpieces, ice sculptures and huge video projections. Opened in 2008, their exclusive So Cool eVenue facility provides 10,000 square feet of event space; the club-like venue features Miami's only Art Deco-inspired ice lounge and bar that can be configured to meet unique event needs.

The So Cool team's mission is to make events extraordinary, and ice is just one of the ways they create excitement. From design proposals to installation on location, So Cool experts create and present stunning ice décor for all occasions. While the pros are happy to carve any of their dozens of thematic, crystal-clear ice sculptures for weddings, birthdays and holidays, custom design is definitely the house specialty. And their creativity is hardly limited to the traditional clear creations displayed on tables. They've frozen small objects into sparkling ice blocks to capture party themes and suspended ice letters to make an impact at corporate events. Ice shapes are often etched and colorized to perfectly match company and team insignias. So Cool's artisans can precisely replicate scale model buildings or famous art sculptures for a dramatic focal point at galas, celebrity events and private parties. Each hand-carved and laser-cut ice design is presented on an illuminated stand—or suspended above one—that collects water as the piece slowly melts. So Cool's core-lighted ice décor includes exquisite frozen centerpieces and sculptures that are clearly amazing art forms.

A formal ambience is even more beautiful on ice. Our custom ice vase holds fresh roses for a centerpiece to remember. Guests may think for a moment that it's hand-cut European crystal. Tiny "pearls" are round scoops packed with snow, and the vase is illuminated by a hidden stand that catches melting ice as the evening unfolds.

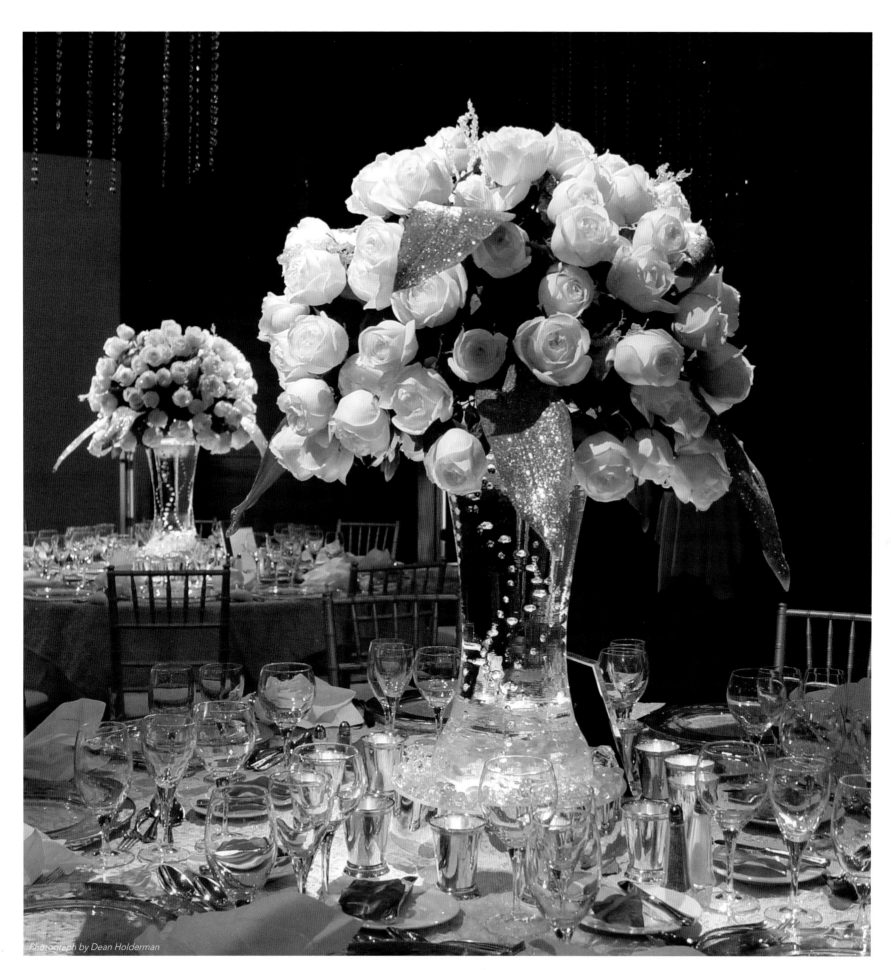

Photograph by Dean Holderman

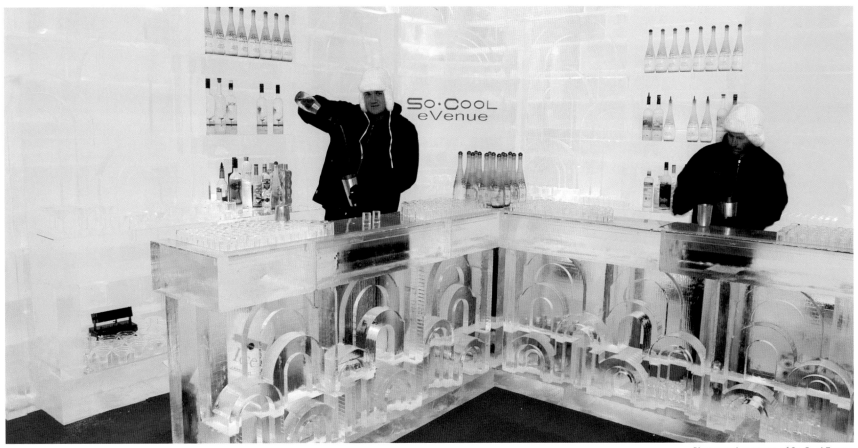

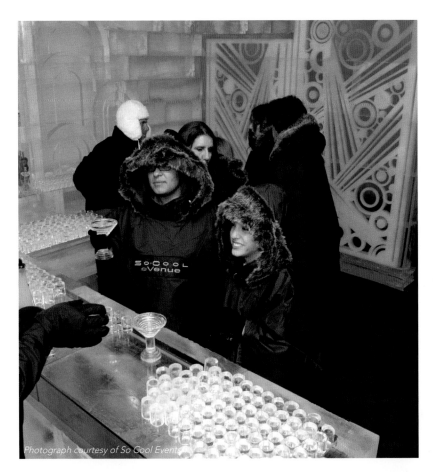

The one-of-a-kind Art Deco ice bar is illuminated with programmable, color-changing LED lighting that attracts Miami partygoers with its unique So Cool eVenue star quality. We provide hooded parkas and warm faux fur-lined Crocs™ footwear to every guest upon arrival, especially appreciated by the ladies. The exclusive ice club has a private entry to the ultra-chilly bar area, and one corner of the lounge features a tiered ice chandelier with igloo-style display shelving that can be customized for any event. We often suspend custom ice logos or designs to add yet another unexpected dimensional effect to fascinate revelers. LED-lighted acrylic lounge cubes display a revolving array of color for a vibrant ambience.

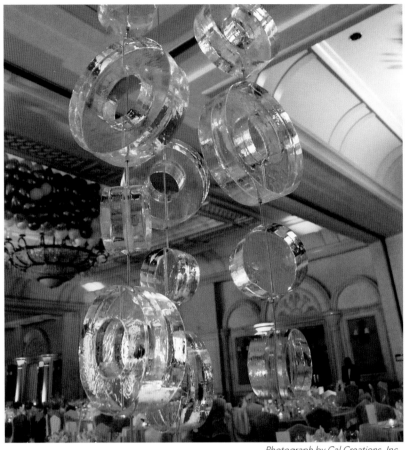

Photograph by Cal Creations, Inc.

"The ice bar room's brisk temperature with its artistically carved frozen décor creates a real 'wow' experience."

—Meg Holderman

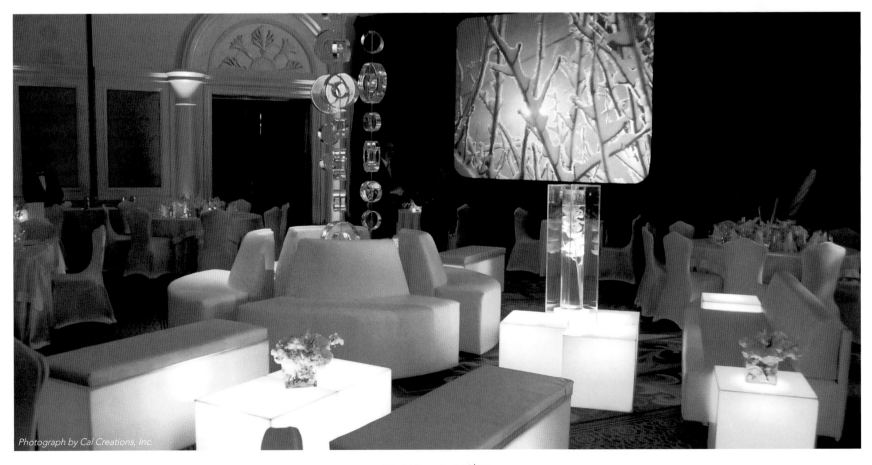

Photograph by Cal Creations, Inc.

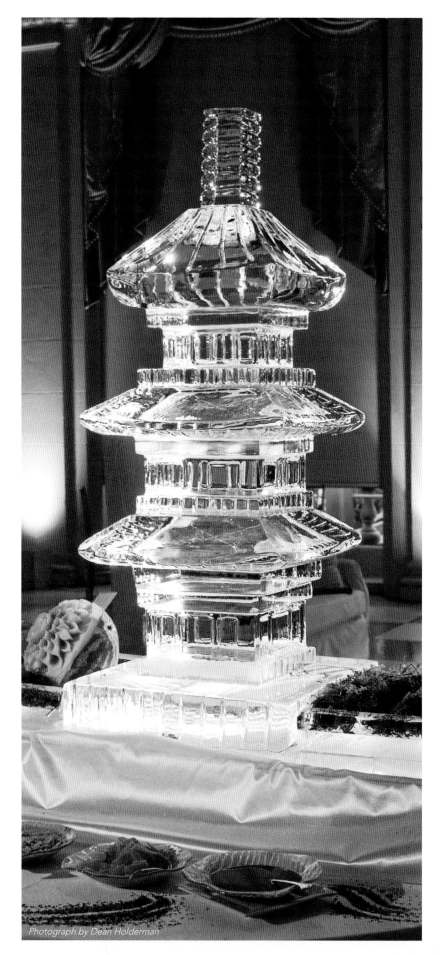

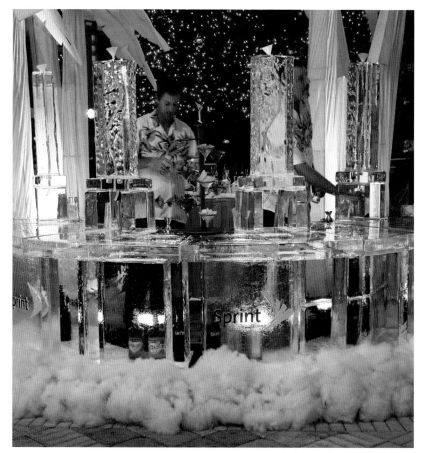

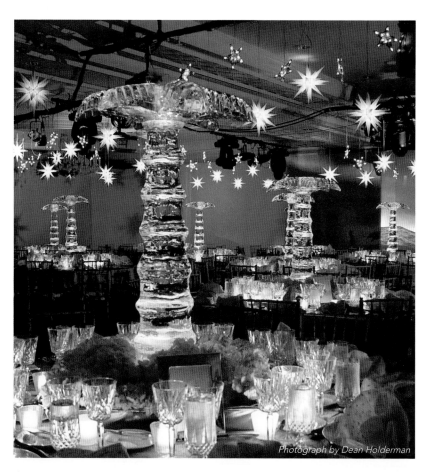

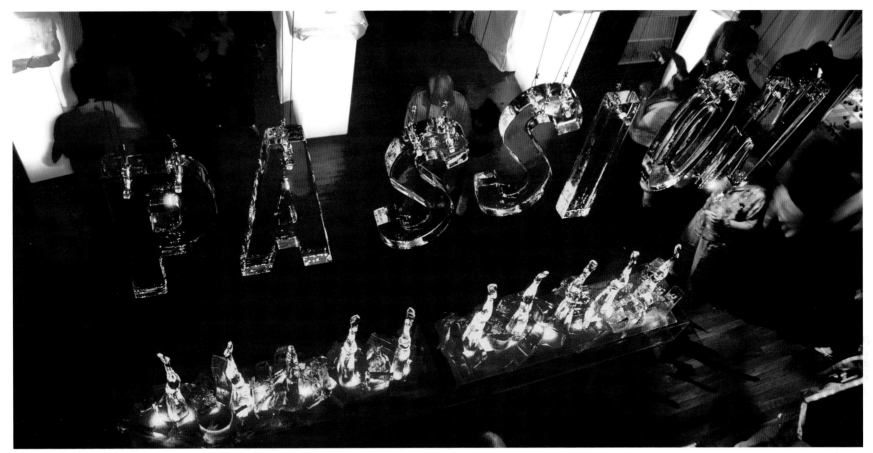

Photograph by Dean Holderman

A pastel pink pagoda graced the themed buffet table, and our full circle ice bar with liquor luges was a show-stopper at a martini station. Ice sculptures create an energy that no other décor can offer. They're cool and hip, exciting and alive. Giant palm trees of ice are a tabletop surprise as well as an architectural feat, but the look is unforgettable. Suspended ice letters spell "passion" while sexy legs resemble hot flames for a sizzling nightclub effect. Our talented sculptors carve flawless, crystal-clear ice creations; vibrant-colored LED lighting accents the form and intensifies the effect.

"No matter how well an event is designed, illuminated ice décor can give the room that extra pizzazz."

—Meg Holderman

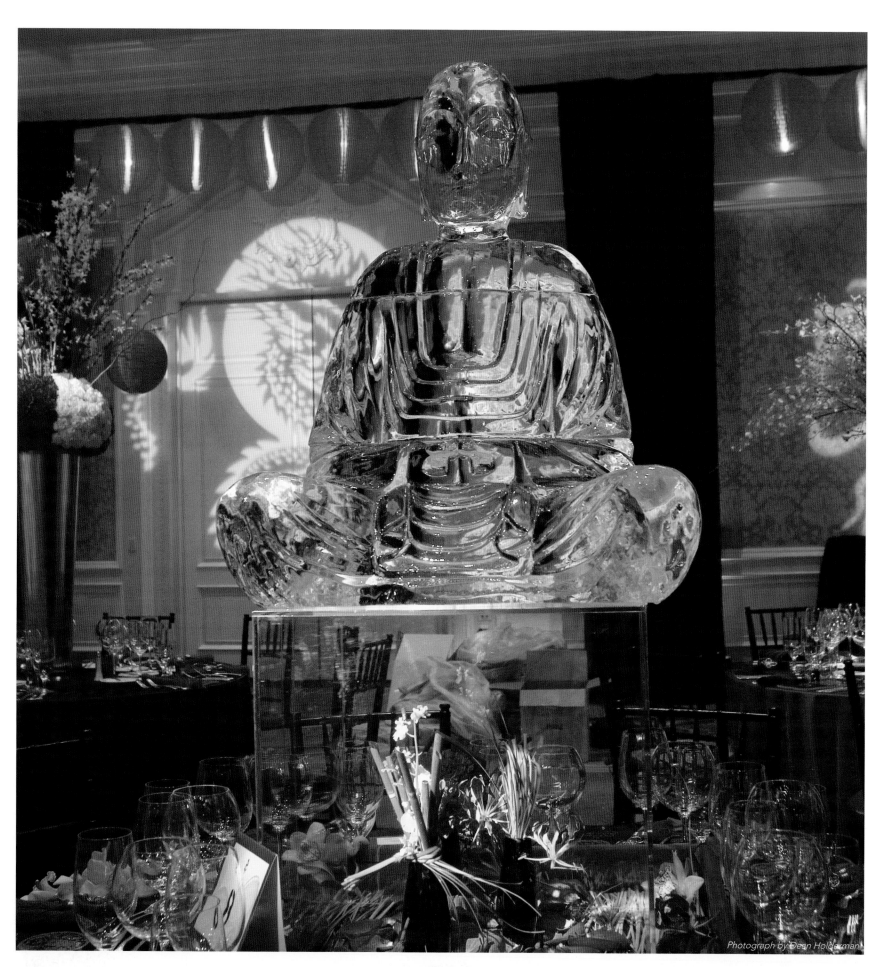

"Ice décor can be elegant or edgy—the creative choices are endless."

—Dean Holderman

Right: The new product debut for a world-renowned French cosmetic company and perfumer culminated with a chiseled 12-foot ice sculpture illuminated in hypnotic blue to mimic the actual crystal fragrance bottle. Our set-up team creatively positioned the ice décor in the reflecting pool at the main entrance of a Miami luxury hotel for instant glamour upon arrival.

Facing page: An impressive ice Buddha, which became the media's favored centerpiece at a chic Palm Beach fundraising gala, meditates in the ballroom amid Asian-inspired décor. For safety and display purposes, we installed the dramatic 200-pound sculpture carefully on an acrylic platform, allowing its omnipresent beauty to be enjoyed from all angles as melting ice was cleverly captured.

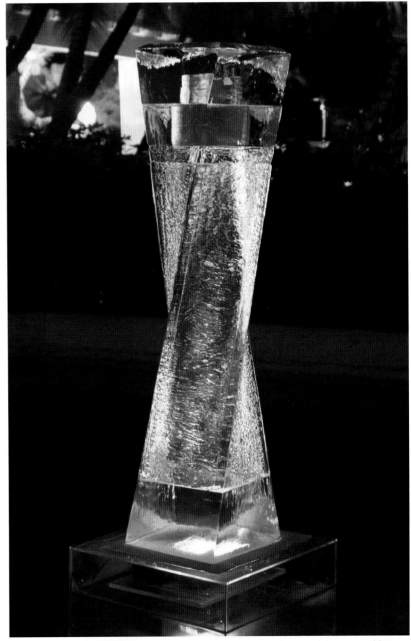

Photograph by Dean Holderman

views

Ice décor is always the focal point of a room, and party planners know this secret. When people bring in ideas for ice elements, we help them understand the limitations as well as artistic possibilities of the impermanent medium. Our team creates and tests complex ice creations well ahead of the event. Live ice-carving events also make a big impression, as guests really delight in watching sculptures come to life before their eyes.

Nüage Designs

PABLO OLIVEIRA

Every great storyteller knows that what truly grabs and holds an audience is the element of surprise—Pablo Oliveira is no exception. Since 2003 Pablo and his team at Nüage Designs have told concise, powerful stories with a flair for the unexpected in the form of intricate event environments. Nüage's unique furniture and custom linens create sophisticated environments that translate clients' stories into physical space, evoking the emotions and ambience that imbue each event with excitement and drama.

Launching his career in the hotel industry afforded Pablo the opportunity to travel and introduced him to the world of event planning. It also equipped him with the business savvy that makes working with Nüage a logistical dream. Clients are treated with the same level of care given to fabric and furniture selection. And Pablo's penchant for exquisite, forward-thinking design ensures that the second guests arrive at the party, they'll be wowed.

Though the company name derives from a French word meaning "clouds," it both sounds and looks like an exotic version of "new age." This resonance is wholly deliberate. It embodies the spirit of Pablo's philosophy: Constantly innovate to provide a new generation of products and fresh takes on familiar styles. In a word, be a trendsetter.

We love to mix textures. It's a great way to add an element of surprise. Combining a gathered taffeta tablecloth with ribbon-appliquéd upholstery subtly transforms a black-and-white theme.

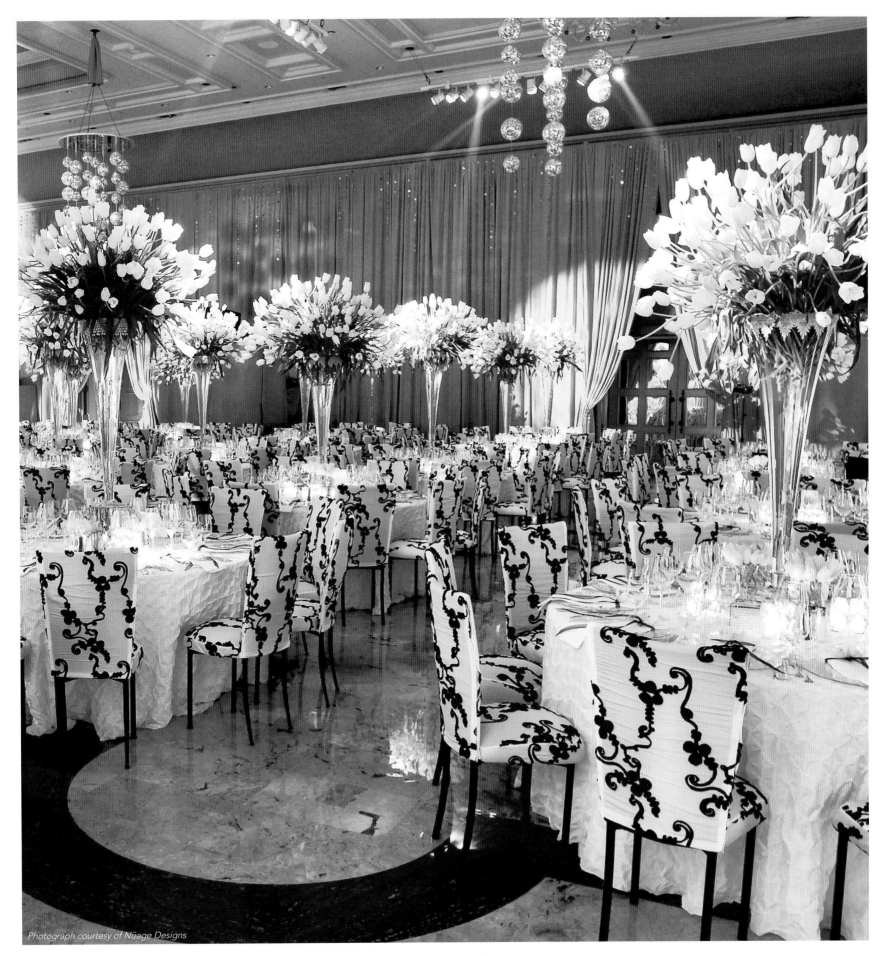

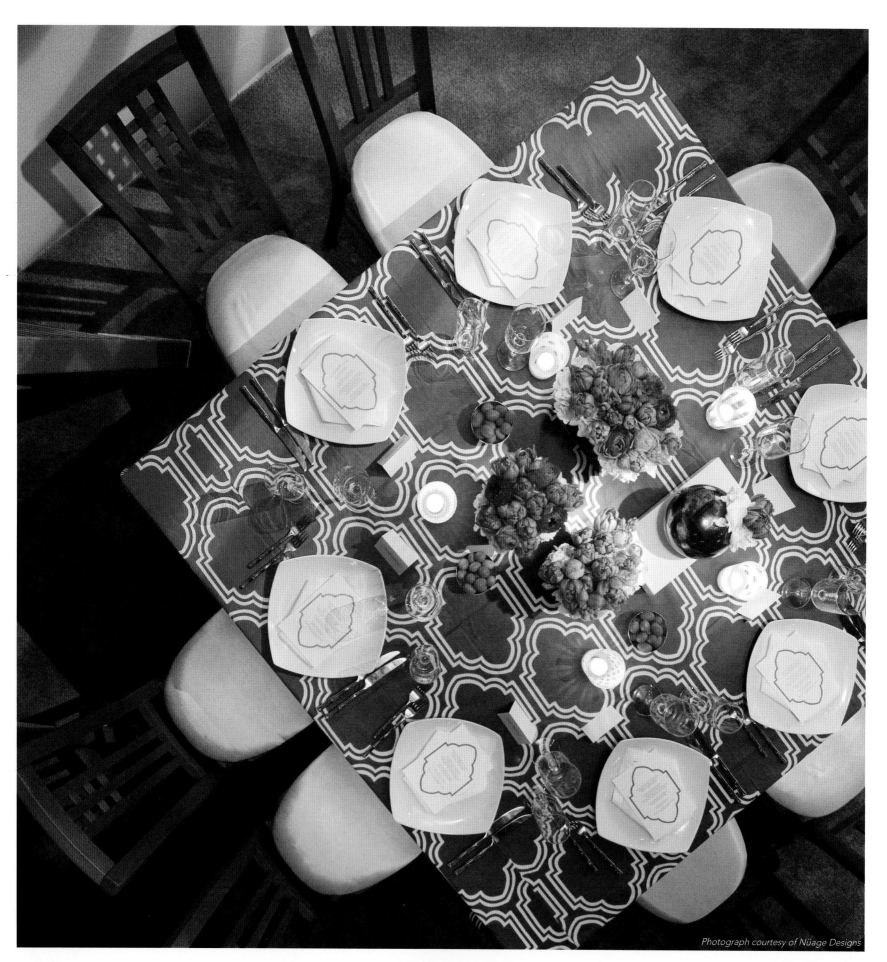

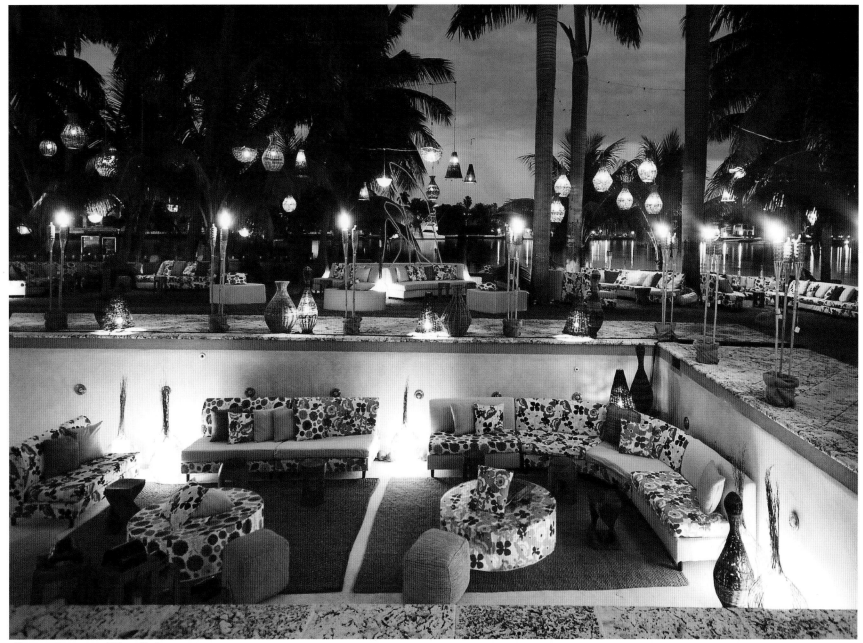

Photograph courtesy of Nüage Designs

Our clients provide the idea—we provide the creative twist. Brazilian furniture designers with a taste for the campy asked us to design a 1950s' Brazilian barbecue. Building on the idea of a cozy neighborhood party, we drained the pool and created a lounge within, mixed bright, floral-patterned upholstery and lit the entire party with mismatched lanterns. The result was equal parts grandma's house and tropical chic—precisely the clients' intent.

Moroccan-themed parties are ubiquitous, due to the rich, sumptuous elements they allow. An atypical color like green can make an original statement even while a familiar pattern reinforces the theme.

"At heart, my job is to tell someone else's story."

—Pablo Oliveira

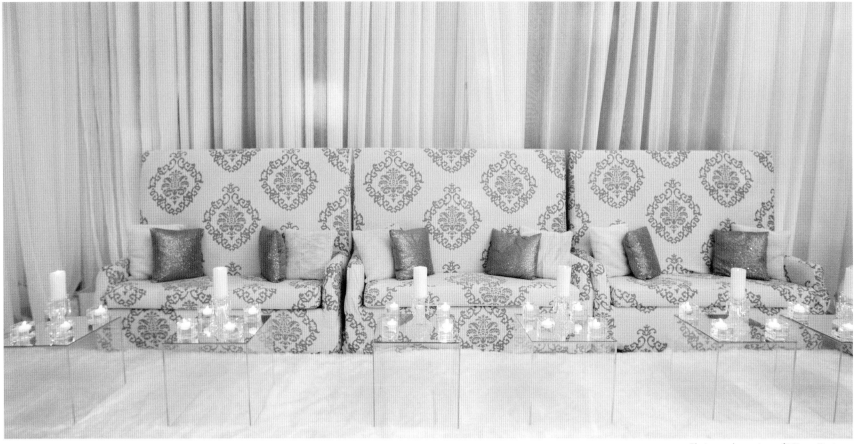

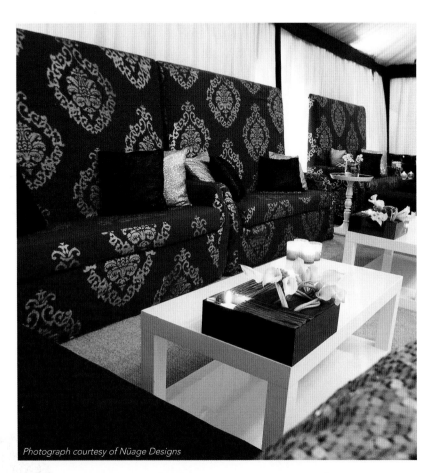

Above & left: The same elements can tell two very different stories when we change their color and use. Covered in ivory and gold and paired with mirrored tables and plush fur carpet, a sofa radiates luxurious formality at a party for hundreds. Fittingly upholstered in red and paired with simple wooden coffee tables, the same sofa creates sophisticated intimacy befitting a small tent party for a Cartier launch.

Facing page: We never want a color or pattern to overpower a room. Our tables often have multiple themes to allow for diversity in color and texture. Brown and black read differently when we vary the patterns and textures. Adding crocodile chargers, beaded napkin rings and velvet appliqué mitigates uniformity in an environment of browns. Contrasting black with a bold color like gold allows for a refreshing departure from traditional black and white.

"I want people to look at my designs and say, 'How come I've never thought of that before?'"

—Pablo Oliveira

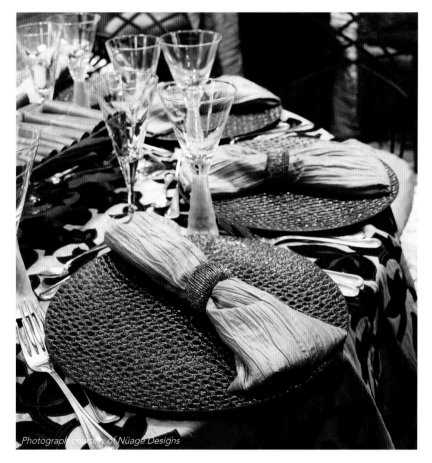

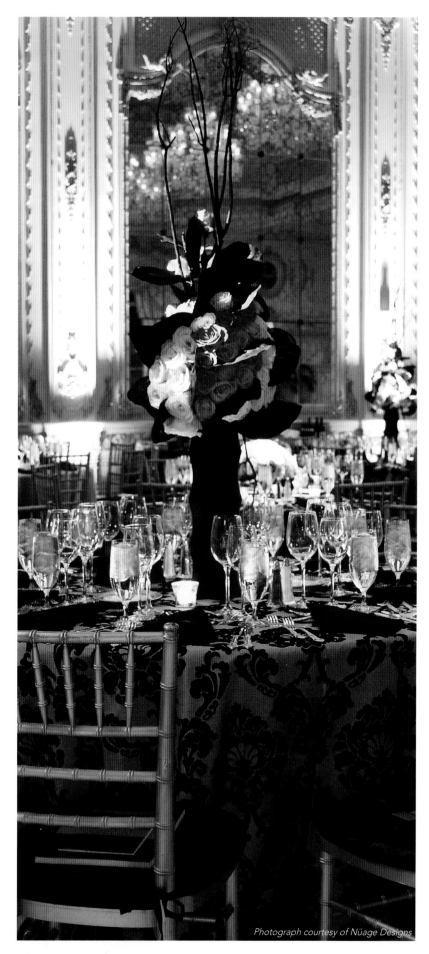

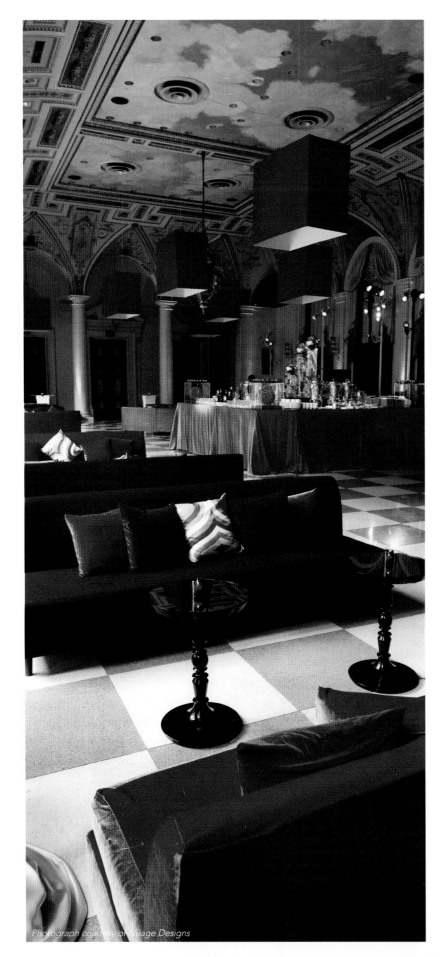

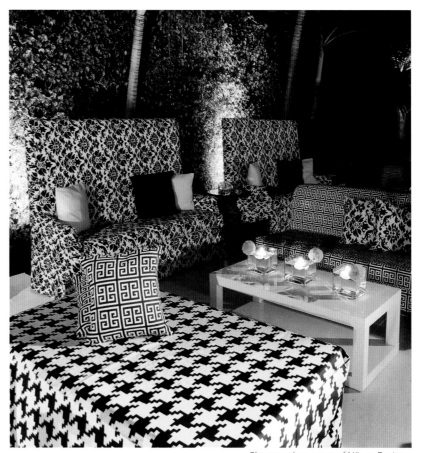

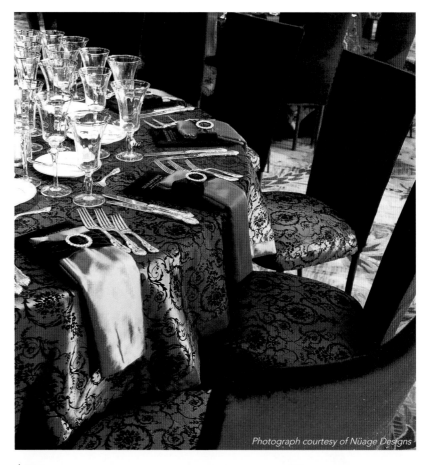

"People's fantasies come to fruition through great design."

—Pablo Oliveira

Choosing the right color and pattern is key to defining an event. An event for a cosmetic company calls for pinks and reds, evoking the feminine even in a traditional lounge setting; various black-and-white patterns washed in yellow light with yellow accents create simple visual contrast; majestic opulence calls for rich plum and purple hues offset by bold black detailing. Of course, the fabric itself can call to mind the theme. For a Vera Wang show, we dressed 20 tables in bridal cloth. Delicate tulle and lace floral appliqués on white tablecloths conjure romantic visions.

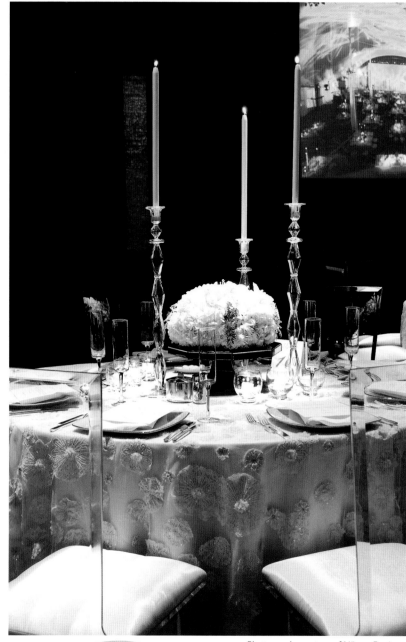

Photograph courtesy of Nüage Designs

views

❖ Let the tables tell your story. Tables are one of the first things people see at an event, so really think about what you want them to say.

❖ Pay attention to what's around you—especially when you travel. Some of the best ideas are born from a trip abroad.

❖ Don't be afraid to experiment with unusual materials and textiles. Our showroom overflows with unique ideas, such as acrylic walls and Velcro chandeliers.

PANACHE—A CLASSIC PARTY RENTALS COMPANY

KELLY MURPHY

South Florida epitomizes the couture scene for fashion, art and culinary delights, punctuated with star-studded celebrations year-round. High-profile social, corporate and community events grace some of the world's most acclaimed architectural wonders including Miami's legendary Delano, the classic Ritz-Carlton, the Historic Alfred I. Dupont Building and some of the most photographed oceanfront properties on the planet. Creating celebrations in partnership with Panache has become an event planner's tradition throughout Central, South and Gulf Coast Florida. Founded and continuously managed since 1992 by entrepreneurs Kelly Murphy and Bob DeFriest, the successful boutique event rental company known for its vast selection of sumptuous linens and unique hand-selected tabletop items was acquired by the nationally renowned Classic Party Rentals in 2007.

Panache represents elegant event furnishings with a trend-setting touch and is a one-stop source, whether for an intimate dinner party for a dozen, a corporate banquet for a hundred or an extravagant charity gala with well over a thousand guests. A support team of more than 200 dedicated staff members works around the clock to support hundreds of special occasions each year, in collaboration with party planners, designers, venue directors and city managers. With offices and warehouses encompassing over 200,000 square feet of space throughout Central and South Florida, the company's deep inventory of rental items includes everything from elegant tables, chairs, linens and fine tabletop décor, to outdoor tent structures, professional cookware and a complete line of catering equipment. Kelly's style and good taste coupled with three decades of events industry experience and relationship building makes Panache more than an ancillary vendor, but a true partner to help bring flair and unique style to life's events.

The winter wonderland tablescape created by Xquisite events during the first annual Panache Fashion Week in 2008 features our new white faux mink tablecloth, silver pebble chargers with white china, Christofle silver-plated flatware and hand-blown crystal stemware edged in ornate platinum banding. The icy-chic formal look quickly became a seasonal favorite, bringing a visual touch of winter to South Florida.

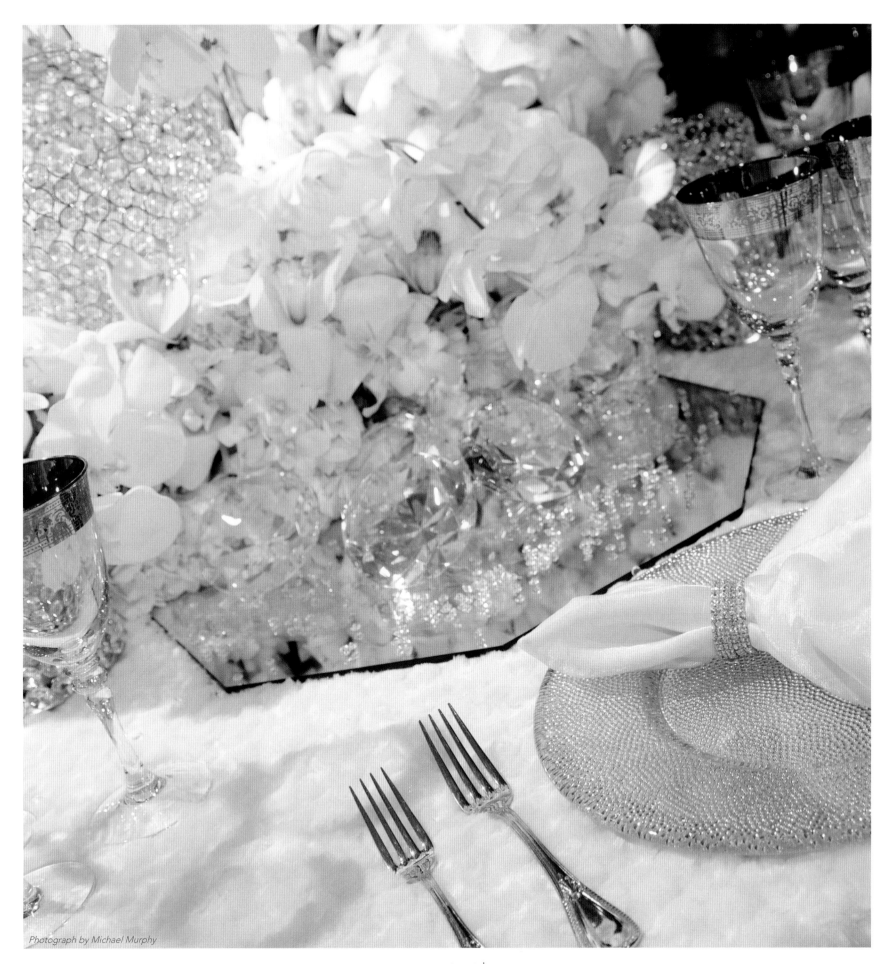

Photograph by Dale Stine

"When setting a table for your event, remember the first taste is with the eyes."

—Kelly Murphy

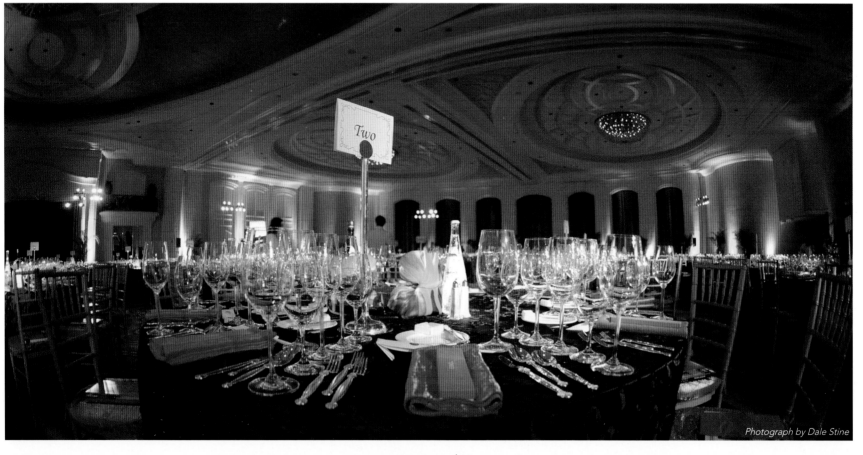

Photograph by Dale Stine

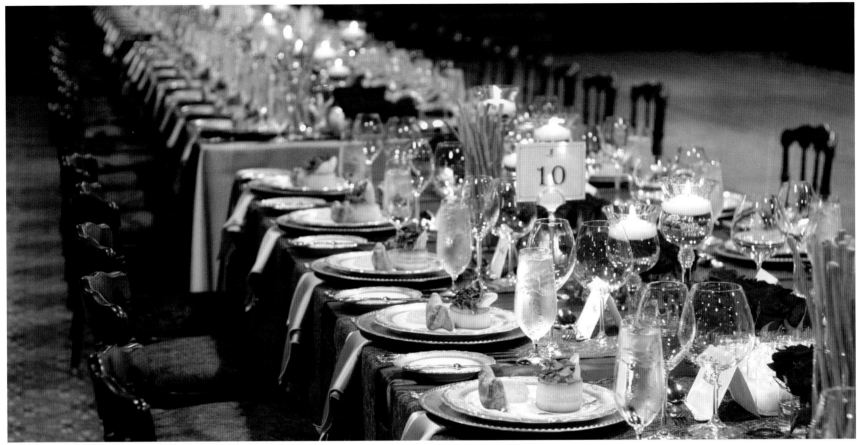

Photograph by Ed Chappel

Above & right: The 70th birthday party for a distinguished gentleman had a guest list of 400 close friends. An elongated room required rectangular and round tables to help make everyone feel like a part of the regal celebration. Custom satin linens and patterned table runners in rich burgundy, olive and gold graced the tables. The feast was set with antique bronze rope base plates topped with our Vanessa gold-rimmed china, crystal stemware and Christofle flatware. Versailles mahogany chairs with burgundy velvet cushions are fit for royalty.

Facing page: A tribute dinner for award-winning international chefs participating in the Food Network South Beach Wine & Food Festival exceeded everyone's expectations. Our specialty linens and tabletop décor include many options to suit any occasion, but our client wanted it to be a bit masculine, yet elegant. Copper Fantasia taffeta tablecloths with sewn ribbon patterns created warmth and texture. Crushed, burnished satin napkins and matching seat cushions accent elegant Chiavari chairs to complete the look.

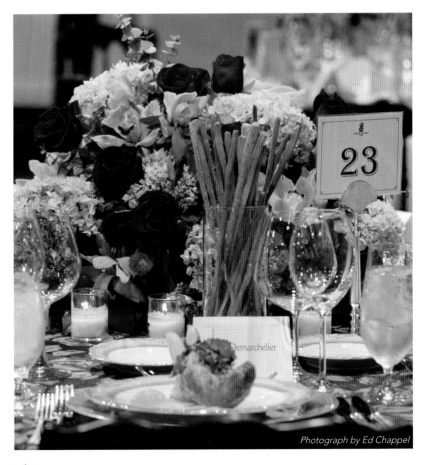

Photograph by Ed Chappel

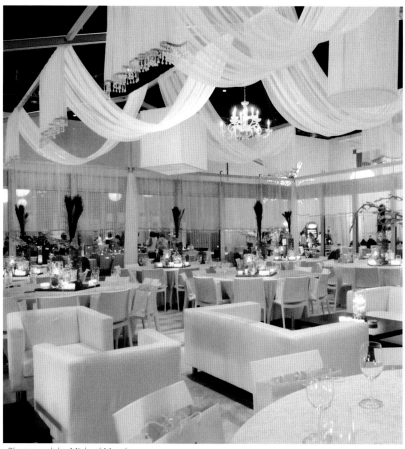

Photograph by Michael Murphy

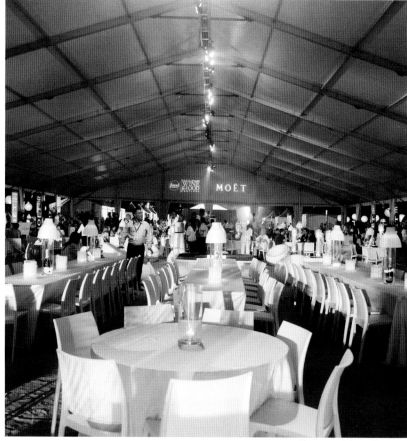

Photograph by Dale Stine

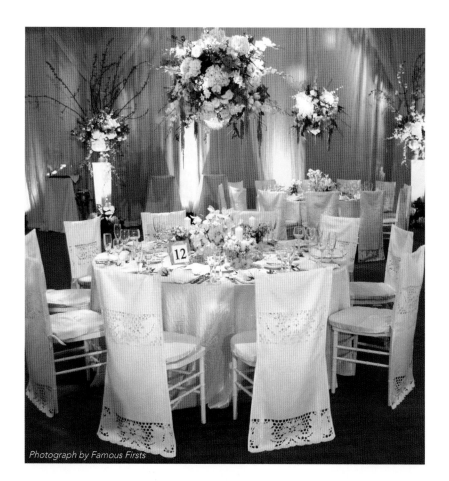

Photograph by Famous Firsts

Above left & right: White-on-white provides a cool, refreshing and contemporary theme at many of Florida's hottest events. The pure white scheme allows a space to take on a variety of different moods through lighting and textural elements.

Left: The designer layered a room with our crisp white linens, lace-embellished chair slips and light-infused draped fabrics to allow guests to see and touch a variety of color and textures.

Facing page: Amber pintuck-patterned linens, antique bronze chargers, amber-hued stemware and copper utensils create a warm, inviting tablescape. We crafted custom linens, chair apparel and tabletop furnishings for the designer to complement the room and the event's theme. Whenever possible, décor should enhance the architectural beauty of the venue and not compete with, or detract from, the client's vision. The artful mix of rich colors and textures works beautifully to balance the grandeur of the historic building.

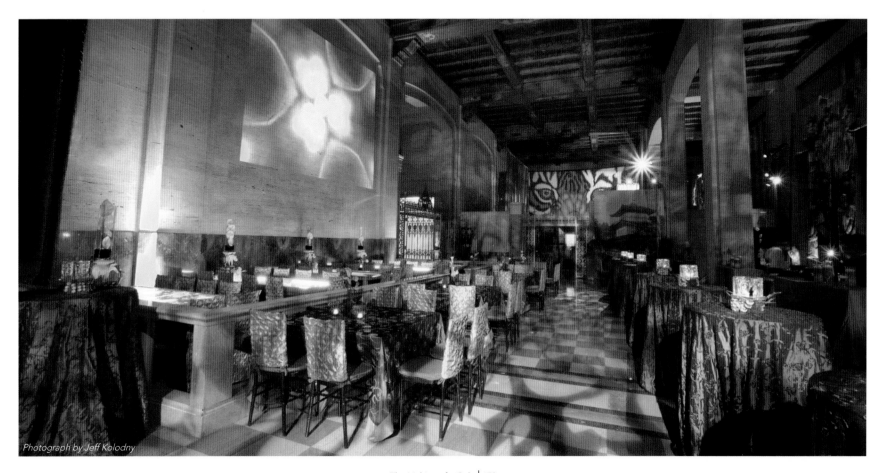

"Choose décor to complement the room without competing with its beauty."

—Kelly Murphy

Photograph by Town & Country Studio

Photograph by Jeff Kolodny

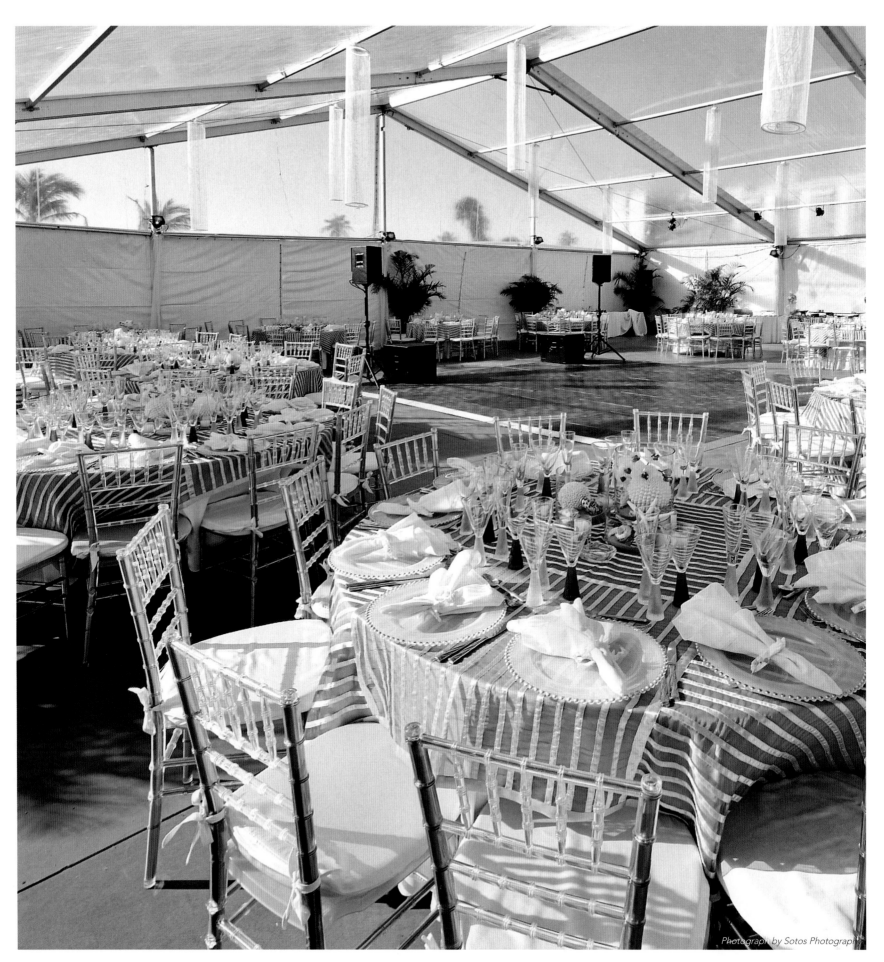

"When simple and elegant is the look you want to convey, attention to detail is vital."

—Kelly Murphy

The soft beauty of sea glass with its frosted patina was the designer's inspiration for an oceanfront wedding. Our textural turquoise and chocolate ribbon-striped overlays accent ivory peau de soie tablecloths, while clear acrylic Chiavari chairs tie the look together. Silver beaded chargers and frosted crystal stemware continue an elegant beach glass effect. The clear-span tent top and sheer perimeter draping brought the natural beauty of the ceremonial beach setting in, while keeping the elements out.

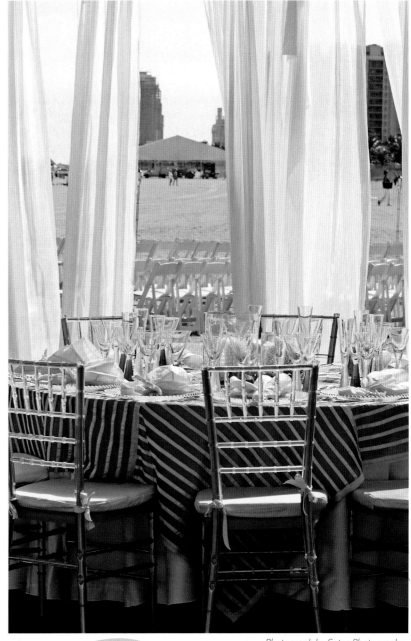

Photograph by Sotos Photography

views

Logistics and communications are important, as access to venue locations can present delivery challenges. Loading and unloading, elevator usage, truck routes and coordinating with designers and other vendors are all crucial to the success of any event. When you only get one shot at a perfect event, you have to be prepared and always expect the unexpected.

Premier Tenting Solutions and Event Rentals

NATE ALBERS | GARY HENDRY

Great events take place in great venues—from estate lawns and beachfront resorts to museums and historic properties where the options are limited only by one's imagination. Since 1996 Premier Tenting Solutions and Event Rentals has been an industry leader in creating innovative tenting solutions to transform open space and landscape into breathtaking venues—venues that are as uniquely distinct, original and fabulous as the people they serve. Through flawless attention to detail and a focus on providing cutting-edge tenting products that fuse function and aesthetics, Premier continues to expand the boundaries of tenting solutions for many of the finest event professionals and events around the globe.

The owners of Premier, Nate Albers and Gary Hendry, believe that being the best rental company starts with buying the best rental products available in the world. In order to maintain the highest level of quality in its rental equipment, Premier has developed an innovative quality assurance program, which incorporates automated tent washing machines, a full-size automotive spray booth, a reverse osmosis system, a custom sewing operation and a wealth of knowledge from an experienced and professional staff.

We transformed the backyard of an elegant private estate into a waterfront venue featuring more than 20,000 square feet of elevated and tented event space that included a covered pool and custom water feature.

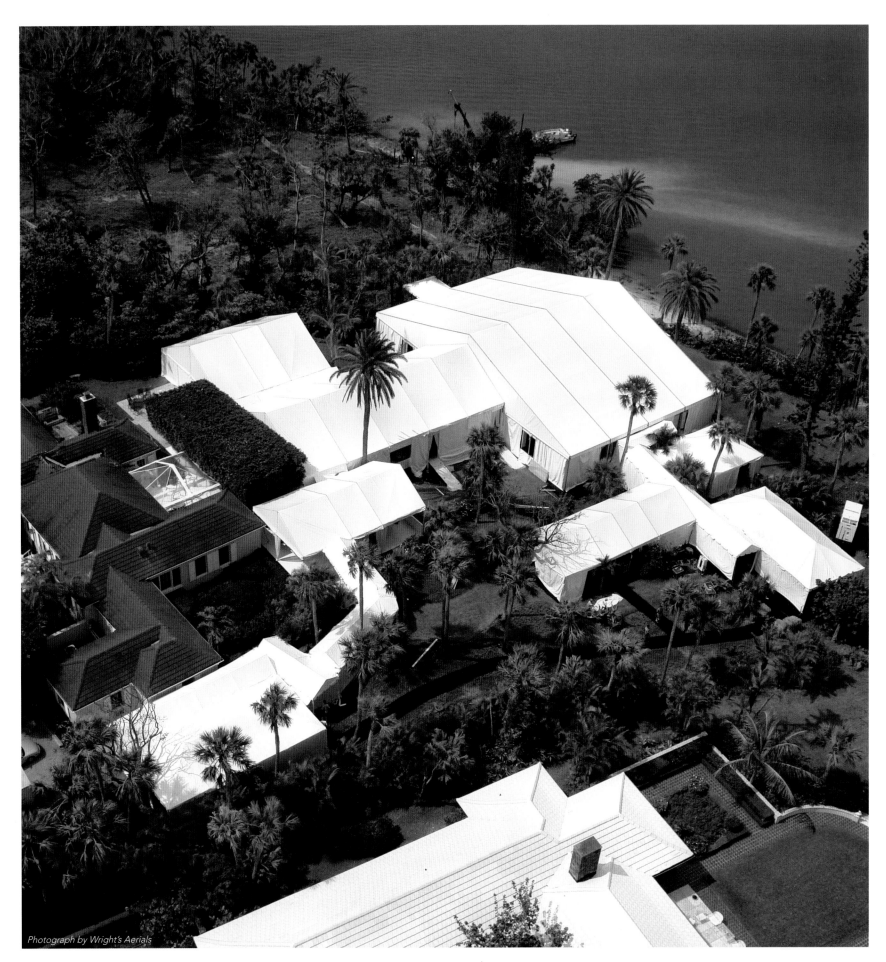

Photograph by Wright's Aerials

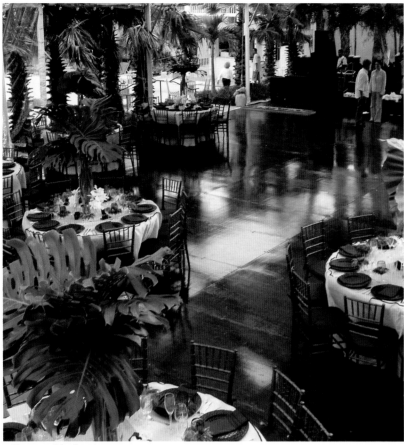

Photograph by Premier

Photograph by Tiger Aerial Photography

We can forge any setting into something memorable, whether for a private, corporate or government engagement. Utilizing the interplay of space and natural light, we render an ambience of sheer luxury and celebration. It's like the rest of the world doesn't exist. And that is our goal—to rise to the challenge in such a way that nothing matters outside of the event—to exceed the hosts' expectations, leaving them to celebrate the moment and know everything's taken care of. To make this happen, we collaborate with event planners, floral designers, lighting professionals, catering companies and entertainers.

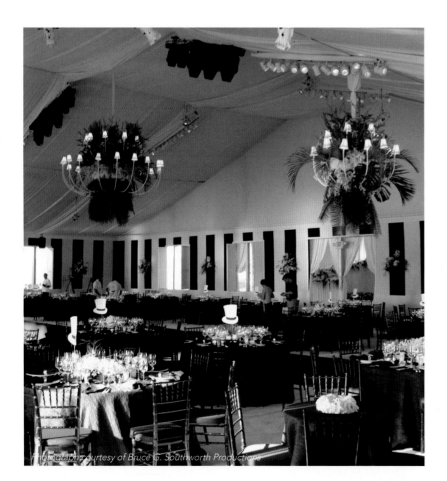

Photograph courtesy of Bruce G. Southworth Productions

"Engineered clear-span structures provide unparalleled tenting solutions for events of unlimited scale."

—Nate Albers

Photograph by Tiger Aerial Photography

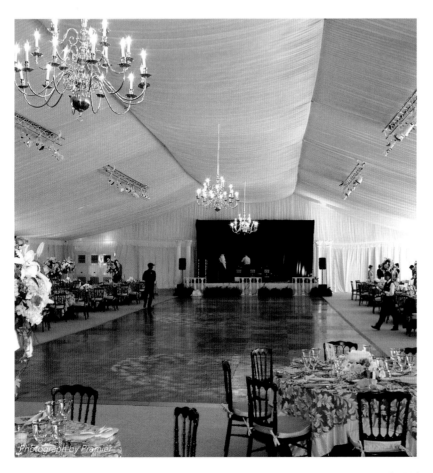

Photograph by Premier

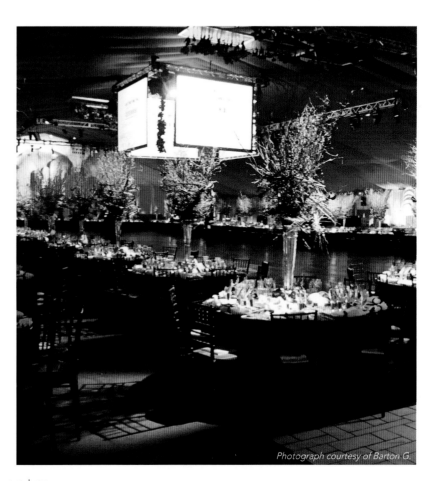

Photograph courtesy of Barton G.

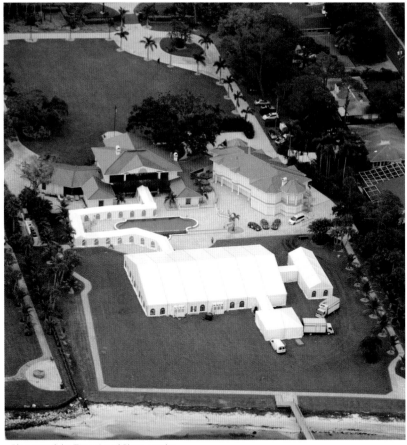

Photograph by Tiger Aerial Photography

Providing new and innovative rental products is our top priority, so we offer a full line of state-of-the-art tent enhancements that allow people to invent their own setting—it can be as simple or sophisticated as their taste, budget or event demands. Elegant glass walls and doors, fabric ceiling and wall treatments, elevated and carpeted flooring systems, crystal chandeliers, clear roof panels, frosted pool covers, temperature control, power generation and upscale restroom trailers are just a few of the many options available. For those interested in something refreshingly new and different, we recommend the Arcum structure, a unique arched roof system that was developed overseas.

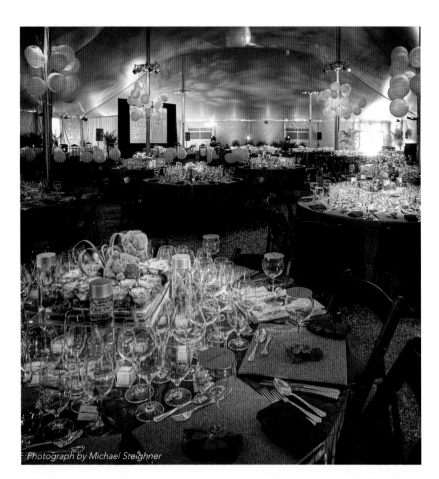

Photograph by Michael Steighner

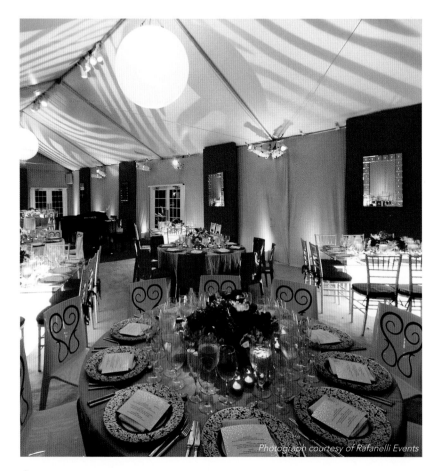

Photograph courtesy of Rafanelli Events

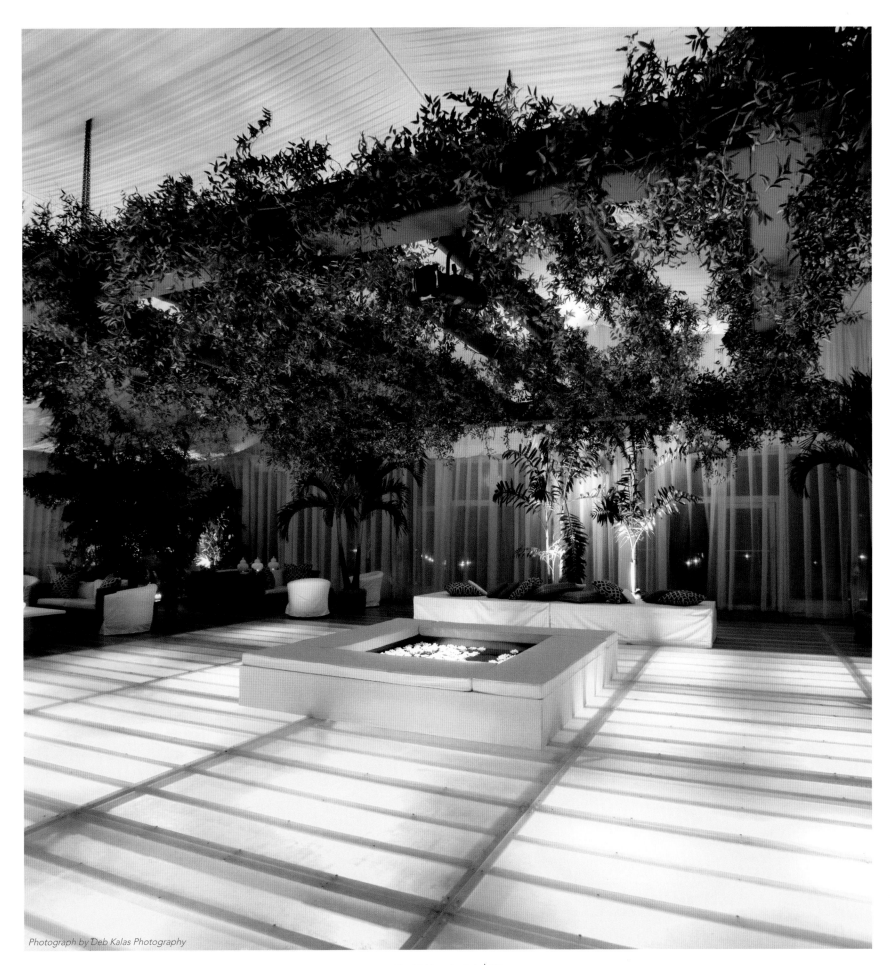

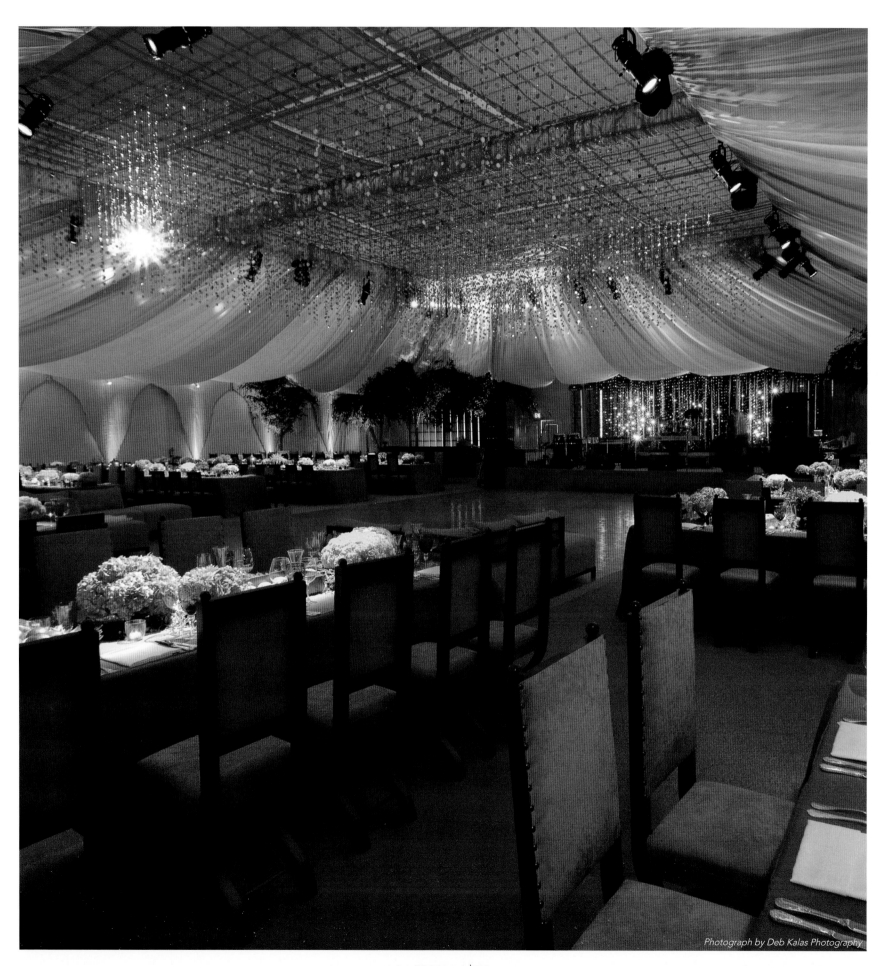

Photograph courtesy of Premier

"The elements that go into an event's production are nothing without a whole team of creative perfectionists working behind the scenes."

—Gary Hendry

The best feeling comes after all of the hard work, when we see guests relaxing, celebrating and savoring the atmosphere, the experience. For us, the sense of awe never ends because we know that events we collaboratively produce will live on in memories.

Photograph courtesy of Sutka Productions

views

❖ When selecting vendors, be sure to check references.

❖ Involve your tent company early in the planning stages, as its professionals are likely to have a wealth of knowledge.

❖ Tent flooring and temperature control are a good idea in many environments.

❖ Be honest—there's no such thing as an insignificant idea or concern.

DESIGN STUDIO–THE BREAKERS PALM BEACH

The Breakers' rich history as a beacon of Palm Beach hospitality has evolved over the last decade to tout many areas of expertise with event design one of its most prized, aesthetic talents. Take the hotel's uncompromising quality, service and style, wrap it up in a luxurious bow, and you have the Design Studio at The Breakers. Its talented team is composed of experts who specialize in event planning and décor, creative directors who bring concepts to life, ingenious producers including project administrators, floral designers, drapers, seamstresses and in-house resources galore.

Creating a mood and capturing a vision for clients in meticulous detail to make dreams come true is the Design Studio's mission. Corporate and social events are treated equally with unrelenting care and attention to detail. The design "dream team" brings ideas into reality by transforming indoor or outdoor venues into breathtaking spaces, from one of the many magnificent ballrooms to beautiful courtyards, gardens and off-property sites—all are within the realm of this creative team.

The Design Studio has access to the best elements of traditional and contemporary décor whether designing an elegant space from floor to ceiling or a small but imaginative alfresco fantasy. Its repertoire includes tabletop design, thematic room designs with furniture, props and décor, floral and lighting design, staging and entertainment. Like the red carpet flair of a Hollywood premiere, an imaginative space designed by The Breakers celebrates the moment and creates memories for a lifetime.

An elegantly tented affair held on the property of a private Palm Beach residence showcases sophisticated, contemporary taste using subtle colors of lavender and deep plum. Crisp white lanterns illuminate centerpieces of green decorative grasses with cherry blossom branches for a nature-inspired theme.

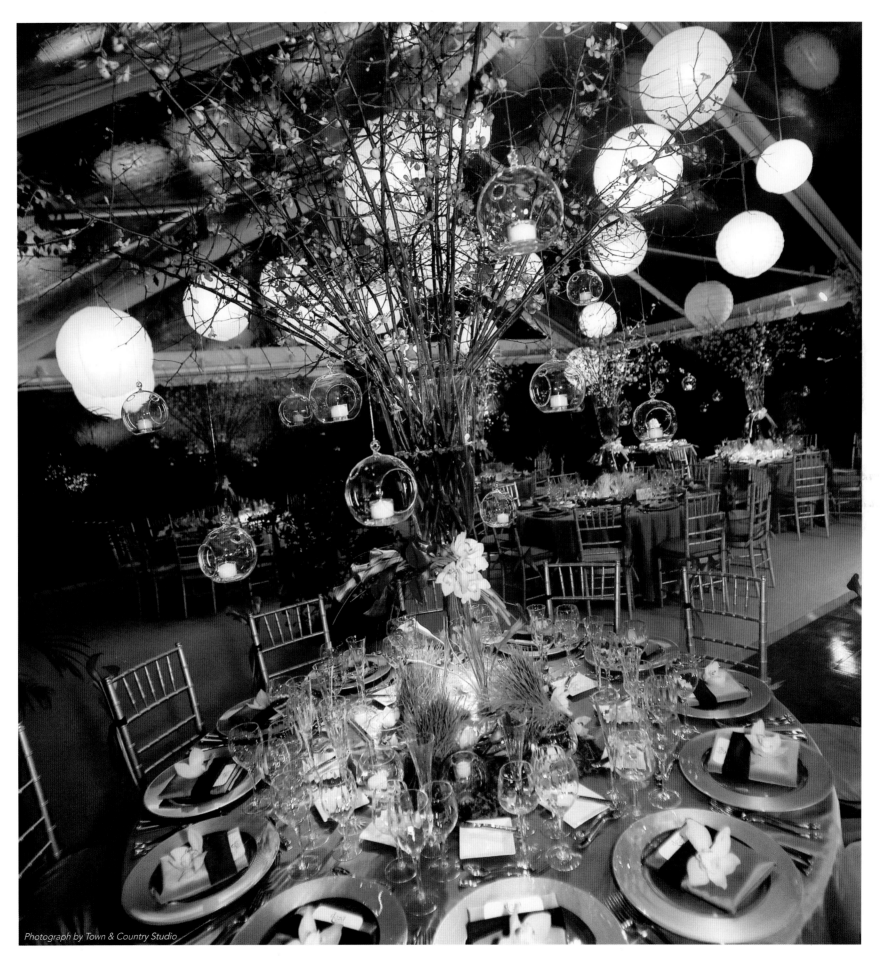

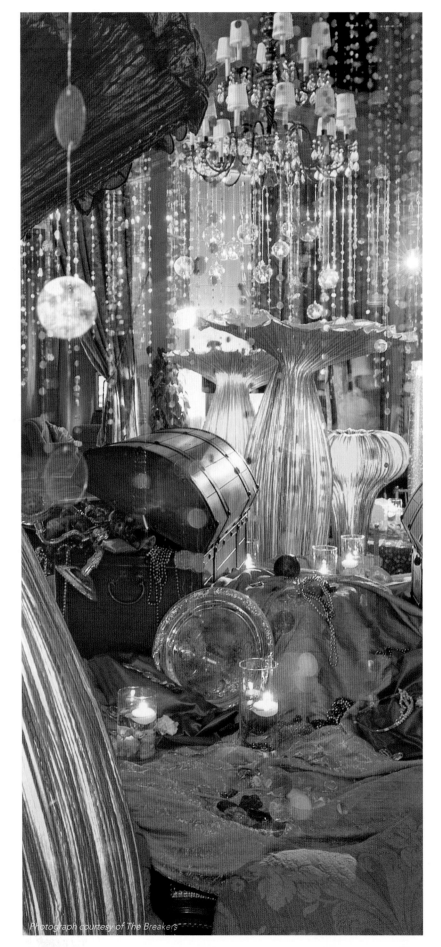

Photograph courtesy of The Breakers

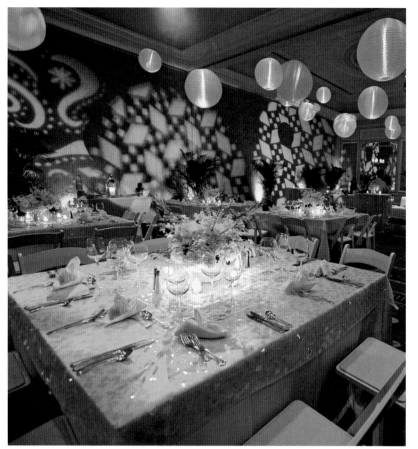

Photograph by LILA PHOTO

Above: Cool and alluring, the pure white tablescape is bathed in soft blue radiance for a monochromatic corporate dinner party with contemporary attitude. Smooth round lanterns glow while theatrical gobo projections add geometric lighting effects.

Left: A spacious room was transformed into an "undersea adventure" after-dinner lounge. Shimmering lighted strands of crystal paillettes were suspended from the 25-foot ceiling for a moonlit ocean effect. A dance floor configured with modular seating surrounds the imaginative treasure chest setting and bright red coral-inspired light sculptures create the perfect ambience for dessert and a nightcap.

Facing page: We envisioned a lighthearted tropical reception and designed the floral design concept featuring a brilliant fuchsia, orange and lime green color palette. Illuminated amber columns highlight the room's architectural detail, while orchid ropes dangle from the tabletop between pineapple replicas made of vivid orange roses set in ornamental wheatgrass beds. A classic dining chair is embellished with exotic hydrangeas, roses and purple orchids cascading to the floor.

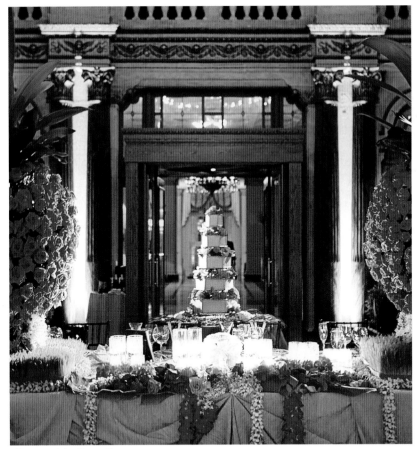

Photograph by Donna Newman

"The secret to creating lasting memories? A vision inspired by desire, then flawlessly presented."

—Joy Cudahy

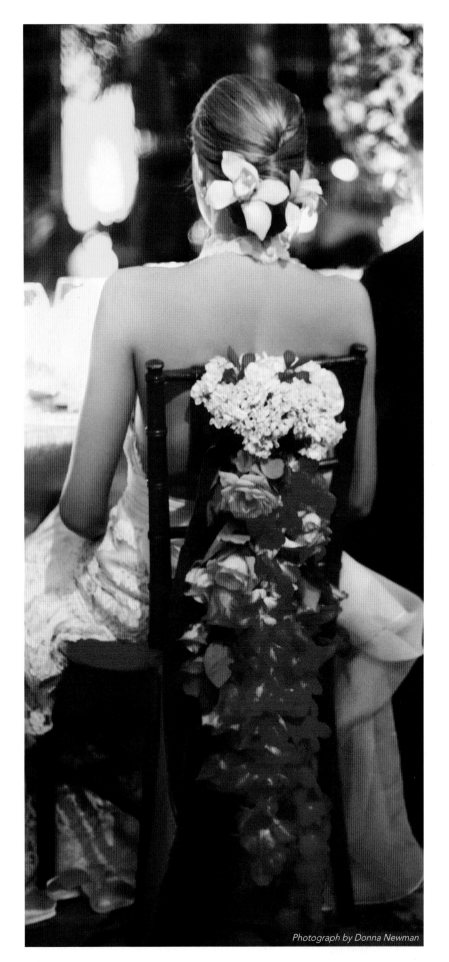

Photograph by Donna Newman

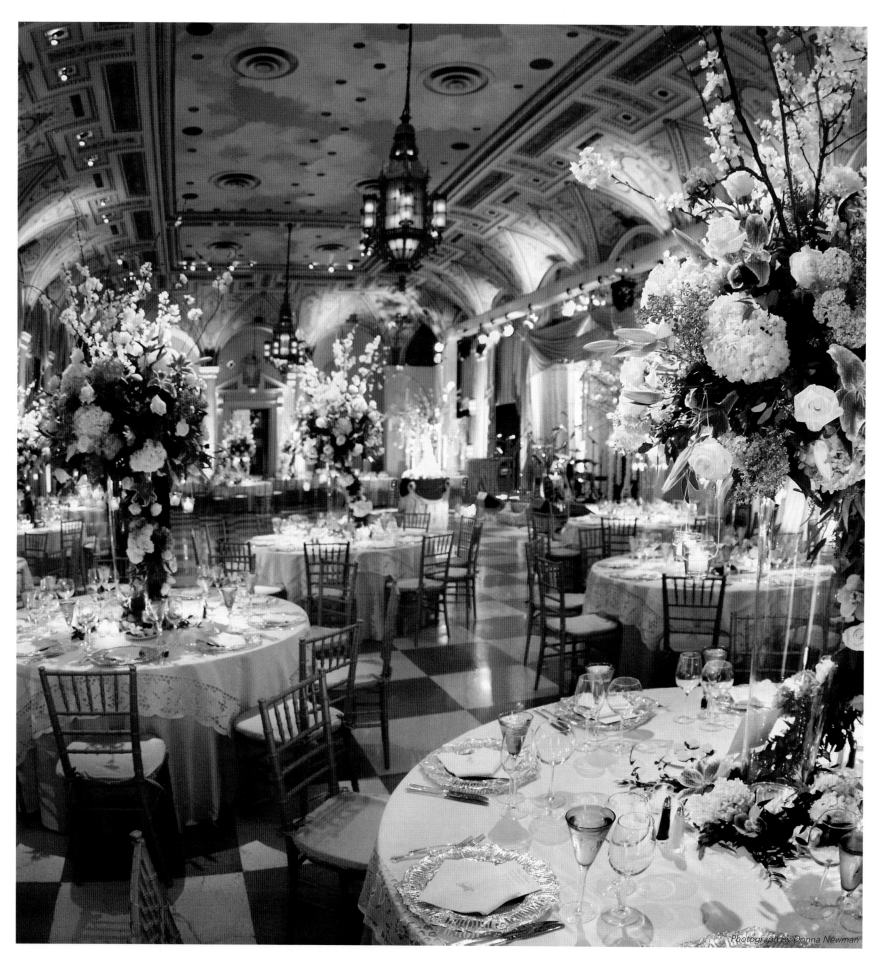

"Whether lavish or minimalist, creativity begins with exceptional resources."

—Joy Cudahy

Right: Anniversary wishes came true with dramatic crystal vases filled with pink peonies and fragrant chocolate cosmos on rose-covered pedestals. In keeping with the dark chocolate and petal pink theme, the room was enveloped in custom satin draperies, matching contemporary cube furnishings and loose pillows for a lounge-like atmosphere. Every last detail must be perfect; dining chairs have pink fabric cuffs on the seats and back caps of pink and brown.

Facing page: The classically painted Mediterranean Ballroom was transformed into a lush, garden environment with an ethereal feeling. A spring seasonal event inspired our white, pink and green color scheme. Impressive seven-foot-tall arrangements of stargazer lilies, white-blossom branches and early blooms were elegantly situated on formal round tables dressed in fine white linens with lace overlays. Silver filigree chargers, monogrammed napkins, sky-blue stemware and silver Chiavari chairs exude elegance.

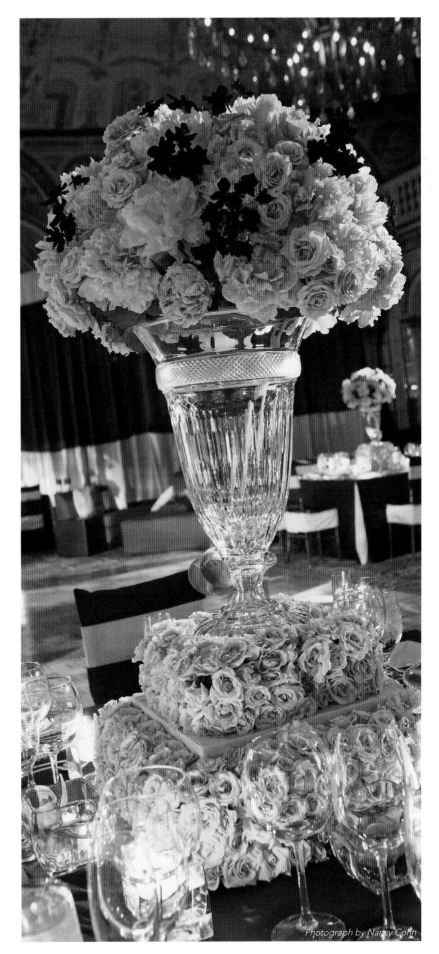

Photograph by Nancy Cohn

Duane Murrell VM Flowers
DUANE MURRELL

When you talk to Duane Murrell, it's easy to understand why he is in the event business: passion. From the planning stages to the execution of an event—it all excites and challenges him. For more than 25 years, he has been building genuine and lasting relationships that have earned him great prominence in the ever-competitive Palm Beach event-planning circle.

Over the past three decades, what Duane began as a floral business has blossomed into a complete event design service thanks to his devoted clientele and their enthusiastic referrals. Though stunning floral arrangements are his steadfast passion, Duane's attention to every detail, from tablecloths to placecards, is truly astounding.

Clients throughout the United States, Canada and the Bahamas trust his every decision, even allowing him complete creative freedom, because time and again he has proven himself with truly imaginative and original creations. His client list includes generations of families who have looked to him to create a wonderful stage for life's milestones. Duane has that great gift of providing clients with a level of comfort during the naturally high emotions surrounding each affair. That assurance allows them to relax and enjoy each perfect moment of their event … the way it should always be.

The hostess wanted anything but an ordinary placecard table for her affair. The table was the first thing guests would see as they entered the room so it was a great opportunity to set the tone for the evening. An elegant spring-inspired table of lily of the valley, hanging amaranthus, hydrangeas, vibrunum and moss is dramatically illuminated by an assortment of candles. To stimulate the senses, crystal bowls of water were filled with gardenias and floating candles, while richly fragrant blooming gardenia plants were placed under the table.

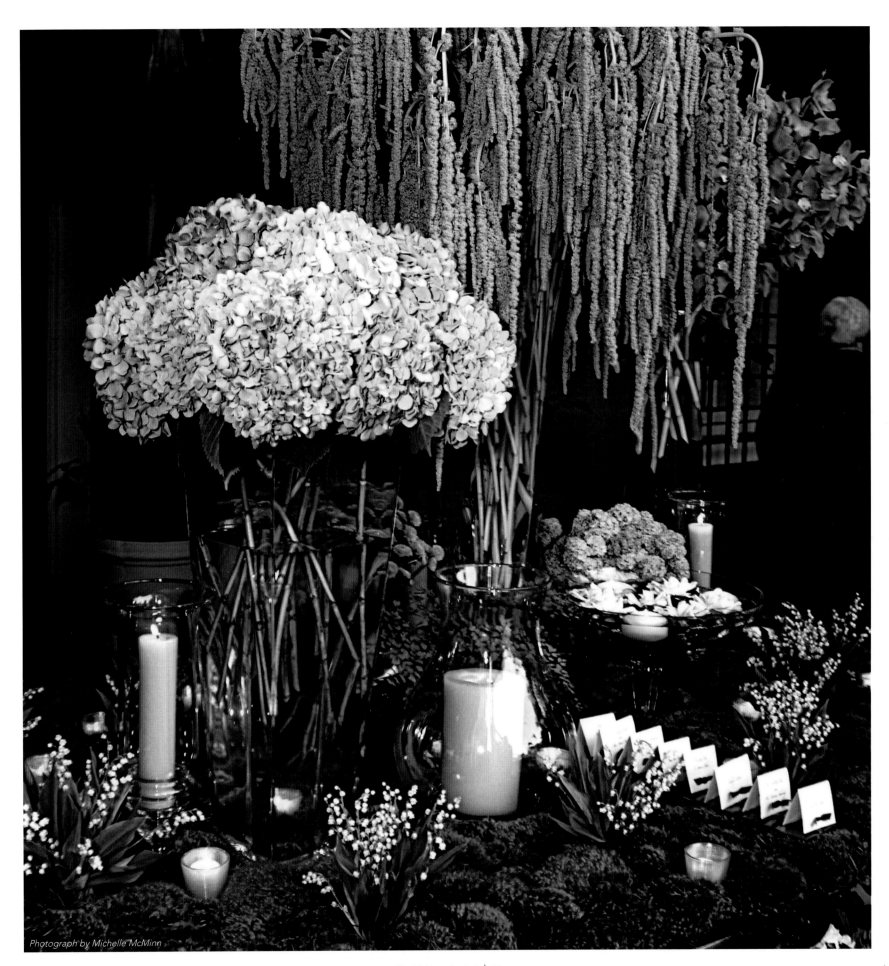

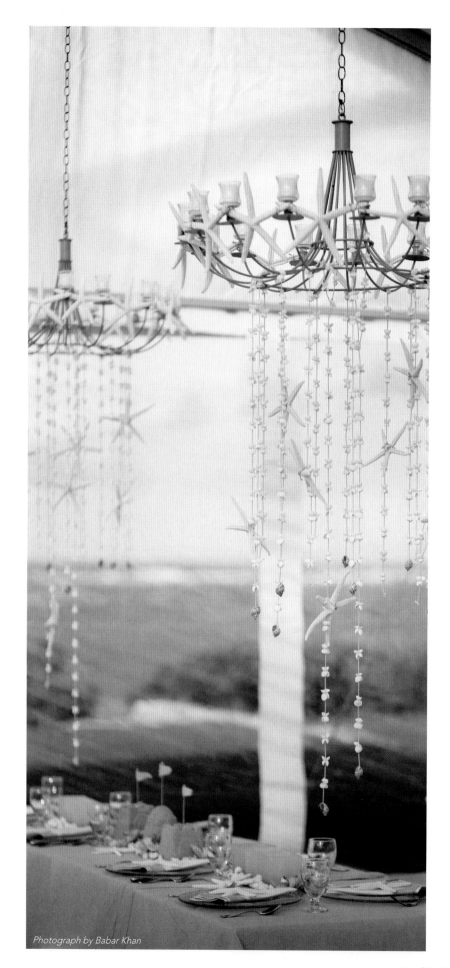

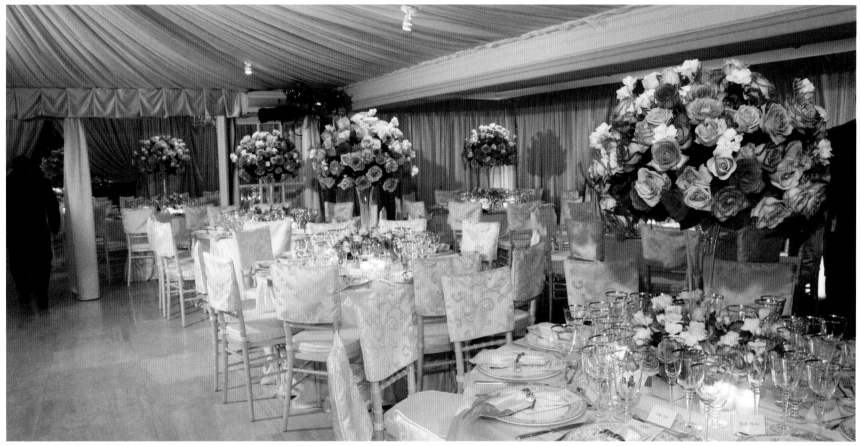

Photograph by Lucien Capehart

Above: I have been blessed in my business to have developed relationships with multiple generations of a family. A daughter hosted a 95th birthday celebration for her father at an exclusive private club in Palm Beach. The club was transformed into an elegantly tented atmosphere with soft lighting, beautifully draped fabric and lush floral arrangements. To create more guest space, an outside garden area was tented and draped with fabric to seamlessly incorporate it with the inside. Guests never felt disconnected from the rest of the party.

Facing page: The honest truth is that very few occasions go exactly as planned. The ability to adapt to any situation in order to achieve the end result is what really counts. Because this party destination was a private island in the Bahamas, everything had to come by boat, which was a challenge in itself. On the morning of the event, an incredibly powerful wind had us rethinking and redoing almost every element we had planned for the beachside celebration. We quickly changed the plan to fit the situation and the guests never knew the difference. Most importantly, the host was able to relax and enjoy the evening.

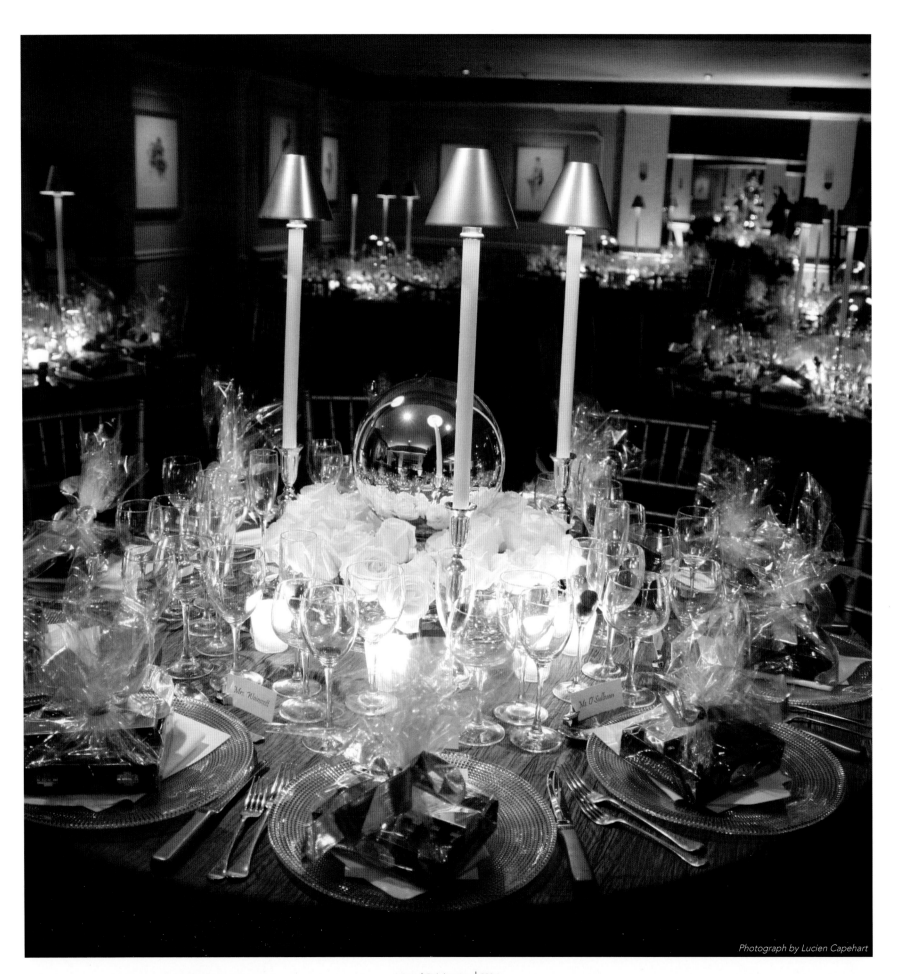

Photograph by Lucien Capehart

"Choose experts that you feel comfortable with, share your ideas and vision, and then turn them loose. In the end you will have the best event possible, because you hired professionals and allowed them to create!"

—Duane Murrell

Right: A gentleman wanted to host a welcome home party for a dear friend who had been away for almost a year. We chose red, a strong vibrant color, and then saturated the room with it. The effect was dramatic the minute each guest walked into the space.

Facing page: In honor of Club Colette's 25th anniversary, a very sophisticated and masculine atmosphere was achieved with dim lighting punctuated by candlelight, perfectly appointed fabrics and an impeccable tablescape. We used both votive and tall taper candles: The votives light up the table, stemware and flowers, while the tall tapers illuminate the guests' faces. Everyone looks fabulous in candlelight.

Photograph by Lucien Capehart

views

❖ Don't be afraid of color! Dramatic colors can illicit so many emotions.

❖ The right lighting is so important—dim the lights and light the candles.

❖ If you're at a loss for ideas, tablecloths, fabrics or flowers can be a source of inspiration for your event.

❖ Always remember what the day is really about; never lose sight of that.

MPS Light & Sound

JOHN DIDOMENICO

The product of a lifelong commitment to and passion for the theatrical and entertainment industry, MPS Light & Sound was incorporated by John DiDomenico in 1997. This niche company owes its success to the dynamic fusion of cutting-edge theatrical, entertainment and architectural audiovisual and lighting design.

As any designer or event planner will well advise, if you're going to focus on a few select areas, never ever skimp on lighting. The venue, décor, flowers, food, tables, dance floor, band and guests are literally in the dark until they are colored and textured according to the overall visual concept of the project. The choices of millions of hues and an unlimited palette of projected patterns must be narrowed into a single, elegant design solution. John prefers to blend classic theatrical lighting techniques with energy-efficient, infinitely variable digital lighting technology. Today's digital equipment uses only a fraction of the power of traditional lighting and contains no mercury. The advent of this technology has made it possible for MPS to apply theatrical lighting effects and techniques to permanent residential and commercial applications as well as special private and corporate engagements. John and his team never fail to impress with their flawless execution, whether commissioned for an intimate event, a themed dinner party, a packed stadium performance, a classic Italian villa or a 40-story building.

We feel fortunate to have the opportunity to be involved in unique, high-profile projects. For Affinity Entertainment's auction, we illuminated yachts, jets and classic vehicles and bathed the entire hangar in a deep, warm red.

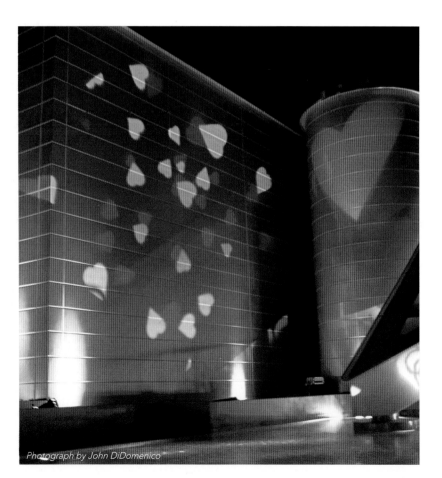

Celebrating a holiday or paying homage to what's going on in pop culture offers the opportunity to constantly surprise guests with visual imagery, color and movement. In these playful designs, we used LED technology and some time-honored theatrical techniques to transform the venue—give it distinctive personalities—and define the memory of the experience for guests. When we've done our job, everything feels right. From the subtle candle illumination of ornate florals to the contemporary dance floor draped in laser light and automated special effects, each element of the design serves a purpose.

"My fascination with the art and entertainment industry lies in the ability to induce an emotional response by employing creative audiovisual techniques."

—John DiDomenico

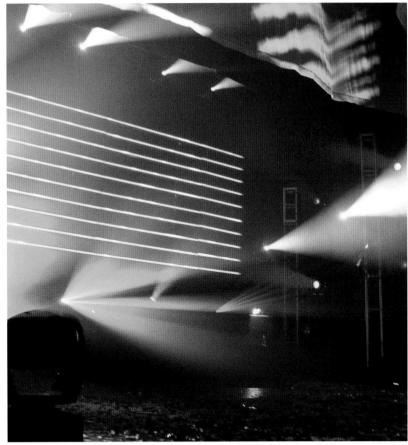

Photograph by John DiDomenico

Photograph by John DiDomenico

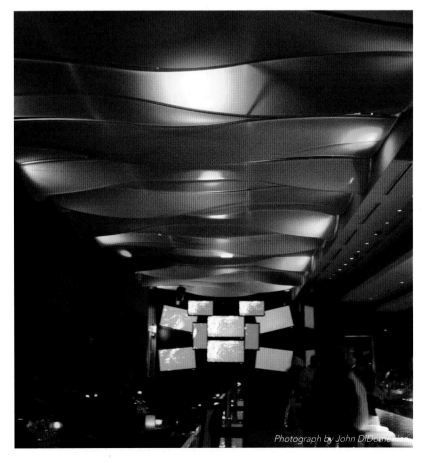

Photograph by John DiDomenico

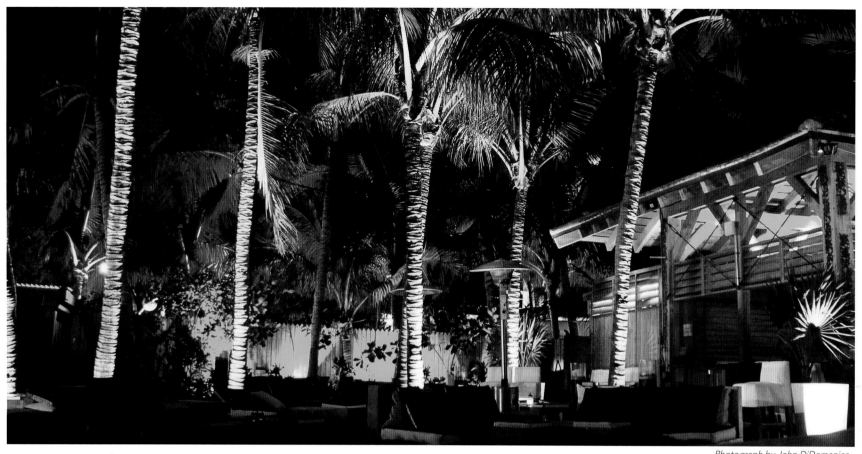

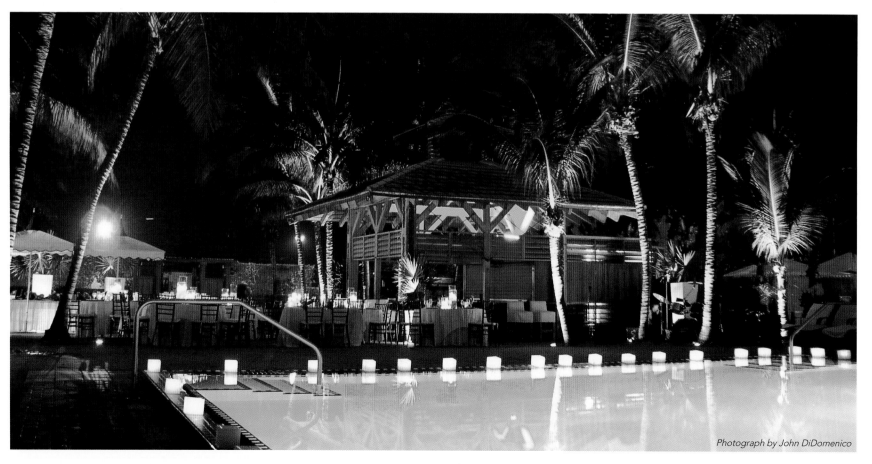

"Today's technology allows us to profoundly affect the viewers' experience through texture, color and intensity. Exploring those qualities of light has made for a very rewarding career."

—John DiDomenico

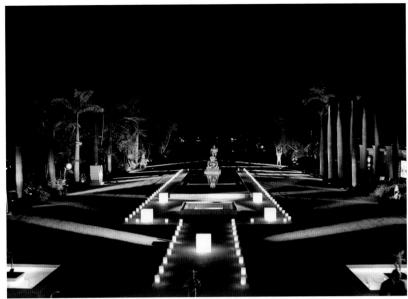

Photograph by John DiDomenico

Right: Two separate fashion shows for Armani illustrate a respect for the desired aesthetic, while simultaneously considering the existing lighting and architectural elements. Each venue inspires and influences the final design.

Facing page: The National Hotel South Beach's landscape and architectural lighting installation addresses everyday needs but is unquestionably SoBe when the party starts. The system is programmed to automatically start the show as the sun goes down.

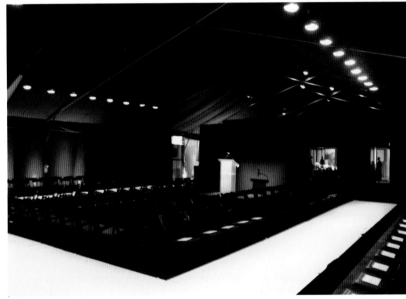

Photograph by John DiDomenico

views

❖ Properly integrated, audio, video, lighting and staging can inform, inspire and evoke every emotion. An event is an opportunity to create a moment in time to be remembered.

❖ There are three qualities to look for in any design team: an accurate understanding of the intended concept; detailed, realistic renderings of the design; and flawless, professional execution.

❖ Specialty architectural lighting systems can and should be far more than static, practical illumination.

TOM MATHIEU & COMPANY

TOM MATHIEU

As a young man, Tom Mathieu loved gardening and was fascinated by the natural beauty of flowers, so when an opportunity to work for a florist after college presented itself, he launched his design career. Flowers and plants have never failed to thrill Tom—the vast array of colors, graceful forms, leafy textures and intoxicating fragrances have captivated him. After college he co-owned a successful Palm Beach floral company for many years. In 1996 Tom established Tom Mathieu & Company: a floral design and special events planning enterprise that has become a Palm Beach institution. People in the know adore his signature approach to creating visually stunning party décor with a focus on flowers.

The undeniable power of flowers is felt at any event where Tom uses his inspired gifts. Whether for a hotel ballroom, an outdoor tent, private terrace or oceanfront home, he creates an elegant atmosphere using imported blooms gathered from top-tier growers in Europe, Asia and South America. Tom masterfully applies his imaginative skill, together with his honed sense of anticipating clients' needs, desires and budgets, to create upscale events. The designer's air of calmness attracts those planning annual charity galas, weddings and high-profile parties; his peaceful demeanor conveys an intense professional passion and perfectionism. Tom's experienced staff assists throughout the creative process with expert personal service to ensure that everything goes according to plan. But it is the boutique studio on fashionable Worth Avenue that attracts new visitors to Tom's unique style. The designer envisions the most breathtaking social and corporate affairs with his award-winning ideas, meticulous attention to detail and gracious guidance.

Fiery flowers, exquisite china and color-rich table apparel echo the look of designer Christian Lacroix; we created the fashion-inspired tabletop ensemble for a Norton Art Museum fundraising event. Exotic orange calla lilies, amaryllis, tropical mangoes and Indonesian starfruit fill metal urns to create a lush look of bright colors and beautiful textures mirroring the layered textiles.

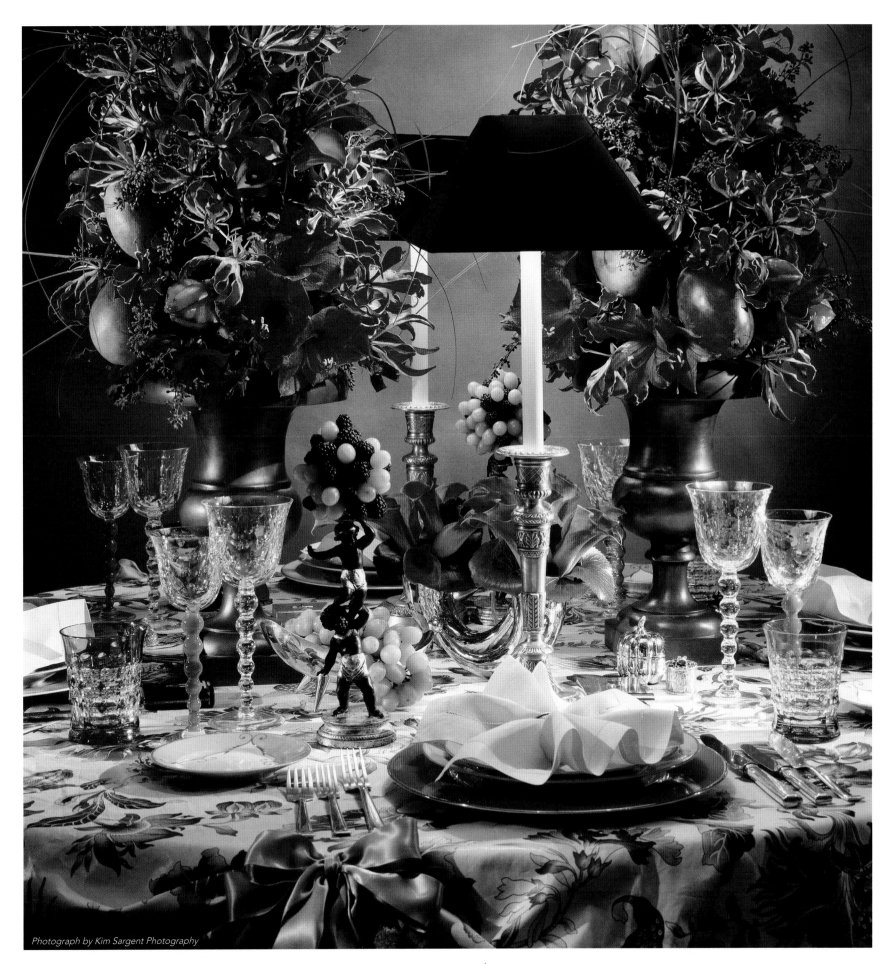

Photograph by Kim Sargent Photography

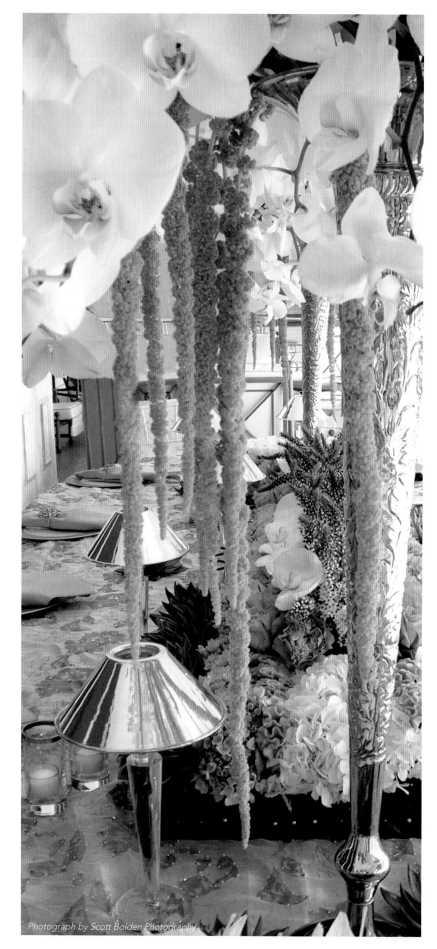

Photograph by Scott Bolden Photography

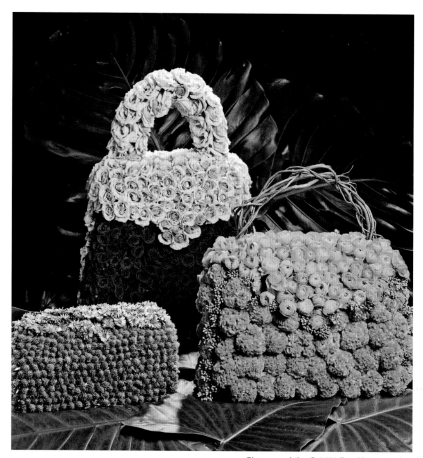

Photograph by C.J. Walker Photography

Photograph by C.J. Walker Photography

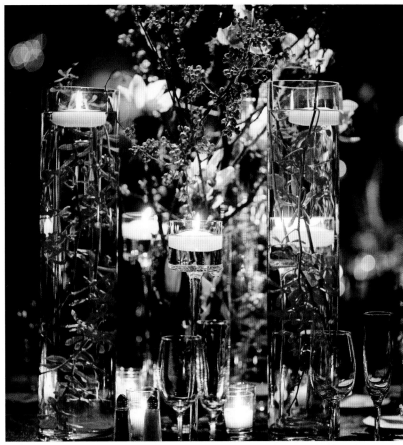

Above: Autumn floral accents and chocolate brown ribbons transform a pure white fondant cake it into a work of art. My lively mélange of votive candlelight and clear vessels with orchids and bittersweet branches form mesmerizing centerpieces.

Facing page left: Lavish white orchid bouquets with flowing green amaranthus were placed in etched silver trumpet vases for garden elegance. Succculents, green roses, white hydrangeas and veronica florets embellish the geometric base. Custom tablecloths made of sheer layers are dotted with pearls and rhinestones to glitter in the moonlight.

Facing page right: We created pavé arrangements of coveted Lana Marks handbags for the designer's Palm Beach store grand opening. Eye candy for the fashion forward, the floral interpretations showcase sweetheart roses, yellow cockscomb, silver-tinted thistle, blue delphiniums and button chrysanthemums—just a few of the tiny blooms used to recreate her sculptural handbags.

"When you approach an idea or color scheme with a fresh perspective, you'll create a fabulous event."

—Tom Mathieu

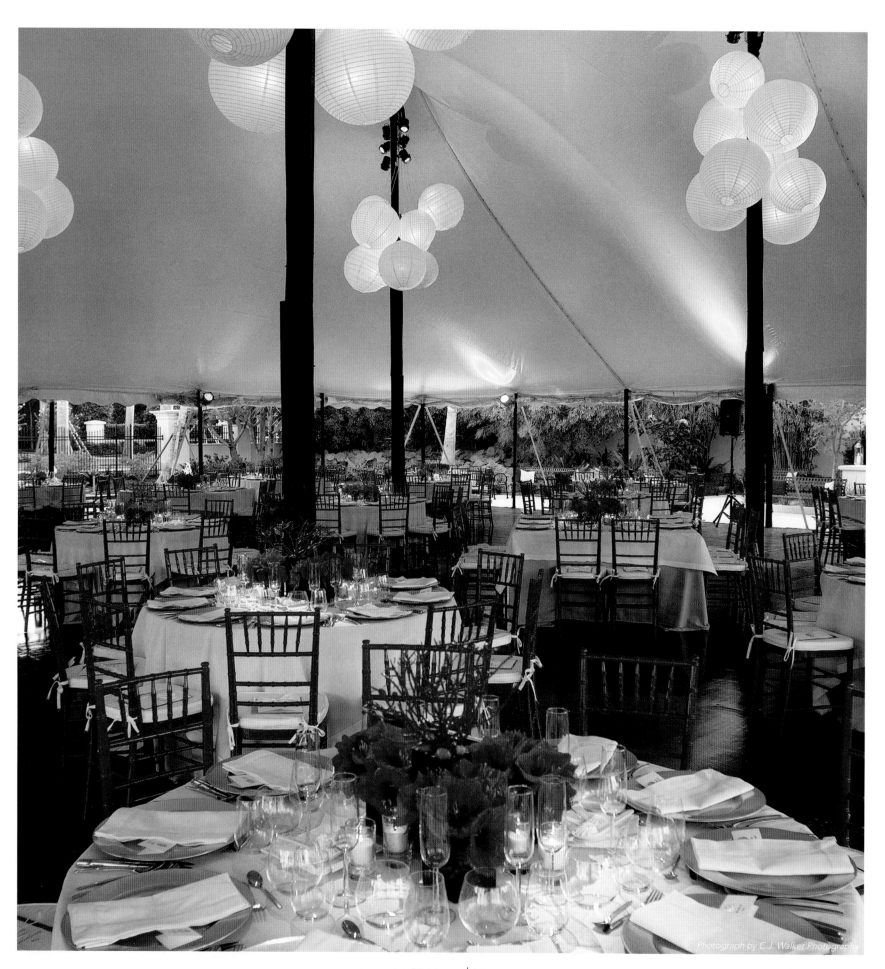

Photograph by C.J. Walker Photography

"Minimalist or over-the-top, good floral design sets a mood that lasts long after the party."

—Tom Mathieu

Right: First impressions are exciting. The summer tent venue has a Moroccan influence with its tropical color palette of fuschia and orange fabric, gilded Chiavari chairs, ethnic lanterns and brilliant bougainvillea vines spilling from four-foot-tall custom iron stands. We hung jeweled Moroccan slippers from the floral arrangement and gave them as mementos.

Left: On the manicured grounds of The Society of the Four Arts, we anchored a tented pavilion with black wood flooring and bamboo-wrapped poles lighted by clusters of paper Japanese lanterns. Red-lacquered Chiavari chairs complemented the coral-inspired centerpieces adorned with red amaryllis. Hand-stitched linens with gold table appointments dressed the night in luxury.

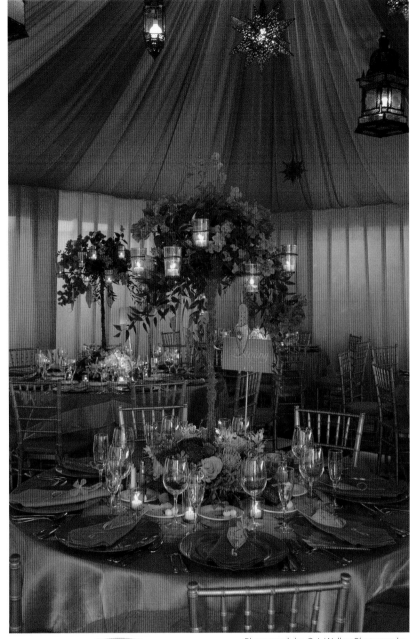

Photograph by C.J. Walker Photography

views

Be sure to consider the overall design of the room in every last detail. Fresh flowers are only one part of an event, albeit they set the mood. Tabletop décor, furniture and lighting should have a unified design in terms of color and theme. Sometimes less is more, so remember to have the finest flowers and décor elements, as superior quality and originality impresses guests most.

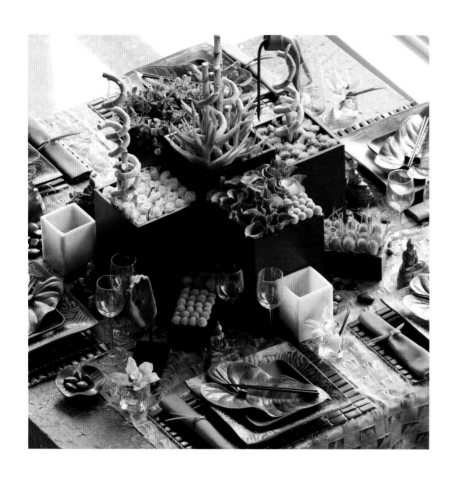

Eat, Drink &

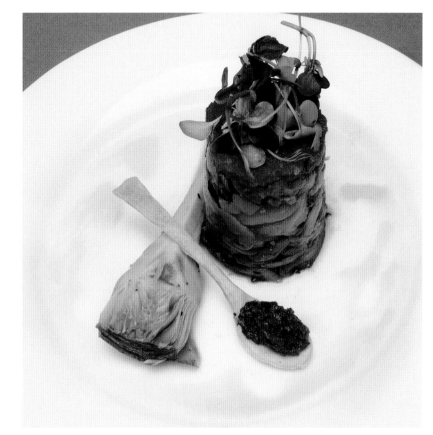

Be Merry

A JOY WALLACE
CATERING PRODUCTION & DESIGN TEAM
JOY WALLACE

The sparkling passion of entrepreneur Joy Wallace is phenomenal. She infuses her dynamic catering and design team with an effervescent spirit surrounded by love. Founded in 1988, A Joy Wallace is comprised of more than 45 top professionals and has grown to become one of Miami's most reputable off-premise catering production and design companies. Twice honored with national acclaim as "Caterer of the Year" by *Catering Magazine* and *Event Solutions*, Joy's creative team annually designs, prepares and serves more than 300 elite events, including private social parties, significant corporate events and fundraising galas. Whether catering in sizzling Miami or haute Palm Beach, the vibrant Florida Keys or chic Naples, this talented team is in demand for what they do best: prepare and present festive cuisine for South Florida's most celebrated events.

Joy's fabulous gourmet fare is not only visually exciting but a gastronomic delight. Award-winning chef de cuisine Elgin Woodman, alongside creative director Richard Randall, orchestrates some of the finest, most original food and decorative presentations ever tasted or seen. Themed party menus, regional Latin flavors, decorative hors d'oeuvre and sampler creations, multicourse continental dinners and exotic desserts are in their repertoire. New artistic décor expressions with taste bud-awakening dishes are whipped up in their combined kitchen-design space that occupies an immaculate and organized 25,000-square-foot facility. Flawless execution has become the firm's hallmark, and Joy's tenure in hospitality management ensures a successful and satisfying experience for clientele. Her brilliant catering production and design family rises to the occasion every time, tapping their vast collective knowledge and experience to create deliciously unforgettable events.

Eye-catching presentation of food is our forte. We designed an environmental green theme blending natural bamboo and wood vases, tropical leaves, miniature flowers, river rocks and eco-friendly wax lanterns to create a tablescape of elegant sophistication. Spiritual touches of symbolic mudras and Buddhas grace the setting in thankful meditation.

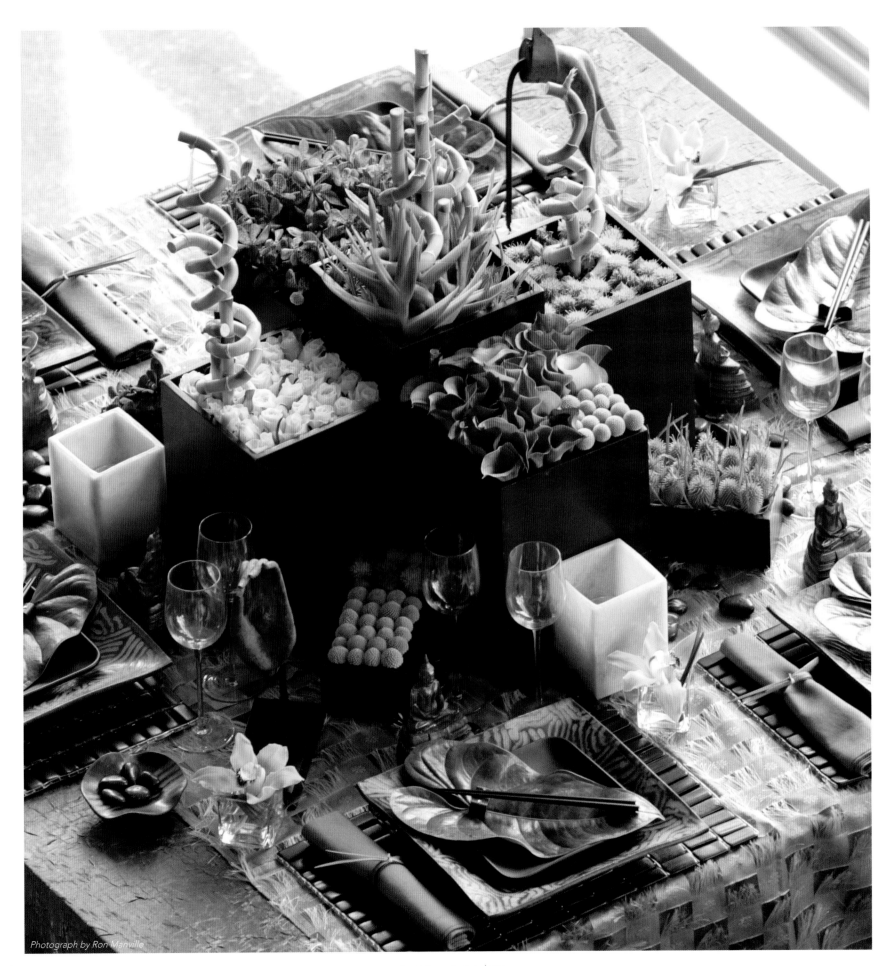

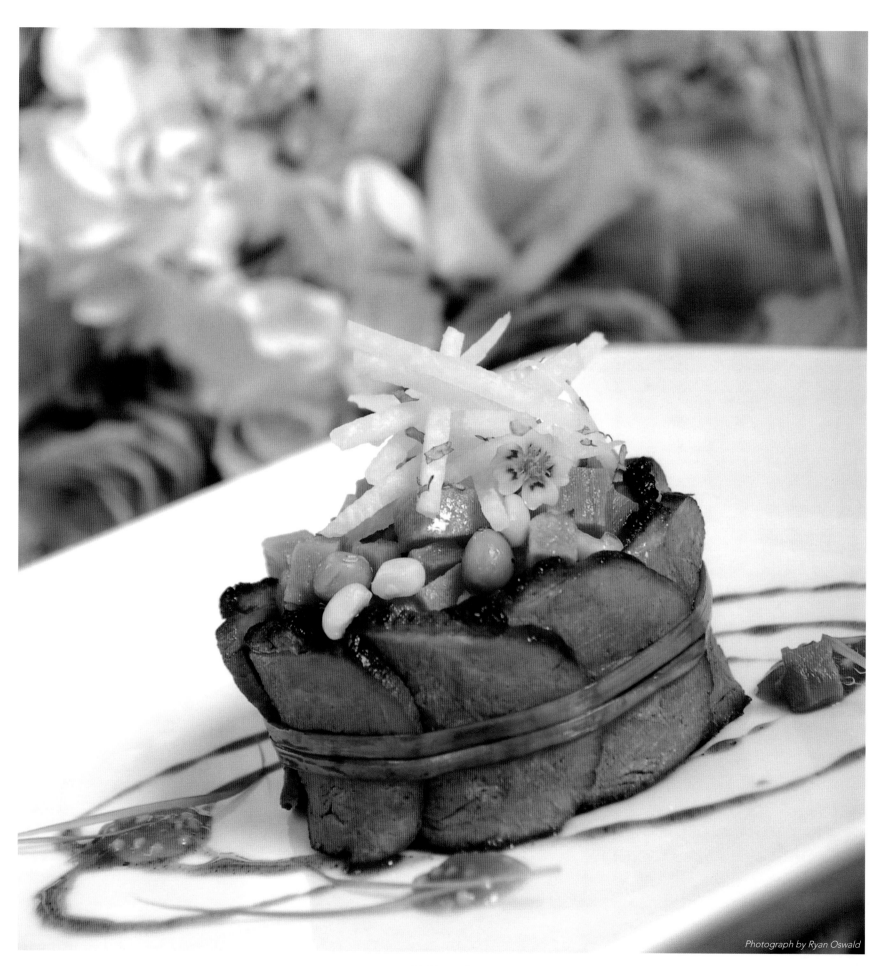

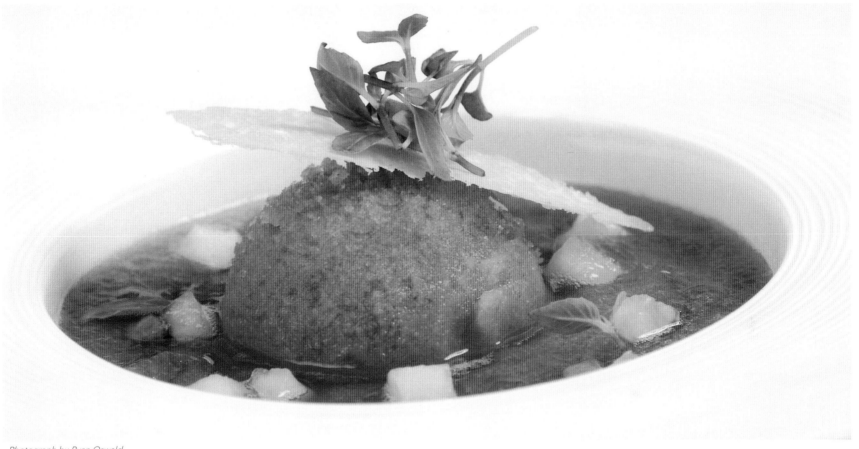

Summer luncheons should go beyond the usual chilled salad or entrée. Light and delicious, smoked-and-rubbed seared duck wrapped around a vivid summer vegetable hash offers a sweet, stone fruit jam and savory spice flavor combination. Colorful, chilled cantaloupe soup with ginger-watermelon sorbet features watermelon and honeydew garnish drizzled with a French vergus reduction and basil oil. We strive to create exciting new tastes presented in unexpected ways.

"Refreshingly creative ideas and beautiful fare give a big first impression."

—Joy Wallace

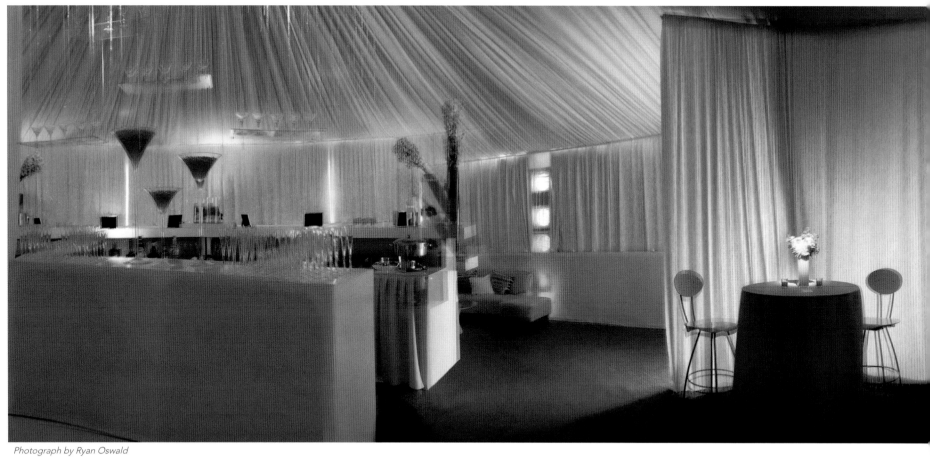

Photograph by Ryan Oswald

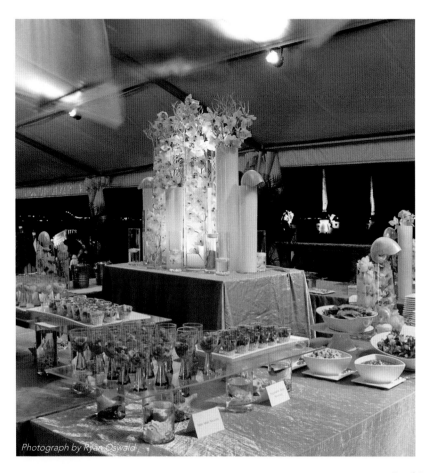

Photograph by Ryan Oswald

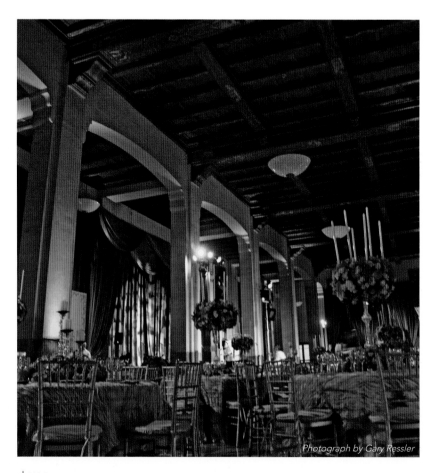

Photograph by Gary Ressler

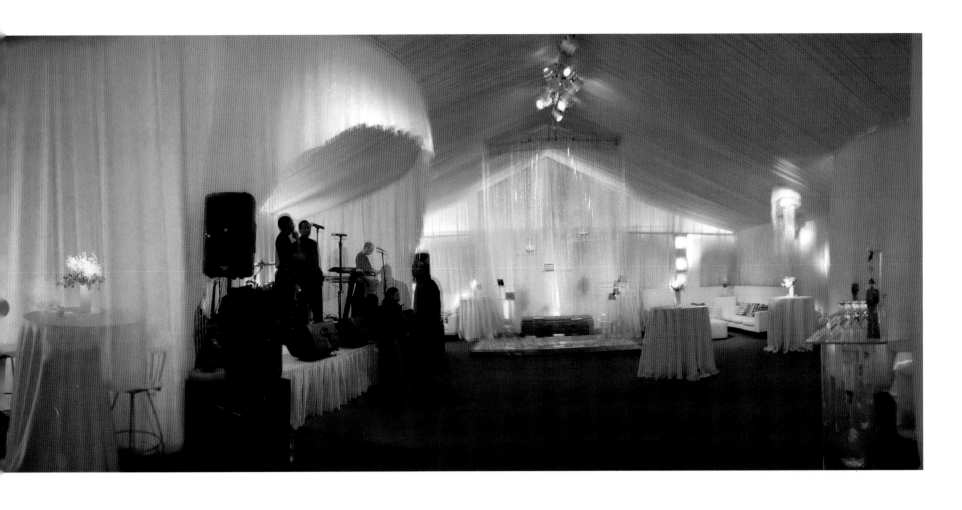

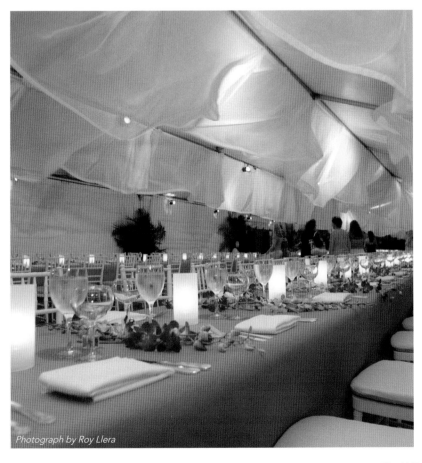

Photograph by Roy Llera

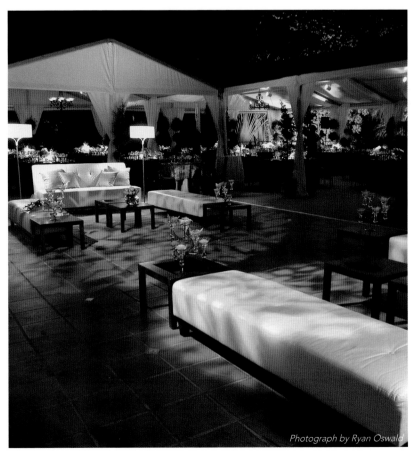

Photograph by Ryan Oswald

Above & facing page: We love it when clients rely on us to create something novel. Our dramatic, molecular gastronomy-inspired dessert station provides an interactive experience for guests. Italian tiramisu tartofu is plunged into a Nambé bowl of liquid nitrogen, and then dipped in chocolate, to instantly form a frozen shell. The wow factor explodes even further with hand-torched, skewered chicken filets and beef medallions. Guests "paint" with sauces, mustard glazes and chutneys using small artist brushes for customized taste sensations.

Previous pages: Food presentation is an art for all to enjoy. When hosting an industry conference or any large party, we approach the décor design to complement the food presentation and create a total dining experience. Lighting, draperies, bar vignettes and elaborate table settings create a mood. Venue designs that showcase beautiful food with style have great impact, entertaining guests down to every last detail. Because we have catering and design capabilities, we seamlessly provide the best of both worlds.

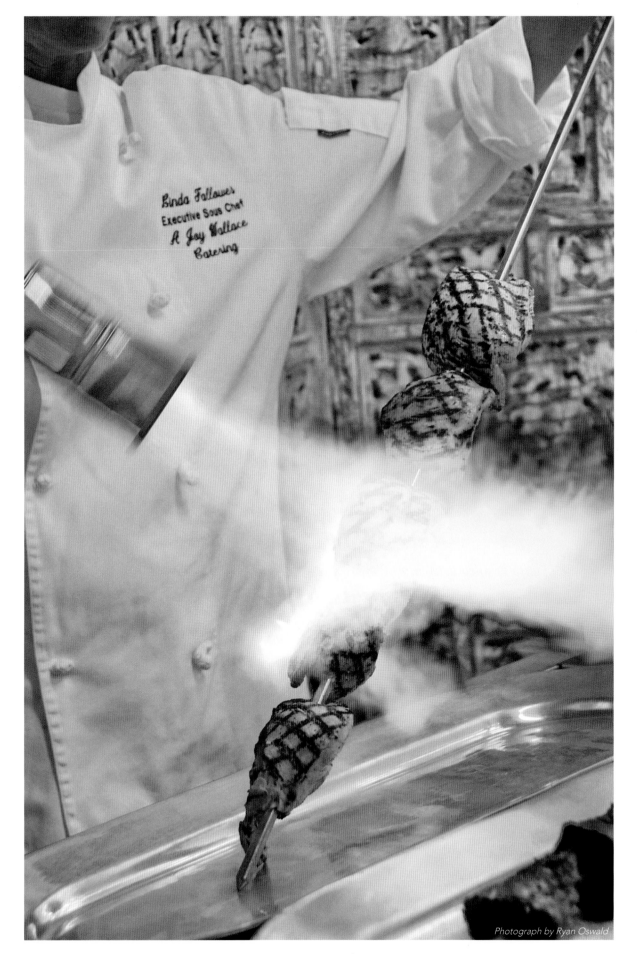

The embroidery on the chef's coat reads:

Linda Fallowes
Executive Sous Chef
A Joy Wallace
Catering

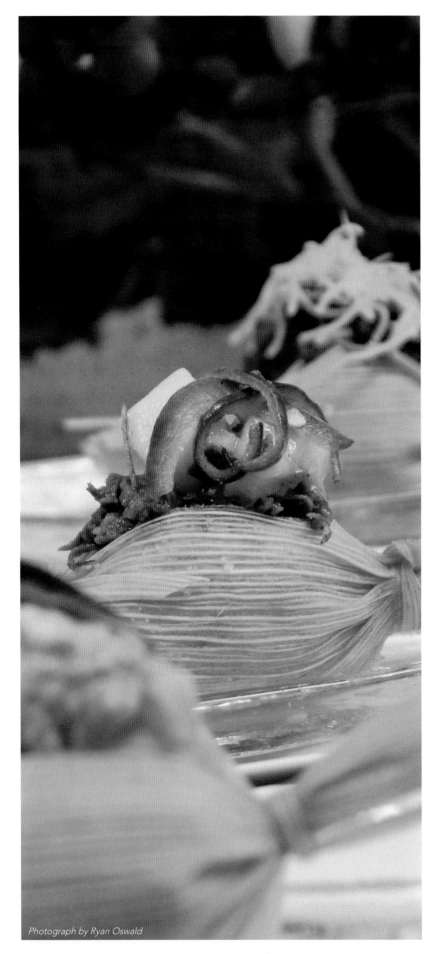

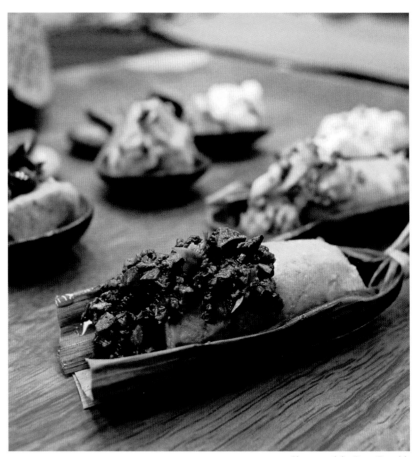

Photograph by Ryan Oswald

Above: Creativity is a secret to party success. An outdoor luncheon menu ends with a twist on a classic sweet confection. S'mores may have first been enjoyed around a campfire, but our fantastic interpretation takes the humble treat to new heights. Chef Elgin's cubed marshmallows are tinted with red raspberry, strawberry and cherry essence atop a graham cracker cookie; guests can toast them and dip in melted dark chocolate for delicious fun.

Facing page: The exciting Latin influence found on a Joy Wallace menu is a culinary trend that extends beyond culturally diverse South Florida. This lively food with extra flair will leave guests wanting more. Cocktail-size sweet potato and corn tamales fill husks and cilantro tamales with olive tapenade sit inside banana leaf boats served on wooden platters. Our signature banana bread pudding is a decadent blend with banana liqueur and Kahlúa, covered in vanilla bean crème anglaise. To accent the luscious dessert, a plantain chip dipped in dark chocolate is adorned with 24-karat edible gold dust.

"It's all in the details. Guests should anticipate edible wonders of style and taste."

—Joy Wallace

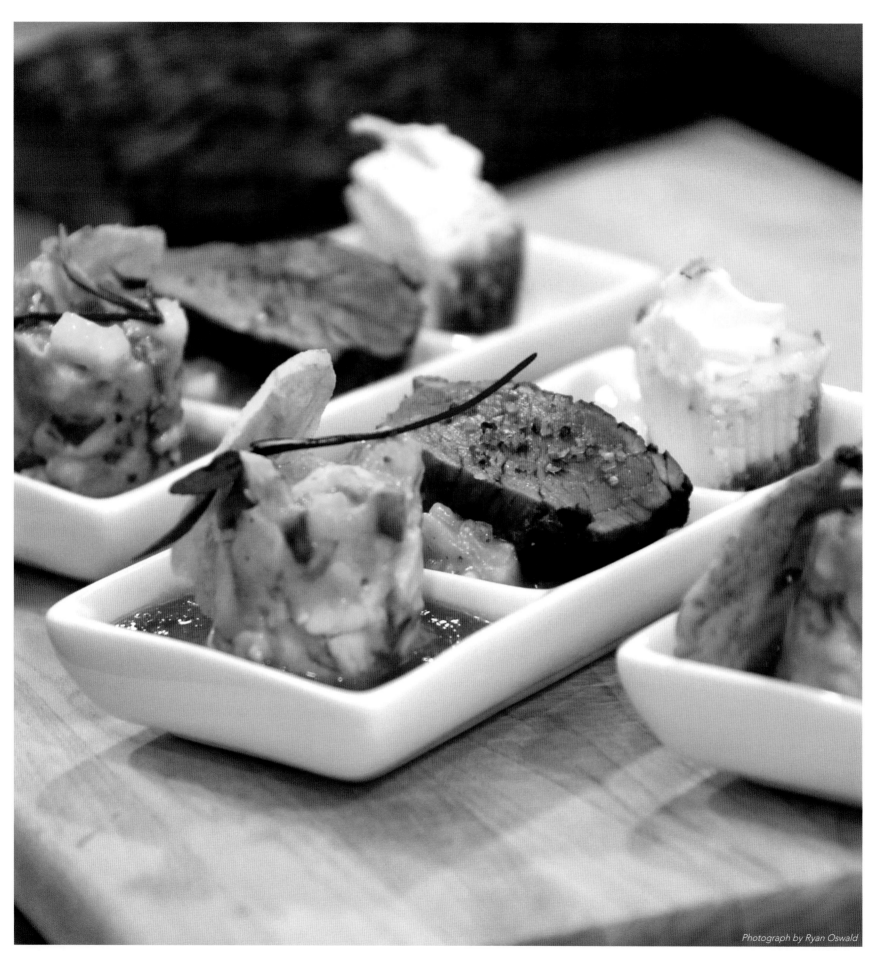

"Special events deserve creative fare to tempt the palate and delight the senses."

—Joy Wallace

Right: Our chef presents cilantro-poached shrimp with avocado relish on tiny cocktail forks for easy-to-maneuver individual servings as the tray is passed across the crowded room. Any affair can take on an elegant air when the details are thoughtfully planned. Butlers immediately collect forks from guests to keep things tidy. Service should include expert food preparation and delivery, plus equipment set up with spotless creative presentation for an effortless event.

Facing page: When cocktail parties call for more than mere canapés to sustain guests, we create our seated meal sampler to satisfy hungry partygoers. Avocado and corn timbale, filet mignon on saffron risotto and tangy key lime pie are displayed on sectioned ceramic ware. Portable and chic, finger food can be satisfying and presented just as sumptuously as a formal dinner.

Photograph by Kristina Raines

views

Visit the kitchen facility before you decide on a catering-design team. Inspect the work space to be sure it is clean and organized. Make sure the cooks and designers feel as passionate about the event as you do. Your affair has to be spectacular because it's a reflection of you. Whether for a lavish wedding, family bar mitzvah, annual company event or charity gala, the design, food presentation, taste and safety can make or break your event.

CHRISTAFARO'S CATERING
DOREEN ALFARO

Fresh—it's a concept that pervades every aspect of Christafaro's Catering. For nearly two decades, founder Doreen Alfaro and her dedicated service staff—many of whom have been with Doreen for close to 10 years and refer to themselves as "Christafarians"—have delighted party throwers and goers with their culinary prowess and unparalleled service.

Determined to provide the highest-quality, freshest food available, Chef Jim Mandio carefully selects the finest ingredients—locally grown, when possible—to create custom menus for all walks of events. Signature homemade hors d'oeuvres, sauces and desserts along with fresh interpretations of classic dishes comprise Christafaro's delectable repertoire.

No doubt the food alone could build the insanely loyal following Doreen and her team now enjoy—but Christafaro's' dependability, attention to detail and conscientious waitstaff complete the package, ensuring that the entire experience is as memorable as each bite.

Doreen's clients range from Neiman Marcus and the Palm Beach Symphony to brides whose bat mitzvahs she catered 18 years prior and charities with strict budgetary limitations. Regardless of the event's scope, the Christafaro's team consistently delivers the finest foods, creatively executed and flawlessly presented.

"Fresh" is the operative word when we interpret clients' menu choices. Our goal is to present classic ingredients in exciting and innovative ways. Antipasto salad takes on a whimsical quality when rich, colorful vegetables are stacked and served with a tapenade-filled edible spoon.

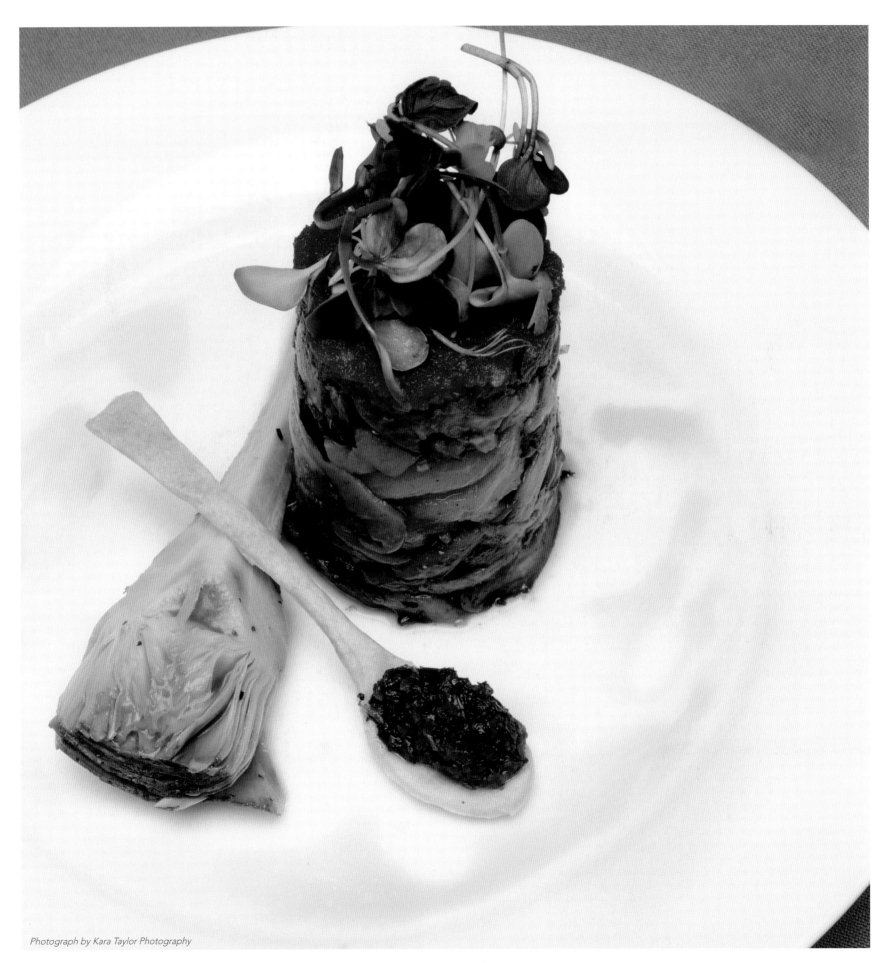

Photograph by Doreen Alfaro

Photograph by Kara Taylor Photography

Photograph by Kara Taylor Photography

Photograph by Kara Taylor Photography

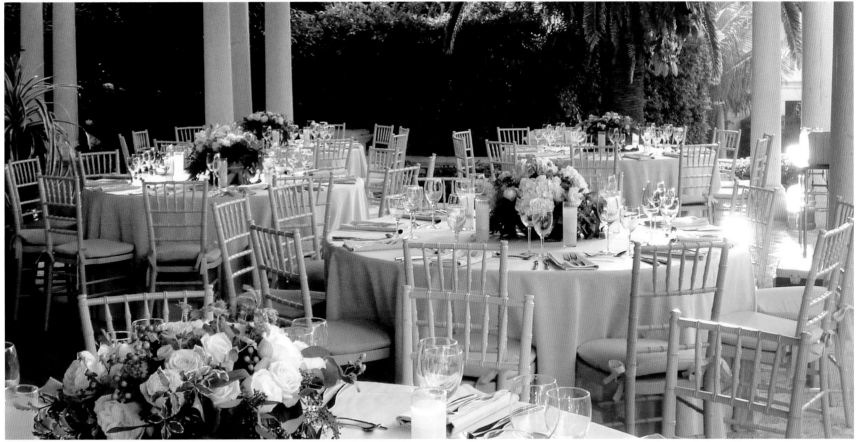

Photograph by Doreen Alfaro

Setting the scene for a buffet or plate service is essential to a party's success. The client should be a primary player in this process, and everyone involved must collaborate to bring the client's vision to fruition. When you've got the right team, it's easy.

With so many repeat clients, we always strive to create the element of surprise. Changing the vessel or using a unique ingredient can turn a familiar hors d'oeuvre or entrée into a sensual celebration. Whether it's serving caviar on handmade corn Madeleines amidst fragrant lavender salt, transforming duck with a wild cherry sauce, rolling baby portabella mushrooms into cigars served in antique ashtrays with lava salt "ash" or turning a vegetarian plate into a colorful, sculptural napoleon, we revise our menus to keep guests'—and our own—interest.

"In this industry, you have to be prepared for change at any moment."

—Doreen Alfaro

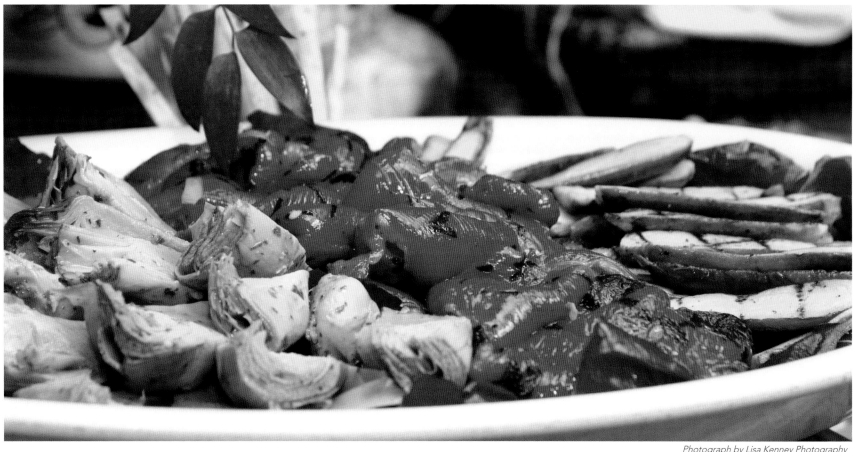

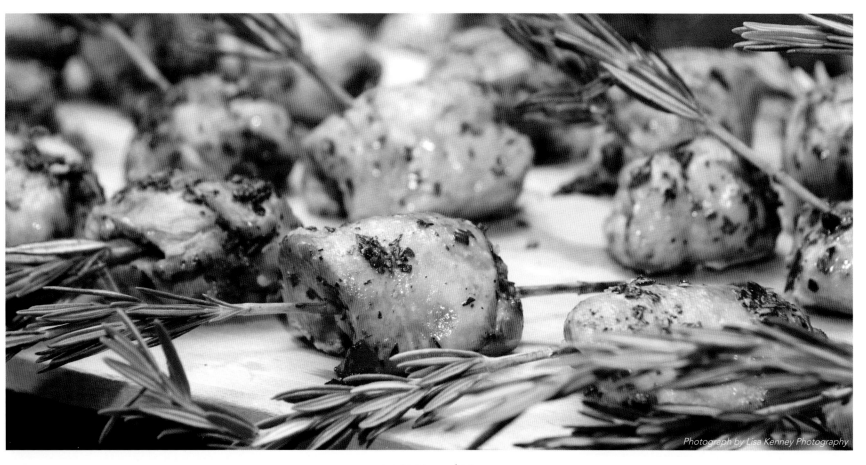

> "It's our job to make every event spectacular, no matter what the budget."
>
> —Doreen Alfaro

As caterers, we are presented with unique challenges. Food not only must be artistically displayed, but also must be the right temperature and size—and of course it must taste great. At our buffets, you'll never see chafing dishes; we set serving platters on glass blocks above direct heat. This preserves the sanctity of both presentation and taste. Properly sized hors d'oeuvres and clever serving solutions are key to throwing a great cocktail party. Elements such as rosemary-sprig skewers for chicken and petite wooden forks used to serve sausage-stuffed cherry-pepper lollipops provide both function and fun.

Photograph by Lisa Kenney Photography

views

❖ When planning a cocktail party, it's all about time! Cocktail parties should end no later than 8:00 so guests can still have dinner.

❖ Food should not be hidden. We like to serve sauces on the side of or beneath an entrée so the ingredients take center stage.

❖ Part of what makes Christafaro's successful is that I am highly visible. Clients appreciate that I am available and attend their events. It's a big part of why they keep coming back.

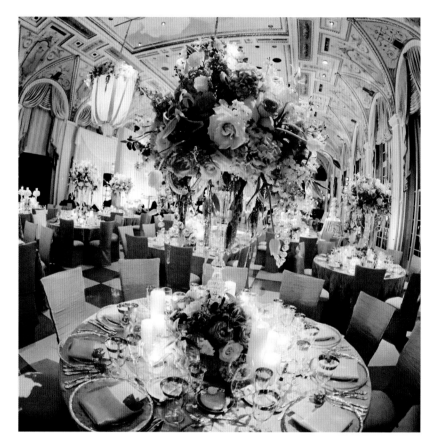

Capturing the

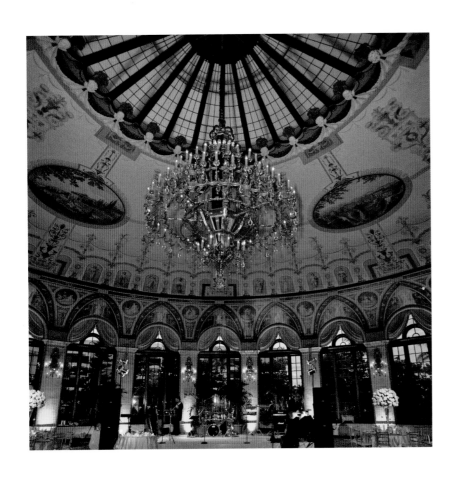

Moment

Donna Newman Photography

DONNA NEWMAN | IAN MCGAFFIC

Every photo tells a story. Upon glancing at a prominently placed photo or opening a special album, you should be transformed into that moment in time, into that especially personal story. Life is filled with wonderful celebrations; Donna Newman Photography captures the events that make up our lives.

This Vancouver native knows a thing or two about photography—from behind the camera and having once been its focus. A former Ford model, Donna became very familiar with the flexibility, glamour and style of fashion photography. Inspired by the artistic beauty of photography, Donna decided to turn the camera around over a decade ago. And another big move was still in store: Donna, along with husband and business partner Ian McGaffic, relocated to Miami to further grow their business.

As bold and fresh in her photographic philosophy as in life, Donna approaches her work from a cinematic perspective. She feels events are like movies and her shots must follow in the tangible still life. Never contrived or formulaic, Donna and Ian's journalistic shots allow the spirit of their subjects to be the soul of the photo, and the moments to unfold naturally.

A bird's-eye view of a grand room illustrates the magnitude of the event. The warmth of the photo and the golden hue of the ballroom make a cohesive shot.

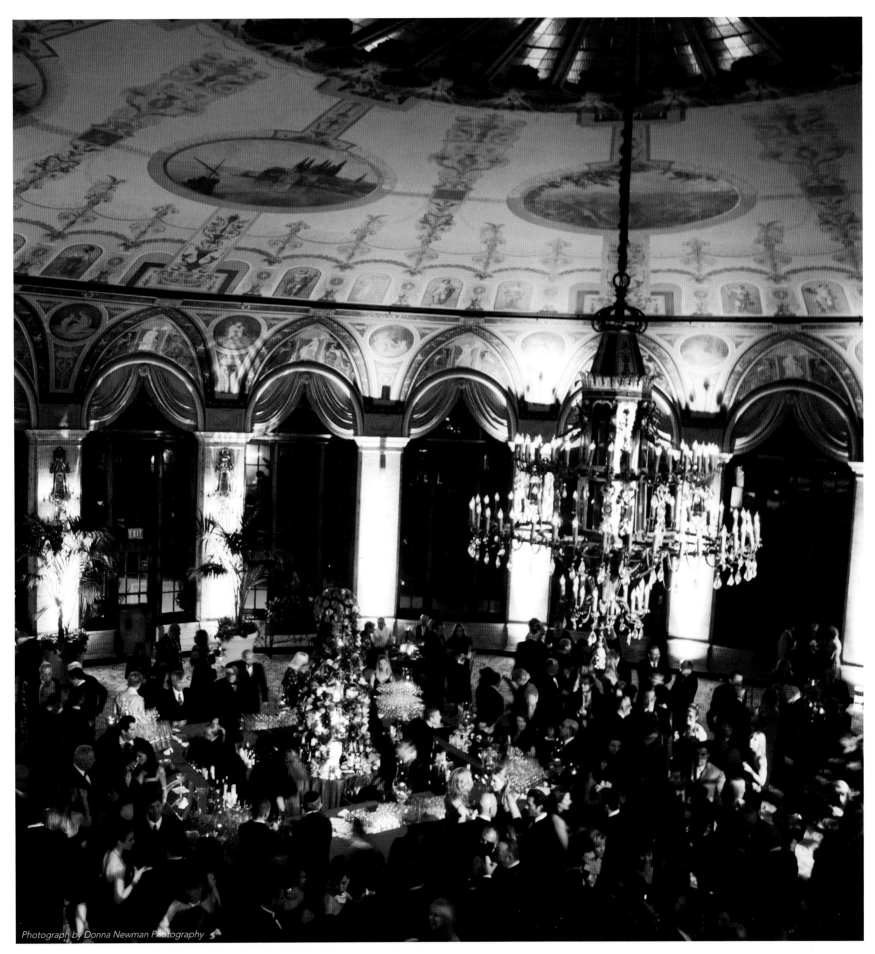

Photograph by Donna Newman Photography

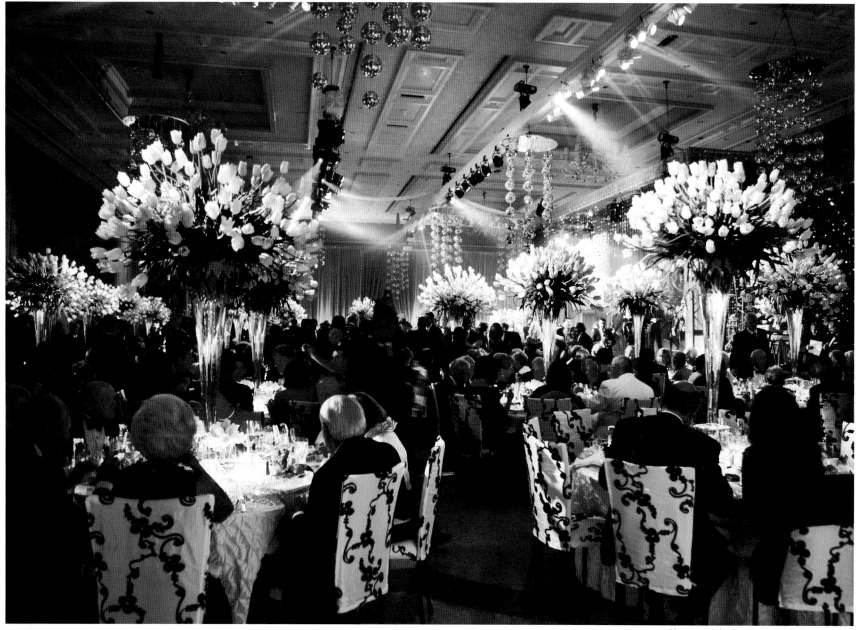

Photograph by Donna Newman Photography

By blurring out the background and focusing on certain aspects of a scene, an entirely new tone is created. The gorgeous floral arrangements are the commanding stars of a wonderful party in which the hosts celebrated nothing specific, just a blessed life filled with cherished friends and family. A large shot with soft-focus background emphasizes the fun, lively disco balls that worked to energize the feeling of the night.

Photograph by Donna Newman Photography

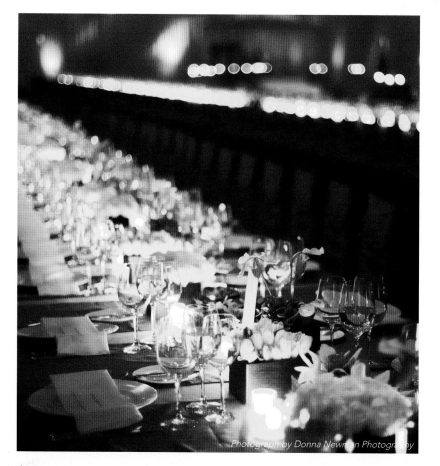

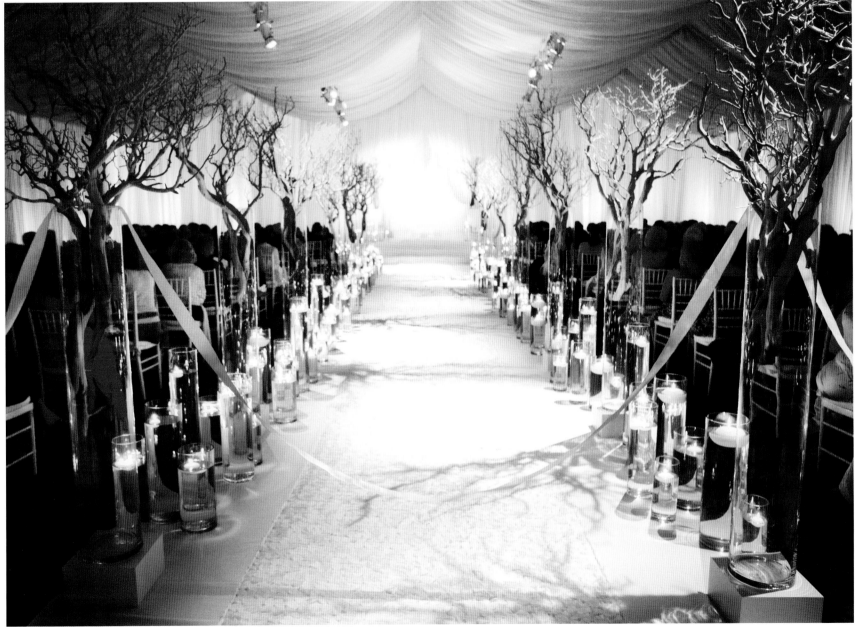

Photograph by Donna Newman Photography

Ambient lighting adds high drama to memorable occasions. Obviously the type and amount of light is critical to either challenge or harmonize a photographer's work. Shooting with long exposure on a tripod picks up all the available light, creating a beautiful warm glow in each scene. No flash is used, which increases the contrast and captures the event the way the human eye saw and will remember it. Where there is interaction, you have to be able to almost feel the movement in the photo, feel as if you are actually witnessing the champagne glasses clinking together.

"There should be feeling in every photo, whether it is the spirit of the subjects or the energy of the room."

—Donna Newman

"Our purpose is not to affect the day, but to record it."

—Donna Newman

Right: It's always important to capture a few breathtaking "product shots" of a space before the guests arrive. A holistic feeling is achieved by viewing the beautiful fuchsia-hued and mysteriously lit room. Often the hosts are too busy to take the opportunity to enjoy the room in this manner and particularly appreciate this photo. In this case, it is also important to have two photographers at an event. While I might be shooting behind the scenes, Ian is capturing the stunning view of the room before the event gets started.

Facing page: Drawing from my experience in fashion photography, black-and-white photography is always classic and eternally beautiful. When color is removed, the focus is solely on certain details including facial expression. Small elements are picked up in black and white, whereas they might have been overlooked in color.

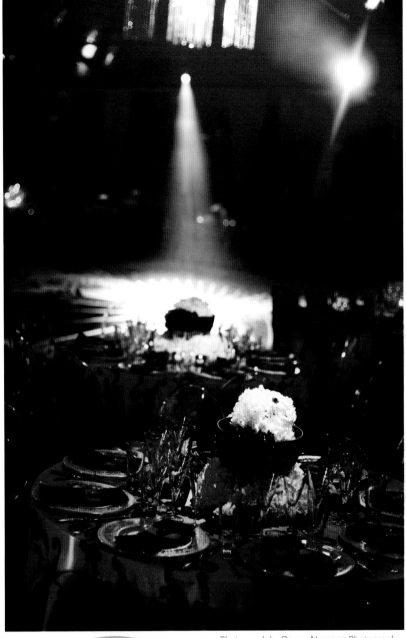

Photograph by Donna Newman Photography

views

❖ Find a photographer who lives and shoots in the moment. It will be obvious by his or her photography.

❖ You will know whether you have chosen the right photographer for you by the immediate feelings and emotions his or her photography stirs within.

❖ Fall in love with the shooting style of your potential photographer. What you see is what you will get.

Town & Country Studio

PATTY DANIELS

Who said you can't turn a creative passion into an amazing career? Patty Daniels did just that with Town & Country Studio. Her photographic talents have given her the opportunity to meet wonderful, interesting people across the country and capture some of the most magnificent events of our time. Patty is definitely a people person with a keen sense for style and elegance. Her ability to position her subjects against the ideal backdrop of architecture or terrain is intriguing. Instinctually, she sees the big picture of each event while capturing the tiniest of details. She's the kind of photographer who, as a colleague once described, "would hang from a chandelier if a shot required it." But Patty isn't obtrusive, she just doesn't wait around for special moments to happen—she seeks them out. She attributes her tireless energy to her desire to give the very best and exceed all expectations.

Early in her career, Patty set her sights high to learn from and be mentored by the best. Over the past several years, she has collaborated with other highly skilled photojournalists on events, and she trains her Town & Country Studio photographers with the same philosophy. Patty is a spiritual person who celebrates their successes, promotes their talents and pushes them to achieve all of their goals. Patty values each of her photographers as they contribute their creative perspectives to produce comprehensive and artful documentaries. Every album reads like a motion picture of the day—not just a collection of isolated images and poses. Her studio encompasses corporate and private events as well as portraiture, documentary photojournalism, fine art and editorial.

Being at The Breakers Palm Beach is an amazing and unforgettable experience, a photographer's dream. The architecture is world-class, the ballrooms are magnificent and affairs held there are sure to leave a lasting impression.

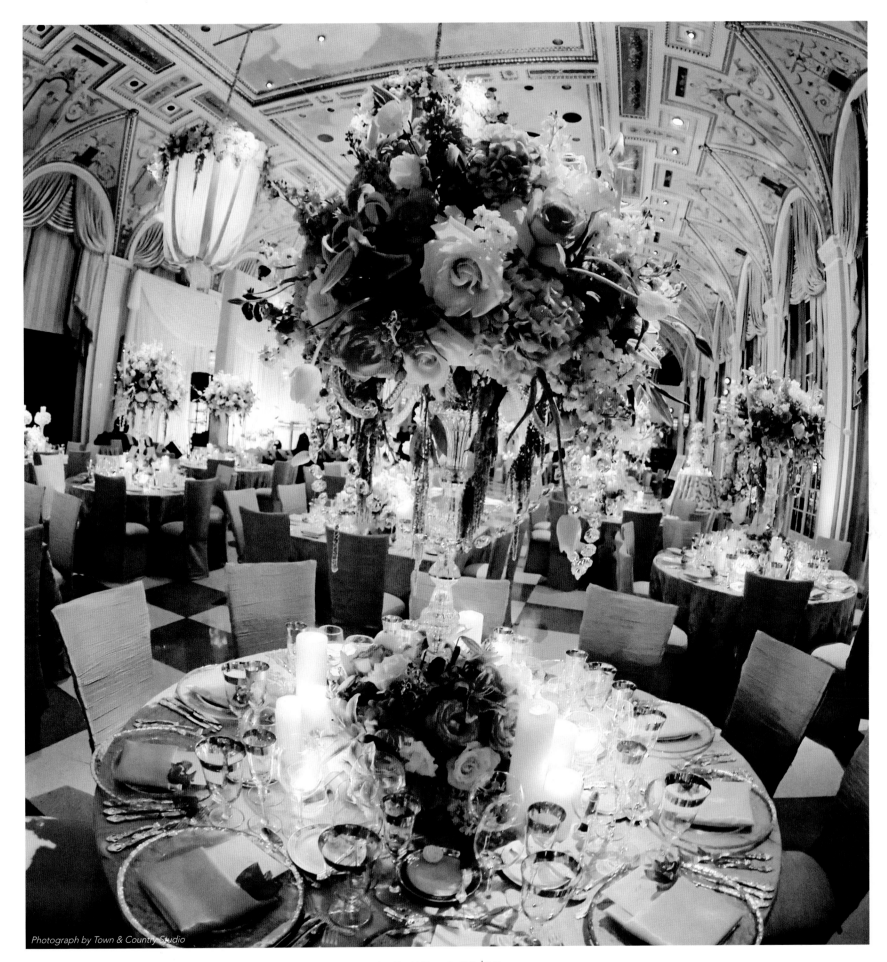

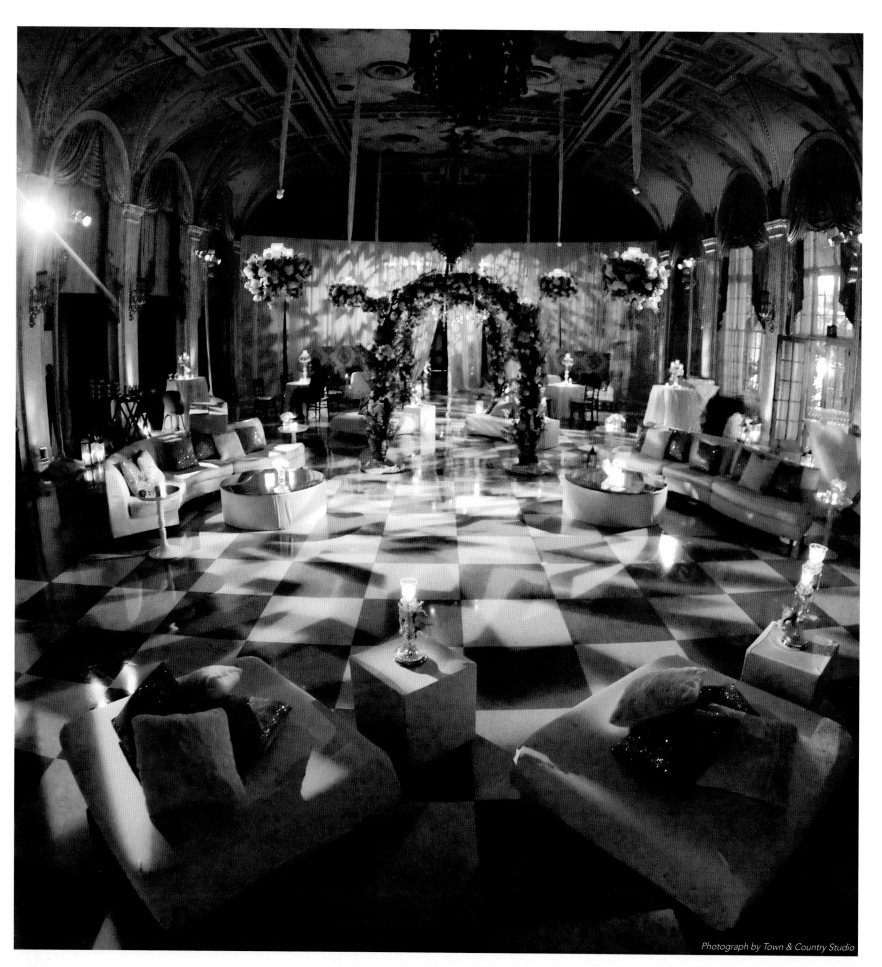

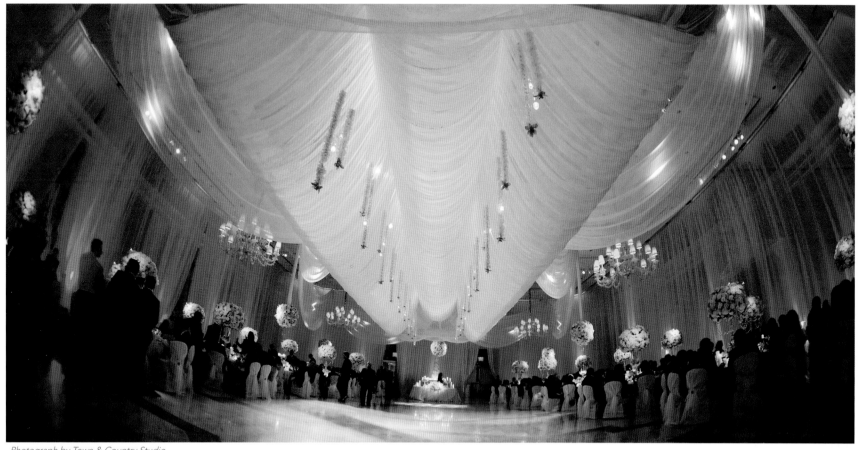

Photograph by Town & Country Studio

"To make a photograph speak, you truly have to capture the 'spirit' of the moment."

—Patty Daniels

It's really incredible to have so many world-class destinations right here in South Florida. The Breakers is one of those places that's inspiration all by itself, even before the event décor is in place and guests arrive.

Photograph by Town & Country Studio

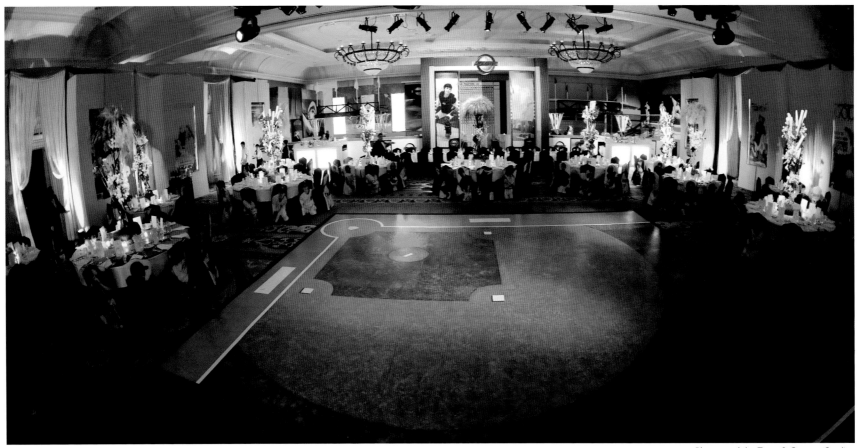

Above & left: Elite events accommodated at The Ritz-Carlton on Key Biscayne are fabulous and artistic inside and outside.

Facing page: Boca Raton is known for high-end venues like Woodfield Country Club. It is fun to photograph in a country club setting and watch what goes into the transformation of a ballroom. These affairs are often intimate and can take on so many different themes and textures for wonderful and interesting photographs.

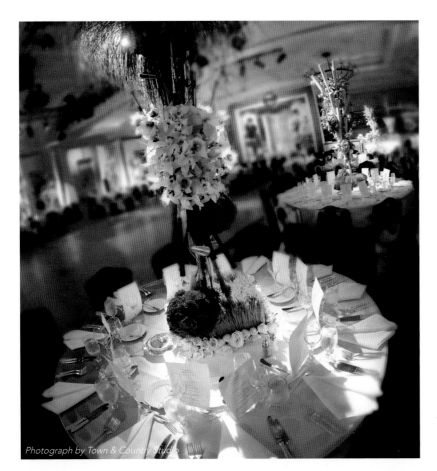

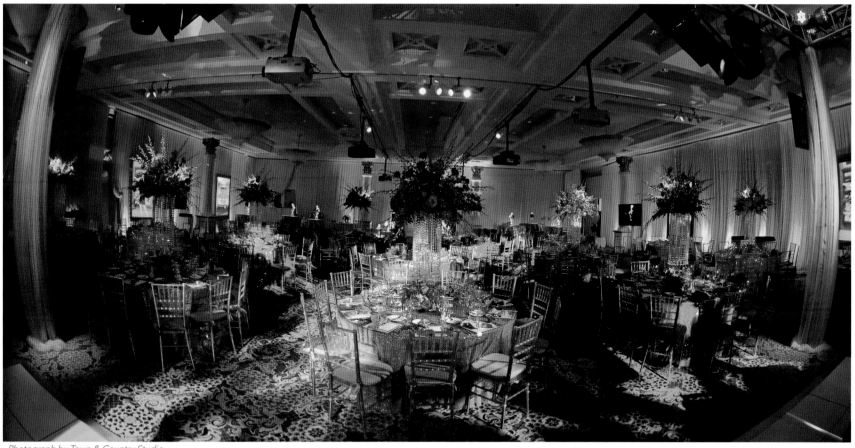

Photograph by Town & Country Studio

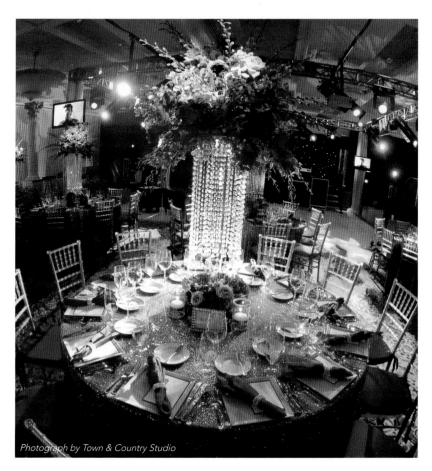

Photograph by Town & Country Studio

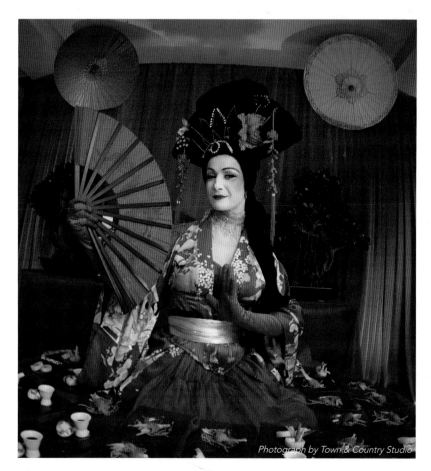

Photograph by Town & Country Studio

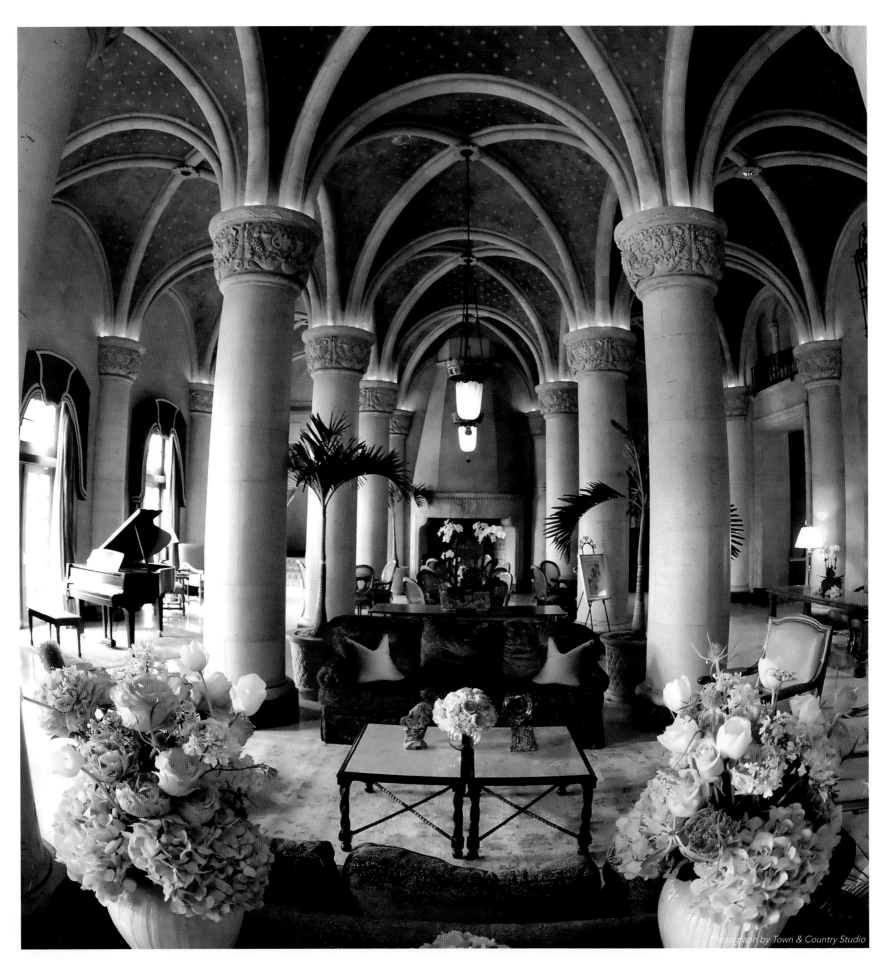

Photograph by Town & Country Studio

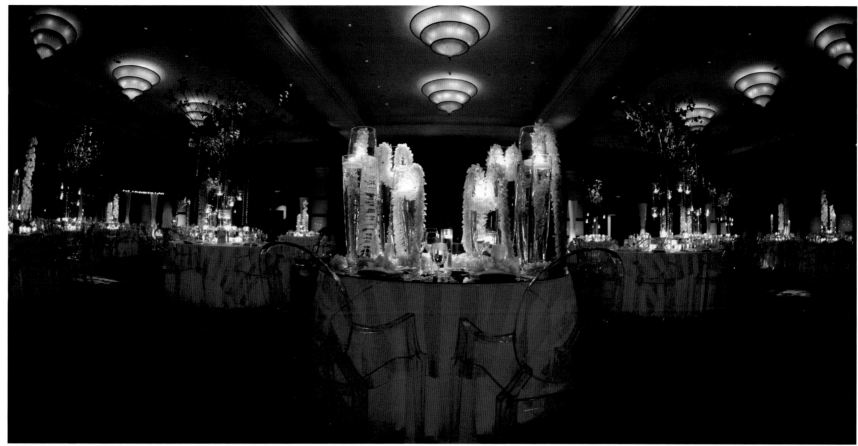

Photograph by Town & Country Studio

Above & right: So much time and attention is spent on the aesthetics of events, and they're often nothing short of exquisite, especially at Mandarin Oriental, Miami. Lighting is key and the room photographs like a dream, but when you get right down to it, the people are what make events unique and special. We don't set out to just photograph people but rather the essence of their personalities and relationships with one another.

Facing page: The Biltmore is a historic landmark hotel that has unique character and Old World tropical charm.

Photograph by Town & Country Studio

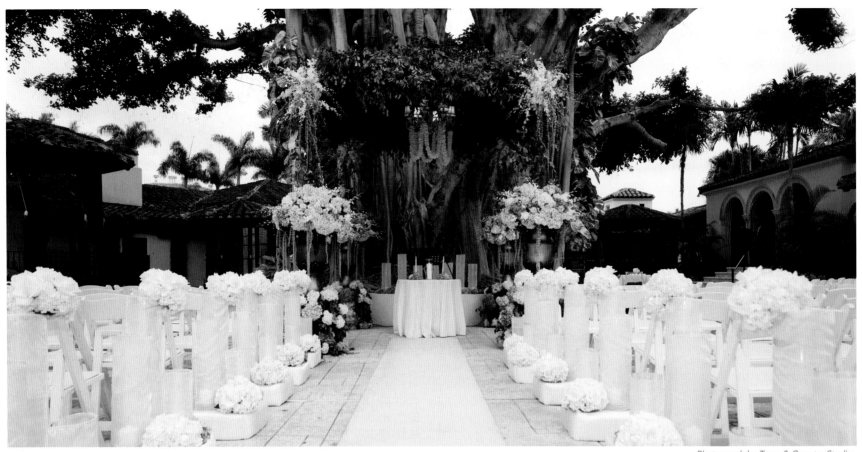

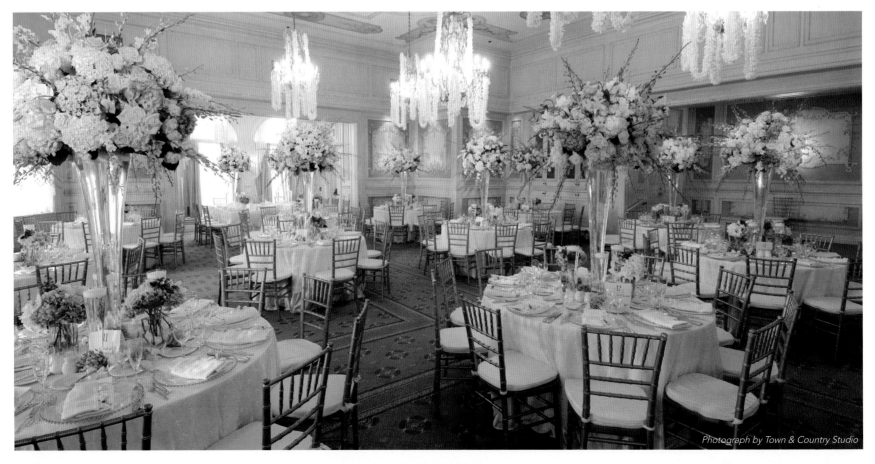

"It is a profound experience when we can translate people's chemistry to a single image."

—Patty Daniels

Right: The event was held at the picturesque nature center Fairchild Gardens during a Chihuly exhibit.

Facing page: Important days and moments in time only happen once. On Fisher Island in Miami, ocean breezes, freely roaming tropical birds, huge banyans and swaying palms create the posh setting where celebrities and the elite live and play. Although it requires a tremendous amount of work and creative energy, photographing events on this island can be a wonderful getaway while shooting a spectacular event.

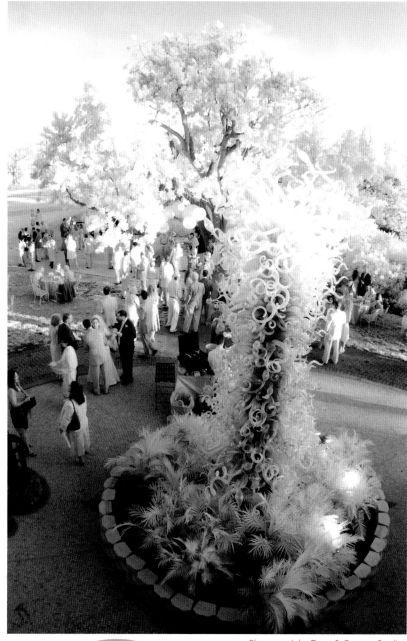

Photograph by Town & Country Studio

views

Capturing an event is like being a storyteller, a digital writer and a visionary. Choosing your event photographer is one of the most important decisions you'll make, because it influences how you will look back on one of the most important days of your life!

MICHELLE McMINN PHOTOGRAPHY

MICHELLE MCMINN

Photographing parade entertainers in Bali, wildlife in Africa, partygoers in Delray Beach and countless other interesting happenings around the globe, Michelle McMinn has come to appreciate that one turn of the head can make all the difference.

Wherever she's shooting, Michelle is entirely focused as she continually scans the scene for an embrace, a glance, a smile that simply says it all. She photographs each moment as if it were part of her own family's story, unable to draw herself away for even a minute's break, until every guest has departed.

More than two decades ago, inspired by her beautiful first-born child, Michelle picked up a camera and saw the world in a whole new light. Her portfolio grew organically through referrals, and the enterprising single mother of two was able to successfully combine her passion for people with her knack for photography in a career that she wouldn't trade for the world. Though legendary entities like The Breakers and The Ritz-Carlton in addition to Mar-a-Lago and The Four Seasons share her name with their most exclusive patrons and she serves as the resident photographer for many celebrity families, Michelle is quick to demonstrate that she's totally down to earth and feels blessed to have the opportunity to capture the most meaningful moments of people's lives.

Set in quite possibly one of the most famous ballrooms in the country, the event required a gentle photographic approach. The glass dome and wall of windows made for a continuously changing lighting design as the sun went down. There's so much history to The Breakers Palm Beach—countless famous people have danced and celebrated there. It's truly an inspiring place to photograph.

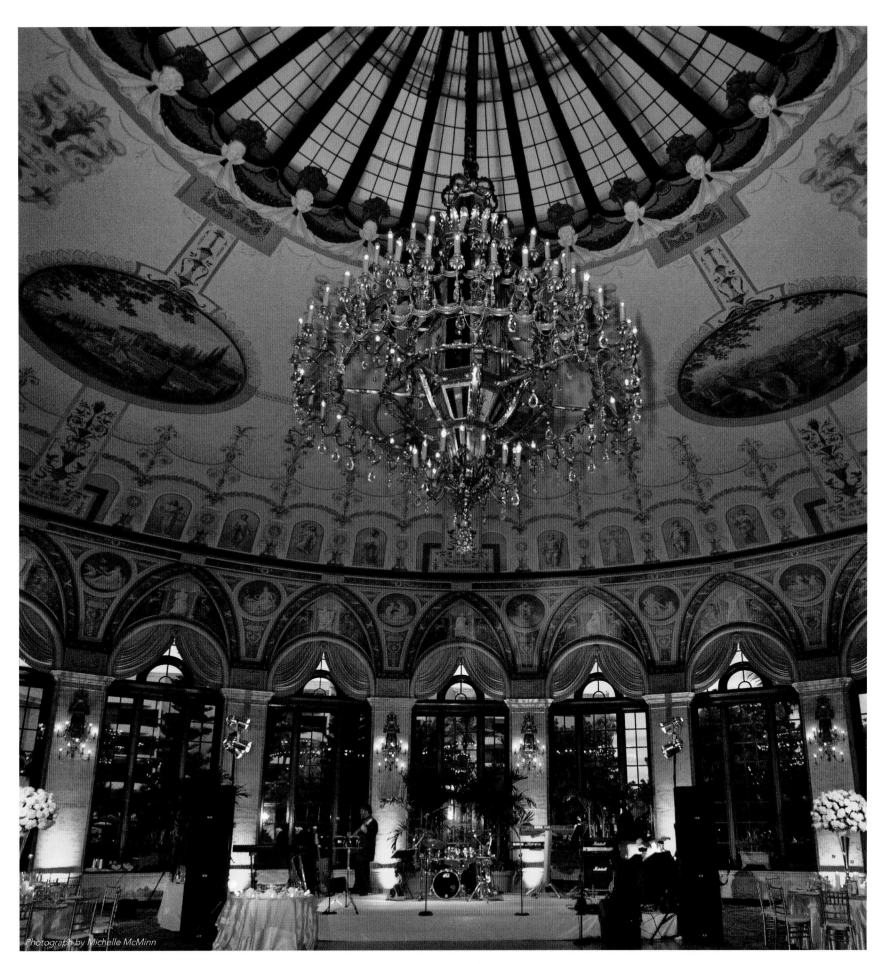

Photograph by Michelle McMinn

Setting the mood for an entire event is extremely important, which makes it imperative to photograph even the tiniest of details. Regardless of the occasion, my goal is to capture every little aspect; sometimes guests and even hosts are so caught up in the moment that they miss a few details the first go-around, but they sure appreciate them after the fact—flipping through an album is like going to a party all over again.

"Photography is about the human experience."

—Michelle McMinn

Photograph by Michelle McMinn

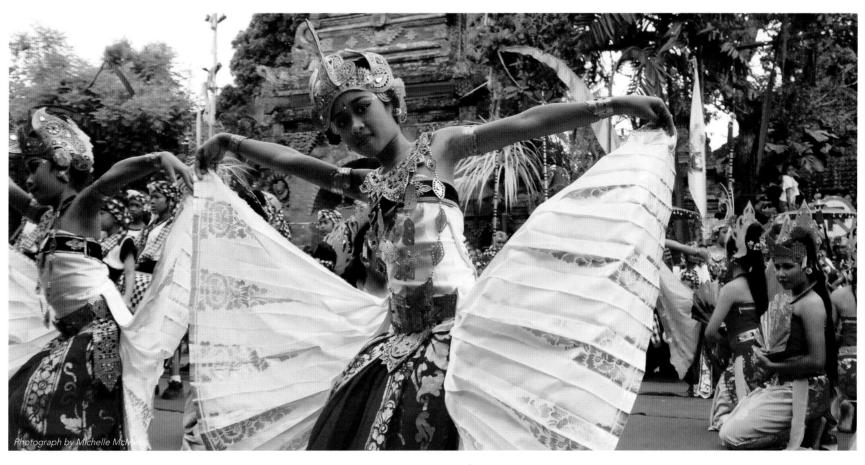

Photograph by Michelle McMinn

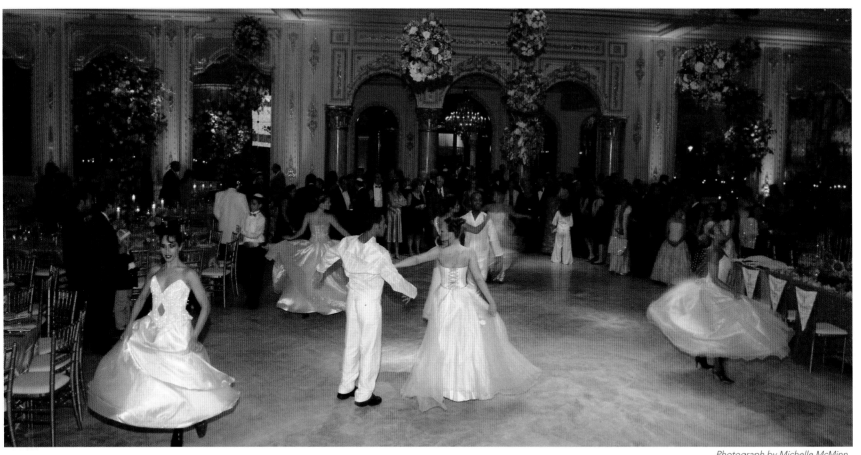

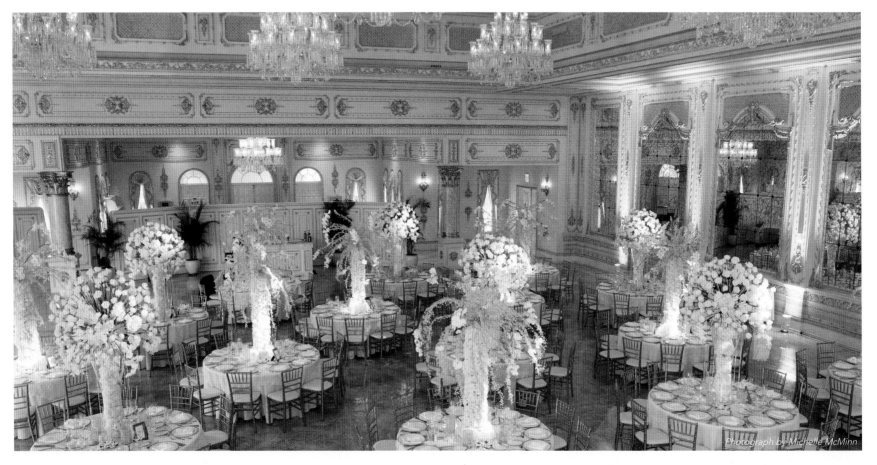

"Special events require months and months of hard work and planning. It's amazing that a single image can communicate all of that effort and creativity."

—Michelle McMinn

I love what I do, and I want others to love my work, so I spend a lot of time visiting with people to figure out what they're all about, what they're looking for. The visual appeal and aesthetic of the illustrious Mar-a-Lago ballroom creates the ambience, but the event isn't about tables and chairs—it's about people, memories. My work is intuitive, based on my understanding of people's history and motivations as well as the purpose of their engagement. That's what I capture.

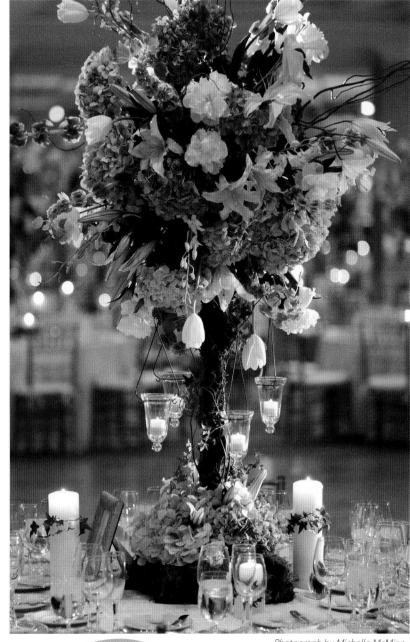

Photograph by Michelle McMinn

views

I've been on both sides of the camera. When you're choosing a photographer, make sure that you not only like the person's work but that the person is someone you feel that you can trust. You want to be totally confident that whoever you choose is wholly devoted to artfully capturing your event.

TROY CAMPBELL PHOTOGRAPHY

TROY CAMPBELL

Before every celebration, there is a perfect moment just before the guests begin to arrive. The event space is luminous, the food is carefully arranged, every elegant detail is in place; one can feel the anticipation. Fortunately, what will fade from the mind in time Troy Campbell captures for event designers and families.

Evolving his talent for photography into a successful career, the Miami native entered the photography scene as Miami was becoming a hot spot for film and production. The fortuitous timing allowed him exposure to many different genres and techniques in photography. Noticing something special in the young photographer, a marketing director suggested Troy explore still-life photography. He not only had an aptitude for it, he was hooked.

Troy feels his job is not to merely document. He strives to breathe life into a space and to tell the story the event designer has envisioned. He does this not only by shooting large overall shots but also by capturing beautiful details and vignettes. His great technical ability and creativity produce the same results every time: beautiful.

There are times when designers want photos focused on certain elements of their vision. One example of this is seen in the dramatic glassware shot.

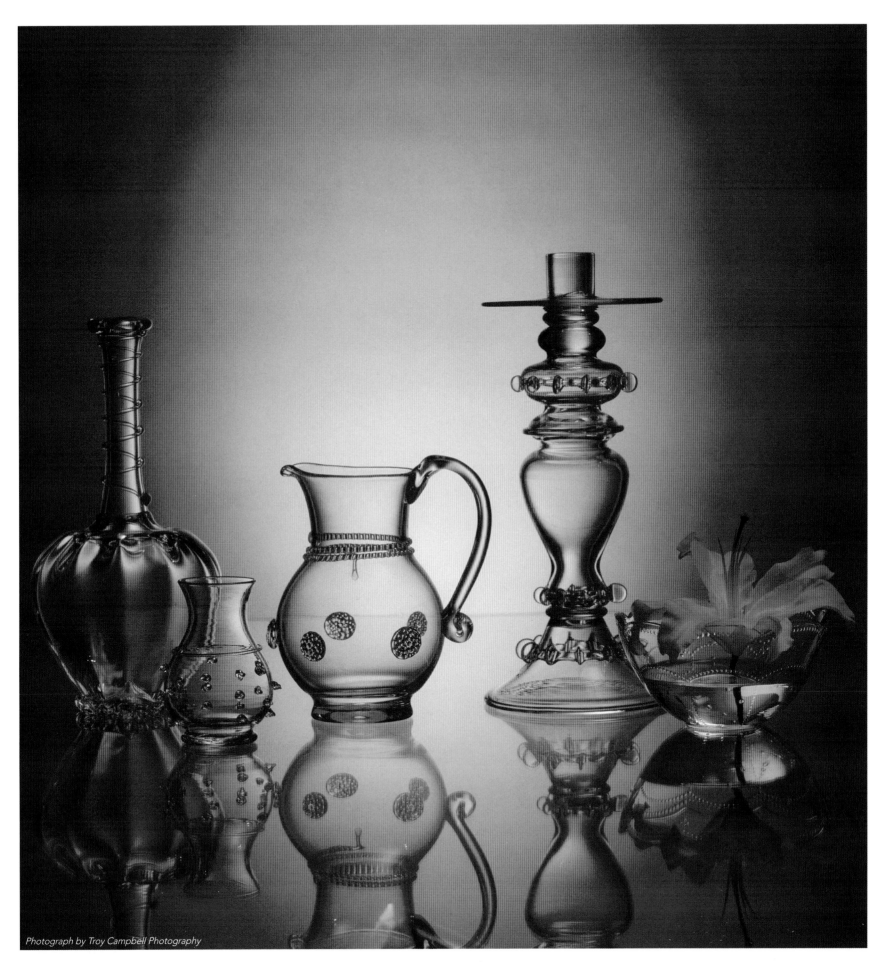

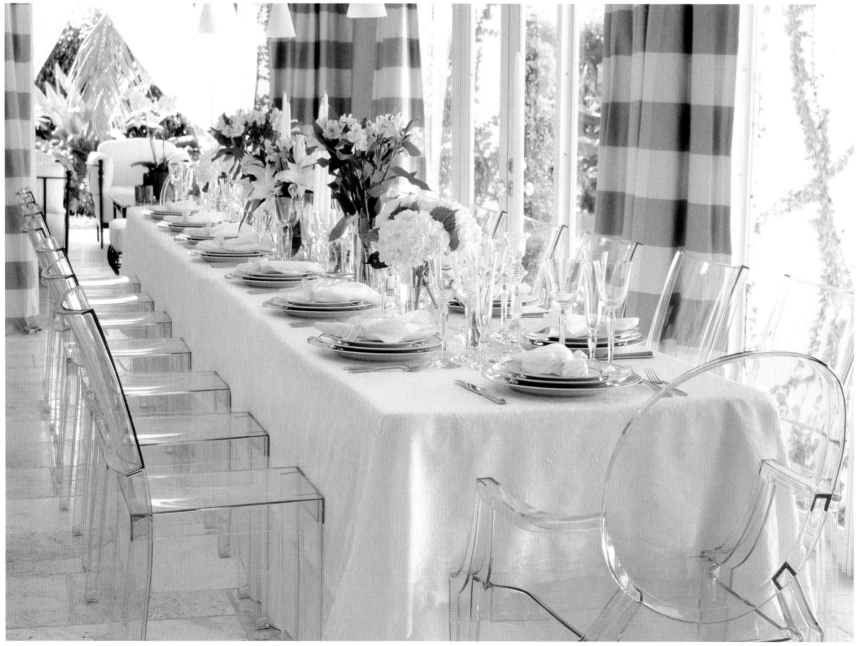

Photograph by Troy Campbell Photography

Above: The goal of my photos is to make the viewer want to be there. There is a softness and leisurely feel to the dining area, which is very inviting. Expansive windows allow natural lighting to spill into the room. One might think that with all this natural light a photographer's job is done. However, getting a natural look often times requires some synthetic lighting. Without lighting, the shot would have appeared distractingly dark on the left side. In a shot like this, my lighting should blend seamlessly with the ambient light so as to do its job and not be obvious..

Facing page: Not all events are formal. That needs to be reflected in the photos. Hamptons picnic-style events will have a very different feel than formal indoor affairs. I create this by shooting "perfectly imperfect." Not everything in the photo needs to be in focus. It is also important to me to capture the food with the reverence it deserves; I know it is created with as much artistry as the overall event design.

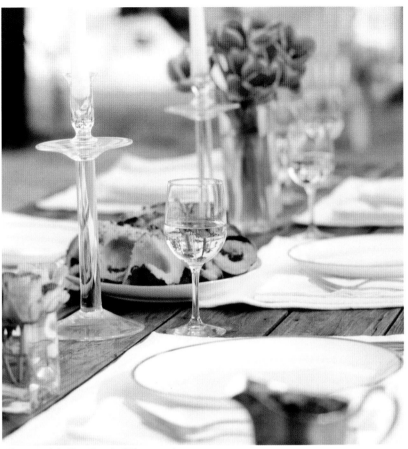

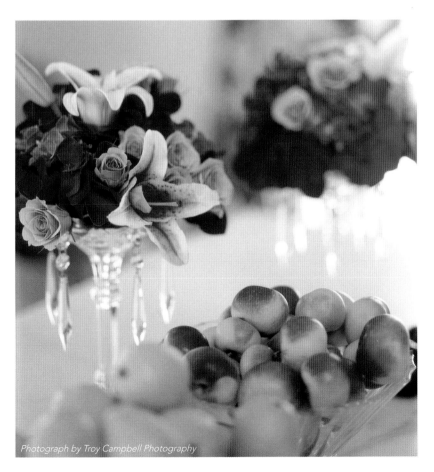

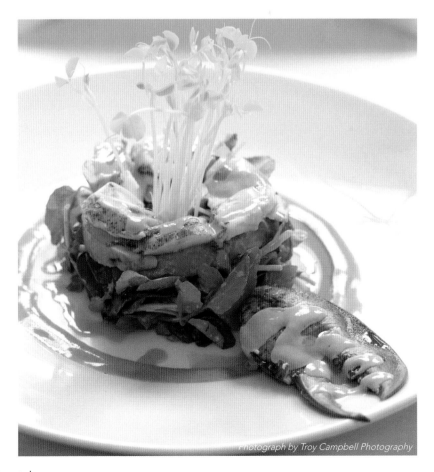

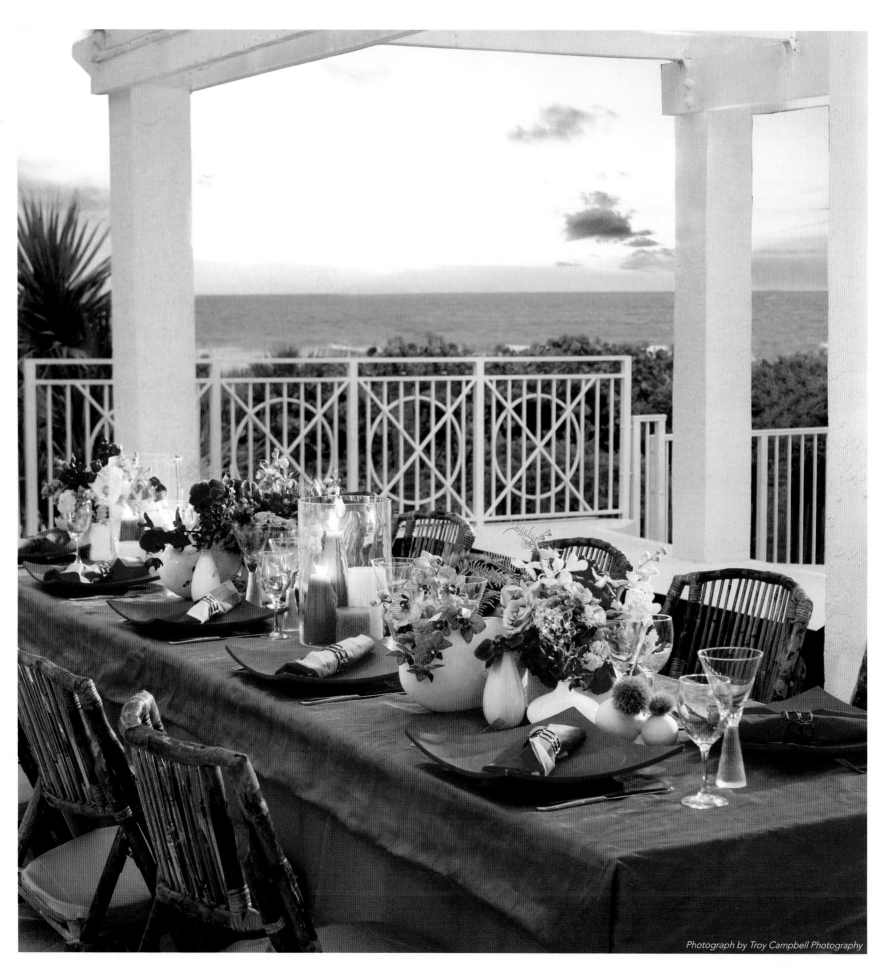

"I capture the scene at its ideal; the way the event designer dreamed it would look."

—Troy Campbell

Right: It is important to get the overall shots of the event and then go back in search of its striking details. Colorful drinks and an orchid floating in water offer a different reaction altogether than an all-encompassing view of the table.

Facing page: Some of the most dramatic and romantic shots are the ones captured at twilight or "magic hour," just as the sun has gone down. The table is lit naturally only by candlelight. I then gently added some of my lights to enhance and register what the eye actually sees in person. There is beautiful contrast between the colorful table in the foreground and the somewhat muted background.

Photograph by Troy Campbell Photography

views

❖ Try to allow the photographer ample time to capture everything before the guests arrive. Some designers will actually do a few table settings away from the party just for photography.

❖ Don't hire the same photographer who is shooting the people at the event to shoot the still-life pictures. The techniques and equipment are completely different for the two fields of photography.

THE ZANADU GROUP

CHERYL BEITLER

If people are the heart of an event, the entertainers are its soul. The Zanadu Group is proud of its ability to merge both heart and soul to create the perfect sensory and visual experience. Cheryl Beitler founded Zanadu in 1985 as an entertainment company, providing interactive performances and specialty acts for all types of events—from halftime shows to company meetings, bar mitzvahs to trade shows.

The firm, which now includes Kendall Barnes, Director of Entertainment Logistics, has since broadened its focus to produce all aspects of an event's planning and creative production, but its theatrical roots still infuse every element with energy, passion and wonder. Because of Cheryl's exuberant persona, she has an intimate knowledge of what it takes to engage and transport an audience through performance art coupled with an intrinsic love for people—the perfect recipe for throwing an unforgettable party.

Zanadu has become synonymous with providing a customized brand of entertainment that caters to the specific needs of the hosts' vision of the party and the event they are producing. All elements—lighting, sound, music, costumes, and makeup—must work together to create an experience larger than the sum of its parts, and Zanadu has a definite knack for achieving this Gestalt effect. For more than two decades, its professional staff has been able to provide its clients full-service production based on the expertise of its creative and technical staff and incredibly gifted executive producers.

But talent and experience alone aren't enough. To create a truly memorable event, you've got to put all of yourself into it. The Zanadu Group settles for nothing less from the performers in every event it produces, and it shows—powerfully, exotically, soulfully.

Sharing the excitement of the experience brings people together. Haute Chile, a 15-piece band, fuses incredible music and energy and electrifies the guests' unforgettable experience.

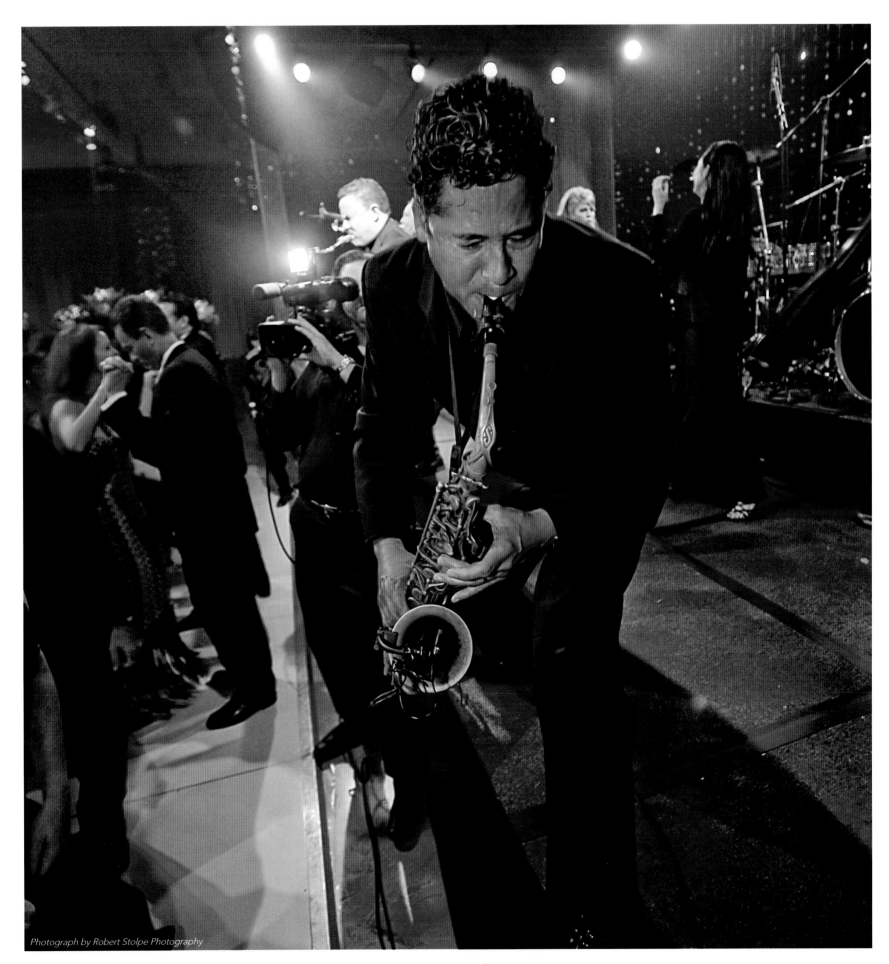

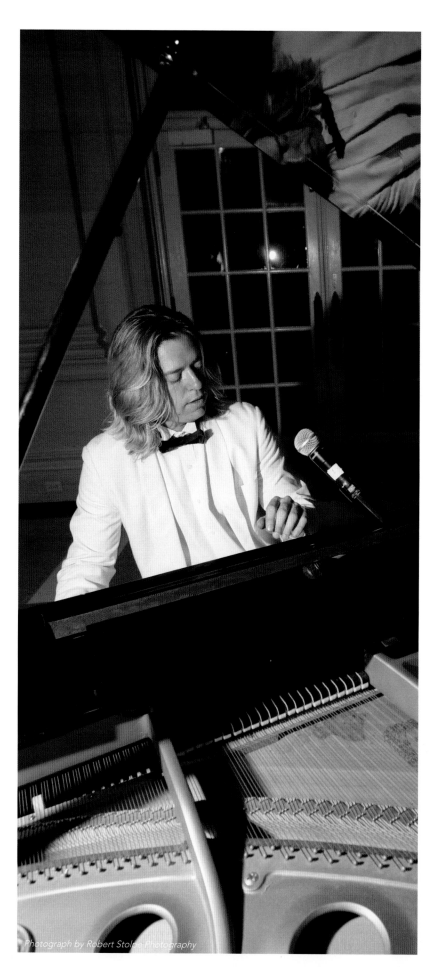

"Interactive entertainment means that the guests and hosts are part of the act. I dare you to embarrass yourself!"

—Cheryl Beitler

First impressions are everything. Having a musician singing and playing beautiful music at the party's entrance sets the tone, letting guests know the night will be elegant, sophisticated, fun, and full of surprises.

Zanadu works with brilliant dancers and choreographers and trained dancers who perform in amazing costumes and know how to identify with their audience. From culinary cabarets to Broadway revues—they can do it all. Incorporating dance is a great way to create that element of surprise. Polynesian dancers can wow guests by incorporating acrobatics and fire, while ballroom dancers can turn a corporate event into "Dancing with the Stars." But whether conservative or edgy, dance lends drama and intrigue that's sure to inspire.

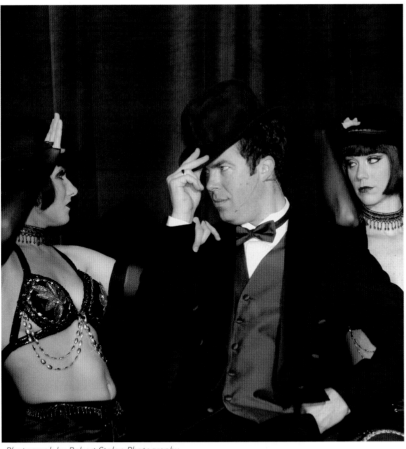

Photograph by Robert Stolpe Photography

Photograph by Event Show Productions

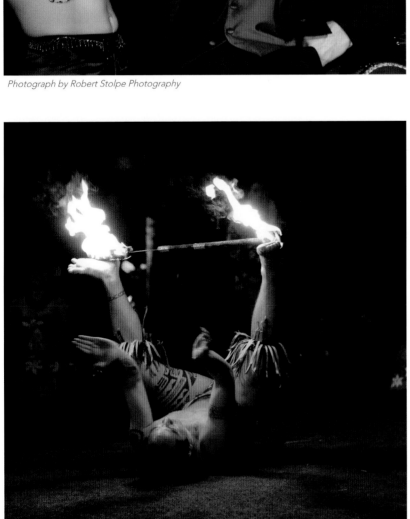

Photograph by LILA PHOTO

Photograph by LILA PHOTO

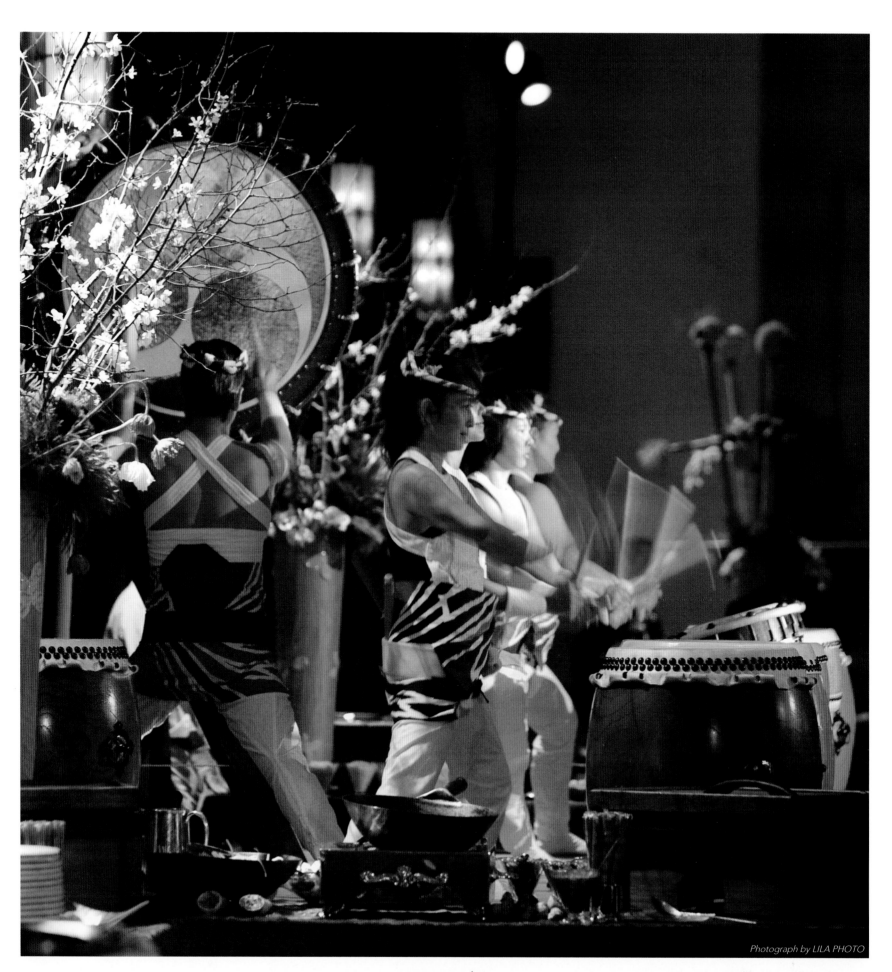

Photograph by LILA PHOTO

"Lighting and sound give the party life."

—Cheryl Beitler

When executing a theme of a different culture for an event, it is important to make sure it is done with accuracy and sophistication. To that end, Zanadu is privileged to work with some of the most creative people in the industry, like the team from Design Studio at The Breakers. Together, they achieve the perfect balance of authenticity and fun. Seen here, the rhythm and grace of traditional Taiko drummers embody an Asian-themed event, while a "Geisha Fountain"—a woman in traditional Geisha garb whose fingers pour water supplied by a hidden pool—brings the magic of the culture to life in a new and whimsical way.

views

Event entertainment isn't limited to stage performances. Interactive experiences, such as beautiful models leading guests to their tables upon arrival, add a personal touch that truly brings the event to life and personalizes it for the guests. We've brought Oompa-Loompas to parties and cut holes in tables for actors to pop their heads through to entertain guests as talking fruit, to name only a few ideas. The range of creativity is infinite—use your imagination, and the possibilities are endless.

ART OF CELEBRATION

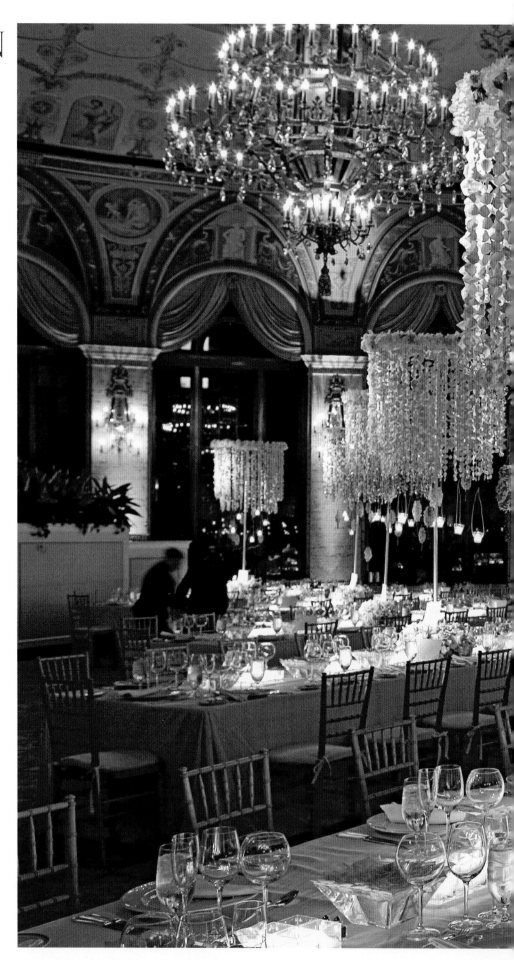

SOUTH FLORIDA TEAM

DIRECTOR OF DEVELOPMENT & DESIGN: Beth Benton Buckley

GRAPHIC DESIGNER: Ashley DuPree

EDITORS: Elizabeth Gionta & Anita M. Kasmar

MANAGING PRODUCTION COORDINATOR: Kristy Randall

HEADQUARTERS TEAM

PUBLISHER: Brian G. Carabet

PUBLISHER: John A. Shand

EXECUTIVE PUBLISHER: Phil Reavis

PUBLICATION MANAGER: Lauren B. Castelli

SENIOR GRAPHIC DESIGNER: Emily A. Kattan

GRAPHIC DESIGNER: Kendall Muellner

MANAGING EDITOR: Rosalie Z. Wilson

EDITOR: Michael McConnell

EDITOR: Daniel Reid

PRODUCTION COORDINATOR: Laura Greenwood

PRODUCTION COORDINATOR: Maylin Medina

PRODUCTION COORDINATOR: Drea Williams

TRAFFIC COORDINATOR: Meghan Anderson

ADMINISTRATIVE MANAGER: Carol Kendall

ADMINISTRATIVE ASSISTANT: Beverly Smith

CLIENT SUPPORT COORDINATOR: Amanda Mathers

Panache Partners, LLC

Corporate Headquarters

1424 Gables Court

Plano, TX 75075

469.246.6060

www.panache.com

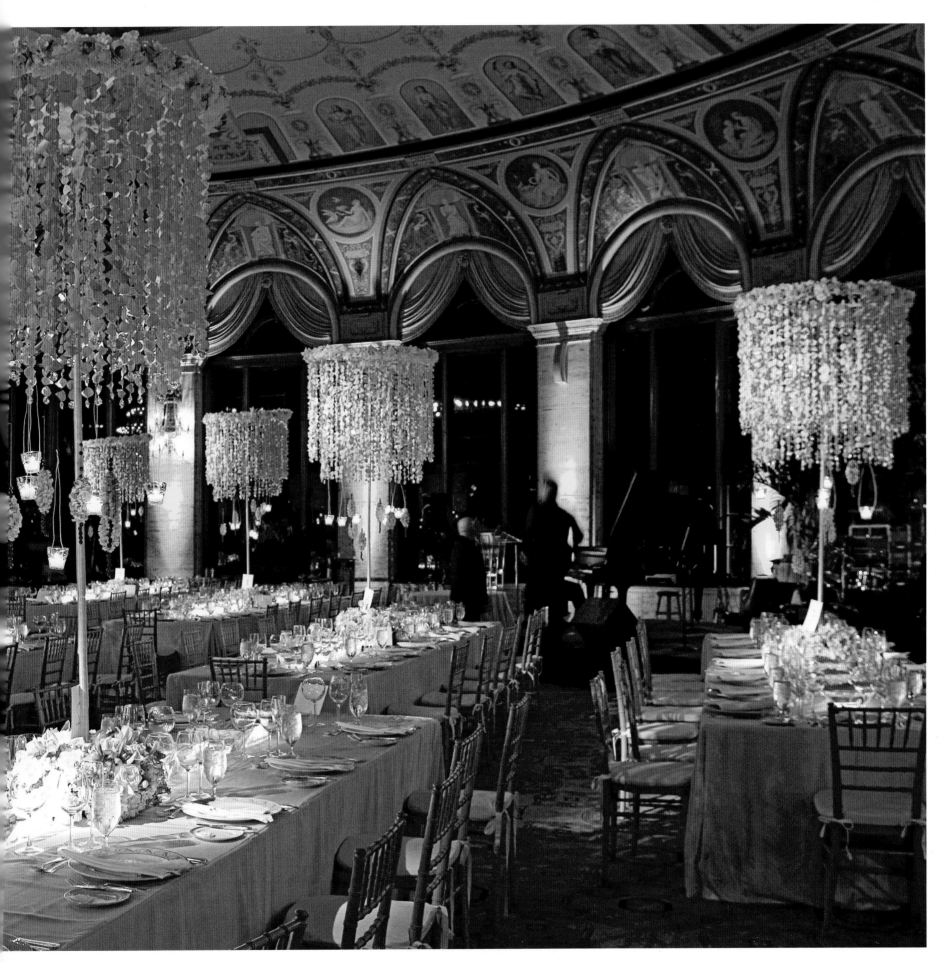

INDEX

THE PANACHE COLLECTION

CREATING SPECTACULAR PUBLICATIONS FOR DISCERNING READERS

Dream Homes Series
An Exclusive Showcase of the Finest Architects, Designers and Builders

Carolinas	New England
Chicago	New Jersey
Coastal California	Northern California
Colorado	Ohio & Pennsylvania
Deserts	Pacific Northwest
Florida	Philadelphia
Georgia	South Florida
Los Angeles	Southwest
Metro New York	Tennessee
Michigan	Texas
Minnesota	Washington, D.C.

Spectacular Homes Series
An Exclusive Showcase of the Finest Interior Designers

California	New York
Carolinas	Ohio & Pennsylvania
Chicago	Pacific Northwest
Colorado	Philadelphia
Florida	South Florida
Georgia	Southwest
Heartlands	Tennessee
London	Texas
Michigan	Toronto
Minnesota	Washington, D.C.
New England	Western Canada

Perspectives on Design Series
Design Philosophies Expressed by Leading Professionals

Carolinas	Minnesota
Chicago	New England
Colorado	Pacific Northwest
Florida	San Francisco
Georgia	Southwest

City by Design Series
An Architectural Perspective

Atlanta
Charlotte
Chicago
Dallas
Denver
Orlando
Phoenix
San Francisco
Texas

Spectacular Wineries Series
A Captivating Tour of Established, Estate and Boutique Wineries

California's Central Coast
Napa Valley
New York
Sonoma County

Art of Celebration Series
The Making of a Gala

New York Style
South Florida Style
Washington, D.C. Style

Specialty Titles

Distinguished Inns of North America
Extraordinary Homes California

Spectacular Golf of Colorado
Spectacular Golf of Texas
Spectacular Hotels

Spectacular Restaurants of Texas
Visions of Design

Panache Partners, LLC 1424 Gables Court Plano, Texas 75075 469.246.6060 www.panache.com

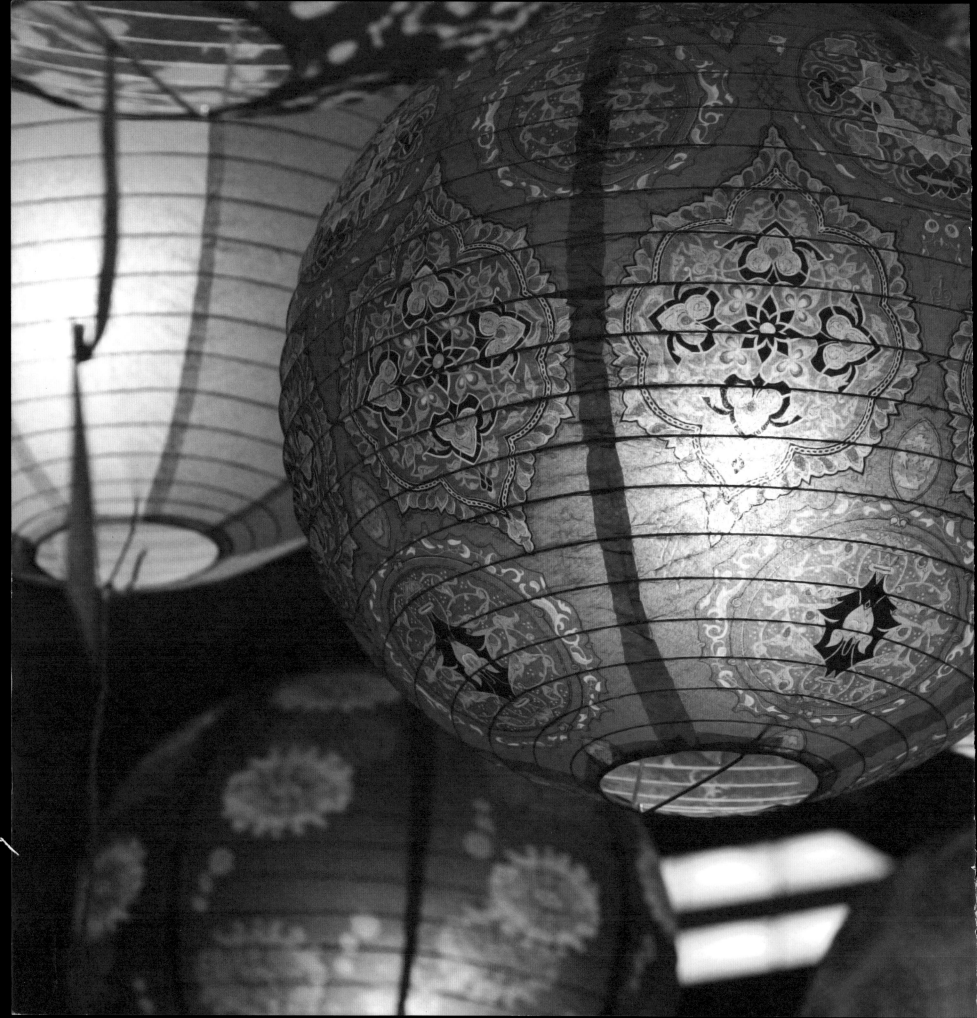